TRANSFIGURATIONS

TRANSFIGURATIONS

Studies in the Dynamics
of Byzantine Iconography

Anthony Cutler

The Pennsylvania State University

University Park and London

Publication of this book was assisted by the American Council of Learned Societies under a grant from the Andrew W. Mellon Foundation and the Slavic and Soviet Language and Area Center at The Pennsylvania State University.

Library of Congress Cataloging in Publication Data

Cutler, Anthony, 1934–
 Transfigurations.

 Includes bibliographical references and index.
 1. Painting, Byzantine. 2. Icon painting—Byzantine
Empire. 3. Christian art and symbolism. I. Title.
ND142.C87 755′.2 75-1482
ISBN 0-271-01194-7

Designed by Glenn Ruby

Printed in the United States of America

for Andrew

Contents

Illustrations

Abbreviations

AA. SS.	Acta Sanctorum . . . notis illustravit J. Bollandus, 59 vols., Venice, 1734–1940.
Acta Norv.	Acta ad archaeologiam et artium historiam pertinentia. Institutum romanum Norvegiae
A.J.A.	American Journal of Archaeology
Anthol. Pal.	The Greek Anthology, ed. Loeb, Cambridge, Mass., 1960
Art. Bull.	Art Bulletin
B.M.C.	W. Wroth, Imperial Byzantine Coins in the British Museum, 2 vols., London, 1908
B.M.C. Vand.	W. Wroth, Catalogue of the Coins of the Vandals . . . Thessalonica, Nicaea and Trebizond, London, 1911
B.S.A.	Annual of the British School at Athens
Burl. Mag.	Burlington Magazine
B.Z.	Byzantinische Zeitschrift
Cah. arch.	Cahiers archéologiques
C.E.B.	Actes (Atti, Berichte, etc.) des Congrès Internationaux d'Etudes Byzantines
C.R.A.I.	Comptes-Rendus de l'Académie des Inscriptions et Belles-Lettres
C.S.H.B.	Corpus scriptorum historiae byzantinae, 50 vols., Bonn, 1828–1897
D.A.C.L.	Dictionnaire d'archéologie chrétienne et de liturgie, ed. F. Cabrol, H. Leclercq, and H. Marrou
D.O.C.	A.R. Bellinger, P. Grierson, and M.F. Hendy, Catalogue of the Byzantine Coins in the Dumbarton Oaks Collection and in the Whittemore Collection, in progress, Washington, D.C., 1966—
D.O.P.	Dumbarton Oaks Papers
Δ.Χ.Α.Ε.	Δελτίον τῆς Χριστιανικῆς Ἀρχαιολογικῆς Ἑταιρείας
E.A.A.	Enciclopedia dell'arte antica, classica e orientale, 7 vols., Rome, 1958–66
Ε.Ε.Β.Σ.	Ἐπετηρίς Ἑταιρείας Βυζαντινῶν Σπουδῶν

Fel. Rav.	*Felix Ravenna*
Gaz. B.-A.	*Gazette des Beaux-Arts*
G.C.S.	*Die griechischen christlichen Schriftsteller der ersten drei Jahrhunderte*
J.H.S.	*Journal of Hellenic Studies*
J.Ö.B.G.	*Jahrbuch des österreichischen byzantinischen Gesellschaft*
J.R.S.	*Journal of Roman Studies*
J.W.C.I.	*Journal of the Warburg and Courtauld Institutes*
Mon. Piot.	*Monuments et mémoires publiés par l'Académie des Inscriptions et Belles-Lettres. Fondation Eugène Piot*
N.N.M.	*Numismatic Notes and Monographs*, The American Numismatic Society
P.G.	*Patrologia cursus completus, series graeca*, ed. J.P. Migne
P.L.	*Patrologia cursus completus, series latina*, ed. J.P. Migne
Πρακτικά	Πρακτικά τῆς ἐν Ἀθήναις Ἀρχαιολογικῆς Ἑταιρείας
R.-E.	A. Pauly and G. Wissowa, *Real-Encyclopädie der classischen Alterthumswissenschaft*, Stuttgart, 1894ff.
R.E.B.	*Revue des études byzantines*
Rend. Pont. Acc.	*Rendiconti della Pontificia Accademia Romana di Archaeologia*
Rev. ét. gr.	*Revue des études grecques*
Rev. ét. sud-est eur.	*Revue des études sud-est européennes*
Rev. hist. relig.	*Revue de l'histoire des religions*
Röm. Mitt.	*Mitteilungen des Deutschen Archäologischen Instituts, Römische Abteilungen*
R.Q.	*Römische Quartalschrift für christliche Altertumskunde und Kirchengeschichte*
Sem. Kond.	*Seminarium Kondakovianum*
Tortulae	*Tortulae: Studien zu altchristlichen und byzantinischen Monumenten*, Freiburg, 1966

Preface

It is always an invidious task to draw up a list of one's creditors and it is one that I admit I have shirked. So many men and women, Byzantinists and scholars in other disciplines, have given freely of their knowledge and good will that a list of them would by its length alone annoy as many readers of this preface as it might offend by its inadvertent omissions. Those who have helped will recognize their contributions in the body of the text rather than in citation in footnotes. I hope that I have neither betrayed their trust nor misrepresented their views where I have found it necessary to disagree.

The notes have generally been held to a minimum. The citation of sources and the customary record of reservations, qualifications, and exceptions do not aspire to be a rival text here. This is partly because I see no virtue in listing a lot of out-of-date references—"*die Wissenschaft des nicht Wissenswerten*," as Arthur Koestler put it in another context—and partly because Byzantinists possess two first-rate bibliographical tools. The *Dumbarton Oaks Bibliographies based on Byzantinische Zeitschrift*, now in progress, covers literature on all aspects of Byzantine art down to 1967 and, for painting, a succinct and generally accurate guide to the essential literature is attached to V. N. Lazarev's *Storia della pittura bizantina* (Turin, 1967). It is assumed that the reader wishing to pursue further a particular work will turn to one or other of these sources. I have generally confined my references to an adequate reproduction of a work of art under discussion, to credit an author whose idea I have borrowed, or to cite important commentary that has appeared since 1967.

If impersonality must attend those individuals who have advised me, I cannot neglect to name the two institutions under whose auspices this book was written. The American School of Classical Studies at Athens, by its award of the Gennadeion Fellowship, enabled me to draft the final version, a task only slightly less arduous than its preparation. The Institute for the Arts and Humanistic Studies and the Faculty Research Fund of the Pennsylvania State University supported my research in its preliminary stages for a length of time and with a generosity that imposes no inconsiderable obligation. To my wife who so intelligently corrected and typed the manuscript I owe a debt that cannot be repaid. This work is dedicated to my son, conceived, born, and grown almost *pari passu* with it.

I *The Dynamics of Byzantine Iconography*

Problems and Purposes

A cynical but half-true view of art historians asserts that for the critic concerned with style everything is different, whereas for the iconographer everything is the same. Historians of Byzantine art are presumably no more exempt from this stricture than students in any other branch of the profession. But, since this view is half-true, it is therefore half-false. There exist superb overviews of particular periods that include observations of stylistic connections no less valuable than the recognitions they contain of problems yet unsolved. Kitzinger's "Byzantine Art in the Period between Justinian and Iconoclasm" (Munich, 1958) and Demus' "Die Entstehung des Paläologenstils in der Malerei," given at the same Congress, are but two that spring readily to mind.

The truth of the dictum reposes rather in its second part and is justly applied to that traditional attitude toward iconography which is content to divide and subdivide the subject matter of Byzantine art into major and minor "set-pieces"—the Nativity, the Washing of the Child, and so on—ignoring variations in the elements of a picture and, worse, assuming that a particular element always conveyed the same meaning. These errors are, of course, not unconnected. The student who looks only at the whole misses those particulars that suggest that it may not be possessed of a consistent and immutable burden of significance. An even more dangerous assumption is that an image, say, of the Nativity conveys a meaning only *in toto* and that its constituent elements or motifs serve merely as inarticulate parts of a purposeful whole. This not only reduces an often highly complex iconographical statement to a set of types— which are themselves almost infinitely subdivisible—but neglects that which is the very raw material of the historian's profession: the evidence for the past of these parts. If these are ignored, then where they came from and what changes they may have undergone in their new context cannot be ascertained. And, in turn, if these readings are not taken, then observations as to a picture's significance are not conclusions but untested hypotheses. Gestalt psychology teaches that the whole may be more than the sum of its parts. But the art historian must at least admit the possibility that the constituent parts of an image, whether or not they have meaning in themselves, may have some bearing on the meaning of a picture as a totality. In this respect, the study

of Byzantine art is considerably in arrears of other areas of art history; and, in this sense, investigations of major compositions within Byzantine iconography are precocious. Until the history of the component parts of a picture is known, until their formal origins and subsequent transformations have been scrutinized, statements as to the significance of these major subjects are premature.

If the flux of form is the first part of any study of iconographical dynamics, changes in meaning are the second. To assert that a particular motif had significance is not to maintain that this significance was always the same. To attach a unique, unchanging meaning to a particular form is to substitute a millennial stasis for the history of Byzantine art. It is one of the purposes of this book to demonstrate an internal dynamism within the body of iconographical tradition, less dramatic perhaps than the much-studied diversity of styles that obtained at different times and in different parts of the empire but surely no less apparent to those who have advanced beyond the untrained eye's observation that "Byzantine saints don't move." Modulation of meaning is as much a part of the thousand-year evolution of medieval art as modification of form, for images are the creations of men and in their growth, diffusion, disintegration, and end reflect something of their creators. A motif is not only a physical object. It is not a salt crystal, identical whether formed in the fifth or the fifteenth century: a pre-Iconoclastic image revived in the Palaeologan era is not necessarily a mere replication. Much more than its original "style" may have changed. The meaning of an event or an image is contained within its history and this history is the sum of its elements. The form of a pitcher in the Washing of the Feet may or may not be significant. But this cannot be established without study of its details and a recognition of their historical dynamism.

Methods and Materials

Two such details, parts of pictures rather than well-known "set-pieces," are studied in the first two parts of this book. Both recur over a sizable chronological span yet neither has been investigated in terms of its evolution nor plotted across the range of its variants. It may be the number of these variants that has deterred previous historical scrutiny, for their classification—the determination of what is and what is not a formal mutation—lies at the heart of our chosen problems. This taxonomic approach must precede the attribution of significance to a particular motif. Indeed, only when a type has been established, its modifications recognized, and similar but historically unrelated forms noted and excluded is it permissible to suggest that the motif in question is in fact an element of iconography: that it carries with it a specific body of meaning. Even then there will be skeptics, against whom I can only say that my worm of doubt is two-headed and now attacks skepticism as it once attacked credence.

The belief that an image bears a load of significance not separable from its form can be supported, if never entirely corroborated, by the use of relevant and sometimes contemporary texts, but the art historian must be convinced of a motif's iconographical value above all by virtue of its repeated presence in works of art. Many iconographical

studies are based upon the existence of written documents that may illuminate the meaning of an image and may even be the source of that meaning. Here I have chosen ideas that to me appear to have their clearest expression in visual forms. Even where a motif such as the lyre-backed throne, the first to be studied here, seems to have had a literary origin, the development of the idea and its gradual incrustation with several and differing layers of meaning took place only after the words had been translated into images. The dynamic here is one of reinforcement, the throne used repeatedly and meaningfully in one context suggesting its application in others. That its visual expression came to prevail over its textual derivation could be demonstrated no more clearly than by the fact that the form persisted long after its pristine exegetical significance was forgotten. But our primary concern is with its origins. Only when the idea was expressed in line and color could its analogical relationship with similar forms be discovered and its range of connotations thereby be made susceptible to enlargement.

This happened, too, I believe, in the representation of proskynesis, our second subject of study. A gesture that was pagan in origin, in Christian hands it underwent a series of formal variations, some of which were incorporated in the iconography of the Anastasis. This complex image of the Resurrection could thereby draw on emotions and attitudes associated with prostrations in other contexts. Reciprocally, the significance of proskynesis—made, for example, before the emperor—was expanded in the light of its role as a constituent part of Anastasis iconography. In this case the dynamic direction is external, reverberations moving outward from the motif until they touched and affected quite another aspect of Christian art.

In our final study, devoted to an image that I call the Virgin on the Walls, we pursue not so much the varieties of a simple motif as a composite picture. Here the dynamism is additive, the totality of both form and meaning drawing on the history of the parts of which it is the sum. But, as is the case in the first two studies, its significance cannot be explicated solely in the light of seemingly germane texts. Not till the history of its constituent elements has been analyzed can its form and function as a monument be fully understood. Of the observations on method suggested here, only this is intended to be prescriptive. Given the much more sophisticated state of text criticism, it is primarily necessary to look after the images. The texts generally look after, and speak for, themselves.

It has been necessary to pursue our motifs across a broad range of artifacts, although it has not been my purpose to catalogue their every known application. The scrutiny of a form as it was variously expressed in the different techniques employed in Byzantium focuses attention upon the criteria necessary to the establishment of a type. Here, although this book is not primarily a collection of numismatic studies, the coins have been of major importance, constituting the longest and most diverse series of representations of our elements. Sometimes, as in the narthex mosaic at Hagia Sophia and on the *hyperpyra* of Andronicus II, motifs are used in conjunction, binding together in terms of practice, as we have connected in terms of method, the forms under surveillance. In this respect the coins are no less useful than the monumental works. More than a point of departure for each of these essays, they offer an indispensable set of controls—given their imperial sponsorship and considerable diversity—for the

heterogeneous aspects assumed by our motifs in both Constantinople and the provinces. By design, then, a great variety of forms in a great variety of media are considered here, even if only as candidates later rejected for their failure to conform to a determined type. This diversity is the very fabric of our investigation, for, as Francis Cornford said of his controversial theory of the origin of Greek Comedy, "the true test of a hypothesis, if it cannot be shown to be in conflict with known truths, is the number of facts that it correlates and explains."

I must hope that the hypotheses presented here meet with more approval than did Cornford's. The prime risk run by the student of iconography, as he seeks to connect apparently discrete images and probe the relationship between picture and text, is that of parataxis. He must be careful lest the links that he recognizes be forged in his own mind rather than in the minds of those who created the works he is studying. Against this danger, there stands the evidence of the monuments themselves and, above all, of what may be inferred from them concerning the working practices of Byzantine artists. Their major iconographical compositions depend upon long-established models and, as such, constitute a *prima facie* case for a tradition of significance handed down with traditions of composition and technique. However, their readiness to borrow motifs and figures, to vary them, and to use them in differing contexts and combinations raises the problem whether meaning inheres in these motifs and figures or only in the conjunction of such details. This is the question of the relationship between form and meaning that these studies set out to answer.

2　The Lyre-Backed Throne

The Coins

On the lunette mosaic above the Imperial Door that leads into Hagia Sophia at Istanbul, the colossal figure of Christ sits enthroned (Fig. 1). He gestures with his right hand, while his left holds an open codex. Flanking the throne are medallions containing images of the Virgin and an angel; below that of the Mother of God, a nimbate emperor prostrates himself. In the forty years since this mosaic was published,[1] virtually every aspect of it has been the object of detailed study. The vast literature on it includes precise measurements and observations concerning the mosaic technique. A place within the stylistic history of early Macedonian art has been assigned to it. Efforts to determine the iconographical relationship of the medallion figures to the enthroned Christ are exceeded in number only by the essays at identification of the emperor himself. Connections between the mosaic and the liturgy, on the one hand, and the imperial ceremonies, on the other, have been established. Finally, several attempts have been made to define the significance of the mosaic as a whole, to explain its unique assemblage of generally familiar motifs.[2]

Some of these endeavors are impressive in their achievement, others in their ingenuity. None except Whittemore, however, has paid more than perfunctory attention to the throne. Whittemore commented on its "great magnificence" but failed to record its precise dimensions, while noting, for example, those of the features of Christ's face and even the size of the accents on the book that the Lord holds. He described the carpentry techniques with which the frame of the throne is joined and, continuing in the unspoken assumption that an actual piece of furniture is represented here, suggested that "if the material of its structure is not metal, it is wood overlaid with gold studded with enamels, pearls and other precious objects."[3]

Speculation concerning the throne's substance seems to have precluded conjecture as to its significance. This is hardly surprising since, abjuring interpretation, Whittemore did not remark the peculiar curve of the throne's back, a form that Weigand had

1. Whittemore, *Prelim. Report, Narthex*, pp. 14–23.

2. To the bibliography assembled by Lazarev (*Storia*, p. 177, note 73) must be added Scharf, "Proskynese"; Breckenridge, *Justinian* II, pp. 49–51; C. Mango in H. Kähler, *Hagia Sophia* (New York, 1967), pp. 53–54; and the important record of E.J.W. Hawkins, "Further Observations on the Narthex Mosaic in St. Sophia in Istanbul," *D.O.P.* XXII, 1968, pp. 153–166.

3. Whittemore, *Prelim. Report, Narthex*, p. 17.

already noted as a specific type and characterized as "lyre-backed."[4] This designation may not satisfy those searching for a ready similarity with ancient or actual instruments but it does denote a form in which the upright members (or supports) of the throne's back curve outward from its seat to a pair of median points (demarcated by jeweled orbs in the tympanum mosaic), then return toward the crossbar that passes through them. At or slightly below this point—and in the mosaic evident only on what is from the spectator's point of view the right side of the throne—a reverse curve appears to begin. In numismatic examples of the form (Figs. 4, 9–11), as well as in numerous works in other media considered below, the reversal tendency described by the arc of the supports is expressed primarily in terms of out-turned finials above the crossbar.

So consistent is this change of direction—even though in degree it may vary greatly from one artifact to another—that it cannot be attributed simply to accidental variation induced by the motion of the drill in the die-cutter's hands.[5] Taken in conjunction with examples in mosaic and wall painting, on icons and miniatures, ivories, enamels, and metalwork, the term "lyre-backed" will be seen to define a type different from, if perhaps related to, throne-backs rendered in terms of simple, single curves that do not reverse themselves either below the crossbar or above it in the disposition of the finials (Figs. 3, 12). It is this distinction that Weigand was the first to glimpse and it is this formal discrimination that must precede any attempt to uncover the significance, if any, of the lyre-backed throne.

Following Weigand, although entirely ignoring his contribution, several attempts have been made to establish catalogues of the monuments in which the lyre-back occurs.[6] These have either omitted important representations or included others that do not meet the stringent criteria necessary to a definition of the type. Maintaining that the form was that of an imperial throne, Whittemore noted that it occurred on the coins of the period (as well as in the Paris Gregory, B.N. MS gr. 510) but failed to specify whether he was referring to the throne of the emperors on early Macedonian coppers (Fig. 4) or one of the various types Christ occupies on the *solidi* of the dynasty from its inception to the middle of the eleventh century (Figs. 3, 10–13).

The differences between the image of Christ Enthroned and the emperor enthroned on the coins of the first Macedonian emperor are significant. On the gold[7] (Fig. 3) the *Rex Regnantium* sits on a throne whose lobed back shows no sign of the double curve

4. Weigand, "Christogrammnimbus," pp. 67–69.

5. It is such variations that make dubious the designation as "lyre-backs" of many of the double thrones that appear on pre-Macedonian coins. (Cf. Breckenridge, *Justinian II*, pp. 49–50.) On the coppers of Justin II and Sophia (Fig. 6), for example, only one side of the throne-back is indicated; on those of Constantine V and Leo IV (Fig. 7), on the spectator's right, the curve of the back begins to reverse at the level of the crossbar but no such tendency is apparent on the left.

6. Lazarev, "Pisan School," p. 61, note 4; to Lazarev's list, Orlandos ("Monastère de Patmos," p. 286, note 1) added some eighteen examples. In his final publication of the Patmos frescoes ('Η αρχιτεκτονικὴ καὶ αἰ βυζαντιναὶ τοιχογραφίαι τῆς Μονῆς τοῦ Πάτμου [Athens, 1970], p. 125, note 1) he has expanded this list. For the numismatic versions, see now P. Grierson, *D.O.C.* III, 2, pp. 152–158. I am obliged to Timothy Gregory for some useful discussions of this evidence.

7. *B.M.C.* II, p. 436, no. 2, pl. L,12. Cf. *D.O.C.* III, pl. XXX,1–2.

evident on at least one side in the narthex mosaic at Hagia Sophia.[8] Much less of the throne's back is exposed on the coin than in the mosaic where major portions of the diaper-patterned upholstery appear on either side of the body. On the coin, Christ's right arm, extended beyond the limits of the throne, is a notable essay in fore-shortening and, as such, a more salient feature than in the mosaic, where the gesture is made in front of the chest. In the monumental work, again, little effort is made to differentiate between the positions of the feet, whereas on the coin Christ's right foot is out-turned to the point of being parallel to the throne.

Much closer to the mosaic in this respect is the slightly earlier copper coin showing Basil I alone (Fig. 4).[9] Neither foot is out-turned and large portions of the throne are not covered by the emperor's body. Nonetheless the imperial figure is here grossly disproportionate. The height of the triangular head is more than one-half the height of the seated body, in contrast to that of Christ on the *solidus* and the mosaic, where it appears respectively to be slightly more and slightly less than one-fourth the length of the body.

For our purposes, however, it is the shape of the throne that is of greatest moment: weakly drawn and pressed into base metal, under Basil I, the first true numismatic analogy to the *imagine* over the Imperial Door appears. Moreover, instead of being abandoned or improved, the type is preserved on the coppers of his son, Leo VI.[10] Whichever emperor, then, is represented in the lunette mosaic,[11] there circulated in the empire a contemporary representation showing the emperor seated on the same type of throne.

It has been maintained that the lyre-backed throne of the Macedonian era is no more than a resuscitation of the double throne found on imperial coinage from the fifth century onward.[12] Breckenridge recalls a *solidus* of Leo I and Leo II (Fig. 5),[13] a *follis* of Justin II and Sophia of about a century later (similar to Fig. 7),[14] and unspecified coins of the Iconoclastic period when the motif "was revived and used frequently." It can be inferred that in this belief he is followed by the author of the first volume of the recent Dumbarton Oaks Catalogue, who frequently recognizes the lyre-backed throne on coins of the sixth century.[15] The form of the throne-back on these

8. This and the immediately subsequent observations are intended as supplementary to the differences already observed by Bellinger ("Const. Porph.," pp. 152–153).

9. *B.M.C.* II, p. 438, no. 8, pl. L,16. Cf. *D.O.C.* III, pl. XXXIII,12.

10. *B.M.C.* II, p. 446, no. 7, pl. LI,12. Cf. *D.O.C.* III, pl. XXXIV,5. Both in this description and in that of Basil's copper showing the lyre-backed throne, p. 438, Wroth describes the throne as having "curved arms." On each coin it is clearly the contours of the back that are curved.

11. The debate is summarized by Breckenridge (*Justinian II*, p. 49, note 13). See also note 84, below.

12. Ibid., pp. 49–50.

13. Ravenna mint, Tolstoi, *Viz. mon.* III, pl. 8,2.

14. *B.M.C.* I, pl. XI,12. Figure 7 of the present study illustrates a copper minted at Cyzicus now at the American Numismatic Society. As on the piece cited by Breckenridge only one upright—that to the empress's left—is shown.

15. A.R. Bellinger, *D.O.C.* I, p. 59, nos. 7–9, pl. XII (*solidi* of Justin I and Justinian I, mint of Constantinople), pp. 204–205, nos. 22–24, pl. L (*folles* of Justin II and Sophia, mint of Constantinople). Where the same form of throne occurs on coppers minted at Thessaloniki (p. 221, nos. 65ff., pl. LII);

coins varies widely, as it does on both gold and copper Iconoclastic coins (Figs. 8, 9).[16] Sometimes a truly lyre-like shape is achieved; on others the double curve is represented by no more than a mere flange on either side of the seated rulers. But there are stronger reasons for believing that no *specific* throne is intended by the die-cutters. From the time of Zeno and the younger Leo (Fig. 6)[17] the *augusti* also appear together on thrones with rectilinear backs. The type of throne represented does not seem to be determined by any formal consideration: straight-backs, lyre-backs, and intermediate forms occur apparently indiscriminately during the same reign, issued by the same mint and bearing the same *synthronoi*.[18]

It does not necessarily follow that the lyre-back when it occurs on the double imperial throne is a mere ornamental motif, as we may suppose of that on the throne occupied by Christ and Mary in the late-thirteenth-century apse mosaic of S. Maria Maggiore in Rome (Fig. 36).[19] But it does mean that, as in the case of the Roman mosaic, we have no cogent reason to believe that the form of this back carries any peculiar load of ideological significance. Again, no more than for the medieval Italian composition is there occasion to suppose that the lyre-backed imperial throne reproduces an actual piece of furniture. To make this assertion is to be faced with a choice of absurdities: one must assume a plethora of thrones both single and double[20] in the palace; a succession of thrones varying widely in design made over the course of five centuries; or a particular *solium regale*, but one that could be represented in such highly diverse ways by the imperial mint that its sacred or political connotations had no relation to its form.[21]

In the light of the manifest differences of form between Christ's throne on the

Nicomedia (p. 226, nos. 92ff, pl. LIII–LIV); and Cyzicus (p. 236, nos. 117ff., pl. LIV), Bellinger does not remark the fact.

16. *B.M.C.* II, p. 382, no. 26, pl. XLIV,14 (Constantine V and Leo IV); p. 394, nos. 3–6, pls. XLV, 21, XLVI,1 (Leo IV and Constantine VI).

17. *Solidus* of 474. Tolstoi, *Viz. mon.* III, pl. 9, 3.

18. This is the state of affairs as late as 527, when Justin I and Justinian I appear on thrones with lyre-backs, rectilinear backs, and no backs at all. Cf. *D.O.C.* I, pl. XII, nos. 1–7a. It should be noted, however, that on coins of Leo IV only a lyre-like back is represented (Fig. 9). This would seem to suggest a deliberate revival of this particular type on the part of the Iconoclastic emperor.

19. H. Karpp, *Die frühchristlichen und mittelalterlichen Mosaiken in S.M. Maggiore zu Rom* (Baden Baden, 1956), p. 16, pl. 158. For the lyre-backed throne in medieval Italian art, see below, "The Throne in the West."

20. The deficiency of the theory that the emperor's lyre-backed throne was an actual object rather than an artistic and intellectual conception is peculiarly patent when the coppers of the first Macedonian emperors are considered. A coin issued presumably during the first eighteen months of his reign shows Basil alone on a throne that is manifestly lyre-backed (*B.M.C.* II, p. 438, no. 8) (Fig. 4). After his first son, Constantine, was crowned (6 January 869), the *augusti* appear together on a *straight-backed* double throne (*B.M.C.* II, pp. 439–440, nos. 17–20, pl. L,18). Basil's second son, Leo, then appears alone as emperor on a weakly drawn lyre-back (*B.M.C.* II, p. 446, no. 7, pl. LI,12); he also appears with his brother Alexander as co-emperor, on a straight-backed, double throne (ibid., p. 447, no. 11, pl. LI,14).

21. The argument for a particular form of throne rendered with greatly varying degrees of accuracy by artisans of greatly varying talent will not stand in the face of the often meticulous representation of such smaller regalia as the *labarum*, the *globus crucifer*, etc.

gold of Basil I (Fig. 3) and the Lord's seat on *solidi* of Leo VI and Constantine VII (Fig. 10), Bellinger proposed that the die-cutters were indeed emulating two different models. Observing the resemblance between the throne on the gold of Leo and that of the narthex mosaic, he suggested that the enthroned Christ on Basil's *solidi* followed instead the mosaic known from *de Cerimoniis* to have existed in the conch of the Chrysotriclinos.[22] At first sight an attractive if unverifiable hypothesis, this neglects some of the data that we do have and leaves several questions still unanswered. First, it does not take into account the clearly lyre-shaped, double-curved back of the broad throne on the coppers of Basil I (Fig. 4)—in each of these respects closer to the throne on the tympanum mosaic at Hagia Sophia than to that on his *solidi*. Second, there is nothing in the Porphyrogenitus' text to suggest the form of the throne represented in the Chrysotriclinos. If this image served "an imperial function such as that of over-hanging the throne,"[23] it is surely more likely to have resembled in some fashion one of the earlier diverse shapes of the *double* throne that include the lyre-back (e.g., Fig. 9b), the only known examples in which historical (as opposed to sacred) figures are seated in this manner. It is these double thrones that we see on imperial *solidi* from the middle of the fifth century (Fig. 5) to the last quarter of the eighth (Fig. 9). If a correspondence of form existed between the throne in the image and that of the *synthronoi* below, then Christ should have been borne on some long bench-like throne—unless we assume that Basil, rather than his predecessor[24] (if not indeed the emperor Tiberius Constantine, who first decorated the Chrysotriclinos, ca. 580), was responsible for the conch mosaic, which he then proceeded to have replicated in the imperial mint. Last, if, extrapolating from the simple, curved throne-back on Basil's *solidi* to the mosaic image, we conclude that the throne in the conch mosaic was not lyre-backed, what monumental model do we have for the indisputable lyre-backs of the non-numismatic, pre-Iconoclastic examples (Figs. 14–17) yet to be discussed, given that the lyre-backed throne of the narthex mosaic is unquestionably a post-Iconoclastic work?

What deserves investigation is not so much the difference between the known aspect of the throne in Hagia Sophia and the conjectural form of that in the Chrysotriclinos as that between the thrones on the gold and those on the coppers of the first two Macedonian emperors. A. Grabar pointed out that the coins of Basil I and Leo VI were the last to carry representations of the emperors enthroned and connected this fact with the new numismatic motif, introduced by the Macedonians, of Christ seated in this fashion.[25] But this useful observation should not obscure the corollary that for nearly half a century—the reigns of Basil and Leo—the images of both the King of Kings and the basileus enthroned circulated on the coinage. Under Basil the distinction between the earthly ruler and the Lord of All is made both in the metal employed and the type of throne represented. On the copper the emperor sits against a back, the borders of which are clearly double-curved (Fig. 4), but Christ, on the

22. *De Cer.* I,1, C.S.H.B., p. 22; cf. *Anthol. Pal.* I,106.

23. Bellinger, "Const. Porph.," p. 166.

24. A verse in *Anthol. Pal.* I,107, celebrates Michael III as the restorer of sacred images in the Chrysotriclinos.

25. Grabar, *L'Empereur*, pp. 25–26.

gold, rests on a throne that as yet shows no sign of these peculiar contours (Fig. 3). Under Basil's successor, however, the *solidus* (Fig. 10) shows Christ on a throne much closer in form to that on the mosaic in Hagia Sophia than to Leo's cumbersome seat on the copper.[26]

Nevertheless, even when the enthroned emperor disappears from the coinage, a uniform lyre-back does not become the standard type of the throne of Christ. The double curve of the back, so evident on the gold of Leo VI (Fig. 10), is replaced by a single curve on a *solidus* of Constantine VII Porphyrogenitus (Fig. 12). This coin, wrongly supposed by Wroth to represent the co-emperor Romanus I and his son Christopher, omitting Constantine from the obverse,[27] shows Christ on a throne without finials above the crossbar. These finials—compared to pine cones by Whittemore in his description of the lunette mosaic[28]—had expressed the outward deflection of the curved throne-back on the gold of Leo VI. Missing on the *solidus*, which in fact bears the images of Constantine and Romanus, there is no apparent reason to read this throne as a lyre-back, particularly when the coin is compared to one of the thirteen-month reign of Constantine's guardian, Alexander (Fig. 11).[29] Struck probably less than a decade earlier, here the extravagant finials leave no doubt about the double-curved profile of the throne's back.

In fact, the form of the throne's back presents variations of this sort down to its last numismatic appearance on a *trachy* of Constantine IX (Fig. 13),[30] where each finial above the crossbar consists of three pommels, much like a pawnbroker's emblem. Nothing is to be gained by an arbitrary decision as to which configuration constitutes the true lyre-backed throne; nor, on the basis of the coins alone, can we determine whether such a throne was a specific iconographical concept. This adjudication can only be made in the light of other expressions of the form, works of art great and small both in size and quality on the monuments that precede and succeed the mosaic over the Imperial Door.

The Virgin Enthroned in Pre-Iconoclastic Art

The numismatic evidence has aided little in the search for a precise iconographical characterization of the lyre-backed throne. Yet this testimony is valuable if only for what it does not tell us. The very variety of the thrones on the coins indicates that

26. *B.M.C.* II, p. 446, no. 7, pl. LI,12.

27. Ibid., pp. 458, note 2, 459–460, nos. 35–38, pl. LIII,1. For the chronology of the coins of Constantine VII, see Grierson, *D.O.C.* III, 2, pp. 533–536.

28. Whittemore, *Prelim. Report, Narthex*, p. 16.

29. *B.M.C.* II, p. 450, 1, pl. LII,1. Cf. *D.O.C.* III, pl. XXV,2.

30. *B.M.C.* II, p. 501, no. 8, pl. LVIII,11. Cf. *D.O.C.* III, pl. LVIII,1–2. Here, as in the narthex mosaic in Hagia Sophia, the tendency of the throne's curved back to reverse itself is evident only on the side to the spectator's right. The right finial is clearly deflected outward in contrast to the simple termination of the curve that it makes on the left. For the possible survival of the lyre-backed throne on coins of the Doukas dynasty, cf. p. 29 below.

the die-cutters were not seeking to reproduce an actual throne. The presence of the emperor on the earlier Macedonian coppers (and on the gold of earlier dynasties, if we accept the double throne as a type of lyre-back) indicates that the throne is not an attribute of the King of Kings alone; nevertheless, it is reserved for Christ on the obverse of *solidi* after the Iconoclastic Controversy, and on all coins after the death of Leo VI. It is in this reign that the Virgin makes her first numismatic appearance; yet neither now nor ever on the coins is she found seated on the lyre-backed throne.

For representations of the Mother of God in this fashion we must turn to a group of works hedged with problems, not the least of which are chronological. All of them are provincial works,[31] although the provenance of the portable examples is much contested. We are primarily concerned here with neither their origin nor their date. In every case ample iconographical problems remain: an elucidation of these enigmas might aid in and should certainly precede the resolution of these other questions.

Among the most problematical is the celebrated silver reliquary now in the cathedral treasury at Grado (Fig. 14). The author of the first extended discussion concerning the iconography of the lid, which bears the image of the Virgin and Child Enthroned, dated the reliquary possibly as early as the mid-fifth century.[32] Others refuse to countenance a date short of two generations later.[33] In 1936 Grabar drew attention to the novel manifestation of the Virgin Enthroned following the decrees of the Council of Ephesus and pointed to the source of this iconography in the latest aulic fashion, the portraits of empresses in the second quarter of the fifth century.[34] But this generic elucidation does not account for the Virgin seated on the lyre-backed throne, a particular collocation of images that occurs neither on the coins contemporary with this reliquary nor on those of any later date. A further difficulty is created by an as-yet-unremarked form of the throne's uprights. These are striated spirally as if to denote an origin in the horns of an animal. Although many lyre-backs are, as we shall see, left unadorned and many more encrusted with various arrangements of gens, I know of no form of throne with comparable uprights in Byzantine painting or sculpture in any medium.[35]

But the reliquary lid is anomalous in other and more striking ways. The Virgin seated *en face* bears, in addition to the Child, at least two unmistakable attributes of Christ.

31. The plethora of lyre-backs bearing either Christ or the Virgin on provincial works makes the numismatic evidence all the more important. The coins are, in fact, the only sure Constantinopolitan representations of the throne that we have before the tenth century.

32. Weigand, "Christogrammnimbus," p. 81.

33. Avery, "Alexandrian Style," p. 134; Arnason, "Early Christian Silver," p. 225.

34. Grabar, *L'Empereur*, p. 189.

35. The textual analogy that suggests itself, Exodus 38:2, which describes Bezaleel's decoration of the altar of burnt offering with horns, is hardly applicable here. The verse specifies that the horns were made of wood and overlaid with brass.

The horn-like uprights of the throne on the Grado reliquary evoke a passage in the *Homeric Hymn to Hermes*, ed. Loeb, lines 25–51, pp. 365–366, which describes Hermes' manufacture of the lyre using a tortoise shell, sheep gut, and the horns of an ox. K. Weitzmann (*Ancient Book Illumination* [Cambridge, Mass., 1959], pp. 129–130) has suggested that manuscripts of the Homeric hymns may have been illustrated with mythological scenes. Phyllis Lehman generously aided in the search for Classical analogies.

Arnason explained her cross-staff and the nimbus enclosing a version of the Constantinian monogram by suggesting that the image is copied directly from a representation of Christ.[36] This plausible hypothesis would seem to be borne out by other examples of iconographical "migration" in the early Middle Ages.[37]

The presence of the lyre-backed throne cannot, at this stage, be used to justify Arnason's hypothesis, for the Virgin is found in this situation on three major monuments of the period. Closest in form to the horn-like uprights of the throne on the Grado reliquary is the one surviving member on the celebrated "palimpsest wall" at S. Maria Antiqua in Rome (Fig. 15), although this painting may well be the latest in the Virgin group.[38] Here the upright is adorned with cabochons alternating with rows of pearls but the decoration is surely intended to be that of no actual throne. Rather it is an extension of the rich regalia worn by the Virgin and serves to separate the iconic frontal image of the *Regina Coeli* from her minister offering a crown. The air of majesty that permeates what is left of the composition is imparted not only by the overall profusion of ornament but also by such details as the *mappa* that she holds and the remote, unfocused gaze of the Virgin and her attendant angels.

Van Marle's supposition that the original ensemble represented a *majestas* of the Virgin flanked by angels[39] is strengthened by what we know of two mosaics, one entirely lost, the other badly damaged—both depicting the enthroned Virgin, holding her son before her and guarded by deferring angels. Beside her, in a mosaic in the inner north aisle at St. Demetrius, Thessaloniki (destroyed by fire in 1917), the angels stood close enough to be partially covered by the uprights of the throne (Fig. 16). Turning toward the Virgin, they each grasped one finial of the throne while, from between the uprights, the Child and his Mother gazed with stern frontality into the spectator's space. To the Virgin's right, the small figure of St. Demetrius accompanied a donor; to her left, an orant saint, possibly St. Theodore, completed the group. The composition was presumably an ex-voto image made by some local artist and has generally been dated to the end of the sixth or the first half of the seventh century.[40] Recently, however, in the light of detailed and previously unpublished watercolors made in 1909, R. S. Cormack has suggested that the series to which the mosaic of the Virgin Enthroned belonged may have been as old as the late fifth century.[41] If correct, such a date would make the Virgin of the arcade spandrel at St. Demetrius the oldest known representation of a

36. Arnason, "Early Christian Silver," pp. 212–215.

37. A similar, if later, "provincial" conflation of the iconography of Christ with that of the Virgin is to be found on a ninth-century slab relief at Breedon in Leicestershire (D. Talbot Rice, "Britain and the Byzantine World in the Early Middle Ages," Athens Catalogue, pp. 31–32, fig. 8. Here a half-length figure of the Virgin makes a Christ-like gesture of benediction and holds a codex.

38. See Lazarev, *Storia*, p. 96, n. 12, to which must be added Matthiae, *Pittura romana* I, pp. 117–124, suggesting a possible date of ca. 600–620. For our purposes it is important to note that Kitzinger, Lazarev, and Nordhagen, although differing on the date, recognize in this group of frescoes the use of Constantinopolitan models.

39. Van Marle, *Italian Schools* I, p. 48.

40. Cf. Lazarev, *Storia*, p. 73.

41. R.S. Cormack, "The Mosaic Decoration of S. Demetrios, Thessaloniki, in the Light of the Drawings of W.S. George," *B.S.A.* LXIV, 1969, pp. 17–52, pls. 3, 7.

sacred figure on a lyre-backed throne, possibly excepting only the Grado reliquary.

The drawing published by Cormack gives us probably as precise a knowledge of this mosaic as we shall ever have. It confirms the fact that the throne here differs from that on the Grado reliquary and the wall painting at S. Maria Antiqua in one important fashion. In these examples, the lyre-like double curve of the uprights occurs below the crossbar: in what we might call this "Italian" type, the finials are mere extrapolations of the already out-turning line of the supports. But on the throne in the Thessalonican mosaic the uprights form a simple curve, the direction of which begins to reverse itself only with the finials. In this respect the form of the throne is close to that found on coins of the tenth century (Figs. 10, 11). On those Macedonian *nomismata* where the finial is in evidence, the reverse curve begins only above the crossbar rather than midway along the upright, that is to say at the Virgin's elbow in the Italian examples.

The difference between these two types is not an absolute one and there are several intermediary forms. Nor does the distinction we have made entitle us to designate the Constantinopolitan type as the "true" lyre-back and to deny this epithet to the Italian. But it is remarkable that it is the Italian type, with its manifest double curve, that is used later in Roman and Sicilian mosaics (Figs. 33, 34), whereas the Byzantine examples will generally continue to employ the form we have seen on the imperial coinage, where the reverse curve is expressed only above the crossbar (e.g., Figs. 29, 31) or where, as in the lunette mosaic at Hagia Sophia, the axes of the finials are perpendicular to the crossbar and no double curve is apparent. The formal distinction is a matter of style that may be helpful in determining the provenance of some portable works displaying the lyre-backed throne but not the peculiar significance of the throne itself. The most important difference between the Italian and the Byzantine examples is, as we shall see, one of iconographical context and not one of form.

For the moment it may be noted that where in Byzantine art the lyre-back bears the Virgin and Child, the Child always grasps a scroll. But on the Grado reliquary and at S. Maria Antiqua, Christ holds a codex. This feature, as much as the often remarked "Western" crown of the Virgin, distinguishes the Italian from the Byzantine iconography. The rotulus is evident, for example, in the hands of the Child—the only figure that is almost entirely undamaged—in the apse of the Panagia Kanakaria, near Lythrankomi, Cyprus (Fig. 17).[42] The throne in this mosaic, which is of Justinianic or slightly later date,[43] is less ornate than those in the Thessalonican and Roman works, but its proposed reconstruction as a lyre-back is incontestable.[44] At the Kanakaria the supports are arcs of an ellipse duplicating the curves of the Virgin's arms between them and those of the mandorla that encloses the group beyond them. The Child thus forms the center of a concentric schema that moves outward beyond the throne and the mandorla, past the inclined forms of palm trees and angels, to the arch of the apse itself.

42. Megaw, "Kanakaria," pp. 199–200.

43. Ibid.; Ihm, *Apsismalerei*, p. 59. Grabar ("Virgin in a Mandorla," p. 307) assigns the mosaic to the "sixth or seventh century." G. Galassi ("Musaici di Cipro e Musaici di Ravenna," *Fel. Rav.* LXVI, 1954, pp. 5–37) assigns the mosaic to the decade 530–540 but does not comment on its iconography. We await A.H.S. Megaw's final report on the mosaic.

44. Ihm, "Apsismalerei," fig. 12.

The mandorla, missing in the Italian examples and at the basilica of St. Demetrius, nevertheless has attracted most attention. Grabar sees in it a precise Early Christian sign of a theophany, used at the Kanakaria to convey the idea of the divinity of Christ enveloping his mother from the very moment of his birth.[45] Although there is nothing in the Lythrankomi mosaic that defines such a chronological consideration, Grabar's idea receives indirect support from a tenth-century (?) miniature inserted into the Etzchmiadzin Gospels.[46] Here the Child, bearing a rotulus, is enclosed within an aureole held by the Virgin. Beside her lyre-backed throne stands the angel who has led the Magi not to the grotto of the Nativity but to the regal scene that confronts them.

The throne here differs from any that we have examined, in that its finials are not separate members but simply lobed ends to the uprights. Again, unlike the mosaic at the Kanakaria, the aura of divinity about Christ does not extend to his Mother.[47] But there can be no mistaking the aulic quality of the scene. The Virgin is enthroned within an apse-like niche, decorated with a conch shell that seems to radiate from her nimbus. The Magi and the angel attend like courtiers, disposed on either side of a throne adorned with the same pearly incrustation as the arch and columns of the background. As in the apse of the Kanakaria, the Child is the hub of the entire composition.

The mosaic and the miniature represent the enthronement of Divine Wisdom, given flesh through the Theotokos. In every instance where the lyre-back supports the Virgin rather than Christ, she appears in her capacity as the Mother of God. The throne may vary in form and decoration; it is found in images of both the *majestas* of the Virgin and the Adoration of the Magi; it occurs in mosaic decoration and wall painting,[48] in metal-work and in manuscript illustration. Yet consistently, through all these variations, the Virgin on the lyre-backed throne holds the Child who, in turn, holds either a rotulus or a codex. The focal element, compositionally and doctrinally, of each of the pre-Icono-clastic monuments we have examined is the embodiment of the Logos. This throne is reserved for Christ either alone or supported by the vehicle of his incarnation.[49]

45. Grabar, "Virgin in a Mandorla," p. 309. Ihm (*Apsismalerei*, p. 188) suggested that the Mother of God here is properly an image of the Divine Child Enthroned, fashioned as that of the Saviour.

46. Erevan, Matenadaran 2374, fol. 228v (Strzygowski, *Etschmiadzin Evangeliar*, p. 69, pl. VI,1). The sixth-century date assigned by Strzygowski to the inserted miniatures can no longer be maintained. For the literature on this problem, see Lazarev, *Storia*, p. 102, note 52.

47. In the subtle polychromy of this miniature the pale blue mandorla about the Child is enveloped by the deep purple of the Virgin's *maphorion*. The juxtaposition of these hues beautifully illustrates both the physical kinship and the theological distinction between the Child and his mother.

48. A further example in this genre may possibly be found at Bawit, on the east wall of Chapel 3. Clédat (*Baouît* I,1, pl. XXI) illustrates a Virgin and Child enthroned upon what would seem to be a lyre-back.

49. The appearance of certain thrones and chairs might suggest that the lyre-back was not exclusively reserved for Christ or his Mother in the pre-Iconoclastic period. However, the exceptions do not conform to the one criterion we have been able to establish for a throne whose representations vary widely: the double curve effected either above or below the crossbar. One example from the East must suffice. On the north wall of Chapel 3 at Bawit (Clédat, *Baouît* I,1, p. 20, pl. XVII), Saul is enthroned as he inspects the armor of David before the battle with Goliath (1 Samuel 17:32–39). Here the throne-back is distinctly pumpkin shaped and its supports lack the distinctive reversal of direction that we have demanded of the lyre-backed type.

The Virgin will reappear on the lyre-back in the Middle Byzantine period and, at the same time, Christ and his Mother will cease to possess the throne exclusively. Old Testament patriarchs and even pagan kings occasionally come to occupy the single lyre-back as the *augusti* had filled the double throne on Early Byzantine coins. These are evidently mere applications of the throne of the King of Kings, who appears in the Macedonian era above the Imperial Door of Hagia Sophia.

But the establishment of this type in the pre-Iconoclastic period is clearly indicated by the evidence from Ravenna. To this we can now turn, as to the mainstream of representations of the lyre-backed throne. The most celebrated mosaic of the Lord enthroned in this fashion between pairs of angels is located near the altar on the south wall of S. Apollinare Nuovo (Fig. 18). Christ on the lyre-back is thus the destination and climax of the saints whose solemn procession, sometime after 570,[50] replaced the original retinue of Theodoric's courtiers. The martyrs march eastward, paralleling the train of virgins moving toward Mary's throne on the opposite wall. But, while it is ingenious to see the figures of Christ and his Mother enthroned as an imperial couple, it remains true that Christ alone occupies the lyre-backed throne. This fact weakens Nordström's attempt to relate the iconography here to the double throne on imperial coins of the fifth and sixth centuries.[51] The throne of the Lord is separated from that of the Virgin not only by the physical space of the nave but also by its precise and characteristic shape.

There is no evidence that the original form of either throne was changed when the friezes were altered perhaps a generation after their creation. Presumably Theodoric, his queen, and their suite approached the same images of Christ and Mary as do the saints today. The palms along their paradisiacal way recall the trees that guard the enthroned Virgin and Child in the apse of the Kanakaria. But the throne of Christ suggests a Western rather than an Eastern analogy: the type is surely the model for that on the palimpsest wall at S. Maria Antiqua. The back of each throne is unmistakably lyre-shaped, the reverse curve beginning below the level of the crossbar. In each, the throne is widest immediately below the elbow of the sitter. The uprights of both are adorned with almost identical schemes of oval and rectangular cabochons set vertically in pairs between double courses of pearls. Finally the two scenes share the same iconic frontality. Notwithstanding their role within larger compositions, the enthroned Christ at S. Apollinare Nuovo and the enthroned Virgin at S. Maria Antiqua are both distinguished from their contexts as much by the lyre-backed thrones that gird them as by their remote impersonality of mien.

It is evident that the Roman wall painting owes much to the mosaic at Ravenna. But to assert that it is a simple adaptation to Mariological purposes of the image at S. Apollinare Nuovo—as the Virgin on the Grado reliquary would seem to be based on an enthroned Christ—is to oversimplify the problem. By the time of Justinian, at the

50. G. Steigerwald ("Christus als Pantokrator in den untersten Zone der Langhausmosaiken von S. Apollinare Nuovo zu Ravenna," *Tortulae*, pp. 272–284) attempts to reconstruct the original composition leaving the form of Christ's throne unmodified.

51. Nordström, *Ravennastudien*, p. 81.

latest, the Virgin on the lyre-backed throne appears to be an iconographical type as well established as the depiction of the Lord in this fashion. Indeed, we have been obliged to discuss pre-Iconoclastic images of the Mother of God for the very reason that, except for the mosaic at S. Apollinare Nuovo, we have no surviving representation of Christ on the throne from this period.[52]

And yet, paradoxically, there seems little doubt that the Virgin on the lyre-backed throne is founded, both formally and doctrinally, on images of her Son. On the monuments that we have examined, both in Italy and in the East, Mary never appears without him. The Child is the focus of every composition, be it a *Marienmajestas* or an Adoration of the Magi. Sometimes he seems to lack any peculiar sign of his divine nature;[53] at others, he is surrounded by the mandorla; once, at the Kanakaria, the mandorla is extended to embrace his Mother. But common to all of these representations is the lyre-backed throne, the seat of majesty and divinity, possessed exclusively when Christ is represented alone, shared with the Theotokos when he is held by his earthly Mother. The function of the Virgin here is to support the Child, the embodiment of the Logos, who holds the book in his hand. Her claim to the lyre-backed throne derives from that of her Son.

Diffusion and Variation

We have not yet elucidated the particular significance of the form of the lyre-backed throne, although its prime relation to Christ has been established. Similarly, on the basis of the monumental and numismatic evidence, we have not been able to determine the source of the type. The first sure Constantinopolitan examples do not antedate the coins of Leo VI (Fig. 10) and the mosaic in Hagia Sophia of the same period (Fig. 1). Yet the lyre-back is found in such important provincial centers as Thessaloniki and Ravenna (Fig. 18) certainly no later than the time of Justinian.

Testifying to the renown of the type as well as to the close artistic relations between Ravenna and the Frankish world,[54] versions of the lyre-backed throne occur in a variety of Carolingian contexts. Foremost among these is the vault mosaic of the Palatine Chapel at Aachen, on which quite possibly was reproduced the iconography that has preoccupied us at S. Apollinare Nuovo: the enthroned Christ receiving a procession of martyrs bearing crowns.[55] Controversy has raged as to whether an enthroned figure was

52. Unfortunately little can be learned from the late-seventeenth-century drawing of the apse mosaic at S. Agata Maggiore at Ravenna published by Ciampini (*Vetera Monimenta* I [Rome, 1690], p. XVI), other than that Christ clearly sat upon a lyre-backed throne. The mosaic, destroyed by an earth tremor in 1668, is dated by G. Bovini ("Mosaici parietali scomparsi," *Fel. Rav.* LXIX, 1955, pp. 5–11) to the bishopric of Victor, 538–545.

53. At S. Maria Antiqua (Fig. 15) and in the Etzchmiadzin Gospel Christ's nimbus contains no cross; on the Grado reliquary (Fig. 14) he has no nimbus, cruciform or otherwise.

54. Cf. R. Krautheimer, "The Carolingian Revival of Early Christian Architecture," *Art Bull.* XXIV, 1942, pp. 1–38.

55. The present mosaic put up by the Count de Béthune in 1881 is based upon a drawing of Ciampini's made before the destruction of the earlier decoration in the eighteenth century and reproduced by Braunfels, *Welt der Karolinger*, fig. 137. See also O. Demus, *Byzantine Art and the West*, New York, 1970, pp. 53–54.

included in the original scheme or whether this was only an addition of the twelfth century. It now seems likely that the throne, restored as a lyre-back, is, like the rest of the mosaic, a fair rendering of the Carolingian representation.[56] There is no point in commenting upon the stylistic niceties of the late-nineteenth-century mosaic. Iconographically, however, it may be observed that if Ciampini's drawing accurately represents the original, then the Carolingian artist apparently had access to a model other than the celebrated composition in Ravenna. While the Aachen mosaic reproduces the train of saints approaching the divine throne, it represents Christ in quite another fashion. At S. Apollinare Nuovo (as later at Hagia Sophia, Constantinople) Christ's gesture is made in front of his body. But in the Carolingian Palatine Chapel he stretches his right hand far beyond the upright of the throne in a manner known first on the gold of Basil I (Fig. 3). It seems probable that Basil's *solidus* and the Aachen vault mosaic both eventually derive from a common and now lost prototype.

The presence of the lyre-backed throne at Aachen accords well with the context of the martyrs received by Christ. But other Western applications of the motif can be seen only as misunderstandings. The Evangelists are shown seated upon what appear to be misconstrued lyre-backs in numerous Carolingian manuscripts. In Count Vivian's Bible, for example, Christ in Majesty is surrounded by the authors of the Gospels shown in the act of writing (Fig. 19).[57] Only Mark's throne has both uprights curved in the requisite fashion and one of these is reversed. Since the Evangelists occupy such thrones on the "author-portrait" pages of several Gospel books,[58] similar illustrations may be understood as part of the raw material out of which the artists of the Vivian Bible fashioned their impressive and original composition of the *Majestas*. It would seem that they were familiar with but uncomprehending of the lyre-backed throne in its Early Christian and Byzantine context: at least in the Touronian Bible, the throne seems to be used merely for the sake of introducing variety among the Evangelist portraits. So banal an application of the motif does not, to my knowledge, occur in Byzantine manuscript illustration until the Palaeologan era. On the single sheet of a fourteenth-century Gospel book in Athens, St. Luke occupies a lyre-backed throne, one side of which is masked by his body as he pensively turns toward his codex (Fig. 20).[59] By the fourteenth century the lyre-back had disappeared from Byzantine art and the motif is here used solely as a decorative device. Even before this date, as we shall see, the throne appears to lose its principal connotation as the seat of Christ.[60] Presumably

56. Cf. H. Schnitzler, "Das karolingische Kuppelmosaik der Aachener Pfalzkapelle," *Aachener Kunstblatter* XXIX, 1964, pp. 1ff.

57. Paris, B.N. lat. 1, fol. 329v (Braunfels, *Welt der Karolinger*, pl. XLI [color]).

58. For example, St. Mark in the Lothair lectionary, Paris, B.N. lat. 266, fol. 75b (Köhler, *Karolingischen Miniaturen* I, pl. 99b); and St. Luke and St. John in the Dufay lectionary, Paris, B. N. lat. 9385, fol. 137b (ibid., pls. 111a and 111b).

59. MS Atheniensis 70, fol. 2v (Buberl, *Miniaturhandschriften*, p. 22, pl. XXIX, fig. 79).

60. The earliest Byzantine use of the lyre-back as a seat for an Evangelist known to me is a crudely drawn, full-page portrait of St. John in an eleventh-century lectionary, Athos, Dionysiou cod. 2, fol. Ov (Weitzmann, *Buchmalerei*, p. 64, pl. LXX, fig. 414). Weitzmann does not comment on the form of the chair. The Synoptic Evangelists appear on variously decorated lyre-backed thrones in a lectionary made in the scriptorium of St. Cecilia at Rome and now in Florence (Laur. Plut. 17.27). The Matthew of

this peculiar significance was unknown to the illustrators of Carolingian manuscripts, who saw in the throne merely an impressively elaborate Byzantine invention appropriate for imitation.

The primary function of the lyre-back as the throne of Christ and, by extension, that of the Theotokos who holds him is strongly suggested by the wall paintings of monastic Cappadocia. Throughout the Macedonian dynasty and into the Comnenian era, we find on rock-cut apses and ceilings those scenes in which we have come to expect a lyre-backed throne. While some representations reflect the forms of contemporary Constantinople and others rehearse pre-Iconoclastic motifs, nowhere in this Eastern province does there occur that variety of applications of the throne that we shall discover in the capital from the late ninth century. In Cappadocia the lyre-backed throne is reserved for the Lord and for his Mother.

The sumptuousness of its form contributes to the awful vision of Christ Enthroned amid the angelic orders in all their diversity in the apse of chapel 3 at Güllü Dere.[61] This blazing manifestation of the heavens in their glory seems to be painted almost in reaction to more than a century of prohibition; certainly it contrasts powerfully with the austere crosses carved and painted before this chapel received its figural decoration.[62] Much of the principal figure is lost, but the gesture of benediction made with the right hand and the open codex held on the left knee suggest an image close to the metropolitan lunette mosaic (Fig. 1). This impression is somewhat modified by the form of the throne. The uprights begin their reverse curve below the crossbar, more in the manner of the mosaic at S. Apollinare Nuovo (Fig. 18) than at Hagia Sophia, where a slighter change of direction is evident. This suggests that the Güllü Dere painter had a model older than, or at least different from, the most celebrated Macedonian example. There is, moreover, a freedom in the swing of the wings belonging to the symbol of St. Matthew, emphasizing the curvature of the throne-back, which is alien to the static monumentality of the composition in the Great Church.

Closer in some ways to the type in the lunette mosaic is the throne occupied by Christ on the ceiling of chapel 3 at Göreme (Fig. 21),[63] although there is little reason to date this decoration any later than that at Güllü Dere.[64] Surrounded by the evangelical symbols as in the apse we have just considered, here the throne's uprights describe a more regular curve and are ornamented at midpoint with bosses much like those on the throne at Hagia Sophia.[65] The finials, however, are taller and more elaborate than

fol. 6v occupies a lyre-backed throne with a broad, ornamental dossal and orchidaceous finials. E.B. Garrison (*Studies in the History of Medieval Italian Painting* I [Florence, 1953], pp. 24, 116; II [Florence, 1955], pp. 24–25, 81, fig. 22) assigns the lectionary to about 1112–1113.

61. Jerphanion, *Cappadoce* I,2, pp. 592–594; Restle, *Asia Minor* III, pl. 333.

62. Lafontaine-Dosogne ("Güllü Dere") dates the decoration of this chapel about 900; Restle (*Asia Minor* III, no. XXVIII) assigns it to the first half of the tenth century.

63. Jerphanion, *Cappadoce* I, pp. 140–141, album I, pl. 39,3; Restle (*Asia Minor* II, no. III) does not reproduce this part of the ceiling decoration.

64. Both belong to Jerphanion's "archaic group." Restle (loc. cit.) assigns this chapel to the ninth century.

65. Such bosses recur in the same place in the apse of the triconch church at Tağar (Restle, *Asia Minor* III, pl. 359).

those at Güllü Dere, where they are close to the "pine cones" that Whittemore noted in Constantinople.

The evidence of these rock-cut churches and chapels is of the greatest importance to our investigation, for the lyre-backed throne occurs more frequently in Cappadocia than in any other region. However, more than mere quantity is involved here. We find the same diversity of shape and ornament that we have observed in the coins. Even if we allow for a good deal of originality on the part of these monastic artists, it is still evident that no single model is being copied. In the triconch church at Tağar all suggestion of serpentine supports has disappeared, since the finials are mere extrapolations of the simple curving line of these uprights.[66] Such "single-curved" forms recur frequently in this environment:[67] on account of their iconographical context we cannot refuse to recognize these thrones as lyre-backs. These contexts are limited in number and quite specific: the Deësis, as in the Direkli kilise at Belisirama and the church at Tağar; and the prophetic visions of Güllü Dere, chapel 3 at Göreme, and the church of St. Theodore at Susum Bayri near Urgüp.[68] Within these groups and despite the intervention of centuries, most iconographical details remain constant. In the Deësis, the Lord's book is closed; in the theophanies it is open and about the throne the evangelical beasts are poised in their canonical order, the winged man and the lion to the spectator's left, the eagle and the ox to his right.[69] In every instance where the lower part of Christ's body is preserved, a marked differentiation between the position of the feet is to be noted, the right foot generally being out-turned. This is in accord with what we have found on the coins (Figs. 10–13) and differs from the almost parallel disposition of the feet in the mosaic at Hagia Sophia.

Of greater significance, however, is the device—varied in its form but unmistakable in its function—that surrounds each of the prophetic visions and none of the Deësis representations. At Güllü Dere, in chapel 3 at Göreme (Fig. 21), at Tavşanli kilise, and at Susum Bayri, the nucleus of the theophany is clearly demarcated. The *Rex Regnantium* on his lyre-backed throne attended by the Evangelists—his immediate and invariable consorts—is defined by a mandorla. Beyond this glory hover the archangels, seraphim, cherubim, and thrones. The multiplicity of Cappadocian examples, painted after Iconoclasm but preserving Early Christian forms,[70] corroborates what we have suggested of the mandorla as it appears about the Virgin on her lyre-back at Lythrankomi (Fig. 17). The brilliant iris fixes the locus of divinity, the seat of majesty, which can be extended to Mary in her capacity as the earthly Mother of the King of Kings. The iconography of the apse at the Kanakaria is surely an adaptation of the scheme preserved in these apses in Cappadocia.

66. Jerphanion, *Cappadoce*, album III, pl. 166,1. The date of this decoration is disputed. Jerphanion (*Cappadoce* II,1, pp. 189–191) attributes it to the thirteenth century; Restle (*Asia Minor* III, no. xxv) dates it about 1080.

67. Cf. Restle, *Asia Minor* III, pl. 383 (Susum Bayri), p. 402 (Tavşanli kilise), pl. 522 (Direkli kilise).

68. Ibid.

69. In a speculative reconstruction of the apse of Tokale I, Wood (*Divine Monarchy*, pp. 25–28) hypothesizes such a distribution of beasts about Christ seated on a lyre-backed throne.

70. Lafontaine-Dosogne, "Güllü Dere," p. 190.

It has been observed that in Cappadocia the image of the Virgin and Child Enthroned never occurs in the same apse as the prophetic visions with which we have been concerned.[71] When she does appear in the conch, as in chapel I (El Nazar) at Göreme,[72] it is in the familiar form of a *majestas*, the Theotokos enthroned between archangels and saints as at St. Demetrius, Thessaloniki (Fig. 16), Lythrankomi, and S. Maria Antiqua in Rome (Fig. 15).[73] Her throne is lyre-backed, but of the simpler variety in which the finials continue the curve of the uprights, here studded with large, square cabochons. The Child in her lap bears a nimbus, without cross, and holds a rotulus. At the apex of the vault, the *manus dei* indicates the source and direction of grace.

Finally, there occurs in Cappadocia a representation of the only iconographical setting apart from the *majestas* in which the Virgin is to be found on the lyre-backed throne. In the Etzchmiadzin Gospels, she appeared as a strictly frontal, aulic figure with the Magi disposed about her like courtiers. On the southern vault of the "Great Pigeon Coop" at Çavuş In, as part of an Infancy cycle dated between 960 and 970, she turns toward those who have come to adore her Son.[74] The Child blesses the Magi with his right hand while his left, barely visible, grasps the roll. The throne on which they sit is perhaps the most crudely drawn of all those that we have considered. One of the uprights is completely masked by the occupants. But the simple curve of the other, uncovered, support, encrusted with square gems and triple rows of pearls, confirms that the lyre-backed throne was, into the Macedonian era, a familiar component of the Adoration of the Magi.

Just as many of these wall paintings and especially the representations of theophanies preserve pre-Iconoclastic forms, so in some notable Macedonian manuscripts we find miniatures that appear to have "migrated" from earlier books, and pages that seem to consist of quotations from earlier works. In a single register, chronologically discrete scenes are placed not only side by side, as is conventional, but overlapping each other. This is done not as a means of establishing figures in space but as if the strip of illustration were too short for all the individual images that it had to contain (e.g., Fig. 22). Weitzmann has suggested a Justinianic or possibly earlier date for the illustrated chronicles that he sees as the source for several of the cycles in the great Paris Gregory (B.N. MS gr. 510). The several types of throne in this manuscript must either be modeled on thrones existing in Constantinople or else appropriated, along with the scenes in which they appear, from a variety of Early Christian artistic models. Their very diversity is instructive. In the scene representing the emperor Julian's presentation of the *donativum* to his officers, only one of the uprights has the reverse curve (Fig. 23).[75]

71. Ibid., p. 187.

72. Jerphanion, *Cappadoce* I,I, pp. 178–179, album I, pl. 40,1; Restle, *Asia Minor* II, no. I, pl. 6. Jerphanion dates the decoration of this chapel between 912 and 959; Restle puts it at the end of the same century.

73. To this list might be added the Virgin and Child seated between archangels on an angular version of lyre-backed throne, at Egri tas kilise (N. Thierry and M. Thierry, *Nouvelles églises rupestres de Cappadoce, région du Hasan Dagi* [Paris, 1963], pp. 46–47, pl. 28).

74. Jerphanion, *Cappadoce* I,2, p. 533, album II, pl. 141,3; Restle, *Asia Minor* III, no. XXVI, pls. 305, 306.

75. Fol. 374v (Omont, *Miniatures*, pl. XIII).

In this respect it is closer to the throne on the coppers (Fig. 4)[76] than to that on the gold (Fig. 3) of Basil I, in the last years of whose reign the manuscript was illustrated.

Julian's throne is adorned with bosses in the middle of each upright, which are set with vertical cabochons much like those on the throne in the lunette mosaic at Hagia Sophia (Fig. 1). Elsewhere in the manuscript such bosses are missing—on the otherwise highly elaborate lyre-back on which the emperor Valens sits watching beside the deathbed of his son (Fig. 22),[77] and again on that of St. Helena enthroned beside the Invention of the True Cross.[78] Given these three imperial scenes, in which the thrones differ in their decoration but not in their essential shape, it might be expected that the illustrators of the Paris Gregory, a sumptuous manuscript made for the emperor himself, reproduced the form of the imperial throne in the Great Palace. Yet the throne of Theodosius, vacated by this emperor as he rises to engage St. Gregory Nazianzenus in conversation, is a round-backed structure with simple, vertical uprights.[79] If the painters' model was the seat of Basil I, it is hardly likely that it would be denied to Theodosius but assigned both to the mother of Constantine and to Julian the Apostate.

Since the texts of the homilies themselves offer no explanation for the variety of imperial thrones in the manuscript, we must deduce that their heterogeneous forms originate in the illustrated chronicles that may have been the source of many of its scenes. Again, whatever the date of these hypothetical prototypes, it seems obvious that their creators were not concerned with rendering any specific model. If we may infer the throne-forms of the chronicle manuscripts from those of Basil's sumptuous codex, then we must recognize a diversity of types as great as that on the pre-Iconoclastic coins that we have examined. As in the late ninth century, so in Justinian's (or in some earlier ruler's) time, the artists' model was not some specific piece of imperial furniture in Constantinople.

The thrones of the *Rex Regnantium* display no more formal consistency than those of the *basileis* in our manuscript. The frontispiece showing Christ Enthroned with an open codex is so heavily flaked that we cannot be sure of its original form.[80] But, as restored in ink in the sixteenth or seventeenth century, the throne has tapering and gem-studded supports shaped as simple curves.[81] In contrast, the Christ of Isaiah's vision, perhaps derived from some earlier Prophet book,[82] sits on a patently lyre-backed

76. The double throne on the coins of Constantine V (Fig. 8) also has dissimilar uprights in this fashion.

77. Fol. 104r (Omont, *Miniatures*, pl. XXXI).

78. Fol. 440r (ibid., pl. LIX). The uprights of both Valens' and Helena's thrones taper toward the finial like those at S. Maria Antiqua, Rome (Fig. 15). They resemble the wall painting also in the manner of ornament applied to the uprights, alternating courses of pearls and cabochons.

79. Fol. 239r (Omont, *Miniatures*, pl. XLI). The throne of Solomon, which one might also reasonably expect to be modeled on the imperial throne, appears in this manuscript (ibid., pl. XXXIX) as a square-backed chair bearing no formal relationship to any other throne in the Paris Gregory.

80. Fol. Av (Omont, *Miniatures*, pl. XV).

81. A meticulous eye might wish to see the beginnings of a reverse curve at the apex of the upright on Christ's left. The loss of the finials here suggests how much our appreciation of the throne-back's nature depends on these members.

82. Weitzmann, "Illustration for the Chronicles," pp. 87ff.

throne within a medallion suspended above the spiky wings of seraphim (Fig. 24).[83] We might wish to contrast the Christ of this theophany—he holds a closed book as in the ceiling of chapel 3 at Göreme (Fig. 21)—with the *pambasileus* at the beginning of the manuscript. But nothing in the examples that we have examined suggests that the lyre-back was reserved for representations of the Lord revealed to his prophets and denied to images of the King of Kings in his majesty.

Evidently, the thrones of Christ in the Paris Gregory no more derive from a single model than do those of the emperors. The throne seen by Isaiah has a horizontal cross-bar, as on all the imperial thrones in this codex and all the *solidi* of the Macedonian emperors (Figs. 3, 10–13); but the crossbar of the throne on the frontispiece forms an arc, as on the coppers of Basil I (Fig. 4). Whereas the uprights of the full-page illustration appear to be smooth surfaces studded with jewels, those in the prophetic vision seem to be made of turned wood, as on the Virgin's throne at St. Demetrius, Thessaloniki (Fig. 16). The significance of the lyre-back, then, cannot be discovered from the internal evidence of one manuscript. Comparative examples must be sought, preferably from the same period. It is here that the absence of a precise date for the mosaic in the narthex of Hagia Sophia (Fig. 1) proves most embarrassing. To fix its chronological situation scholars have attempted to identify the emperor prostrate at Christ's feet: the choice between Basil I and Leo VI has generally been decided in favor of the latter.[84] Stylistically, the figures in the mosaic have been recognized as close to those of the Paris Gregory, illustrated toward the end of Basil's reign. Yet at least one important attempt at iconographical exegesis has connected the mosaic with an ode of Leo VI's in which the emperor sees himself beseeching the Virgin and the heavenly powers to intercede for him at the Judgment throne.[85]

We are left, then, with a work that probably dates between 886 and 912 but that could have been put up as early as the beginning of the last quarter of the ninth century. Unfortunately, the form of Christ's throne cannot help us in this regard. Although we have been able to recognize aspects of this throne elsewhere, the sum of its parts as put together here has no precise analogue anywhere.

This does not mean, of course, that the lunette over the Imperial Door of the Great Church was without influence. In the case of the painting in the apse at Güllü Dere there is reason to suspect an older prototype than the mosaic in Constantinople.[86] But

83. Fol. 67v (Omont, *Miniatures*, pl. XXV).

84. See note 2 above. Breckenridge (*Justinian II*, p. 49) has returned to the position of recognizing Basil as the emperor portrayed. He argues that the mosaic is "the very image" of the coins of Basil showing Christ Enthroned (Fig. 3), a view that can be sustained only if one ignores the entirely different form of the throne-backs in the two instances. In this interpretation he has recently been followed by A. Veglery ("Narthex Mosaic"), who argues for a date of "late 867" for the image in the tympanum. While in itself constituting no argument for the belief that it is Leo VI who is represented on the narthex mosaic, Veglery's refusal to recognize the difference between the single-curved and un-ornamented uprights without finials of Christ's small throne on the *solidi* of Basil I (Fig. 3) on the one hand, and, on the other, the much broader throne, its uprights and crossbar encrusted with jewels, on the mosaic, weakens one of his main arguments for attributing the monumental work to Basil.

85. *Oratio X (Hodarion katanyktikon)*, P.G. 107, cols. 96–113, cited by Mirković ("Mosaik über der Kaisertür"). Cf. p. 110, below.

86. Cf. p. 51 above.

other frescoes in Cappadocia, such as the enthroned Christ on the ceiling of chapel 3 at Göreme (Fig. 21), certainly owe much to the metropolitan exemplar. The form of the throne, Christ's strictly frontal pose, and, above all, his head-type at Göreme are all very close to the mosaic. And as much is true of a mid-tenth-century painting discovered at Carpignano in Apulia by Diehl in 1894.[87] Here the throne is less ornate than that at Hagia Sophia and, as on the Göreme ceiling, Christ's book is closed.[88] But there can be little doubt that these two monastic versions, one in Cappadocia and the other in southern Italy, reflect the geographical extent of the lunette mosaic's impact within at most a century of its creation.

This wide diffusion of the type, as well as its presence in a location of supreme importance in Constantinople, suggests that the image of Christ on the lyre-backed throne conveyed some idea that was both specific and significant. Evidently, however, a degree of iconographical latitude was acceptable, a variety that cannot be explained merely in terms of artistic competence. The book, for example, may be either open or closed. The image of Christ may be purely frontal, as at Hagia Sophia and in Isaiah's Vision in the Paris Gregory (Fig. 24), or turning slightly to his left, as in the restored frontispiece of the same manuscript. The throne may have a horizontal or arching cross-bar between supports that may describe a simple or a reverse curve. Other modifications, in the form of the finials, the cushion, the footstool, and so on, do not impair the image that a large number of artists, in both monumental and miniature works, intended to convey.[89] Manifestly, in the tenth century, the lyre-backed throne could be denoted in a variety of ways and yet preserve its peculiar connotations.

That this could be so implies certain limits beyond which formal variation might not go; we shall endeavor to recognize these limits. More informative, however, are the contexts within which the lyre-back occurs, and those in which it is apparently never or rarely employed. One such is the Hetoimasia, the Judgment Seat prepared for the Lord.[90] Usually rendered as a backless throne, flanked by the instruments of the Passion and supporting a codex, it is found once, in a Chrysostom manuscript assigned by Grabar to the tenth century, with a form of lyre-back (Fig. 25).[91] The Gospel book

87. Diehl, *Italie méridionale*, pp. 33–34, drawing on p. 35. The painting is dated by inscription to the year 959. Although Diehl noted only that this throne had a "dossier circulaire," Bertaux (*Italie méridionale*, p. 138) recognized the lyre-back and adduced the *solidi* of Leo VI.

88. Bertaux (*Italie méridionale*, pp. 142–143) records a later and similarly enthroned Christ, holding an open book, in the grotto of S. Lorenzo near Fasano. The relation of this painting, undated by Bertaux, to the mosaic in Constantinople cannot be doubted since in each case Christ's codex bears the same inscription, eclectically combining John 20:19 and 8:12.

89. However, the manner of ornament—often gems set in pairs between courses of pearls—is not a peculiar attribute of the lyre-backed throne. It is found on architectural backgrounds in the Etzchmiadzin Gospel (cf. note 46 above). In the Paris Gregory, fol. 355r (Omont, *Miniatures*, pl. L) such incrustation adorns the throne holding the Gospel at the Second Ecumenical Council of Constantinople. Elsewhere in the same manuscript, e.g., fol. 71v (ibid., pl. XXVII), it ornaments an arcade framing the Cappadocian Fathers. We have here a mode of ornament conventionally applied in many ceremonial settings and not a significant feature of the particular type of throne under investigation.

90. For the origins of this motif and its rôle in representations of the Last Judgment, see Brenk, *Tradition und Neuerung*, pp. 71–73, 98–100.

91. Grabar, "Un Manuscrit des homélies," pl. XXI,4.

rests on its seat before a hanging suspended from a crossbar between the uprights. These exhibit a more pronounced reverse curve than on any other depiction of our throne and end in long, pointed finials like those on the *solidus* of Alexander (Fig. 11). Between the finials, a three-lobed headpiece carries a cross on its central member. This being unique among representations of the Hetoimasia, we have no way of determining whether its painter sought deliberately to evoke the lyre-backed throne. Such an interpretation would, however, be appropriate to the miniature's context. From the throne flows a river of fire that hungrily licks the foundation of Sodom, paralleling the Flood and the Serpent which destroy men and their habitations in the image above. Each miniature thus represents divine retribution of the unwise and historically illustrates prefigurations of the subject of Chrysostom's eschatological homily, *On the Endless Punishment.*[92] The singular iconography seems to include the throne, understood here as the seat of wisdom from which the Eternal Judgment proceeds.[93]

The association of justice and the throne is revived in a later and much more celebrated Chrysostom manuscript in Paris made for Nicephorus Botaneiates between 1078 and 1081.[94] Behind the emperor's chair hover two allegorical figures identified by inscription as Truth and Justice. Their presence is surely intended to suggest imperial participation in these qualities that, together with Judgment and Mercy, are attributed to the divine throne and its occupant in several biblical passages.[95] The throne bears very little resemblance to the lyre-back as we have known it. Only the curving upright to Botaneiates' left shows the slightest degree of reversing itself, while both uprights and the crossbar are decorated not with the familiar incrustation of gems but with a conventional, highly stylized vegetable ornament.

Omont noted the differences between the throne on which the emperor sits in this miniature and that in the immediately preceding illustration in the manuscript, which he described as the imperial throne.[96] The supports of this smaller throne are adorned

92. Chrysostom *P.G.* LXI, col. 72.

93. If this surmise is correct, it would support the largely unsubstantiated hypothesis of Mirković ("Mosaik über der Kaisertür," pp. 215–217), who saw an analogy between Christ's throne, before which the emperor prostrates himself in the narthex mosaic at Hagia Sophia, and the Hetoimasia as on the bronze door of the Great Church. Unlike the throne in the mosaic and that in Atheniensis 211, the throne on the door is the customary, backless type of Judgment Seat.

In turn, if our understanding of the lyre-backed throne's significance is correct, then there exists an important analogy between its use and the Gospel book resting on thrones of various types in both art and liturgical practice. In addition to the Hetoimasia, the presence of the enthroned book in the ambo of early Syrian churches (J. Lassus, *Sanctuaires chrétiens de Syrie* [Paris, 1944], p. 214, pl. LX, 1–2) and and in later representations (cf. K. Weitzmann, *The Fresco Cycle of S. Maria de Castelseprio* [Princeton, 1951], pp. 4, 79, fig. A) must be taken into account. On such lectern-thrones the word of God is placed; on the lyre-back, the incarnation of the Logos is enthroned.

94. Paris, B.N. MS Coislin 79, fol. 2r (Omont, *Miniatures*, pp. 32–34, pl. LXIII).

95. E.g., Psalm 88 [89]:14: Δικαιοσύνη καὶ κρίμα ἑτοιμασία τοῦ θρόνου σου. ἔλεος καὶ ἀλήθεια προπορεύσονται πρὸ προσώπου σου. Cf. Psalm 96 [97]: 2.

96. Omont, *Miniatures*, p. 33, pl. LXI. Presumably Omont based this belief on the presence of the ciborium above the throne and the fact that here the emperor is engaged on business (with the monk Sabas) rather than iconically posed and attended by personifications as in fol. 2r. But high officers of the court wait beside him in this miniature, too, and there is no reason to suppose that one picture rather than the other represents "the imperial throne."

with precious stones but otherwise it is hardly closer to the lyre-back than the throne attended by Truth and Justice. Whether this deformation, which occurs in many manuscripts and monumental works of the eleventh and twelfth centuries, means that the shape—and the significance—of the lyre-backed throne was no longer understood requires further investigation. Certainly it is remarkable that these apparently distorted versions of the throne should be used for the emperor, rather than for the Lord who had occupied it exclusively since the reign of Leo the Wise.

The late Macedonian and early Comnenian periods witness not only the degeneration of the lyre-back as an unambiguous type but also its employment in contexts entirely different from those of the first two centuries after Iconoclasm. Beyond restoring the emperor to a version of the throne as in the Paris Chrysostom, metropolitan artists extended its use by making of it a seat for the mighty of antiquity. Among the mythological figures that fill the margins of Athos, Panteleimon 6, Dionysus is born from Zeus' thigh as the Olympian sits enthroned on a true lyre-back (Fig. 26).[97] While the lower portions of the throne are decorated with the same stylized rinceaux as the uprights and crossbar of Botaneiates' chair, its supports appear to be made of turned wood in a manner reminiscent of the throne of the Virgin at St. Demetrius in Thessaloniki (Fig. 16) and frequently applied to her throne into the thirteenth century (Fig. 30). Since Zeus is clad in Middle Byzantine imperial vestments, including the *loros* and crown with *prependulia*, it might be supposed that the lyre-backed throne was now generally employed to represent the father of Dionysus in his capacity as ruler of the gods. However, since his throne has no such back in other illustrations of the same text,[98] we can infer that the form here was the conceit of a Constantinopolitan painter who, toward the end of the eleventh century, felt less bound by the traditional and strictly limited number of applications of the lyre-backed throne than artists of an earlier age or those working outside of the metropolis.

This impression is confirmed by another miniature in the manuscript, in which King Midas is shown similarly garbed and holding a piece of food that had turned to gold as it touched his mouth (Fig. 27).[99] His throne is less ornate than that of Zeus, but the reverse curve of the upright to Midas' left clearly shows the painter's intention. We might contrast the throne here with that abandoned by David as he flings himself before Nathan in the Psalter of Basil II.[100] In this manuscript, decorated about 1019, the uprights of the throne show no double curvature and there is no reason to believe that the painter proposed to represent the lyre-back. Throne-backs with such simple curving supports become a convention in the late eleventh and twelfth century. As is the case with the seat of St. John Climacus in a manuscript in the Vatican,[101] neither their form

97. Fol. 163v (Weitzmann, *Greek Mythology*, p. 49, fig. 58).

98. Cf. Paris, B.N. MS Coislin 239, fol. 121v (ibid., fig. 57); Jerusalem cod. Taphou 14, fol. 311r (ibid., fig. 52); Vat. cod. gr. 1947, fol. 147r (ibid., fig. 53).

99. Fol. 116v (Weitzmann, *Greek Mythology*, pp. 23–24, fig. 22).

100. Venice, Marciana cod. gr. 17, fol. IV (Rice, *Art of Byzantium*, fig. 127).

101. Vat. gr. 394, fol. 132r (J.R. Martin, *The Illustration of the Heavenly Ladder of John Climacus* [Princeton, 1954], pp. 77–78, pl. XLI, fig. 123).

nor the context suggests that we should recognize them as lyre-backs.[102]

The problem of identification is more difficult with regard to images of the Virgin. Given the long tradition of representing her enthroned in this fashion, it might be assumed that custom alone would preserve both the form and the significance of the lyre-back as the seat for the Mother of God holding her Son. In fact, the number of post-Macedonian instances in which the back of the Virgin's throne displays the characteristic reverse curve is extremely small.[103] In this respect, we can contrast the distinctive form of Christ's throne, its uprights rendered in a variety of ways but preserving their essential configuration down to and perhaps beyond the Latin conquest of Constantinople.

On the one hand, the failure to recognize the lyre-backed throne as an iconographical concept has led to the omission of this significant motif from otherwise adequate discussions of images of the Virgin. Thus an elegant lapis lazuli cameo in Moscow, showing the Hodegitria seated on what is immediately recognizable as a true lyre-back, has been described simply as an enthroned Virgin (Fig. 28).[104] On the other hand, insufficiently precise definition of the throne in catalogues of the lyre-backed type has allowed the inclusion of images that in no way display the requisite criteria. Orlandos, for example, arbitrarily includes in his list of lyre-backs[105] one of the five representations of the Virgin Enthroned in the now-destroyed eleventh-century fragment of Cosmas Indicopleustes at Smyrna,[106] which in the form of the uprights no more conforms to the type we are discussing than any of the other thrones in this codex.

Each of the thrones in the Smyrna Cosmas has uprights that are either perpendicular or less curved than those in a psalter in Vienna made in Constantinople about 1077 (Fig. 29),[107] and even here there is little enough to justify designating the throne as a lyre-back. Only the abiding tradition of representing the dossal frame as turned wood, which goes back through the tenth century to the Justinianic period or earlier (Fig. 16), and continues into the thirteenth century (Fig. 30), suggests that we should read this throne with its simulation of bead-and-reel molding in this way.[108]

102. On formal grounds, an antique ruler's throne in one of the most problematical pre-Iconoclastic manuscripts must similarly be excluded. In the Pentateuch of Tours, fol 56r (O. von Gebhardt, *The Miniatures of the Ashburnham Pentateuch* [London, 1884], pl. XIV), Pharaoh gives instructions concerning the destruction of the Jewish infants from a throne framed by double-curved uprights. Its extremely high, rounded dossal and elaborate base remove any possibility that the artist intended to evoke the sort of throne with which we are here concerned.

103. E.g., an image of the Virgin in Majesty enthroned between SS. Peter and Paul on an ivory diptych in the Cathedral Treasury at Chambéry (*Les Trésors des églises de France*, Musée des arts décoratifs [Paris, 1965], no. 699, pl. 24). I am indebted to Roger Adams for drawing my attention to this ivory.

104. Kremlin Armory no. 226/bl (Banck, *Byzantine Art*, pp. 305–360, no. 160), dating to the eleventh or twelfth century.

105. Cf. note 6, above.

106. Evangelical School, MS B8, p. 162 (Strzygowski, *Physiologus*, p. 57, pl. XXVI).

107. Vienna, Nationalbib. cod. theol. gr. 336, fol. 16r (Lazarev, *Storia*, pp. 189, 248, note 16 [bibliography], fig. 209).

108. That the bead-and-reel molding was a feature of Middle Byzantine icons of the enthroned Theotokos may be inferred from a throne of this type on the silver repoussé *pala* now in the Museo

An almost contemporary miniature, inserted into an Ottonian codex in Cividale, suggests in what purely decorative fashion the throne was now understood, at least by some provincial painters.[109] The Virgin's high throne here carries an insubstantial back framed with tenuous gold bands. From the crossbar is hung a lavishly pleated fabric that extends to the uprights. Only in the finial to Mary's left is there the slightest suggestion of the curve reversing its direction. Degenerate as the form of the lyre-back may have become, it was not yet entirely a motif used out of meaningful context by miniature painters. In at least two later examples it persists as the seat of the Platytera in monumental apsidal compositions. At Bačkovo, in the upper church of the Archangel at this important Bulgarian center, the Virgin rests on a throne adorned with supports and pumpkin-folded dossal much as in the Cividale manuscript.[110] The honor guard of angels flanking the throne entitles us to recognize the composition as a survival of the pre-Iconoclastic *majestas* of the Virgin.[111] The same scheme survives in the Panagia Mavriotissa at Kastoria where the Theotokos in the conch is probably part of an early-thirteenth-century program.[112] Attended by the archangels Michael and Gabriel, her throne retains a version of the traditional ornament of alternating pearls and jewels but has lost all signs of a double curve in its uprights.

Until the discovery in 1960 of previously covered frescoes in the monastery church of St. John the Divine on Patmos, it was possible to believe that the true lyre-backed throne had lost its association with the Virgin in the eleventh century. Now in the light of the Mother of God enthroned on the east wall of the chapel of the Virgin, it must be recognized that, at least in monastic circles in close contact with Constantinople, the form, if not the significance, of this throne subsisted until about 1220 (Fig. 30).[113] Nearly all the iconographical elements of this composition bespeak the continuity of tradition. Mary is a strictly frontal figure gently holding the Child, who blesses with his right hand while holding a rotulus in his left. She is flanked by Michael and Gabriel, each resting one hand on a finial of the throne as in the lost mosaic at St. Demetrius, Thessaloniki (Fig. 16). While the Virgin's throne in the Cividale miniature rests on heavily stylized Ionic columns, at Patmos elaborate Corinthian capitals are used. The crossbar reproduces the bead-and-reel molding that we have seen more crudely expressed in the Vienna Psalter (Fig. 29). And, finally, the turned uprights—a type of

Provinciale at Torcello (G. Mariacher, *Arte a Venezia dal Medioevo al Settecento*, exhibition catalogue [Venice, 1971], no. 106). On this Italo-Byzantine piece, the Virgin and Child occupy a throne with double-curved uprights and a diapered dossal akin to that of the throne in the tympanum mosaic at Hagia Sophia, Constantinople.

109. Cividale dei Friuli, Museo Archeologico cod. CXXXVI, fol. 141r (W.D. Wixom, "The Byzantine Art Exhibition at Athens," *Art Quarterly* XXVII, 1964, p. 468, fig. 432; Athens Catalogue, no. 374).

110. A. Kostova and K. Kostov (*Bačkovski Manastir* [Sofia, 1963], pls. 27–28) date this fresco to the year 1083. Lazarev (*Storia*, pp. 222–223, 264, note 178) and the authorities whom he cites all place the painting in the second half of the twelfth century.

111. Cf. pp. 39ff. above.

112. Pelekanides, Καστορία, pl. 63. For the bibliography on the disputed date of this decoration, see Lazarev, *Storia*, p. 340, note 106.

113. Orlandos, "Monastère de Patmos," pp. 286–290, fig. 3. Lazarev (*Storia*, p. 262, note 139), citing the frescoes of Kurbinovo, prefers a date in the last decade of the twelfth century.

decoration rendered only less frequently (Figs. 24, 26) than the scheme of pearls and gems—clearly describe a reverse curve beginning well below the level of the crossbar.

Despite all these features, it is the Patmos fresco that signals the virtual disappearance of the lyre-backed throne as the seat of the Virgin in later Byzantine art. Since the second half of the eleventh century no other surviving representation of this scene includes the elements that we have discerned in the Chapel of the Virgin, and only one throne, that on the Moscow cameo, pretends to preserve the traditional form of the lyre-back. Elsewhere the back has become a screen of pleated fabric formed between lean bands.

Even if the Patmos fresco was executed in the period of Frankish domination, it was not this type of throne that was transmitted to the art of the Latin Orient. For the Crusaders a milder type of Hodegitria was created, as on an icon at Sinai, in which Mary gazes past one of the angels while the Christ Child turns toward the other.[114] The complex intersections of lines of sight and angles of movement produce an elegant *sacra conversazione* that is closer to Coppo di Marcovaldo (Fig. 35) than to any Eastern prototype. The angels still turn, raising one hand to the back of the throne as in Early Byzantine art. But the crossbar is now a narrow strip supporting decorative, flame-like finials and the uprights rehearse the simple arcs of twelfth- and thirteenth-century examples. Not antique traditions but current conventions were appropriated by the new masters of the East.

Variety of form but no such total degeneration occurs in contemporary representations of the throne of Christ. We are rarely in doubt as to whether a lyre-back is intended in the enamel, metalwork, and other minor arts that preserved the motif down to the Latin Conquest. It is noteworthy that, after the narthex mosaic in Hagia Sophia and the wall paintings in Cappadocia and southern Italy that derive immediately from it,[115] Christ never again appears enthroned in this fashion in Byzantine monumental art. Moreover, the diversity of shapes that the throne assumes in the examples we have to consider suggests that the lyre-back was no longer the precise concept that it had been through the Macedonian era.

This loss is evident even in works produced in the capital. Thus the throne of Christ on the *nomismata* of Constantine IX (Fig. 13), a design in which the curve of the support begins to reverse itself only in the finial to the Lord's left, will be distorted to the point where, describing a coin struck in the following decade,[116] Wroth was induced to speak of its having "twice-bent arms"! The curving uprights here border a throne-back very close to that on the central panel of the Khakhuli triptych in Tiflis.[117] The Deësis with this icon of Christ at its center has been assigned to Constantinople and dated before 1072.[118] If this date is not too early, we have in this enamel and the coins of Constantine

114. Sotiriou, Εἰκόνες I, pp. 173–174, II, fig. 191, Weitzmann, "Crusader Icons," p. 186.

115. Cf. p. 23 above.

116. *Nomisma* of Constantine X Ducas (1059–1067) (*B.M.C.* II, p. 515, nos. 4, 5, pl. LXI,2). Even in photographs it is evident that these curved forms are uprights in a vertical plane rather than arms extended horizontally.

117. Amiranashvili, *Emaux de Georgie*, pp. 103, 107. Amiranashvili does not remark the lyre-backed throne, although it is noted by Wessel (*Emailkunst*, p. 110, no. 34).

118. Amiranashvili, *Emaux de Georgie*, p. 102.

IX and Constantine X a group of mid-eleventh-century metropolitan examples that retains most of the iconographical elements of the Hagia Sophia mosaic but that has lost the formal distinctness possessed by the throne in that paradigmatic work.[119]

Nonetheless there are subtleties of coloration and draftsmanship in the Khakhuli icon absent in contemporary provincial works. A cloisonné triptych of the Deësis, now in the Hermitage and possibly of Syrian manufacture, repeats the pellet ornament adorning the uprights of the Constantinopolitan icon.[120] But where on the piece in Tiflis this decoration denotes the physical limits of the throne-back, on the Leningrad enamel the uprights and their cumbersome finials seem to be decorative additions, applied after the "construction" of the throne.

More and more, it is evident how many varieties of the lyre-back occur first on the imperial coinage. The clumsy finials on the enamel in the Hermitage are travesties of the pommels on the uprights of Constantine IX's *nomismata* (Fig. 13). On the other hand, the sharp, flame-like forms in which the uprights of Christ's throne end on a casket in New York (Fig. 31)[121] are the same as on the coins of Alexander (Fig. 11). The Lord on the lyre-back is here once again the focus of a Deësis composition: Mary, the Baptist, and the archangels turn toward the strictly frontal image of Christ in the largest of the five medallions on this ivory lid. Although the internal form of the throne is unusual—both the dossal and the base seem to use a system of arcades—the flat, bony laths of the uprights and the crossbar are perfectly suited to the material of which the casket is made. Only once before, on the throne at the Panagia Kanakaria (Fig. 17), is the evidently ivory fabric of the supports so clearly rendered in their form.

The uprights on a last example of Christ Enthroned on the lyre-back also appear to have a numismatic precedent, although in this instance it is the double throne of the Iconoclastic emperors rather than the Orthodox, Macedonian image of the Lord seated in this fashion. On the coppers of Constantine V (Fig. 8) the curving uprights of the imperial throne begin to reverse themselves well below the crossbar. The resulting

119. To this group should be added the Deësis enamel on the lid of a silver coffer holding the head of St. Praxede in the Lateran (Ph. Lauer, "Le Trésor du Sancta Sanctorum," *Mon. Piot* XV, 1906, pp. 73–78, pl. X). The back of the throne, accurately described by Lauer as "un dossier semi-lunaire très développé," is covered with a dossal bearing the same inverted heart motif as the throne of Christ on the triptych in Tiflis.

With the Khakhuli enamel, a piece taken to Georgia from Constantinople, we can compare an indigenous eleventh-century icon depicting the same subject on a reliquary lid (Amiranashvili, *Emaux de Georgie*, pp. 45–46). They resemble each other (and all post-Macedonian examples of Christ on the lyre-backed throne) in the closed book held on the left knee and the marked differentiation between the position of the feet. But, while the delicate, hair-like *cloisons* on the Khakhuli icon are matched by the subtle curvature of its throne-back, the figure on the Georgian piece is built up with broad swathes of enamel and squats on a massive throne defined by thick supports that almost parody the form of the lyre-back.

120. Inv. no. Ω 1192 (Banck, *Byzantine Art*, pp. 311–312, figs. 191–192 [color].

121. Metropolitan Museum, acc. no. 17.190.238 (Goldschmidt-Weitzmann, *Elfenbeinskulpturen* I, no. 100, pl. LX, where the ivory is dated to the eleventh or twelfth century). This image is, as far as I am aware, the only certain representation of Christ on the lyre-backed throne to be found on an ivory casket.

serpentine effect is carried even further on a bronze icon now in Leningrad (Fig. 32).[122] Assigned uncertainly to the twelfth or thirteenth century, the icon is evidence that the form of Christ's lyre-backed throne did not undergo the degeneration that befell the throne of the Virgin and Child in the same period. This fact alone does not prove that any meaning attached to the form survived equally well, especially since, as we have suggested, many of these late works of minor art seem to be purely derivative.[123] Yet it does suggest that the iconographical type primarily associated with Christ did not decay so quickly or so thoroughly as it did when used, by extension, for the throne of Mary or that of the emperor.[124]

The Throne in the West

The lyre-backed throne as a vehicle for the Virgin disappears from Byzantine art with the Patmos *majestas* of about 1210–1220 (Fig. 30). As the seat of Christ, it appears no later than the Leningrad icon. It seems safe to assume that the lyre-backed throne disappeared, along with so much else of Greek tradition, during the Latin occupation. In the West, however, the type enjoyed a *Fortleben* not in the largely miniature context in which we find the Late Byzantine examples but in commissions and contexts of considerable stature. Its last major, datable appearance coincides with the work of Giotto at Padua.

An interval of at least six hundred years occurs between the last Roman monumental example at S. Maria Antiqua (Fig. 15) and the first single lyre-back of the medieval series at S. Francesca Romana (Fig. 33),[125] dedicated as S. Maria Nova and intended to replace the older church of Mary at the other end of the Roman Forum. It might be supposed that acquaintanceship with the throne was renewed by one of the waves of Byzantine influence that have been recognized in the impact they had on Western European art. In fact, however, both the throne of the Virgin in the conch mosaic of

122. Hermitage Museum, inv. no. X 1033 (Banck, *Byzantine Art*, pp. 313–314, fig. 202).

123. One such feature, either *retardataire* or, less probably, a revival, on the Leningrad icon is the allover compartmentalization of the throne-back. This was customary decorative practice into the tenth century (cf. Fig. 1) but thereafter tends to disappear in favor of the draped, "pumpkin-folded" dossal.

124. Lazarev (*Storia*, p. 348, note 198) suggests that the lyre-backed throne survives in the early-fourteenth-century Epithalamium of Andronicus II, Cod. vat. gr. 1851, fol. 3v. However, the throne on which the *augusta* sits on this page is square-backed with curving arms. It has nothing in common with the other thrones "a forma di lira" included in Lazarev's list. A similar throne is used in a portrait of Eudokia Makrembolitissa, wife of Constantine X Doukas and Romanus IV Diogenes, in Paris, B.N. cod. gr. 3057 (S.P. Lampros, Λεύκωμα βυζντινῶν αὐτοκρατόρων [Athens, 1930], pl. 61). This backless throne might possibly be described as "lyre-sided."

Concerning the disappearance of the throne as the seat of the basileus, it should be noted that in a manuscript as full of representation of enthroned emperors as the late-twelfth- or early-thirteenth-century Madrid Skylitzes, not a single lyre-back occurs.

125. Matthiae, *Mosaici medioevali* I, pp. 315–320, II, figs. 269, 271. Although he discusses the church under its old name, Matthiae does not remark upon the distinctly lyre-backed shape of the throne nor this mosaic's deliberate reminiscence of S. Maria Antiqua.

S. Francesca Romana, which belongs to the second half of the thirteenth century,[126] and the slightly earlier, double throne that carries Christ and his Mother in the apse of S. Maria in Trastevere[127] are quite different from the types found in later Byzantine art. Distinct from each other in many respects, each has gem-studded uprights as on pre-Iconoclastic and Middle Byzantine thrones (Figs. 1, 18); these taper, however, toward the finial in the manner of the throne at S. Maria Antiqua (Fig. 15). The horn-like supports of the throne-back are particularly noticeable in the mosaic at S. Francesca Romana, where the reverse curve is effected well below the crossbar. Below the bar, the dossal is divided into lozenge-shaped compartments very close to those on Christ's throne in the lunette at Hagia Sophia. When these facts are added to the un-Byzantine, spade-like faces and physical types, it is obvious that there can be no question of a connection between this work and East Christian art of the twelfth century. Rather, the chief and conscious debt of this image of the crowned Virgin is to her equally regal counterpart at S. Maria Antiqua.

The mosaic of Christ Enthroned with the Virgin at S. Maria in Trastevere has no closer relationship with contemporary Byzantium. As the arcades that frame Mary and the apostles at S. Francesca Romana recall architectural devices on Early Christian sarcophagi and ivories,[128] so the jeweled bench in the Trastevere church suggests at first the throne of the *synthronoi augusti* on coins of the fifth and sixth century. However, when the co-emperors are represented together it is nearly always the junior partner that appears to the spectator's right (Fig. 5),[129] and when the empress is enthroned beside her husband she always appears in this fashion (Fig. 7). Mary, to the spectator's left, is here embraced not only by Christ's right arm but also by the throne he occupies. But the sacred figures are far from being equilibrated either compositionally or iconographically. Where the *manus dei* indicates the Virgin at S. Francesca Romana, here it points to Christ alone. The invitation to share his majesty is displayed on the codex that he holds and answered on Mary's scroll.[130] Her crowned figure balances not that of her Son but that of St. Peter; the Virgin and the Prince of the Apostles are the inner members of a symmetrical scheme extending through the groups of three saints associated with the basilica and disposed on either side of the central triad. The apse mosaic is an adaption neither of post-Macedonian art nor of earlier imperial coinage. As Matthiae has shown, it is founded upon indigenous apsidal com-

126. Matthiae (ibid., I, pp. 319–320) argues that there is no necessary connection between this apse mosaic and the new dedication of the church in 1161, as had previously been supposed. He would date it in the second half of the thirteenth century or the very first years of the fourteenth.

127. Oakeshott, *Mosaics of Rome*, pp. 250–255, pl. XXV (color), fig. 173. Matthiae (*Mosaici medioevali* I, pp. 305–309) suggests a date about or slightly after 1150.

128. Matthiae (ibid., p. 318) seems anxious to stress any Byzantine connections he can find, pointing out that such arcades are also found as ornaments in the canon tables of Gospel books from the fourth century. This is indeed so, but the observation provides no more than a decorative analogy.

129. One of the few exceptions is the *solidus* of Zeno (Fig. 6), where the young Leo appears to the spectator's left. When the double throne is revived on Iconoclastic coppers, the junior emperor reverts to his traditional place (Fig. 8).

130. For the inscriptions and an ingenious analysis of the composition's origins, see Matthiae, *Mosaici medioevali* I, pp. 306–307, 314, note 7.

positions,[131] contemporary with the coins showing the *synthronoi* but independent of this imperial image.

If the thrones in these two Roman mosaics owe nothing to later Byzantine art, and the contexts in which they occur derive from local and traditional iconographical schemes, can we expect differently of the gigantic image of the Virgin Enthroned at Monreale (Fig. 34)?[132] Here Mary is displaced from the conch but, even without the crown, presents no less majestic a figure than in the Roman examples, surrounded as she is by a hierarchy of archangels, apostles, and saints. Where in the apse at Cefalù[133] Gabriel and Michael had deferred to a standing *orans* figure, they now reverence the Virgin between them seated on the only lyre-backed throne in Norman Sicilian art. As we might expect, the Child in her lap holds the rotulus and blesses with his right hand.

But this is not—or at least, not only—the Enthroned Queen of Heaven with her Son. She is identified as *H ΠΑΝΑΧΡΑΝΤΟ*[S], an inscription that, to Demus, indicates a Constantinopolitan source.[134] The art of contemporary Byzantium is indeed suggested by the pumpkin folds of her throne's dossal (cf. Fig. 30) but the substantial gem-studded uprights and their double-curved contours recall thrones of the Macedonian and pre-Iconoclastic eras.[135] Moreover, the entirely frontal attitude of the central figures and the symmetrical disposition of the flanking archangels suggest a prototype that may have been reflected earlier in the apse of the Panagia Kanakaria (Fig.

131. Matthiae suggests (ibid.) as a prime source the mosaic in the apse of SS. Cosmas and Damian, although a composition centered upon an enthroned figure, as at S. Teodoro, would seem more likely.

132. Demus, *Norman Sicily*, p. 114, pl. 63; Kitzinger, *Monreale*, p. 29, pl. 86. Both writers believe that the decoration of Monreale was finished in the early 1190s, although Kitzinger (p. 24) would have it begun in the late 1170s and Demus (p. 148) perhaps a decade later.

133. Demus, *Norman Sicily*, pl. 1.

134. Demus (ibid., p. 310) cites a long list of monuments to support his contention that this "became the favourite type of mid-Byzantine apses, and was, on the whole, fairly stationary from the sixth to the sixteenth century." He notices small variations in the gestures of Mary's hands and in Christ's manner of blessing but not the use of the lyre-backed throne, which, among the works he cites, is present only at St. Demetrius, Thessaloniki (Fig. 16), at the Panagia Kanakaria, Cyprus (Fig. 17), and in the Gertrude Psalter at Cividale, fol. 141r (H. Sauerland and A. Haseloff, *Der Psalter Erzbischof Egberts von Trier. Codex Gertrudianus in Cividale* [Trier, 1901], pl. 46). One can infer that the throne was not an essential constituent of the Panachrantos type.

135. The reverse curve is here more clearly delineated than on any other representation of the lyre-back. This clarity is not affected by the "awkward" repairs to the support and the fabric of the dossal noticed by Kitzinger (*Monreale*, note to p. 86). Another unique feature of the Monreale throne is its curved crossbar, which *rises* toward its midpoint where most Byzantine examples have a horizontal bar or, occasionally, one depressed toward the midpoint. The rising crossbar occurs only in Italian art (cf. Figs. 35, 36).

An extraordinarily deformed version of the throne in the apse of Hagia Strategos at Boularioi in the Mani has been assigned to the twelfth century and related to the image at Monreale by N.B. Drandakes (Βυζαντίναι τοιχογραφίαι τῆς μέσα Μάνης [Athens, 1964], pp. 33–34, pl. 28). The Platytera's throne exhibits double-curved uprights studded with cabochons; the upper part of each support is not reversed in relation to the member below but rather reproduces it so that the throne takes on a singular, figure-eight format. The dossal is ornamented with pseudo-Kufic calligraphy akin to that at Patmos (Fig. 30).

17) and at S. Maria Antiqua (Fig. 15). Whether this prototype was an icon of the Pana-chrantos, as supposed by Kondakov,[136] is impossible to say since, as has been pointed out,[137] the image at Monreale is our sole evidence for such an icon. Kitzinger may be right in his suggestion that the inscription is an allusion to the idea of the Virgin's Immaculate Conception, much debated in the West in the second half of the twelfth century. But even if this is so, and even if the "Madonna may have local and Western antecedents and connotations," the mosaicist used as the vehicle for this idea an ancient and particular type of throne traditionally associated with the Incarnation of the Word addressing the world from the lap of his Mother. The gesture of the Child's right hand and the roll in his left thus endorse the attributes of the Pantocrator in the conch above.

The antique form of the Virgin's throne at Monreale is particularly evident when it is compared to that of Christ in the Deësis at Grottaferrata.[138] The two mosaics have long and wrongly been related both stylistically and chronologically;[139] only recently has the Deësis been separated from the apsidal Pentecost at Grottaferrata, a composition that poses considerable iconographical problems in its own right but that is formally close to the late Comnenian "mannerism" in evidence at Monreale, Patmos, and else-where in the Byzantine provinces.[140] The Deësis, on the other hand, must have been set up at the end of the eleventh or possibly the beginning of the twelfth century. Matthiae's chronological revision is strengthened by the iconography of the throne. Its supports entirely lack the reverse curves so apparent at Monreale. They thus conform to the "degenerated" type that we have observed, the type apparently deliberately avoided in the Sicilian mosaic. Whether or not the model for the Grottaferrata Deësis was a portable work of metropolitan manufacture,[141] it is clear that we have here a coarsened version of the composition at Hagia Sophia, located in a lunette over the main portal of the church as in Constantinople.

The rejection of a Venetian source for the mosaics of Monreale[142] makes less sur-prising the absence of any lyre-backed throne in the art of that great *entrepôt* of Byzantine forms. However, in the region immediately to the north of Venice, more or less accurate versions of this throne occur about the year 1200. Each, however, is distinguished by a *retardataire* iconographical context that connotes the provinciality of these western Adriatic examples. In the central vault of the crypt at Aquileia, a program whose date is much disputed,[143] the Virgin appears on a throne with simple

136. Kondakov, *Ikonografiía* II, pp. 25–26, 321–322.

137. Kitzinger, *Monreale*, p. 29.

138. Oakeshott, *Mosaics of Rome*, p. 243, fig. 243.

139. Cf. Lazarev, *Storia*, p. 240.

140. G. Matthiae, "I mosaici dell'abbazia di Grottaferrata," *Rend. Pont. Acc.*, XLII, 1969–1970, pp. 267–282.

141. Matthiae (ibid., pp. 280–282) suggests a hypothetical, Constantinopolitan enamel as the source for this mosaic. Of the throne itself he notes only that it has a high back, an element that—together with the white cross of Christ's nimbus—"in genere non ricorre in opere bizantine autentiche."

142. Demus, *Norman Sicily*, passim; Kitzinger, *Monreale*.

143. D. della Barba Brusin and G. Lorenzoni, *L'arte del patriarcato di Aquileia* [Padua, 1968], p. 58, note 1.

curved arms, holding a Child bearing a rotulus and within a mandorla surrounded by the evangelical beast-symbols. It is precisely this association of the throne with the four beasts that had disappeared from Byzantine art in the tenth century. Further north, on the apsidal wall of the chapel at Castel d'Appiano, lyre-backed thrones with crossbars, animal-headed finials, and very narrow uprights are used as the seats of the apostles.[144] In contrast to this egregious application of the motif, the throne of Christ himself is backless.

No such solecisms are evident in Tuscan versions of the throne in the second half of the thirteenth century. Presumably through such ports as Pisa there arrived Greek exemplars of the post-Macedonian type, although these were adapted to suit the tastes of the late dugento. For instance, a Pisan panel now in Moscow[145] shows the Virgin on a throne with turned wooden uprights and crossbar strikingly akin to those in the Vienna Psalter (Fig. 29). The dossal repeats even the serpentine bands of the Byzantine example, and in the supports of neither throne is there the reverse curve that has generally defined our lyre-back. The image is, however, that of the Hodegitria, the type found on Crusader icons but never associated with the lyre-backed throne in medieval Greek art. As in many later Italian versions the Child has abandoned the rotulus, and the iconic severity of the Byzantine models is exchanged for a complex, chiastic organization in which the angles of view of the Virgin and her Son are intersected by those of the attendant angels.

The thrones in such panels have been intensively studied but their relationship to Greek prototypes, and particularly their progressively diminishing connection with the lyre-back, remains unclarified.[146] Nowhere is this Italian transformation made clearer than in Tuscany and in the work of no Tuscan artist is the purely decorative significance of the lyre-backed throne more palpably revealed than in that of Coppo di Marcovaldo. He introduced the throne-back into dugento Tuscan art in a Hodegitria painted for S. Maria dei Servi in Siena in 1261.[147] Here the head and shoulders of both the Madonna and the Child rise above the crossbar, while the uprights, simulating turned wood, describe a double curve similar to that at S. Apollinare Nuovo in Ravenna (Fig. 18). About seven years later, in a panel for the Servi church in Orvieto,[148] the back of the throne has risen to a point where it passes behind the back of Mary's

144. Demus (*Romanische Wandmalerei*, pp. 62, 131–132, pl. XXIX) assigns this cycle to the end of the twelfth or beginning of the thirteenth century. I am indebted to R. Clark Maines for drawing my attention to this Tyrolean example. Beast-finials occur perhaps half a century earlier as attachments to the lyre-backed throne of the Virgin and Child in the apse at St. Laurent, Palluau-sur-Indre (ibid., p. 427, fig. 167).

145. Lazarev, "Pisan School," pp. 61–62; idem, *Storia*, fig. 448, ascribing the panel to the second half of the thirteenth century.

146. G. Coor ("Coppo di Marcovaldo: His Art in Relation to his Time," *Marsyas* V, 1947–1949, p. 16, note 9) provides a list of Tuscan lyre-backs (as does Stubblebine ["Throne in Dugento Painting," p. 29, note 18], which remains the only serious approach to this paradigmatic problem of the relationship between Byzantine and medieval Italian painting. His article is, however, addressed to the rendering of the throne considered as an object in real space rather than as an iconographical motif).

147. Stubblebine, "Throne in Dugento Painting," p. 29, fig. 5.

148. Ibid., fig. 6.

head, curving upward to an apex hidden behind her nimbus (Fig. 35). This new, sinuous element is extraordinarily effective, answering, as it does, the curves of the uprights and the gentle arcs of the Virgin's arms as they enfold the Child. Never had the aesthetic potential of the lyre-back's curvilinear form been more cogently exploited. Never was one form of the lyre-back—the low, turned throne in Siena—so swiftly abandoned for another: the high throne that we find in the Orvieto picture, its supports inlaid with bands and rectangles of pearls.

In view of this development, it is purely of antiquarian interest to speculate upon what model Coppo had in mind when he first employed the lyre-back.[149] The import of the form to him can be discerned solely in the light of his second picture. Here it becomes clear that the lyre-back, from the start, offered an elegant, plastic shape that could be modulated according to the artist's powers of invention. This feature rather than any precise body of meaning attached to a significant form constituted the appeal of the throne in Tuscany.

The ultimate stage in the use of the throne for purely aesthetic purposes is to be found a generation later in two mosaics at S. Maria Maggiore in Rome. Both Torriti's Coronation of the Virgin in the apse, dating from the papacy of Nicholas IV (1288–1292) and Filippo Rusuti's façade mosaic (Fig. 36),[150] put up shortly before the artist left for France in 1308, represent theophanies in which the protagonists are seated on thrones that have their formal origin in the lyre-back. Unlike the apsidal mosaic at S. Maria in Trastevere,[151] Torriti's composition affords a central role to both Christ and his Mother. Their bench-like throne hovers like some interstellar platform within a circular mandorla seemingly supported by troops of diminutive angels on either side. The pleated dossal of the Trastevere throne is replaced by a lozenge-decorated back as at S. Francesca Romana (Fig. 33). But beyond an inscription elsewhere in the church,[152] which suggests that the original image in the apse portrayed the Virgin attended perhaps by martyrs, there is nothing to indicate any connection between Torriti's mosaic and its Early Christian predecessor. The form of the throne has as little to do

149. Stubblebine (ibid., note 18) adduces the examples of S. Apollinare Nuovo (Fig. 18) and S. Maria Antiqua (Fig. 15). He is more to the point in hypothesizing Byzantine models for the angels introduced into Coppo's Siena and Orvieto pictures, although the half-length figures behind the emperor's throne in Paris, B.N. MS Coislin 79, fol. 2r are not angels, as he suggests (p. 31, note 20), but personifications. Unlike their Roman and Alpine counterparts, Tuscan artists seem to have drawn on Byzantine works of the late eleventh and twelfth centuries rather than pre-Iconoclastic models. However, the long, bench-like throne in the Last Judgment mosaic at the Florentine Baptistery upon which sit the Virgin and six apostles (A. de Witt, *I mosaici del battistero di Firenze*, III: *Le storie del Giudizio Finale* [Florence, 1956], pl. IV) has no Byzantine parallel. Its back ends in double-curved, lyre-like forms, a feature missing in the corresponding throne of the other six apostles to Christ's left (ibid., pl. XXIX).

150. The relationship between Rusuti's façade and Torriti's apse mosaic, as well as the chronology of these and other portions of medieval decoration, has recently been considered by J. Gardner ("Pope Nicholas IV and the Decoration of Santa Maria Maggiore," *Zeitschrift für Kunstgeschichte* XXXVI, 1973, pp. 1–50; see esp. p. 25).

151. See p. 31 above.

152. Quoted by Oakeshott, *Mosaics of Rome*, p. 313.

with Byzantium[153] as the iconography of the Coronation enacted here or St. Francis, who, with five others, salutes the deed from the wings of the conch.

Both this throne and that of Christ on the façade (Fig. 36) have attenuated and diminishing uprights whose main function would seem to be to prevent the encroachment of these elaborate pieces of furniture upon their confining mandorlas. The uprights are studded with single vertical bands of gems and terminate in finials that spiral tightly in the manner of pegs on a stringed instrument. It is these terminals that lend the air of a lyre-back to the thrones at S. Maria Maggiore. In Torriti's apse mosaic, they recall the one visible finial on the *folles* of Justin II and Sophia (Fig. 7), but, as at S. Maria in Trastevere, the position of the male and female figures is the reverse of that on the coin. Rusuti's Enthroned Christ, where a lyre-backed throne would be appropriate, recalls on the other hand Middle Byzantine theophanies (e.g., Fig. 21) in which joyous angels disport themselves about the throne of the Lord. On the façade of S. Maria Maggiore, Christ's gesture is rendered almost identically to that at Hagia Sophia (Fig. 1) and his book bears a text[154] that is the second part of the compound quotation used at Constantinople.

But such analogies are delusory. Although the mosaic was badly damaged and restored in the middle of the eighteenth century when the façade was remodeled,[155] it seems fairly certain that we have here an accurate account of Rusuti's work. The hallmark of this is a somewhat clumsy attempt to suggest a sense of real space that derives immediately from Cavallini. In the apse mosaic the hand of Christ, raised to place the crown on the Virgin's head, overlaps one of the stars in the "background" and in this way suggests the forward position of the seated figures; so, too, on the façade the angels partially hidden behind the mandorla swing their censers in front of it, thus defining its existence in a three-dimensional world. The seat of Rusuti's throne is, moreover, seen slightly from the right so that we shall not miss the depth in space implied by this foreshortening. Finally, in contrast to the stable, frontal image enthroned at Hagia Sophia, the Christ at S. Maria Maggiore is enlivened by a contrapposto that animates the figure from the pupils of the eyes, moved far to the right within the irises, to the out-turned right foot balancing the book displayed in the left hand. It is surprising to find in this pragmatically concerned world of the early trecento that even the form of the ancient lyre-back should be retained to the slight extent that it is in the work of Rusuti.

By this time Western artists had received and translated into their own idiom the major lessons that Byzantine art had to teach. They had absorbed elements of Greek style that, among other things, enabled them to realize their figures as palpable and articulated objects in real space, and had appropriated aspects of Byzantine iconography, especially of the aulic variety, that transmogrified Western images of rulers both heavenly and earthly. Yet one finds, particularly north of the Alps, perhaps as

153. It does, however, have an arcuated register immediately behind the *suppedaneum* remotely reminiscent of that on Byzantine ivories such as that in the Metropolitan Museum (Fig. 31). On Rusuti's mosaic (Fig. 36) this motif occupies two such zones.

154. EGO SUM LUX MUNDI QUI ... (John 8:12).

155. Matthiae, *Mosaici medioevali* I, p. 381.

many examples of iconographical resistance. Some Byzantine subjects and motifs would obviously be rebuffed for reasons of doctrine; others, for which no such explanation can be found, never took root or, if they did, were transformed almost out of recognition. One such is the lyre-backed throne. Unknown in northwestern Europe since the Carolingian era, when as I have suggested it was largely misunderstood (Fig. 19),[156] it makes a final appearance in a familiar context, as the seat of the Virgin and Child within an apsidal mandorla.[157] Occupying the conch of a small chapel at Nôtre-Dame, Montmorillon (Vienne), the painting has been dated shortly before 1200 and its cursive linearities related to the manneristic phase of contemporary Byzantine art as at Kurbinovo and Lagoudhera.[158] That the more clement art of the Crusaders intervened between some majestic Byzantine prototype and this fresco seems likely, for the work is a curious combination of the solemn and the sprightly. The leaping Child, crowning a female figure that is either St. Catherine or Ecclesia, is matched in agility by the swirling draperies that both he and his Mother wear. And into this agitated picture the swan-like arms of the throne fit naturally, their reverse curves showing that the lyre-back is here interpreted, like the folds of the *maphorion*, purely as a form to be molded. The arms now have no more iconographical significance than the serpentine back of the throne enclosing the Virgin like an inner mandorla.[159]

If this apse contains only the slightest reminiscence of the Byzantine lyre-back, it must not be assumed that the throne was entirely unknown in the medieval West. Illustrated in the Rhineland about the same time as the Montmorillon fresco, the *Hortus Deliciarum* of Herrade of Landsberg contained two such thrones. The close connections between this manuscript and the Greek East have frequently been insisted upon.[160] What has not been remarked is the frequency with which Byzantine motifs are adapted rather than simply copied. In the representation of a royal feast, for instance, a king sits on a lyre-backed throne[161] while, elsewhere, Christ welcoming the figure of Ecclesia presented by the apostles sits on a backless throne.[162] This is not exceptional: we have seen the lyre-back used as the seat of kings in the eleventh century (Fig. 26). But later in the manuscript a full page is devoted to an image of Abraham,

156. See p. 17, above.

157. Demus, *Romanische Wandmalerei*, p. 72, pl. LXIII.

158. Ibid., p. 151. Without further particulars, Demus suggests Byzantine "ikonographische Vorbilder" for the throne, the gesture, and the dress of the Virgin.

159. The lobed back of the Montmorillon throne recalls the unique form of the throne-back on a Macedonian ivory of the Virgin and Child in Cleveland (Goldschmidt-Weitzmann, *Elfenbeinskulpturen* II, no. 79, pl. XXXII).

160. The most important studies are O. Gillen, *Ikonographische Studien zum Hortus Deliciarum (Kunstwissenschaftliche Studien* IX) (Berlin, 1931); and Cames, *Peinture romaine*, pp. 282–283, and passim.

161. Straub-Keller, *Hortus*, pl. XXIV, bis. There are discrepancies between the two editions of the tracings made by Count Auguste de Bastard before the fire of 1870 which destroyed the MS. The edition of J. Walter, *Herrade de Landsberg, Hortus Deliciarum*, Strasbourg-Paris, 1952, is less complete than Straub-Keller. We await the reconstruction of the *Hortus* in preparation by Rosalie Green and her collaborators.

162. Ibid., pl. XLII.

clasping the souls of the blessed to his bosom as he sits on the most Byzantine of lyre-backed thrones to occur in western European art (Fig. 37).[163] Although the supports taper upward and lack central bosses, their manner of ornament and the finials that crown them are as close to those on the throne in the mosaic at Hagia Sophia as the horizontal crossbar and the completely frontal image of the patriarch.

The figure of Abraham is obviously derived from an enthroned Christ and even the palm trees that flank him are known in a context where the lyre-back represents the throne in Heaven (Fig. 17). But nowhere in Byzantine art that I am aware of does this scene, a familiar constituent of the Last Judgment, include the lyre-backed throne. It may be that the artist of the *Hortus* copied a rare Byzantine application of the throne but, until evidence for such a hypothesis is forthcoming, it seems more reasonable to assume that the German illustrator of the late twelfth century saw in the lyre-back simply a majestic throne appropriately employed in a variety of exalted situations. Unlike the Montmorillon fresco or the panel of Coppo di Marcovaldo, where the form of the lyre-back shows that it had lost much in translation to the West (Fig. 35), here it is the context in which the lyre-back occurs that suggests the misapplication of the Byzantine motif. In none of these Latin instances represented in a variety of ways is there any indication of understanding that the lyre-backed throne had expressed a particular and precise idea in the Greek East.

Ancient Sources and Modern Conjectures

Neglected by Byzantine artists only during the final period of their history, the lyre-backed throne has been generally disregarded by historians. Its recurrent appearances through nine centuries of East Christian art have been occasionally noted, rarely linked,[164] and never investigated. This omission may be due to the fact that the throne assumes what at first seem to be a bewildering variety of shapes. As used by Wroth the term applies to thrones of considerably diverse form. When to these numismatic varieties (Figs. 3, 4, 10–13) are added the multifarious lyre-backs found in monumental and minor art, it becomes necessary to ask if we are justified in connecting such diverse shapes. Are the thrones that we have noticed variants of a single artistic type but taken by the die-cutters, mosaicists, wall painters, and manuscript illustrators from different models? Or is the diversity due only to artists endowed with varying gifts of representational ability? If there was but one principal type of lyre-back in Byzantine art, did this throne possess some iconographical significance or was it merely the product of an inventive, decorative imagination as, say, the throne of the Pantocrator on the Pala d'Oro in Venice?

Answers to these questions would still not solve the problem of whether such a throne

163. Ibid., pl. LXXVIII; Bastard drawing, fol. 119. The form of the throne, its uprights, and its finials are quite different from those in the drawing cited in note 161, above. The artist of the *Hortus* was obviously familiar with more than one type of lyre-back.

164. Cf. notes 4 and 6, above.

existed historically or was instead an idea, deformed—as a neoplatonist might put it—in the act of realization. More pragmatically, but in fact with no more evidence, historians of Byzantine art have argued that there was such a throne in Constantinople. Following Whittemore's assertion that Christ's seat in the narthex mosaic at Hagia Sophia (Fig. 1) is "an imperial throne,"[165] Breckenridge sought to connect it with the Palace[166] while Nordström suggested as much of the throne at S. Apollinare Nuovo (Fig. 18).[167]

Ignoring for a moment the absolute lack of any historical evidence for the lyre-backed throne, it should be noted that the postulate of a *particular* imperial throne raises some awkward questions. If there was one throne of this type in Constantinople, why was it represented in a variety of ways before Iconoclasm and why, especially, do such variations increase, in number rather than disappear during the Macedonian era when Byzantine iconography—at least in its major themes and motifs—tends to become stabilized? To argue for a specific, actual throne, akin presumably to that in the mosaic over the Imperial Door, is no more justified than to hypothesize the existence of several different thrones corresponding to the heterogeneous types found on the coins. The argument from art to history is untenable unless we are ready to believe that Leo I and his co-emperor sat on a throne with a curved back (Fig. 5), which his successor Zeno threw out and replaced with a straight-sided piece of furniture (Fig. 6) for his joint rule. Was this double throne—of protean shape—then abandoned after Iconoclasm and a single lyre-back substituted, even though co-emperors were crowned until the fifteenth century?

Common sense must reply to such questions for there are no written documents to answer them. We have a sizable body of medieval Greek texts, such as the *de Cerimoniis* and the *de Officiis* of the Pseudo-Kodinos, which describe in detail the forms and attributes of Byzantine aulic ritual. These recount, for example, the badges worn by court officials, the color of the patriarch's horse, the number of obeisances required of an ambassador. But nowhere among these minutiae of Constantinopolitan ceremonial is so conspicuous an object as a lyre-backed throne even mentioned. The imperial throne recurs frequently in the Book of Ceremonies[168] and is described as made of gold, encrusted with precious stones, and covered with cushions and precious carpets. No reference is made to its shape nor to that of other celebrated thrones in the great reception halls of the Palace.[169] An interval of two hundred years provides no more support for the belief in the lyre-back as an aulic appurtenance. Anna Comnena uses at least seven different terms for the thrones of her father and even briefly describes

165. Whittemore, *Prelim. Report, Narthex*, p. 17.

166. Breckenridge, *Justinian II*, p. 49: "The lyre-backed throne is not a generalized type of throne, but a very specific one which appears on the imperial coinage from the fifth century onward, and is almost certainly a particular throne used in the imperial ceremonies."

167. Nordström, *Ravennastudien*, p. 81.

168. E.g., II, 15, *de Cer. C.S.H.B.* pp. 568, 575, 580, 587 and passim. The terms βασιλικὸς θρόνος, σέντζος, and σέντζος are used apparently indiscriminately; the last of these, as Grierson (*D.O.C.* III,1, pp. 46, 146) points out, had earlier given its name to the coins of Basil I bearing the lyre-backed throne.

169. E.g., the throne of Solomon (*de Cer.* II,15, pp. 566, 567, 570, 583, 593); the throne of Constantine (II, 15, p. 587); the throne of Arcadius (II, 15, p. 587); the throne of Theophilus (II, 15, p. 595).

some of them.[170] But not once is there the suggestion that any of these approached the form that we are pursuing.

Even if we assume the improbable, that the lyre-backed throne was, for a Greek, too celebrated an object to warrant identification,[171] the tales of foreign visitors are of no greater help. We have accounts of the city, its liturgies, and its court written by awed travelers such as Benjamin of Tudela and skeptics like Liudprand of Cremona across a span of eight centuries. Jews, Arabs, Spaniards, Russians, and Crusaders recorded, often in detail, what they saw—and sometimes what they imagined they saw—but not one testifies to the existence of such a throne. Nor is this due, in several instances, to a lack of familiarity with the imperial furnishings. Benjamin, for example, in his account of the Blachernae Palace describes the jeweled inlay of the throne and the golden crown suspended by a chain above it.[172] An *argumentum ex silentio* is by definition imperfect, but in the case of the lyre-backed throne the weight of negative evidence against its existence is overwhelming.

The silence of the chroniclers and the travelers confirms what the monuments, the manuscripts, and the coins have suggested: the source of the image is not to be found in historical actuality. Is it to be found then in antique literature, either scriptural or classical? There are over three hundred references to thrones in the Old and New Testaments but none is described as lyre-backed. No throne made or represented in the period between the Egyptian Old Kingdom and Alexander[173] remotely resembles the lyre-back. And no Hellenistic or Roman throne hints at this form before the modest *klismos* upon which the poet is portrayed in the so-called House of Menander at Pompeii.[174] The curved back and uprights of this chair, however, do not approach in complexity of shape—let alone in ornament—the characteristics of the lyre-back.[175]

170. E.g., IX, 9, *C.S.H.B.*, p. 263. Anna's wealth of synonyms includes βῆμα, καθέδρα, κλήνη, θρόνος, θῶκος, περιωπή, and σκίμπους.

171. An omission for such a reason would be consonant with neither the purpose nor the practice of Constantine Porphyrogenitus.

172. *The Itinerary of Benjamin of Tudela*, trans. M.N. Adler (London, 1907), p. 13.

173. Cf. H. Kyrieleis, *Throne und Klinen. Studien zur Formgeschichte altorientalischer und griechischer Sitz- und Liegenmöbel vorhellenistischer Zeit* (Berlin, 1969).

174. G.M.A. Richter, *The Furniture of the Greeks, Etruscans and Romans* (London, 1966), p. 102, fig. 511.

175. It must be emphasized that this observation applies only to the throne, not to the instrument the shape of which was appropriated. Because of the variety of form and fabric in the thrones even before Iconoclasm, there is little point in trying to identify a single type of antique lyre as a source. Generally, however, in the single or double curves of their uprights ending in a more or less elaborate finial, they correspond to an instrument recognizable at least as early as the third century B.C. on the Achilles sarcophagus formerly in St. Petersburg (C. Robert, *Die antiken Sarkophag-Reliefs* II [Berlin, 1890], pp. 23–26, fig. 20a). Achilles' instrument, identified by Robert as a *phorminx*, is essentially the same as the lyre held by Nero on copper coins of his reign (Mattingly, *Roman Empire* I, pp. 245–246, 249–250, nos. 234–238, 254–258, pl. 44, 7–10, 12). The type persists through the middle of the second century, occurring, for example, as an instrument made of antelope horn on the grave relief of the poetess Petronia Musa in the Villa Borghese (W. Altmann, *Die römischen Grabaltar der Kaiserzeit* [Berlin, 1905], p. 212, no. 273). The lyre here may be compared with a cithara on the same relief. For the complex relationship

Occasionally, late antique chairs suggest a simpler form of our throne. Thus the *sella curulis*, originally an ivory folding seat without back or arms used by magistrates *cum imperio*, becomes in Early Christian hands a seemingly possible antecedent of the lyre-back. On one wing of a late-fourth-century diptych in Florence, St. Paul sits on what might be called a lyre-backed chair but which is plainly a version of the magistrate's *sella*.[176] In fact there is no antique source for the throne; it appears in the art of the fifth century after Christ apparently spontaneously and without artistic prototypes.

Beyond this particular observation, it must be remembered that the Christian association of the throne with the *Rex Regnantium* developed in a world imbued with pagan ceremonies revolving about the *solium regale* as cult object. The Hellenistic rite of *solisternium* was practiced at Rome from the time of the Principate[177] and a variety of cosmic functions were assigned to the throne in Sassanian Persia.[178] As Grabar has pointed out, numerous images of sacred thrones became components of the imperial state iconography at the latest in the reign of Diocletian and were henceforth available as models for Christian artists.[179] But the point critical to our investigation is that the lyre-back was not among this number. Although we have probably lost many important early representations and are thus dependent on such provincial and problematical examples as the Grado reliquary, the lyre-backed throne is manifestly an invention of the Early Christian era. Established as a type by the time of Justinian, it endures—albeit in many varieties—in the major or minor arts of Byzantium through every century until the fall of Constantinople to the Franks. The Christian significance of this persistent motif deserves investigation.

Solomon and David

If we except the doubtful and double imperial thrones on fifth-century *solidi* (Figs. 5, 6), we find that the majority of early lyre-backs are used as the seat of the Virgin and Child. This may be no more than fortuitous and none perhaps is older than the mosaic of Christ Enthroned at S. Apollinare Nuovo (Fig. 18). The image at Ravenna is the first

between *phorminx*, lyre, and cithara (distinguishable by its large sound box), see *R.-E.*, s.v. "Saiteninstrumente."

The diversity of form evident in representations of the lyre-backed throne is matched by the various forms the instrument itself assumes in Late Antique and Early Christian art. Differing shapes, numbers of strings, and manners of playing are most evident on the ivories of the period, for which see Volbach, *Elfenbeinarbeiten*, nos. 68, 71, 79, 80, 91, 96.

176. R. Delbrück, *Die Consulardiptychen und verwandte Denkmäler* [Berlin, 1929], p. 274, pl. 69.

177. A. Alföldi, "Insignien und Tracht der römischen Kaiser," *Röm. Mitt.* L, 1935, pp. 124–139. For further evidence of throne cults in the Hellenistic world, see Ch. Picard, "Le Trône vide d'Alexandre dans la cérémonie de Cyinda et le culte du trône vide à travers le monde gréco-romain," *Cah. arch.* VII, 1954, pp. 1–17.

178. Cf. L'Orange, *Cosmic Kingship*, pp. 37–47. The ancient Near East and especially Iranian precursors of Sassanian throne cults are discussed by Alföldi, "Throntabernakel," pp. 542–565.

179. Grabar, *L'Empereur*, pp. 199–200.

of a long series of representations of the Lord who thereafter possesses the throne almost exclusively through the Macedonian era. Not till the second half of the eleventh century would the Theotokos return with any frequency to the lyre-back she had occupied in iconic majesty during the pre-Iconoclastic period. But then, from the time of the Vienna Psalter (Fig. 29) on, she appears, with her Son in her lap, as often as the image of Christ Enthroned, while in the West the lyre-back becomes the peculiar property of the Madonna and Child.

We have suggested that the Roman thrones, and the bench-like seat of Christ and Mary in the apse of S. Maria in Trastevere, owe little to contemporary Byzantine art. Like the dugento Tuscan examples that are formally more closely related to Greek models, the lyre-back occurs here in an iconographical context deriving primarily from the Mariological devotions of the Roman Church. Independent of often similar Orthodox sentiments,[180] the Latin West developed its own corpus of typological and analogical encomia of the Virgin. Foremost among these was the recognition of Mary as the *Sedes Sapientiae*, the throne that the Logos, identified with the wisdom of the Lord,[181] had prepared for himself in the Virgin. In the late eleventh century, the idea received an important expansion in the comparison of this act with the throne built by Solomon, whose wisdom was the gift of God.[182] Like the Jewish king, the Logos built a throne when he prepared a seat for himself in the Virgin.[183]

Unlike many Western representations (e.g., Fig. 33), the Child held by the Virgin on the lyre-backed throne never lacks the rotulus.[184] So, too, Christ enthroned in this fashion always holds the open or closed book. It behooves us to ask, therefore, whether the lyre-back, as the seat of divine wisdom incarnated through the Theotokos, is not a version of the throne of Solomon. Byzantine iconography did not associate the Virgin herself with the image of Sophia. Divine wisdom appears either as a personification, as in the Rossano Gospel,[185] or else as embodied in Christ.[186] It therefore remains possible that the throne of Solomon was considered the locus of wisdom and that in actuality and in art it should occur in the guise of the lyre-back.

The biblical descriptions of the throne contain nothing to suggest this but we know that a throne, reputed to be Solomon's, was preserved in the Magnaura, in Constantinople.[187] Medieval accounts of this prodigy, such as Liudprand's, improve upon scriptural tradition in having its attendant lions roar and the throne itself equipped with

180. Cf. chapter 4, note 140 below.

181. I Corinthians 1:24, 30.

182. I Kings 10:18–20; 2 Chronicles 9:17–19. These biblical descriptions are developed by Josephus (VIII, 140). For the history and significance of the throne in antiquity, see Alföldi, "Throntabernakel."

183. The *locus classicus* of this idea is Guibert de Nogent, *De laude S. Mariae*, Book VI, chapter 3, *P.L.* 156, cols. 541–542. Its artistic manifestations have been studied by I. Forsyth (*The Throne of Wisdom* [Princeton, 1972]).

184. In some Western examples (e.g., Fig. 15) a codex is substituted for the rotulus.

185. Fol. 121r (A. Muñoz, *Il codice purpureo di Rossano e il frammento sinopense* [Rome, 1907], pl. XV).

186. A. Grabar, "Iconographie de la Sagesse Divine et de la Vierge," *Cah. arch.* VIII, 1956, pp. 254–261.

187. See note 169 above.

a mechanical device that could lift it far above the head of astonished spectators.[188] But despite such evidence of familiarity, not one indicates that the marvel had a lyre-shaped back. Again, when the throne of Solomon is specifically represented in Byzantine painting, as it is in the Paris Gregory,[189] it is shown studded with jewels and on a high base but with a chair-like, straight back. Evidently, Christ's lyre-backed throne is not one derived by analogy from that of the wisest king of the Jews.

Given the Davidic genealogy of the Saviour, there remains the possibility of a transmission by "inheritance." Was the lyre-back the seat of the Psalmist? King David enthroned is a rarer figure in Byzantine art than the youthful shepherd, but in those instances where he does appear in this fashion it is usually upon a backless throne. So it is in the full-page miniature in the Vatican Cosmas, where the bearded king, with Solomon at his side, plays for the wheeling choirs about him.[190] This late-ninth-century manuscript probably reflects a model of Justinianic date, but there is no reason to believe that the lyre-back was later attributed to David. In a tenth-century Ambrosian psalter, in a prologue to which the anonymous author confesses his familiarity with a Greek psalm book, a David in imperial regalia occupies a throne so accurately rendered that an ultimate Byzantine source is incontrovertible.[191] As he plays, his chant is recorded by his four scribes but the miniature includes no dancers or musicians. This image, however, would appear to be a *hapax*. The standard throne of the psalming David is backless, as on the twelfth-century façade reliefs of the Demetrius cathedral at Vladimir.[192] We must assume that the Milanese psalter illustration represents an iconographical appropriation of the throne of Christ, and that the Byzantine exemplars carried to Russia and the West showed David upon a backless throne.

Rather than the "impropriety" of showing the enthroned king as an inspired minstrel,[193] it was probably the large body of scriptural allusions to his musicianship that induced medieval artists to prefer the image of David, the sweet-sounding shepherd. The Psalms and other texts in the Septuagint employ a wealth of different names for the instrument that accompanies the songs of jubilation or despair[194] and,

188. Liudprand, *Antapadosis* VI, 5; F.A. Wright, *The Works of Liudprand of Cremona* (London, 1930), pp. 207–208. For other sources, see Alföldi, "Throntabernakel," pp. 539–542.

189. Fol. 215v (Omont, *Miniatures*, pl. XXXIX).

190. Cod. Vat. gr. 699, fol. 63v (Stornajolo, *Topog. crist.*, pl. 26).

191. Munich cod. lat. 343, fol. 12v (D.H. Wright, *The Vespasian Psalter* [Copenhagen, 1967], pl. VI,h).

192. D. Ainalov, *Geschichte der russischen Monumentalkunst der vormoskovitischen Zeit* [Berlin, 1932], pp. 80–82, figs. 52a, 54a.

193. For the iconography of the Psalmist's divine inspiration, see Wright, loc. cit., p. 71. Besides his customary appearance as royal musician in many psalter frontispiece miniatures, David occurs as king and musician in other important Byzantine manuscripts. In the Psalter of Basil II, Venice, Marciana cod. gr. 17, fol. 1v (Rice, *Art of Byzantium*, fig. 127), he stands playing beside the bed of Saul. In the Vatican psalter, cod. gr. 1927, fol. 245v (DeWald, *Vat. gr. 1927*, pp. 39–40. pl. LVII), David, nimbed, crowned, and seated on a hillock, looks oddly out of place as he plays a rectangular harp, while the lamenting Jews hang their instruments in the willows beside the "waters of Babylon."

194. For example, Psalm 70 [71]:22: Καὶ γὰρ ἐγὼ ἐξομολογήσομαί σοι ἐν σκεύι ψαλμοῦ τὴν

in this diversity, are followed by the illustrators of Middle Byzantine psalters. Despite this, art historians have generally described miniatures of the young musician as David the Harper.[195] This is often quite unjustified. Surrounded by a variety of animals, obviously intended to evoke the beasts of all sorts whom he enjoins to praise the Lord,[196] David in the Paris Psalter plays a right-angled psaltery.[197] The instrument here is part of an iconographical complex that includes the figure of Melody sitting beside the Psalmist shown in profile.[198] The gathered flocks surround the shepherd in another scheme found in such eleventh- and twelfth-century manuscripts as the Barberini and Ambrosiana psalters.[199] But here David is shown *en face*, while Melody, usually, although not always, stands rather than sits at his side.[200] The essential and unremarked point is that in this tradition he holds a lyre-shaped instrument although there is no substantiation in Psalms for such a motif.

David plays a similar instrument in Vatopedi cod. 761, important to our investigation since it has been connected with a much older tradition.[201] Although this psalter is dated to 1088, Weitzmann has suggested that this David miniature reflects one of the early-seventh-century silver plates found in Cyprus in 1902 now in the Antiquities Museum at Nicosia (Fig. 38).[202] Here the shepherd, seated on a rock as majestically as if he were enthroned, salutes Samuel's messenger with his right hand. In his left he holds an instrument closely akin to that in the Vatopedi miniature, which Weitzmann identifies as a lyre.[203] Recent descriptions of this plate refer to it as a harp.[204]

ἀληθείαν σου ὁ θεός, ψαλῶ σοι ἐν κιθάρα, ὁ ἅγιος τοῦ Ἰσραήλ; Psalm 136 [137]: 2: Ἐπὶ ταῖς ἱλέαις ἐν μέσῳ αὐτῆς ἐκπεμάσαμεν τὰ ὄργανα ἡμῶν. Cf. the description of David playing to the melancholy Saul, I Kings [I Samuel] 16:23: Καὶ ἐλάμβανε Δαυὶδ τὴν κινύραν καὶ ἔψαλλεν ἐν χειρὶ αὐτοῦ.

195. Cf. Buchthal, *Paris Psalter*, captions to figs. 19–23.

196. Psalm 148:10.

197. Buchthal (*Paris Psalter*, p. 13, pl. I) identifies the instrument as a harp; so too does Weitzmann (*Geistige Grundlagen*, p. 9, pl. 3 [color]). As against this, but with no greater justification, Tikkanen (*Psalterillustration*, p. 23, fig. 21) describes David playing the harp in the Khludov Psalter (Moscow, Hist. Mus. cod. add. gr. 129, fol. 147v) as "den leierspielenden Hirtenknaben." The most recent study of these representations is T. Seebass, *Musikdarstellung und Psalterillustration in früheren Mittelalter* (Berne, 1973).

198. The type is preserved in a late-eleventh-century psalter in the British Museum (Add. 36928, fol. 44v [Buchthal, *Paris Psalter*, fig. 19]), and in a thirteenth-century miniature inserted into a psalter in Leningrad (Public Library cod. 269, fol. 1r [Weitzmann, *Geistige Grundlagen*, pp. 43–44, fig. 42]).

199. Buchthal, *Paris Psalter*, figs. 21, 22.

200. Ibid., pp. 14–17, for the classical sources of these two schemata. Cf. Weitzmann, *Geistige Grundlagen*, pp. 10–12.

201. Fol. 11r, Weitzmann, "Vatopedi 761," pp. 21–51, fig. 3.

202. Inv. no. 454 (Rice, *Art of Byzantium*, p. 306, fig. 72). For the development of Weitzmann's thesis, see his "Prolegomena to a Study of the Cyprus Plates," *Metropolitan Museum Journal* III, 1970, pp. 97ff.

203. Weitzmann, "Vatopedi 761," p. 23. Cf. most recently S.H. Wander, "The Cyprus Plates: The Story of David and Goliath," *Metropolitan Museum Journal* VIII, 1973, pp. 89–104, esp. p. 100.

204. Ibid., p. 38; Rice, loc. cit., both presumably following the text of I Kings [= I Samuel] 16:16–23, where the instrument is referred to as ἡ κινύρα, rather than the form represented by the silversmith. However, O.M. Dalton ("A Second Silver Treasure from Cyprus," *Archaeologia* LX, 1905, p. 8), followed by P. Dikaios (*A Guide to the Cyprus Museum* [Nicosia, 1947], p. 116), correctly identified it as a lyre.

Yet the double curves of its frame and the manner in which it is held clearly differentiate this lyre from the rectangular psalteries and harps found in the Paris Psalter and other manuscripts of the "aristocratic" recension. We may not discover any stage nearer the prototype than this silver plate of the early seventh century but it may be presumed that its iconographical scheme included a lyre, just as it excluded the personifications missing in both the Vatopedi psalter and the plate in Nicosia.

David's lyre, then, when he has one, is an instrument but, in Byzantine art, never a throne. When he is shown seated it is as a shepherd on a hillock or an outcrop of rock and less often as a king on a throne.[205] But his attitude as the youthful musician, especially in early examples like the Cyprus plate, is so close to that of Christ Enthroned[206] on the lyre-back (and on other types of throne) that it would seem worthwhile to pursue earlier, analogous images that might account both for this similarity and for the common presence, if differing application, of the lyre.[207]

Orpheus and Christ

The errors that have attended the description of David's instruments can lead to confusion in the search for prototypes. They can also obscure the relationship between the melodious king and other antique musicians represented in Byzantine art. Unfortunately, David is not the only figure to have suffered a mistaken instrument. Orpheus has sustained a similar slight in an account of a manuscript containing a text in which the Thracian singer is already under disdain. In a miniature showing Orpheus and Homer in the ninth-century copy of Gregory Nazianzenus at Milan, the former has been assigned a lyre despite the fact that the image is accompanied by the legend *ΟΡΦΕΨΣ ΜΕΤΑ ΤΗC ΚΙΘΑ ΡΑ Σ*.[208] It is true that the homily illustrated here

205. H. Stern ("Un Nouvel Orphée-David dans une mosaïque du VIᵉ siècle," *C.R.A.I.*, 1970, pp. 63–79) discusses the important floor mosaic found in 1966 in a synagogue at Gaza. It depicts a seated, nimbed figure surrounded by beasts, identified by inscription as David and wearing a Byzantine imperial diadem. For Stern the figure is one of a series of conflations of Orpheus and David, an interpretation based partly on the "harp" that he recognizes in David's hands. The instrument is certainly not a lyre but precision is hardly possible upon this point. Stern suggests that both of its curved, finial-crowned sides are evident. In fact only the right side of the frame (from the spectator's point of view) is preserved. Nonetheless, whatever the instrument, the close relationship between the iconography of the Thracian singer and the model and ancestor of the Messianic king is clearly evidenced by this mosaic.

206. Note the gesture made with the right hand while the left is occupied with the object it is holding, the frontal position with the face and nimbus parallel to the picture plane, the knees apart with cascades of drapery between them, and the differentiation between the positions of the feet.

207. Grabar (*L'Empereur*, pp. 25–26, 189–195) of course pointed to the dependence of the image of Christ Enthroned upon imperial iconography; and Weitzmann ("Vatopedi 761," pp. 38–40) suggested the origins of the image of David the musician in an Early Christian illustrated Book of Kings. My purpose is neither to challenge these suggestions nor to offer specific prototypes for these motifs. Rather I hope to point to a body of images and ideas that surrounds the core of the relationship between the lyre held in the hand and the Logos seated on a lyre-backed throne.

208. Ambros. cod. E. 49–50 inf., p. 751 (Weitzmann, *Greek Mythology*, p. 89, fig. 96).

specifically ridicules Orpheus and his lyre[209] but the rectangular instrument in this miniature, adorned with bulbous pommels similar to those in some late antique representations, bears no resemblance to a lyre.

Lacking any sign of a curved frame, it is in fact closer to the instrument borne by Orpheus in a late-eleventh-century Gregory manuscript and recently identified as a harp (Fig. 39).[210] Buchthal has suggested the dependence of the type of David shown *en face*, in psalters such as the Barberini, upon late antique images of Orpheus and noted the preservation of the type in Middle Byzantine illustrations to Gregory's invective against the pagan musician.[211] This is an important contribution to our understanding of the David-Orpheus nexus but also, in several respects, an oversimplification of a complex situation. It ignores, for example, the traditional Byzantine distinction between Orpheus, who rests his instrument upon a pedestal beside him, and David, who supports his on his knee or on the rock that serves also as his seat. It overlooks the great variety of dress, pose, and type of instrument found in Late Roman and Early Christian representations of Orpheus. And, of most immediate significance to us, Buchthal disregards the fact that while in most Middle Byzantine miniatures Orpheus is assigned either a cithara or a harp, there existed at the same time a tradition that endowed him with a lyre.

Iconographical differences of this sort imply the need for caution in dealing with manuscripts that have been grouped together on stylistic grounds.[212] Although in cod. gr. 1947, a much-damaged Gregory manuscript in the Vatican, Orpheus is surrounded by the familiar *paradeisos* of animals, he sits on a marble bench and plays an obvious, if disproportionately large, lyre as in no other illustration of the text that we have considered.[213] This detail is of as great moment as the nimbus Orpheus wears[214] in elucidating the interrelationship between images of the Hebrew and the Greek musician in Byzantine painting. It assumes greater significance when one remembers that the lyre-playing Orpheus is not confined to the manuscript illustration of one sermon of Gregory Nazianzenus. The singer is found with his traditional instrument in much more immediately "mythological" contexts on ivory caskets of the eleventh and twelfth centuries. One such in the Louvre shows him half-naked, a plectrum in his right hand and a broad lyre with seven strings and sharply pointed finials to his left.[215]

209. *P.G.* 35, col. 653.

210. Athos, Panteleimon 6, fol. 165r (Galavaris, *Liturgical Homilies*, p. 211). A similar miniature in a nearly contemporary Gregory manuscript in Paris (B.N. MS Coislin 239, fol. 122v [Weitzmann, *Greek Mythology*, fig. 84]) is described by Galavaris (*Liturgical Homilies*, p. 247) simply as Orpheus.

211. Buchthal, *Paris Psalter*, p. 15.

212. Thus Galavaris (*Liturgical Homilies*, p. 254) relates Panteleimon cod. 6, and Paris, B.N. MS Coislin 239, in which Orpheus plays a harp, to Vat. cod. gr. 1947, in which he holds a lyre. All three manuscripts are here assigned to the late eleventh century, the Vatican codex probably being the latest.

213. Fol. 149v (Weitzmann, *Greek Mythology*, p. 67, fig. 82).

214. Cf. ibid., p. 68.

215. Ibid., p. 156, fig. 172. In Goldschmidt-Weitzmann, *Elfenbeinskulpturen* I, p. 33, no. 26, pl. XII,h, this casket was dated to the first half of the eleventh century and the seated musician identified as Apollo. In *Greek Mythology*, p. 67, Weitzmann has since argued that the lyre-player might with equal justice be

The presence of a partly draped Orpheus on ivories, a medium more exclusively redolent of the Macedonian "Renaissance" than book illustration, serves to recall the diversity of Late Antique representations. Considering for the moment only those found in floor mosaics,[216] the transfigurations of Orpheus and his instrument are more than sufficient to account for the varieties found in medieval art. At the end of the ancient world, in the mosaic found near the Damascus Gate in Jerusalem, Orpheus' customary menagerie is invaded by Pan and a centaur, who, in the peculiar perspective of the sixth century, dwarf the animal attendants.[217] Dressed in Phrygian costume, Orpheus plays not a lyre but a type of harp akin to that in numerous eleventh-century images of both Orpheus and David (cf. Fig. 39). Unlike the Orpheus of Middle Byzantine manuscripts, however, he rests his instrument on his thigh.[218]

In the Jerusalem mosaic there is no evidence of any physical support for the squatting figure. Perhaps a century earlier in a mosaic at Ptolemais, a nimbed Orpheus sits on a pillow-shaped rock and carries a horned lyre on his right knee.[219] These attributes are common to the majority of Antique representations of Orpheus, as is the simulation of tortoise shell for the body of the lyre. The myth of the instrument's origin[220] is recalled earlier in a pavement from Oudna[221] and a mosaic at Palermo dated to the beginning of the third century (Fig. 40).[222] In both the sound box consists of a mottled shell-like form, but otherwise the two lyres are quite different from each other. The North African instrument has horns that curve in the same direction toward the musician, while those in the Sicilian mosaic diverge sharply and end in sharp finials high above the crosspiece. Again, although both figures are surrounded by isolated animal emblemata drawn in profile, the central figures differ considerably. The semi-nude Orpheus from Oudna has legs spread far apart to balance the energetic

recognized as Orpheus. The same revision presumably applies to other representations of "Apollo" on three other ivories cited by Weitzmann, *Greek Mythology*, p. 156, note 6. The interpretation of the bare-chested musician as Orpheus is strengthened by comparison with a *cippus* of the late fourth or early fifth century, showing a similar lyre-player, found in southeastern Asia Minor and now in Istanbul (G. Mendel, *Catalogue des sculptures des musées ottomans* II [Constantinople, 1914], pp. 420–423).

216. To the catalogue of some forty-seven Orpheus mosaics compiled by H. Stern ("La Mosaïque d'Orphée de Blanzy-les-Fismes," *Gallia* XIII, 1955, pp. 41–77), Harrison ("Ptolemais") added another eight examples. See also a study by M.A. del Chiaro ("A New Orpheus Mosaic in Yugoslavia," *A.J.A.* LXXVI, 1972, pp. 197–200), who stresses the considerable variety apparent in Roman Orpheus mosaics.

217. Now in the Archaeological Museum, Istanbul (H. Vincent, "Une Mosaïque byzantine à Jerusalem," *Revue biblique* X, 1901, pp. 436–444). For the literature on this mosaic, originally part of the pavement in a Christian tomb, see Friedman, "Syncretism," pp. 2–3.

218. One of the few ancient examples in which Orpheus supports his lyre on a pedestal is the mosaic from Oudna, now in Tripoli (G. Guidi, "Mosaico di Orfeo," *Africa Italiana* VI, 1935, p. 124, fig. 16). In this mosaic Orpheus is bare-chested as in the ivory cited in note 215 above.

219. Harrison ("Ptolemais," pls. I, II) suggests a date between the second half of the fourth and the first half of the fifth century. Unlike the lyres in most Orpheus mosaics, the frame of this instrument has striated horns, as on the throne of the Grado reliquary (Fig. 14), which may date not much more than a half-century later.

220. Cf. note 35 above.

221. See note 218 above.

222. I.B. Marconi, *Museo Nazionale Archeologico di Palermo* [Rome, 1969], p. 49, fig. 101.

movement of his playing hand. But the feet of the Palermo lyre-player are set close together and, instead of playing, he gestures with his plectrum to an unseen spectator beyond the animal audience.

The heterogeneous poses and costumes of Orpheus passed, not surprisingly, into Early Christian iconography when the Thracian singer was assimilated by the new religion. More to our purpose, however, is the diversity of instruments and, even among the lyres, the variety of form displayed, for example, in paintings in the Roman catacombs.[223] Dated between the late second and the late fourth centuries, they generally conform to the seated, *en face* position canonically assigned to Orpheus in the floor mosaics. Early Christian sarcophagi, on the other hand, while more consistently representing Orpheus with a lyre,[224] frequently show him in profile or turning in three-quarter view.

Of these two types, the frontal Orpheus was much longer lived and far more widely diffused. It is found, for example, on the eastern confines of the empire above the Torah niche in the synagogue at Dura-Europos.[225] The presence of Orpheus (even of an Orpheus-David) in a synagogue has occasioned a good deal of controversy,[226] some of which is germane to the theme of the lyre-backed throne. At Dura, he is perched in a vine, as against his familiar pose beside a tree harboring his audience of birds. But he still holds the horned lyre and must be understood to sing of a Messianic advent[227] just as to the pagans, in the same Phrygian garb, he had brought the message of a paradisiacal era. This Jewish painting of the early third century may contain a more complex program, but the figure of the singer surely derives from the same Late Antique revival of Orphism that insinuated itself into the cults of Mithra and Jesus Christ.[228]

It is difficult to believe, on the basis of the artistic and textual evidence surviving from this syncrètistic age, that the rôle of Orpheus was greatly dissimilar in the various cults. In the painting at Dura, the singer in the vine seems to mediate between

223. Wilpert, *Catacombe*, pp. 223–224, pls. XXXVII, XCVIII, CCXXIX.

224. The difference between the lyres on two such third-century profile reliefs of Orpheus is nonetheless remarkable. Wilpert (*Sarcofagi* II, p. 351, pl. CCLVI,6) illustrates an instrument the frame of which has semicircular flanges well below the crosspiece, similar in form to the throne on the *solidi* of Leo I and Leo II (Fig. 5). G. Pesce (*Sarcophagi romani di Sardegna* [Rome, 1957], pp. 102–103, no. 57, fig. 114) reproduces a similar Orpheus, who yet plays an utterly different sort of lyre with double curved horns for a frame akin to the throne on *nomismata* of Alexander (Fig. 11).

225. Goodenough, *Jewish Symbols* XI (New York, 1964), pl. IV, figs. 74, 323; XII, pp. 27, 161.

226. The discussion to 1958 is summarized by Stern ("Orpheus," p. 3). To these views must be added that of Grabar ("Recherches sur les sources juives de l'art paléochretien," *Cah. arch.* XII, 1962, pp. 118–119), who sees the Jewish Orpheus as a symbol of divine activity in the cause of peace on earth, expressed in the form that the prophets used, e.g., Isaiah, 11:6. The latest contribution is by Stern (see note 205 above), who, in the light of the newly discovered synagogue mosaic at Gaza, insists on the iconographical approximation of Orpheus and David here and at Dura.

227. At the top of the reredos is shown the enthroned Messiah, added in the second stage of the painting. The stages of its creation are analyzed by Stern ("Orpheus," pp. 1–2). A Messianic interpretation was first propounded by Grabar ("Le Thème religieux des fresques de la synagogue de Doura," *Rev. hist. relig.* CXXII, 1941, pp. 159–172).

228. Cf. F. Cumont, "Mithra et l'Orphisme," *Rev. hist. relig.* CIX, 1934, pp. 63–74; F. Saxl, "Frühes Christentum und spätes Heidentum," *Wiener Jahrbuch für Kunstgeschichte* II, 1923, pp. 69ff.

the sacramental elements on a table below and the supreme Messiah on his high throne. His lyre stills the beasts in the tree as it lulled the sleep of the martyrs beneath the soil of Rome. There, in cemeteries legally protected from pagan intrusion, the Christians depicted Orpheus seated *en face*, preferring this image to the standing type, turning in three-quarter or in profile view, found on sarcophagi made in pagan work-shops. It was this frontal pose that would survive the Peace of the Church,[229] an iconic attitude assumed by the emperor and the *pambasileus* alike.

In the catacombs, then, we are confronted not with an indiscriminate and highly diverse group of images of the singer but with a particular type. Orpheus among the animals illustrates not so much a body of doctrine[230] as a myth of a potent music, which calmed the soul and guided its ascent from the underworld. It is an emblem entirely appropriate both to its general funerary context and to the specific hopes of the Christian in "Noster Orpheus," as he is called in the Easter hymn "Morte Christi celebrata."[231] And the lyre is not merely the attribute but the *instrument* of the psychopomp, for the soul responds instinctively to its seven strings, which are fashioned after the seven spheres of the universe. Reverting to Plato's well-known figure of the harmony of the soul played upon the body's well-tuned lyre,[232] pagan and Christian commentators, almost without number, employed the lyre as the image of a mechanism whereby man could attune himself to the divine harmony of the celestial forms.[233]

It is significant that analogies of this sort preceded the artistic conflation of Orpheus with Christ. Almost from the start, these literary comparisons are made at the expense of the Thracian.[234] While for Clement of Alexandria[235] the lyre remained a permissible

229. While the profile type disappeared in favor of the frontal attitude, this in no way affected the diversity of the instruments represented. Constrast, for example, that held by Orpheus on the Jerusalem mosaic in the Archaeological Museum, Istanbul (see note 217 above) and the curious instrument played with an oversize plectrum on the Orpheus marble in the Byzantine Museum (G. Sotiriou, *Guide du musée byzantin d'Athènes* [Athens, 1955], p. 10, no. 93, pl. X). Sotiriou describes this as a lyre and the entire work as symbolically representing "le Christ attirant les païens à lui par l'Evangile."

230. The ignorance of Orphic doctrine, even among cultivated Christians, is discussed by Boulanger (*Orphée*, pp. 159–165).

231. For this and related hymns of the Early Christian period and the Middle Ages, see Friedman, "Syncretism," p. 6, note 19.

232. *Phaedo*, 85E–86D.

233. The *locus classicus* is Cicero (*Somnium Scipionis* V, 2), who notes how gifted men, imitating the harmony of the spheres on stringed instruments, have gained for themselves a return to the celestial regions. Glossing this passage, Macrobius (*Commentary on the Dream of Scipio*, II, 3, 4–7, trans. W.H. Stahl [New York, 1952], pp. 194–195) notes the use of the lyre or cithara by the priests of various nations and, citing Orpheus and Amphion, observes that "every soul in this world is allured by musical sounds . . . for the soul carries with it into the body a memory of the music which it knew in the sky." Friedman ("Syncretism," pp. 10–13) summarizes pagan philosophical interpretations of the lyre during the first Christian centuries. For their Christian counterparts, see the exhaustive references in Goldammer, "Christus Orpheus," pp. 224–227.

234. However, writing before 165, the Pseudo-Justin (*Cohortatio ad Graecos* 15, *P.G.* CI, cols. 269ff.) sees Orpheus as a pagan witness to the truth of Christ; and Athenagoras, addressing an *Entreaty for the Christians* (177–181) to Marcus Aurelius and Commodus, describes Orpheus as the first and greatest of the Greek theologians. Cf. O. Kern, *Orphicorum fragmenta* (Berlin, 1922), nos. 57–59.

235. Clement of Alexandria, *Paedagogus* I, 3, 2.

symbol for Christian use, he finds Orpheus an imposter whose chants hold captive the soul, as against Christ whose new song ends the bitter slavery of the demons that lord it over us. Written about the year 200, Clement's is the first important text to exhort the Greeks to abandon Orpheus. They should leave their poets on Mount Helicon and meet on Zion, where the divine Logos is to be heard, singing a new harmony in a mode that bears the name of God.[236]

But the most extended Early Christian analogy between Christ and Orpheus is that drawn by Eusebius, bishop of Caesarea. In his *Theophany*, written about 333,[237] he compares the historical manifestation of Jesus to an instrument on which the Logos, like a skillful musician, played the song that can save all mankind. He recalls the myth of Orpheus, whose expert lyre softened the fury of the brutes and transformed the oaks. How much wiser then, how much the most harmonious of songs, is that of the Logos! The instrument of divine wisdom heals Greeks and barbarians in body and soul and teaches all men the wisdom by which they can come to salvation.[238]

How far this simile went beyond conventional uses of Orpheus may be understood by comparing it with a passage of Eusebius' written in the second decade of the century, where, in a discussion of ancient poetry, Orpheus appears merely as a pagan witness to Christ.[239] Yet the passage might have remained an elaborate device in a purely theological work had its author not decided to incorporate it (together with many other passages from earlier works) in the oration in honor of the thirtieth year of Constantine's reign.[240] The *Laus Constantini*, delivered in the city the emperor had founded, turns the image into a political symbol. As the Logos, playing the dissimilar parts of the cosmos like an instrument—ὄργανον μέγα μεγάλου Θεοῦ—brings forth harmony, so he is mirrored in the reign of the emperor. The imperial rule is a manifestation of God's truth, for the basileus not only comforts all mankind but evinces divine wisdom in his laws and his administration. He has harmonized theological discords (at Nicaea) and proclaimed to Greek and barbarian the victory of the Word of God.

The Early Christian analogy between Orpheus and Christ has been converted into one between Christ and the emperor, a theme that was to resound throughout the Byzantine world as long as it lasted. The artistic transformation was completed no

236. Clement of Alexandria, *Protrepticus* 1, 2–4, *P.G.* 8, col. 60; *Clemens Alex.*, ed. O. Stählin, *G.C.S.* 1 (Leipzig, 1936), pp. 3–5.

237. *Eusebius Werke, Die Theophanie, G.C.S.*, ed. H. Gressman (Leipzig, 1904), pp. xiii–xx. The Greek text of the *Theophany* is known only in fragments. Gressman's translation is from a Syriac text of the fifth century.

238. *Theophanie*, III, 39, ed. Gressman, *G.C.S.*, p. 143.

239. Eusebius, *Praeparatio Evangelica* XIII, 12, 4, ed. K. Mras, *G.C.S.* (Berlin, 1956), p. 191.

240. *Laus Constantinii* XIV, *P.G.* 20, cols. 1409–1411; *Eusebius Werke, Tricennatsrede an Constantin, G.C.S.*, ed. I. Heikel (Leipzig, 1902), pp. 242–244. The relevance of this passage to Orpheus iconography was suggested in passing by Harrison ("Ptolemais," p. 18). Goldammer ("Christus Orpheus") connects it with the lyre-backed throne at S. Apollinare Nuovo but overstates, or rather anticipates, the case by seeing in the oration a commentary on the meaning of art in a state church. The only connection between Eusebius' panegyric and the art of his time is the reference it makes to the dedication of the Church of the Holy Sepulcher in Jerusalem.

later than the first nave mosaics of S. Apollinare Nuovo. From the palace of the Gothic king, the martyrs, bearing crowns in their hands, advance toward what may be the earliest surviving representation of Christ on a lyre-backed throne (Fig. 18). The procession of martyrs may have replaced the courtiers of Theodoric but there is little doubt that the Orthodox renovation of the mosaics in the Arian church left untouched the majestic epiphany at its eastern end.[241]

What was left unharmed in the middle of the sixth century was radically changed in the middle of the nineteenth. About 1855, Felice Kibel placed what has been described as a scepter in Christ's right hand. This had once, according to early modern descriptions, held a codex bearing part of the text used at Hagia Sophia in Constantinople (Fig. 1): *Ego sum lux mundi.*[242] Bovini has argued that a recent attempt to see a plectrum[243] in the "scepter" is defeated by the fact that its author is as ignorant of the original object as was its restorer. On the archaeological grounds he cites he is surely correct. And yet the ingenious if misguided attempt to find a plectrum for the lyre upon which the Lord sits at S. Apollinare is not in the least weakened by the suggestion that the shape of the throne derives only from the need to accommodate Christ's ample figure.[244] To offer so purely aesthetic an account of the shape of the lyre-back is to impose the same explanation on every other image, monumental and miniature, of the Lord on this throne; and it is to be left without any explanation for the Virgin so enthroned elsewhere.

One further point, ignored by both antagonists in the argument, takes us back to the source of the lyre-back. The object in Christ's left hand at Ravenna is an inverted form of the plectrum held, albeit in his right, by Orpheus in the Palermo floor mosaic (Fig. 40). It yet might be that the nineteenth-century artist, unaware of the codex in the original decoration, knew more of the history of art than the art historian wishes to believe.[245]

The plectrum, and the lyre that it struck, disappeared with the Thracian singer in the period of Justinianic Orthodoxy: the Jerusalem mosaic would seem to be the last antique example of Orpheus among the animals. And yet, perhaps even before his final consignment to Hades, his lyre had been assimilated by Christian iconography. In this as in many other instances the artistic vocabulary of the ancient world was treated not as an idol to be spurned but as a useful token to be appropriated. The

241. Cf. p. 15, above.

242. For Kibel's amendments to this mosaic and the documents pertaining to its original state, see Bovini, "Osservazioni," pp. 118, 120.

243. Goldammer, "Christus Orpheus."

244. Bovini ("Osservazioni," p. 119) contrasts the weighty figure of Christ with the vertical form—and hence the rectilinear throne!—of the Virgin. The Virgin is, in fact, hardly less amply robed than her Son on the opposite wall.

245. In an article that appeared as this book went to press, H. Stern ("Orphée dans l'art paléochrétien," *Cah. arch.* XXIII, 1974, p. 2, fig. 3) published a lyre-playing Orpheus who holds in his right hand a plectrum akin to that with which Kibel invested the Christ at S. Apollinare Nuovo. He dates this painting in the Catacomb of Peter and Marcellinus to about 310–330. The article constitutes a résumé of Stern's views on many of the monuments and texts cited in this section of the present study.

harmonizing instrument played by the seated musician became—as early as the middle of the fifth century if we read as lyre-backs the double thrones of Leo I and his successors—the seat from which the Logos, through his intermediaries, harmonized the conflicts of the world. By the early sixth century at the latest, the throne was the seat of the New Song[246] embodied either in the Christ or, by extension, the Child Jesus in the lap of the Theotokos.[247]

Until the reign of Leo the Wise, the basileus continued to occupy the lyre-back not as a piece of furniture in the palace but as an emblem upon his copper coins.[248] After 912, however, the living emperor gave up the throne which Eusebius had all but offered to the wisdom of Constantine. The lyre-back remained the seat of the *Rex Regnantium* throughout the Macedonian era, although toward its end we find it used increasingly for the Virgin, for the mighty of antiquity, and, less often, for David, the singer of psalms. Evidently, by the middle of the eleventh century, the pristine significance of the throne had begun to be forgotten and, concomitantly, its characteristic form began to be dissipated. The lyre-back had long since exchanged the horn-like uprights of its origin for supports studded with gems or turned in wood.[249] It had never displayed a single, precise shape, but, again, never before it came to be imitated for the Latins had it entirely lost its distinctive double curve. In dugento Florence the form of the throne yielded to those who would manipulate it as a real object in space; in Rome it vanished under a wealth of Gothic decoration. It is difficult to doubt that in the alien West there had long since disappeared, too, the Greek idea of the lyre-back as the seat of harmony, the throne of the Logos in incarnate majesty.

246. *Protrepticus* I, 3 (= *Clemens Alex.*, ed. O. Stählin, *G.C.S.* I, p. 4).

247. To the hypothesis that the lyre-back became the throne of Christ shortly after Eusebius' Tricennalian Oration must be added the suggestion that its extension to the Mother of God occurred no sooner than a century later, i.e., after the Council of Ephesus.

248. *B.M.C.* II, p. 446, no. 7, pl. I, 12.

249. Nonetheless, the horn-like throne-back on the gold of Alexander (Fig. 11) and Comnenian ivories (Fig. 31) continued, atavistically, to recall its derivation.

3 *Proskynesis and Anastasis*

The Idea and its Antecedents

Beside the lyre-backed throne in the narthex mosaic at Hagia Sophia a nimbed emperor is shown in an attitude of abasement (Fig. 2).[1] His legs are drawn up beneath the body till they almost touch the elbows held on either side of his chest. His uncovered hands are open and held apart as if about to embrace Christ's right foot. Despite oddities of proportion and drawing,[2] few individual figures in Middle Byzantine art are more moving than this massive form[3] clad in the imperial regalia and hunched beneath the side of the throne and the *clipeus* containing the Virgin above. Unconfined by any frame, the emperor is as detached from the other figures in the composition as is Christ by the structure of the throne about him and Mary and the Archangel by their surrounding medallions. While the Virgin's hands repeat the emperor's gesture, she looks past him toward the Lord enthroned; Christ and the Archangel gaze outward beyond the realm into which this living being has been admitted.

To Whittemore the emperor appeared to be "kneeling . . . in the act of adoration."[4] He then, somewhat laboriously, attempted to define the precise moment represented in the mosaic: "The movement of the Emperor's body suggests that he has partly lifted it after having prostrated himself, and that now he has raised his hands in a pose of supplication." Presumably we are intended to understand from this that the act of kneeling is a subsequent stage in a movement that earlier included total prostration, and that the ceremony depicted required first self-abasement and then genuflection.[5] Ignoring the complexities inherent in so literal an interpretation of the mosaic, Grabar

1. Whittemore, *Prelim. Report, Narthex*, pp. 17–20, pl. XIV. For the identity of the emperor and the exegetical literature concerning this mosaic, see p. 22 and notes 2, 84, 85 above.

2. Note, for example, the small head and very large hands.

3. Whittemore (*Prelim. Report, Narthex*, p. 15) describes the figure as "half as large again as a human being."

4. Ibid. Neither Whittemore nor, I believe, any other writer has commented on the fact that the emperor's knee does not rest on the same ground as his toes. He kneels upon a raised, curved surface that may represent a cushion. If this is so, it would strengthen the argument that a particular imperial ceremony is depicted here. No other representation of the imperial proskynesis includes such a provision for the emperor's comfort.

5. The dangers implicit in the interpretation of forms in Byzantine art as literally accurate representations of reality have already been suggested in connection with Whittemore's account of Christ's throne, p. 39 above.

saw it as an image of the triple proskynesis described in the Book of Ceremonies[6] as made by the emperor before entering the nave of Hagia Sophia.[7] In turn, this interpretation has been objected to on the grounds that, first, the lunette mosaic does not show the candles borne by the emperor according to this text, and, second, that he is merely depicted as "kneeling" before Christ.[8]

Much of this argument hinges on the meaning of the term proskynesis in this—and other—passages of *de Cerimoniis*. But more than this is at stake. Another ingenious interpretation of the mosaic seeks to relate it not to the Ceremonies book but to an event at the Eighth Ecumenical Council, held in Hagia Sophia in October 869. On this occasion Basil I addressed an emotional appeal to his "brothers" in the Council to join him in self-abasement, an act he defended as appropriate for an emperor to make in the presence of God.[9] Adducing this passage, Scharf insisted that the basileus is shown completing proskynesis and raising his hands in supplication.[10] He recognized that the meaning of the mosaic depended upon our understanding of the emperor's position but, in the service of this idea, cited a text that (however important) does little to clarify the nature or significance of proskynesis.

If such texts cannot in themselves provide the sort of precision for which we are searching, it may be that the introduction of other visual examples can define the attitude, or range of attitudes, assumed by a medieval Greek when he prostrated himself. The place of the emperor's position in the mosaic at Hagia Sophia might then be plotted within such a range. Byzantine representations of prostration, genuflection, and related poses offer, however, a diversity exceeding even the latitude that we have found in depictions of the lyre-backed throne. If, for the moment, we confine ourselves to images of the emperor revering Christ, we find that not only is the Greek term proskynesis now applied so variously as to be almost meaningless but that simple English expressions such as kneeling and bowing suggest a host of different attitudes to different critics.

Some four centuries after the mosaic of the emperor's self-abasement was set up, there was struck in the mint of Constantinople the last such image that we can unhesitatingly attribute to an imperial workshop. The gold *hyperpyra* of Andronicus II's sole reign (1282–1295) show on their reverse the emperor "kneeling with back bent ... before Christ" (Figs. 41–43).[11] The editor of the British Museum catalogue related

6. *De Cer.* I,I, *C.S.H.B.*, p. 14.

7. Grabar, *L'Empereur*, p. 101. In *L'Iconoclasme* (pp. 239–241) Grabar amplified this opinion, seeking to relate it to an oration of Leo VI on the Annunciation.

8. C. Mango in H. Kähler, *Hagia Sophia* (New York, 1967), p. 54, suggests that in this passage of *de Cerimoniis*, the emperor does not prostrate himself.

9. Mansi, XVI, col. 94A.

10. Scharf, "Proskynese," pp. 27–30.

11. *B.M.C.* II, p. 614. Recently in a three-part article, A. Veglery and A. Millas ("Gold Coins for Andronicus III [1328–1341]," *Numismatic Circular*, December 1973, pp. 467–469; January 1974, pp. 4–7; and February 1974, pp. 50–51) have divided these coins between the reign of Andronicus and his namesake and grandfather. Despite this distribution—convincing in itself—no attempt is made to distinguish between the great variety of "kneeling" attitudes assumed by the emperor. For the iconography of the obverse of these *hyperpyra* see pp. 54f. below.

these coins to the lunette mosaic,[12] treating them as if they each displayed the basileus in the same position. Concentrating on differences in their inscriptions, the numismatist ignored variations that are of significance to the art historian. For example, he described the figure of Christ as "facing," where it is evident in some examples that the Lord turns slightly toward the emperor whose head he blesses.[13] This movement is most obvious on a copper coin of Andronicus II, on the obverse of which the blessing figure turns in three-quarter view and stoops toward the supplicant (Fig. 44).[14] The blessing is made with a raised hand rather than an arm extended downward as on the gold, a gesture necessitated by the quite different position of the basileus. Here Andronicus crouches with bent knees in an attitude similar to that found on some of his *solidi*.[15] But the emperor's posture on the gold cannot be described simply as kneeling.[16] While in each instance illustrated the basileus' knees rest on the ground, the rest of his body assumes very different positions. On one example his knees are drawn up under him almost to the elbows (Fig. 42); on this coin his back and calves are parallel to the ground in a position similar to that on the lunette mosaic. On another and unfortunately damaged example, there is an oblique inclination of the calves with feet apparently raised in the air (Fig. 41). On a third coin, even while the knees remain on the ground, the entire upper part of the body is raised at an angle so that the emperor's head is thrown sharply back as he addresses himself to Christ (Fig. 43).

Should these varieties in the imperial posture be understood as versions of the same attitude, the image on different dies all intended to convey the same idea? If this is so, then the significance of the emperor's attitude is manifestly not determined by a specific position and the die-cutters would appear to have enjoyed considerable freedom in their disposition of the body. And what is the relationship of this image of the Palaeologan emperor before Christ to that of the Macedonian ruler in the mosaic at Hagia Sophia? Has the form of imperial veneration—if this is the subject here— changed in the intervening four centuries, or are the deviations merely the product of differing degrees of artistic competence? Do bowing, genuflecting, and prostrating before Christ represent the same veneration or is one act (or more) depicted on the coins and another on the lunette mosaic? Finally, what is the connection between the diverse poses we have noted and the various terms used in Byzantine literature to de-

12. *B.M.C.* I, p. lxxx.

13. This is even more obvious in *B.M.C.* II, p. 616, no. 8, pl. LXXIV,11, where Christ turns and inclines slightly toward the emperor, a movement important within the broader context of the development of Palaeologan art. This is the last Byzantine numismatic occasion on which such a movement is found. On coins struck during and after Andronicus' joint reign with his son and grandson, i.e., after 1295, all figures are shown in strict frontality.

14. Dumbarton Oaks, unpublished.

15. *B.M.C.* II, pl. LXXIV,15, where, however, the emperor's head is bare.

16. On no coin of this type is Andronicus' body upright as on the coins of his predecessor, Michael VIII Palaeologus (ibid., p. 608–610, nos. 1–6, pl. LXXIV, 1–4), where the emperor is also described as "kneeling." The search for numismatic precedents for Michael's genuflection must take into account silver coins of Leo II of Armenia (1185–1213) (V. Langlois, *Numismatique de l'Arménie au moyen âge* [Paris, 1855], p. 38, pl. I,1, 2). Western European examples of this motif are, of course, legion (cf. literature cited by Bertelè, *L'Imperatore alato*, p. 70, note 170).

scribe attitudes of reverence and adoration? Does proskynesis, for example, mean any such veneration, an attitude of *mind* rather than of the body?

There exist several extensive studies[17] and numerous briefer commentaries[18] on prostration as an aspect of aulic ritual. But the majority of these depend almost exclusively on the Book of Ceremonies. The evidence provided by *de Cerimoniis* must bulk large in any consideration of proskynesis. But to concentrate exclusively upon this tenth-century text, which deliberately sought (albeit in popular language) to preserve and describe archaic forms,[19] is to treat Byzantine ceremony as a millennial stasis. Even those works that consider the variety of self-abasing gestures in the light of other documents[20] neglect the factor of time as a dimension in which earlier forms were modified, distorted, or entirely abandoned. The possibility that new modes and applications of prostration were introduced after the time of Constantine Porphyrogenitus has scarcely been considered.[21]

Unique in Byzantine studies for its treatment of proskynesis both as a mutable posture and as a major iconographical theme, in works of art as well as works of literature, Grabar's *L'Empereur dans l'art byzantin* is deliberately limited to an examination of gestures of reverence made by and to the basileus. Since the number of such examples in Byzantine art is strictly limited,[22] a mere fraction of the available evidence is examined in this invaluable book. Still unexplored is the relationship between the imperial proskynesis and similar gestures made by lesser mortals. And, in this larger context, we need to know whether representation of a particular attitude, from among the great diversity known, is determined by the person making proskynesis or by the object of his veneration. Again, is there in Byzantine art a consistent vocabulary of images into which scriptural and other literary descriptions of prostration were translated? And, even if such a tradition existed, what models did an artist use when he had no written source?

17. The two most important modern studies are Treitinger, *Kaiseridee*, and Guilland, Προσκύνησις.

18. Reiske *ad* Constantine Porphyrogenitus, *de Cer.* 1, 91, *C.S.H.B.* II, pp. 418–419; J. Ebersolt, "Mélanges d'histoire et d'archéologie byzantines," *Rev. hist. relig.* XXVI, 1917, pp. 37–40; Vogt, *Cérémonies*, Comm. I, pp. 29–30. F. Dvornik (*Early Christian and Byzantine Political Philosophy. Origins and Background*, 2 vols. [Washington, D.C., 1966], index s.v. "proskynesis") has discussed prostration in both its Christian and antique political setting. Most recently, Walter (*Conciles*, pp. 253–256) has considered the forms of prostration assumed by penitent heretics before Church Councils.

19. *De Cer.*, *C.S.H.B.* I, pp. 3–4.

20. Notably Koukoules, Βίος I, 2, pp. 104–114. I owe this reference to the kindness of George Galavaris.

21. Guilland (Προσκύνησις, p. 259) calls attention to one such innovation in Cantacuzenus 1, 34, *C.S.H.B.*, pp. 167–168. The chronicler describes how Andronicus III, meeting his estranged grandfather, Andronicus II, while both were on horseback, dismounted and kissed the elder's foot. Customarily, the younger man was required only to uncover his head but, at this particularly tense moment in the civil war, Andronicus III's reconciliatory gesture was received with tears of joy. From such breaches of custom, new ceremonies are born.

22. Grabar (*L'Empereur*, p. 101, note 3) counts only five examples of the basileus in proskynesis for comparison with the mosaic in Hagia Sophia. Two of these five are known only from citation by Byzantine historians. Drawing on Grabar, Bertelli (*Madonna*, pp. 60–62) lists some fifteen examples of proskynesis in works of art before the year 1000. This catalogue, however, includes no discussion and does not explore the range of attitudes found in these works.

It is an index of the state of research in the field that we are much better informed about the predecessors of Byzantine proskynesis, from the ancient Near East to late antiquity, than we are about its use and representation in Constantinople and the medieval Greek empire. However, the practice of prostration even in the fifth century B.C.—the most extensively studied period of ancient history—remains clouded in mystification. The belief that, in contrast to the Persians, "the Greeks went down on their knees only before the gods"[23] dies hard despite Alföldi's demolition of this myth more than a generation ago.[24] Sponsored by tales of the Persians' prostration before the Great King[25] and disseminated in classical art,[26] it lived on to haunt "humanistic" historians who wished to see the decline and fall of Rome neatly epitomized in the introduction of oriental proskynesis into the court ritual of the late empire.[27] Unaware that self-abasement might later be considered a form of self-abuse, many of Alexander's companions prostrated themselves before joining with him in a sacramental bond[28] and Hellenistic kings enjoyed similar veneration.[29] We have, unfortunately, no surviving images to tell us what form emperor-worship took in the first two centuries after Christ[30] but it is difficult to believe that the repertoire of gestures did not include, for example, at least some of the adulatory attitudes lavished on Theseus after his destruction of the Minotaur in two Campanian wall paintings now in Naples.[31] It is worth stressing that the youths who kiss the saviour's hand and prostrate themselves at his feet in these varying derivatives from Greek models are not defeated barbarians but grateful, well-bred Athenians.

This is not to deny that the most common application of proskynesis in imperial iconography was as an emblem indicating the inferiority of a defeated, and usually oriental, enemy. It should, however, be recalled that simple genuflection was not the only means by which such subjection was conveyed. On the *denarii* of Augustus we find kneeling Parthians in their skin coats offering up their vexilla,[32] yet a later king of

23. Brilliant, *Gesture and Rank*, p. 15.

24. Alföldi, "Ausgestaltung," pp. 46–47.

25. E.g., Herodotus VIII, 118, ed. Loeb, IV, p. 122. The *locus classicus* for Greek abstinence from self-abasement is, however, also to be found in Herodotus. At VII, 136, he relates how envoys at the Persian court refused to make the required proskynesis, which they believed due only to the gods.

26. Notably on the "Darius Vase" in Naples, an Apulian pot of the second half of the fourth century (M.H. Swindler, *Ancient Painting* [London, 1929], pp. 294–295, fig. 471).

27. Cf. Alföldi ("Ausgestaltung," pp. 48ff), who suggests that the Roman ceremony of *adoratio* grew out of rites of supplication (consisting of genuflection and the kissing of hands and knees) addressed to both gods and men and practised before the Principate. H. Stern ("Some Remarks on the 'Adoratio' under Diocletian," *J.W.C.I.* XVII, 1954, pp. 184–189) has since shown that the *adoratio* was officially introduced into imperial ceremonies only in the late third century.

28. G. Méautis, "Recherches sur l'époque d'Alexandre," *Revue des études anciennes* XLIV, 1942, pp. 305–308.

29. Taylor, "Ruler Cult," pp. 53–62.

30. See note 27 above.

31. Reproduced in color in R. Bianchi Bandinelli, *Rome the Centre of Power*, New York, 1970, fig. 115 (from Herculaneum, Basilica, inv. no. 9049), fig. 116 (from Pompeii, House of Gavius Rufinus).

32. Mattingly, *Roman Empire* I, p. 8, nos. 40–42, 56–59, pl. II,2, 12.

the same people agreed to lay his diadem at the feet of an effigy of Nero. *Quanto minus quam captivum*, as Tacitus observed of Tiridates on this occasion,[33] the ceremony in which the Parthian was required to participate signified much more than military defeat. The discomfited king was compelled to acknowledge the power of his overlord even while the latter was not physically present. Just so in a Middle Byzantine psalter, David prostrates himself before an image of Christ in a lunette, and one that is manifestly an icon made by human hands rather than the Lord in his actual human shape (Fig. 46).[34]

Again, while coins of the Principate celebrate the subjection of the Armenians, the attitude assigned them in defeat is different. Where the Parthian kneels in an upright position, his back straight from his neck to his hips, the Armenian appears on the *denarii* as a crouching figure with back bent and the palms of his hands turned upward in supplication.[35] Precisely this attitude is used in Paris. gr. 20 to illustrate a verse concerning the Lord's mercy upon the sick (Fig. 47).[36] In this miniature, the two foremost figures kneel before Christ; behind them, another makes a standing entreaty. Similar combinations of attitudes occur in Roman art. In scene CXVIII of Trajan's Column, the emperor receives the submission of one Dacian, genuflecting with upturned palms, while behind this leader stand his no-less-docile companions.[37]

The device of magnifying the glory of the victor by multiplying the number of his supplicants is a persistent theme in imperial iconography. At the end of the fourth century it received monumental expression on the base of the obelisk of Theodosius in Istanbul, where the vertical perspective and the isocephalic disposition of the barbarians suggest that the *kathisma* containing the emperor and his family weighs upon the heads of the captives (Fig. 45).[38] Confined in their narrow register, the dependent status of the Persian and Dacian prisoners is emphasized by their representation in profile, as against the purely frontal attitude of the Romans. But the formal element that most forcefully imparts the triumph of the emperor is the number of the barbarians bearing their tribute and pressing in from the very edges of the base. This reiteration of gift-bearing figures would be used effectively in Byzantine art to illustrate the Adoration of the Magi. For example, at Tokale II in Cappadocia, the kings, still en route, form part of a frieze that culminates in the scene of their oblation to the Christ Child.[39] As on the obelisk base, the variety of deferring forms within an overall unity of purpose and direction suggests a more profuse reverence than a single figure, however respectful, could intimate.

In this wall painting the subject is identified by the inscription *H ΠΡΟCKYNHCIC TON MAΓON*. The phrase derives directly from the Gospel account, where the Magi

33. *Annales* XV, 29, ed. Loeb, IV, p. 260.

34. Vat. gr. 752, fol. 128r (DeWald, *Vat. gr. 752*, pl. xxvi).

35. Mattingly, *Roman Empire* I, pp. 4–5, nos. 18–21, pl. I,10; p. 8, no. 43, pl. II,3.

36. Psalm 102 [103]:3 (Dufrenne, *Psautiers grecs*, p. 44, pl. 36).

37. K. Lehmann-Hartleben, *Die Trajansäule. Ein römisches Kunstwerk zu Beginn der Spätantike* [Berlin-Leipzig, 1926], pl. 56.

38. Grabar, *L'Empereur*, pl. XII,2.

39. Restle, *Asia Minor* II, pls. 113, 114.

are said to worship the Child by falling to the ground.[40] Yet here they make only a slight bow rather than kneel or prostrate themselves. Should we, with Treitinger, see the same simple gesture in that made, according to the Book of Ceremonies, by many dignitaries when approaching the emperor in the course of their official duties?[41] Constantine Porphyrogenitus, writing apparently for those familiar with the ritual of the court, merely records that such courtiers make the form of reverence [τό σχῆμα τῆς προσκυνήσεως] required by protocol, qualifying this by noting that the knees are not bent. Interestingly, when describing the attitude of submission required of prisoners in the Hippodrome, the Emperor observes that they fall to the ground, head forward, but says nothing of proskynesis.[42] Nor does this omission occur only in the context of defeat: the conduct enjoined upon victorious drivers in the Hippodrome is described in virtually the same terms and again without mention of proskynesis.[43] One can deduce that, at least in *de Cerimoniis*, the term proskynesis indicates a set of related mental attitudes—ranging from veneration to respect—as much as any physical posture. But this leaves us no wiser regarding the precise manner in which such mental attitudes were expressed.[44]

Given the proliferation of biblical imagery in both the monumental and "minor" arts, a more fruitful approach might be to collate illustrations of acts of reverence with the scriptural texts that were their occasion. While Greek and Roman poets and historians conveyed to Byzantium a wealth of allusions to proskynesis,[45] the richest and most diverse body of literary sources for the term was available in the Septuagint and the New Testament. In Genesis, for example, when Abraham meets the three angels at his tent-door in the plains of Mamre, he is said to "bow himself towards the ground."[46] This is interpreted at Monreale to mean that he falls and embraces the foot of the foremost messenger (Fig. 48).[47] Similarly, the children of Israel are required by Nebuchadnezzar not merely to reverence but to "fall down and worship"[48] the golden image.

40. Matthew 2:11.

41. Treitinger (*Kaiseridee*, p. 86, note 198), on the gesture made by the *praipositos* at the promotion of *patrikioi* (*de Cer.* I, 48, *C.S.H.B.*, pp. 244–245).

42. *De Cer.* I, 69, *C.S.H.B.*, p. 332.

43. Ibid., p. 330.

44. On occasion, *de Cerimoniis* specifically describes the attitude assumed by a reverential figure. It is significant, for example, that the gesture made by an officer of the Blue faction on Easter Monday I, 10, *C.S.H.B.* I, p. 82) is described as προσκύνησις τούς πόδας τοῦ βασιλέως. The emperor then raises him from a position that would not have been defined by the term proskynesis alone. However, we cannot assume a simple distinction between proskynesis and the act of "falling to the ground." Constantine Porphyrogenitus sometimes finds it necessary specifically to exclude this latter gesture, e.g., when describing the reverence paid to the emperor at Pentecost by the *patrikioi* and *strategoi* (ibid., I, 9, *C.S.H.B.* I, pp. 62–63), they are recorded as προσκυνήσαντες τὸν βασιλέα μὴ πέσοντες κάτω.

45. *R.-E.* I, s.v. "adoratio"; *Supplementband* V, s.v. "Kuss."

46. Genesis 18:2: καὶ προσευκύνησεν ἐπὶ τὴν γῆν.

47. Demus, *Norman Sicily*, pl. 103; Kitzinger, *Monreale*, pl. 33 (color). At the Capella Palatina (Demus, *Norman Sicily*, pl. 33), Abraham drops before the angel in similar fashion but does not touch his foot.

48. Daniel 3:15: πεσόντες προσκυνήσετε τῇ εἰκόνι τῇ χρυσῇ.

In the Old Testament, moreover, prostration is indicated in many situations that do not directly involve worship. The act of supine adoration would seem to have its roots in the worshiper's sense of his own littleness and powerlessness, from which follows his total dependence on his overlord.[49] Both stages of this awareness are expressed in the Septuagint in terms of prostration. The Psalmist sings of the condition of Zion, believing itself abandoned by God, and concludes with the words "Our soul is bowed down to the dust; our belly cleaveth to the earth."[50] In no less distress—and in a scene canonically illustrating the Penitential Psalm 50—David receives Nathan's rebuke and returns to his house to "lay all night upon the earth."[51] Neither of these texts suggests worship; the term proskynesis is not used. Yet Byzantine artists frequently embodied such descriptions of self-abasement in attitudes hardly distinguishable from that of adoration.

Sometimes a prone position is no more than an effective compositional device that serves to express the spirit rather than the letter of the biblical incident. Thus neither the Septuagint text[52] nor that of Gregory Nazianzenus' oration,[53] illustrated in Paris gr. 510, refers specifically to the prostration of the Israelites as they drink the water from the rock struck by Moses in Horeb (Fig. 50).[54] The attitude assumed by the thirsting Hebrews—legs drawn up under their bodies, open hands outstretched to scoop up the water of deliverance—is obviously appropriate to the physical demands of the situation. Yet the resemblance between this position and the proskynesis made by the emperor in the lunette mosaic at Hagia Sophia may be more than accidental. In the light of numerous passages of Early Christian exegesis,[55] the Israelites' prostration should be understood as acknowledgment of the living waters flowing from the rock that is Christ.

The illustration of the Gospel offers similar instances where an artist introduces a figure in an abasement not designated by the text but rather amplifying and perhaps even fulfilling its meaning. The Evangelist relates that when Jesus ate in the house of Simon the Pharisee a woman of Bethany "stood at his feet behind him" and washed his feet with her tears and wiped them with her hair.[56] At Monreale, for example, the woman, identified by inscription as Mary Magdalen, is shown kissing the Lord's feet before anointing them with the unguent contained in a small amphora (Fig. 49).[57] Posed in the foreground between Christ on one side of the table and the apostles on

49. Cf. Treitinger, *Kaiseridee*, p. 84.

50. Psalm 43 [44]:25.

51. 2 Kings [=2 Samuel] 12:16.

52. Exodus 17:1–17.

53. *Hom.* 30, *P.G.* 36, cols. 265–280.

54. Paris gr. 510, fol. 226v (Omont, *Miniatures*, pl. XL).

55. Both the Pauline interpretation of the rock and that of Gregory of Nyssa as the source of life-giving water are discussed by Der Nersessian ("Homilies of Gregory," p. 213). St. John Damascene (*P.G.* 94, cols. 1408D–1409A) quotes Severianus, the early fifth-century bishop of Gabala, to the effect that Moses struck the rock twice so that inanimate nature might reverence the sign of the Cross.

56. Luke 7:37–38.

57. Demus, *Norman Sicily*, p. 120, pl. 89b; Kitzinger, *Monreale*, pl. 75 (color).

the other, her huddled form is of central importance in the scene. The mosaic may be contrasted with a manuscript example—again the Paris Gregory—where her presence is merely ancillary to the instruction of Simon proceeding at the table (Fig. 51).[58] Here she is a kneeling figure squeezed between the teaching Jesus in the Pharisee's house and the raising Jesus beside the tomb of Lazarus. But Mary's attitude here is not only the result of pressure of space upon the artist. She functions also as a link between the two scenes, visually affirming the connection that the Evangelist makes between the Anointing at Bethany and the sickness of Lazarus.[59] The same ochre-colored robe that she wears in the two incidents affirms her identity (even while she is designated only as Η ΠΟΡΝΗ in the miniature to the right), but her different positions indicate the diversity of her rôles first, with her sister, as supplicant for her brother and then as penitent humbling herself before the Lord, the disciples, and the Pharisee.

In our discussion of proskynesis in New Testament illustration we shall, of course, find many examples where prostration in one form or another is justified by the formulae ἔπεσεν ἐπὶ πρόσωπον, ἔπεσεν εἰς τοὺς πόδας αὐτοῦ, or ἔπεσεν ἐπὶ τῆς γῆς, which recur in the Gospels. There are even more examples where προσ-κύνησαν αὐτῷ, or some variant of this form, is apparently used to suggest worship without any specific description of the attitude assumed by the worshiper. But perhaps as many instances occur where an illustrator—or rather the artist responsible for the prototype—has "inserted" prostration as a motif appropriate to the context but not explicit in the scriptural text or in commentary upon it.

Such innovations are also to be found in the illustration both of the Septuagint and much later, patristic literature. The reasons for the introduction of such motifs are best examined in the context of individual representations. It is nonetheless possible to discern a few general causes as to why post-Iconoclastic painting contains proportionately many more images of prostration than are to be found in Early Christian and Early Byzantine art. First among these must be numbered the Church's reluctant acceptance of what it could not prevent:[60] that its members would adore both the person and the image of the basileus. Far from rejecting such veneration, the first Christian emperor seems to have instituted the ceremonial transport of his own image through the city on the anniversary of its foundation, a rite that John Malalas describes as including in his day the imperial proskynesis made before the image of Constantine.[61] The Church of the fourth century accepted such behavior without question,[62] regarding it as much in the nature of due honor and respect as Eusebius

58. Fol. 196v (Omont, *Miniatures*, pl. XXXVIII).

59. John 11:2. Der Nersessian ("Homilies of Gregory," p. 204) points out that the Bethany scene is not mentioned in the text of the oration illustrated here and offers a more complex, typological explanation for its presence on this page of the manuscript.

60. Alföldi, "Ausgestaltung," pp. 61–62.

61. Malalas, *Chronographia* XIII, C.S.H.B., p. 322.

62. Nonetheless, the theoretical distinction between the divine, to which true worship [*latreia*] is due, and images and men, to which only reverence [proskynesis] may be paid, had been made at least as early as the middle of the third century. In his commentary on the Decalogue, Origen (*Hom. VII in*

regarded Jesus' adoration of the Father.[63] We do not know in what precise manner the image of Constantine was revered by the people in its progress through the city. But even if it was not that of his soldiers who threw themselves on the ground about the body of the emperor at his death, presumably it was no lesser gesture than that of the *comites*, judges and magistrates who, on the same occasion, saluted their sovereign on bended knees. To the author of the *Vita Constantini*, this form of proskynesis before the body lying in state was no more than a continuation of the honors customarily paid to him in life.[64]

If the Christian emperor was adored even in his image, how much more veneration was due that of his spiritual suzerain and the heavenly court of saints, worshiped at first through the Cross and relics.[65] However, it has been pointed out that there exists incontrovertible evidence for the veneration of images no later than the middle of the sixth century.[66] The earliest surviving Christian picture *representing* proskynesis— a wall painting of two figures prostrate on either side of a martyr in SS. Giovanni e Paolo, Rome—is customarily dated about 390.[67] There is no reason to believe that the practice of adoration followed rather than preceded its representation in art. If saints were revered in this fashion by the end of the fourth century, one may fairly suppose that images of Christ were the object of such veneration even earlier.

Certainly the intensification of the cult of icons in the period between Justinian and Iconoclasm, a development brilliantly illuminated by Kitzinger,[68] must be seen as part of a general intensification of interest in all forms of devotion. Writing toward the middle of the seventh century, Sophronius, patriarch of Jerusalem, describes how the saints themselves made proskynesis. He attributes to Saints Cyrus and John the healing of a young man afflicted with gout who had decided to join the Church. Descending from an icon in which they formed part of a company of prophets, apostles, and martyrs around a Deësis group, they "fell to their knees before the Lord, bowed their heads to the ground, and prayed for the cure of the young man."[69]

It is in this text, too, that the term proskynesis, in addition to its Early Christian

Exodum, *G.C.S.*, ed. W.A. Bährens [Leipzig, 1920], p. 223) interprets the prohibition against graven images literally and intransigently. This distinction would be revived with great force during the Iconoclastic Controversy by St. John Damascene. Cf. p. 64, below.

63. Eusebius, *Historia Ecclesiastica* X, 4, 68 (=*P.G.* 20, col. 83; *Eusebius Werke*, II,2, *G.C.S.*, ed. E. Schwartz [Leipzig, 1908], p. 882).

64. Eusebius, *Vita Constantini* IV, 66–70, *P.G.* 20, col. 1221 B–C; *Eusebius Werke* I, *G.C.S.*, ed. I.A. Heikel (Leipzig, 1902), p. 145.

65. Kitzinger, "Cult of Images," pp. 89–90.

66. P.J. Alexander, "Hypatius of Ephesus: A Note on Image Worship in the Sixth Century," *Harvard Theological Review* XLV, 1952, pp. 177–184. On Hypatius' letter defending such veneration on the ground that it was useful for the soul that still needed guidance, see also Kitzinger, "Cult of Images," p. 94.

67. Wilpert (*Mosaïken und Malereien* IV, p. 638, pl. 131,2) suggests that the figures in proskynesis may be the patrons of the basilica. Their bodies are drawn up rather than extended on the ground, their hands are open, and their heads turn to gaze out at the spectator.

68. Kitzinger, "Cult of Images," pp. 95–110.

69. Sophronius, *Miracula SS. Cyri et Ioannis*, *P.G.* 87³, col. 3561B.

connotations, is used to mean a pilgrimage to a holy place.[70] The descriptions of such journeys multiply in number and contain an increasingly diversified vocabulary of veneration and prayer.[71] That total prostration was practiced at the Court already in Justinian's reign is reported by Procopius in a passage that provides one of the few detailed physical descriptions of proskynesis available in Byzantine literature.[72] The textual evidence, then, suggests that by the onset of Iconoclasm[73] the Greeks had long since overcome the nice scruples against proskynesis displayed in a famous (if possibly spurious) letter of Libanius to St. Basil.[74]

Only one body of evidence remains largely silent concerning the efflorescence of prostration that we have noted in sacred and profane ceremonies: fewer than ten artistic representations of proskynesis are known before the official onslaught upon images.[75] Only three of these are without doubt Byzantine works and each of these is known only through literary *testimonia*. The absence of detailed accounts makes certainty impossible, but it would seem that the mid-fifth-century mosaic of the empress Verina before the enthroned Virgin in the Church of the Blachernae,[76] the statue of Justin I (518–527) in some unknown public place in Constantinople,[77] and a

70. Ibid., col. 3613C. E.A. Sophocles (*Greek Lexicon of the Roman and Byzantine Periods* [New York, 1893]) points in addition to the use of προσκυνητής—literally a worshiper—as an *adnomen* applied to those who had visited the Holy Land and thus analogous to the Arabic *hadji*.

The last Byzantine term formed on the basis of proskynesis—αἴ προσκυνήσεις, used for icons taken down from the templon and placed on a lectern—probably evolved only in the early eleventh century. For the history and nature of such images, see V.N. Lazarev, "Trois Fragments d'epistyles peintes et le templon byzantin," Δ.Χ.Α.Ε., 4th series, IV, 1964–1965, pp. 117–143.

71. Kitzinger, "Cult of Images," pp. 95–97.

72. Procopius, *Anecdota* XXX, 23, ed. Loeb, V, p. 354. Despite this passage, which, like much of the *Secret History*, is deliberately tendentious, objections to indiscriminate prostration remained strong in official circles. As late as 927, the Roman Senate was unwilling to make proskynesis before Symeon of Bulgaria, as is made clear in a difficult and important palace oration translated and explicated by R. J. H. Jenkins ("The Peace with Bulgaria Celebrated by Theodore Daphnophates," *Polychronion, Festschrift Franz Dölger zum 75. Geburtstag* [Heidelberg, 1966], p. 299).

73. Texts of the seventh and eighth centuries pertaining to proskynesis are noted by Kitzinger ("Cult of Images," p. 99, note 47).

74. Letter 349, *St. Basil, The Letters*, ed Loeb, IV, p. 316. Libanius affects to object both to the garlic-laden breath and the prostrations rendered to him by two youths sent to him at Antioch by the Cappadocian Father.

75. In his study of the early-eighth-century Roman icon known as the *Madonna della Clemenza* in S. Maria in Trastevere, Bertelli (*Madonna*, pp. 60–61), lists only four pre-Iconoclastic works for comparison with the proskynesis made by the pope in this panel. (His first example consists of three sarcophagi of the late fourth or early fifth century, each with the same motif.) To these four must be added the Madonna icon itself, the wall painting in SS. Giovanni e Paolo (cf. note 67 above), a miniature in the Vienna Dioscorides (cod. med. gr. I, fol. 6v), and a sixth-century Coptic fresco showing a genuflecting monk (ibid., note 128).

76. A. Grabar (*L'Iconoclasme*, pp. 21–23) provides a full discussion of the sources. Verina, the wife of Leo I, is described as holding her grandson Leo in her arms and as προσπίπτουσα. The term does not suggest a precise position but the presence of the infant would surely inhibit prostration.

77. A.A. Vasiliev (*Justin the First* [Cambridge, Mass., 1950], p. 86) suggests that the statue "may have represented the emperor genuflecting in adoration [in *proskynesis*]."

similar image of Justinian II (probably dating from his second reign, 705–711)[78] all showed the imperial figure genuflecting.[79] Assuredly some of the miniature and monumental paintings discussed later in this chapter revert to early prototypes, just as the pose of the figure in proskynesis in the Vienna Dioscorides,[80] apparently unique among the sixth-century manuscripts, recurs in many later works. But the vastly greater number, diversity, and elaboration of attitudes of prostration is, in the main, a development of the post-Iconoclastic era.

Grabar's observation that proskynesis became, after 843, the most effective demonstration of adherence to the official doctrine of the Church[81] both explains and is supported by this thesis. Since the central debate of the Controversy, as defined by the Second Council of Nicaea in 787,[82] had concerned the distinction to be made between the worship of God and the reverence bestowed on holy figures, places, and objects, which are cherished, as St. John Damascene put it, not on their own account but because they show forth the divine power,[83] it is hardly surprising that the visible expression of such veneration should become a matter of great import. While the Council was able to discern a difference between true worship [$ἀληθινὴ λατρεία$] and honorific reverence [$ἀσωμασμόν καὶ τιμετικὴν προσκύνησιν$], for the iconodule polemicists *latreia* was only one specific mode of the generic concept of proskynesis.[84] Only in ritual and in art could the distinction be embodied, and only in these outward manifestations could the unlettered perceive both the meaning of the theologians' discrimination and the orthodoxy of the basileus before whose scepter the cosmos in turn prostrated itself.[85]

In the Macedonian era a wide range of such attitudes and gestures was in use in different ritual situations. This diversity is recorded in *de Cerimoniis* and finds its

78. Ibid. Cf. Bertelli, *Madonna*, p. 122, note 132. Mango (*Brazen House*, p. 50) has shown that this statue stood in the basilica built by the consul Illus in 478 on the site where Justinian's Cisterna Basilica was later excavated.

79. The literary sources make no mention of the object of Justin's and Justinian's devotion. If this silence means there was none, then these images can be contrasted with otherwise similar imperial representations of the Comnenian and Palaeologan periods. A verse by Manuel Philes (*Carmina*, ed. E. Miller [Paris, 1857], pp. 354–355) describes a painting of John II Comnenus bringing gifts to, and abasing himself before, the *pambasileus*. The poem, especially lines 5ff., suggests a much more profound prostration than Grabar (*L'Empereur*, p. 99, note 1) implies. A statue of Michael VIII Palaeologus, reported by Pachymeres (*De Andronico Palaeologo* III, 15, C.S.H.B. II, p. 234) and Nicephorus Gregoras (*Historia byzantina* VI, 9, C.S.H.B., p. 202) showed the emperor in proskynesis before the archangel Michael. The same emperor knelt before the Virgin, raising his arms to her in a lost fresco at Hagia Theodoroi, Mistra. (See Millet, *Mistra*, pl. 91,3 [line drawing].) The various submissive poses of Andronicus II Palaeologus on the coins (Figs. 41–44) are always made before an image of Christ.

80. On this problematic figure, see p. 76 below.

81. Grabar, "Un Manuscrit des homélies," p. 280.

82. Mansi, XIII, col. 377D–E.

83. St. John Damascene, *Pro Imaginibus, oratio* III, P. G. 94, cols. 1352–1356.

84. Thus St. John Damascene (*Pro Imaginibus, oratio* I, P.G. 94, col. 1237) insists that one should not adore any creature more than one adored its Creator, "nor give the worship of *latreia* except to the demiurge alone."

85. *De Cer.* I, 74, *C.S.H.B.* I, p. 294.

counterpart, and sometimes its record, in the art of the period. These representations can be analyzed not only more conveniently but perhaps more appropriately in a functional rather than a chronological manner.[86] In no sense, however, can the categories to which we assign these images be considered as mutually exclusive. Time and again there will be reason to stress the multiple significance of proskynesis in a particular situation. To take but one obvious instance: Martha and Mary prostrate themselves before Christ to beseech his aid for their brother (Fig. 51), but their position is equally an acknowledgment of both his power and his glory. Such ambiguities are at the heart of many medieval works of art; their iconography is more than the visual translation of a written or verbal formula, which, like most human discourse, suffers the limitation of expressing only one idea at one particular moment. If we distinguish between an image of adoration and one of supplication, it is not assumed that these attitudes were conceived in terms of so rigid a categorization. We distinguish in order to test the extent to which a varied vocabulary of bodily gesture was evoked by the Byzantines for different situations; to examine whether, within the context of such situations, significant mutations occurred in time; and finally to establish, once the varieties of proskynesis have been noted, what interconnections between different images of prostration are indicated in the art of Constantinople and its provinces. If this much can be determined, it will illuminate an important area of the Byzantine mind, to its last days ever more concerned with the form of ceremonies.

Defeat and Submission

A notable example of the multiple connotations suggested by prostration may be found in Middle Byzantine illustration of the story of Joshua. In sheet VIII of the much-debated Joshua Roll (Fig. 52), as well as in related Octateuch manuscripts, the defeat of the Israelite raiding party by the men of Ai is demonstrated in a variety of engagements between cavalry and foot soldiers.[87] However, only in the Roll itself does a major scene intervene between this defeat and the trial of Achan, whose appropriation of spoils forbidden to the Israelites led to their rout. This is devoted to the passage, occupying no less than ten verses in the text, in which Joshua and the elders lament the defeat, inquire of God the reason for it, and are instructed as to the discovery of the miscreant.[88] Verse 6 of chapter VII, inscribed below the figures of these leaders, describes how Joshua rends his clothes and, falling upon his face together with his elders, puts dust upon his head. Each of these actions is redolent of defeat and all the figures save Joshua grovel on the ground, with heads lowered and hands extended in supplication.

86. The first such analysis to be made was that of St. John Damascene (*Pro Imaginibus, oratio III*, *P.G.* 94, cols. 1348–1356), who defined five kinds [*tropoi*] of *latreia* and seven kinds of reverence. For our purposes his scheme is too narrow, since it excludes types of proskynesis in use in his own day (e.g., for submission before a military leader and the oblations of artists), as well as types introduced (e.g., as attitudes of prayer) after his time.

87. Weitzmann, *Joshua Roll*, p. 19, fig. 23; for the Octateuch *comparanda*, ibid., figs. 27, 29.

88. Joshua VII:6–15.

Yet there is no sign of an enemy, no victorious antagonist before whom they abase themselves. The object of their prostration is rather the hand of God emerging from the heavens and diagonally aligned with the upper part of Joshua's body raised toward the apparition. Far from being the simple picture of defeat that is at first suggested by the general context and the prone bodies of the elders, the scene is a compound image first of acknowledgment of the epiphany and second of entreaty concerning the plight of Israel. The uses of prostration are thus often complex in Byzantine art, richer than the unequivocal attitudes of defeat and submission imposed by[89] or on[90] Roman emperors.

Such attitudes are found in a small number of well-known examples in which the abased figures exhibit considerable variety of posture. But these are either very early works, like the barbarians relief on the Theodosian obelisk (Fig. 45), or representations deriving from late antiquity. Of the latter the most celebrated is the miniature of Bulgarians in proskynesis before the emperor in the Psalter of Basil II (Fig. 53).[91] Although no specific ancient prototype has been found for this composition, the emperor's anachronistic garb has been noted: where in most Middle Byzantine manuscripts the basileus is usually shown wearing the *divitision* or the dalmatic, here he appears in Roman military garb.[92] Further evidence for an early source would seem to be the turned heads of the vanquished, most of whom gaze out at the spectator— as in the late-fourth-century wall painting at SS. Giovanni e Paolo, already cited— rather than at or past the recipient of their veneration—as in most later proskynesis scenes.

Grabar has called attention to the rarity of scenes of prostration before the Byzantine emperor.[93] Equally remarkable is the scarcity of representations of actual military conquest, involving the prostration of the enemy on the battlefield, as opposed to those of commemorative triumphs in the Forum, where the emperor placed his foot on the head of the captive.[94] The images that survive often depend upon the Joshua cycle. One such, on an ivory casket in New York,[95] epitomizes the death of the 12,000 inhabitants of Ai in a group of hapless individuals caught between two groups of Israelites

89. E.g., medallions of Diocletian and Constantine negligently crushing suppliant barbarians under foot (Brilliant, *Gesture and Rank*, p. 193, pls. 4, 14; 9,1).

90. E.g., on the reliefs at Bishapur and Naqsh i Rustam. Cf. W. Sunderman, "Zur Proskynesis in sāsānidischen Iran," *Mitteilungen des Instituts für Orientforschung* X, 1964, pp. 275–286.

91. Venice, Marciana cod. gr. 17, fol. 1 (Rice, *Art of Byzantium*, pp. 84, 318–319, pl. XI [color]).

92. Grabar, *L'Empereur*, p. 86.

93. Grabar, *L'Empereur*, p. 85; also Treitinger, *Kaiseridee*, p. 87, note 199. One may, in addition, infer a Byzantine model for a crude relief, possibly of the tenth century, in the baptistery at Split (J. Strzygowski, *Die altslavische Kunst* [Augsburg, 1929], pp. 197–204). Now constituting part of the font, it shows a totally prone individual with extended arms and open hands adoring an enthroned Croatian prince.

94. Cf. *de Cer.* I, 16, *C.S.H.B.* I, p. 332; II,19, p. 610; II,20, p. 651.

95. Metropolitan Museum, acc. no. 17.190.135 (Goldschmidt-Weitzmann, *Elfenbeinskulpturen*, I, no. 1, p. 23, pl. I,1).

and beaten to the ground. But images of this type are generally eschewed or else translated into a theological idiom.[96]

It is here that both the relationship and the difference between the art of Constantinople and the life of its people becomes apparent. The penultimate sheet of the Joshua Roll shows the five kings of the Amorites bound, prostrate, and suffering the feet of the Israelites upon their necks.[97] Such scenes were known to the Byzantines from military triumphs, including perhaps that of the Bulgaroctonos in 1017, associated with the miniature in the Venice psalter (Fig. 53). But much more familiar to them must have been the experience reported as an everyday occurrence by Nicetas Choniates. "In the vestibule of the house [of the Lord]," writes the historian, "every monk that enters exposes his neck to be trodden upon."[98] The change suggested by this contrast is not simply a transposition from the military to the spiritual realm. It is also the record of Roman ceremony transformed into Christian ritual, the historical into the diurnal. But most important for the history of proskynesis, it attests to the metamorphosis of the pragmatic into the symbolic. The classical attitudes of defeat and submission are converted in Byzantium to other uses, some of which pertain only distantly to their pagan forebears.

Salutation and Veneration

Where Roman iconography presented a particularly succinct or readily adaptable image, it was appropriated for Christian purposes. Perhaps the most studied of such translations is the imperial *adventus*, employed as the basis of the Entry into Jerusalem and the Flight into Egypt.[99] Celebrated on imperial monuments and disseminated through the empire on its coins, the canonical figure of the welcoming province or city retains her place at the gate of the Holy Family's destination. But where the personification does occur,[100] she displays no more consistency than the principal elements in the composition, which may, for example, show the Child held by his Mother, or

96. Thus in Pantocrator 61, fol. 16r (Dufrenne, *Psautiers grecs*, pp. 21–22, pl. 2), the iconodule triumph at the Council of 815 is represented by figures lying in front of the patriarch Nicephorus. These are his adversaries, Leo V, the Armenian, and the displaced patriarch, Theodotus. The "defeated" emperor lies upon the ground but not in any position resembling proskynesis. He is, rather, a collapsed hulk of a man about to fall completely prostrate, the more pathetic for not being in any ceremonial attitude. The relationship between the miniature in Pantocrator 61 and Psalm 25 [26], to which it is attached, is analyzed by Walter (*Conciles*, pp. 27–29).

97. Weitzmann, *Joshua Roll*, pl. 28, fig. 45.

98. Nicetas Choniates, *De Manuele Comnen.* II, *C.S.H.B.*, p. 106.

99. Grabar, *L'Empereur*, pp. 234–236; E.H. Kantorowicz, "The 'King's Advent' and the Enigmatic Panels in the Doors of S. Sabina," *Art Bull.* XXVI, 1944, pp. 207–216.

100. In several versions of the Infancy cycle (e.g., Florence, Laur. Plut. VI, 23), no personification appears in the Flight into Egypt. This fact exemplifies the justice of T. Velmans' recent observations concerning the fidelity of these miniatures to the text (*Le Tétraévangile byzantine de la Laurentienne* [Paris, 1971], pp. 13–14).

carried on Joseph's shoulders and thus displacing the nimbus[101] that the head of the family customarily wears. Even in works as closely related stylistically and chronologically as Paris gr. 74 (Fig. 54)[102] and cod. Taphou 14,[103] the welcoming figure assumes quite different positions. In the Paris Gospel book, Egypt is kneeling but her body is almost upright, an attitude softened by the slight bow that she makes and the movement of the hands extended toward the newcomers. In the Jerusalem Gregory, however, she is nearly prostrate, her elbows and hands near the ground and her head and shoulders raised in a manner close to that of Abraham in proskynesis at Monreale (Fig. 48). The two personifications are dressed almost identically and obviously discharge the same function, but a much greater deference is conveyed by the latter figure.

There is nothing in Scripture or in Gregory's homily on the Nativity to suggest that Jesus, in any literal sense, came as a conqueror to Egypt or that he was acclaimed in triumph. The attitudes of the personifications, different as they are, are testimonies to the divine rather than to the human nature of the Child. The presence of prostrate Egypt transmutes the historical narrative of the Gospel into a doctrinal myth in which the gentile world recognizes and salutes the advent of the Lord in the guise of a human infant. She is as much a representative of this world as the Magi, who elsewhere in the manuscript likewise make proskynesis before him.[104]

A simpler order of salutation is used in cod. Taphou 14 and other manuscripts of the Homilies to represent the greeting of St. Gregory Nazianzenus and St. Gregory of Nyssa. This meeting, conventionally employed in title miniatures of Gregory's orations,[105] is nonetheless rendered in a wide variety of ways. In the Jerusalem codex, the two bishops bow to each other—Nyssa more profoundly than the other—their curved forms describing a semicircle beneath the arc of heaven above.[106] Set between the verticals of architectural coulisses, their bodies stand out against the void in a composition whose simplicity conveys both the individual dignity and the mutual respect of the Fathers. This symmetry is retained in a Gregory manuscript in Paris, where the saintly friends kneel before each other, their upturned hands almost touching and their heads brought nearly together above virtually identical bodies.[107] A third such manuscript, at Vatopedi, shows the two figures—in a miniature still described by Galavaris as the "Gregorys in Proskynesis"—standing side by side, holding each other's hands beneath a bustate image of Christ.[108] In other manuscripts,[109] the similarity of the figures and the symmetry of the composition is abandoned as Nazian-

101. As at the Capella Palatina at Palermo (Demus, *Norman Sicily*, pl. 18).

102. Fol. 4v (H. Omont, *Evangiles avec peintures byzantines du XI^e siècle* [Paris, 1908], pl. VII).

103. Single leaf now in Leningrad, Public Library (Lazarev, *Storia*, fig. 203).

104. At fol. 112v, angels, shepherds, and the Magi adore the Child on his mother's lap. The prostration of the Kings is almost identical to that of Egypt on the page in Leningrad.

105. For this scene in the various Gregory manuscripts, see Galavaris, *Liturgical Homilies*, pp. 54–56.

106. Fol. 219v (ibid., fig. 117).

107. B.N. MS Coislin 239, fol. 158v (ibid, fig. 229). This relationship and posture are found again in Athos, Panteleimon 6, fol. 214r (ibid., fig. 174).

108. Cod. 107, fol. 203v (ibid., fig. 331).

109. Cf. ibid., figs. 271, 294.

zenus abases himself further than the doctor in whose honor he is delivering the homily. In some miniatures additional elements are suggested iconographically,[110] yet the essential constituent remains unchanged. The Fathers, one the author and the other the subject of the sermon, meet, greet, and revere each other's learning and orthodoxy. Yet in these manuscripts, all of the late eleventh or early twelfth century, this content is imparted in very different ways. As in the case of Egypt in proskynesis before the Infant Christ, the central idea is not tied to one inflexible, unvarying attitude.[111]

This is quite contrary to the impression gained from a reading of the Book of Ceremonies, the pages of which are filled with descriptions of apparently timeless and immutable rites. The nature of ritual is such that it does not change: an action becomes a ceremony only when it is repeated constantly and observed *de rigueur*. How, then, can the range of attitudes used for salutation in Middle Byzantine art be explained? Are we confronted with a difference between the ritual of the Court and that of the Church? We are accustomed to the idea that variations occur in life, in practice, but that iconography—and especially Byzantine iconography—implies a set of constants. Yet the evidence of the works just considered, illustrations of the same subject matter, suggests that the precise form of proskynesis represented varies with the identity, and perhaps even with the whim, of the artist. Within fairly broad limits, it seems as if the details of iconography are as susceptible to modification as the characteristics of style.

Such liberty is again denied by the textual accounts of ceremonies that, seen in historical perspective, appear all the more changeless. Shortly before the Fourth Crusade, for example, Euphrosyne Dukaina, the wife of Alexius III Angelus, received the same ceremonial prostration[112] as the *de Cerimoniis*, two and one-half centuries earlier, requires at the coronation of an *augusta*.[113] Again, a precious fragmentary manuscript, now in Florence and recently published, describes the meal taken in the "inner palace" after the coronation of Manuel II Palaeologus, at the conclusion of which the dining senators made proskynesis to the new emperor.[114] No such meal is described by Constantine Porphyrogenitus, but his account of the coronation ceremony specifies senatorial prostration in the Konsistorion before the procession left the palace for Hagia Sophia.[115] Although the nature of the proskynesis is sometimes left unqualified in the Book of Ceremonies, there is little reason to believe that the prostrations—whatever form they took—required by Macedonian protocol disappeared during the fourteenth century. The *de Officiis* of the Pseudo-Codinus enjoins pros-

110. Galavaris (ibid., p. 54) notes the liturgical significance of the Fathers' draped hands in Oxford cod. Selden. B. 54 (ibid., fig. 294) and points out that the text of the homily indicates that the saints are praying.

111. For literary parallels to this variety of expression for the same idea, see Koukoules, *Βίος* I,2, pp. 104, 108.

112. Nicetas Choniates, *Historia*, C.S.H.B., p. 607.

113. *De Cer.* I, 40, C.S.H.B. I, p. 203.

114. P. Schreiner, "Hochzeit und Krönung Kaiser Manuels II im Jahre 1392," *B.Z.* LX, 1967, p. 79.

115. *De Cer.* I, 38, C.S.H.B. I, p. 192: καὶ πίπτουσιν οἱ συγκλετικοὶ πάντες ἅμα τοῖς πατρικίοις.

kynesis upon the empress at the coronation,[116] upon bishops and other clerics at the elevation of a patriarch,[117] and upon the imperial family when one of its members dies.[118] Always it is to the basileus that this veneration is addressed and in one case its constituent elements are recorded: Michael VIII is said to have concluded a treaty of perpetual peace with the Genoese, which specified that their *podestà* make a double genuflection before kissing the foot and hand of his imperial host.[119] While other Franks refused to demean themselves in this fashion,[120] in Byzantium it was considered a privilege reserved for the highest in the land.[121] Little wonder, then, that in the Palaeologan era—when, as the *de Officiis* attests, attention was lavished upon minutiae of ceremonial and regalia—proskynesis flourished rather than withered away.

Of these millennial, ritual abasements Byzantine art records virtually no trace. Although many such scenes may have figured among the mass of lost, secular decoration, proskynesis before the emperor is a rare motif in surviving religious painting, even when such works were undertaken at the imperial behest. In one such manuscript, the Paris Gregory (cod. gr. 510), a page devoted to scenes from the life of Joseph closes with a frontal image of the overseer, set by Pharaoh in a quadriga. Joseph is clad as a Byzantine emperor and carries the imperial regalia.[122] Before him two figures lie prostrate in tightly drawn-up positions of proskynesis, representing the acclamation accorded to the new "ruler over all the land of Egypt."[123] The scene indirectly alludes to the basileus, and the figures demonstrating the reverence of the people are dwarfed by that of Joseph in his chariot. This relative scale is, as we shall see, a commonplace in other images of proskynesis, particularly those in which a donor or an artist prostrates himself before Christ or the Virgin. It is notably absent, however, in a miniature in the Menologion of Basil II commemorating the Seventh Ecumenical Council some two centuries earlier (Fig. 55).[124] Here neither the basileus, Constantine VI, nor his clerics usurp the spectator's attention. The center of the stage, a semicircular void in front of the *synthronon*, is held by a large, prone form, not quite fully

116. Verpeaux, *De Offic.*, p. 261.

117. Ibid., p. 283. Cf. the mid-twelfth-century text of Cedrenus (*Historiarum compendium* II, C.S.H.B. II, p. 307), who records that when Stephen, metropolitan of Amasia, was elevated to the patriarchate in 927, the candidate came to the palace and was permitted to adore the emperor. By contrast, in the West, the prostration of churchmen was made before their superiors. A miniature in a pontifical dated 957–984, in Rome, Bibl. Casanatense cod. 724 B.I. 13 (M. Avery, *Exultet Rolls of Southern Italy* II [Princeton, 1936], pl. CVII, 9), shows candidates for ordination before a bishop in an attitude of proskynesis almost identical with that of the emperor in the lunette mosaic at Hagia Sophia. In the same manuscript (ibid., pl. CV,4), ordained readers receive benediction in the same position.

118. Ibid., p. 285.

119. Ibid., pp. 235–236.

120. Thus Anna Comnena (*Alexiad* XIII,9, C.S.H.B. II, p. 220) notes that Bohemund was refused audience with Alexius I for this reason.

121. Cf. Treitinger, *Kaiseridee*, pp. 87–89.

122. Omont, *Miniatures*, pl. XXVI.

123. Genesis 41:43. Der Nersessian ("Homilies of Gregory," p. 223) suggests an imperial model for this scene but does not comment on the absence of proskynesis in the manuscripts that she cites (p. 224, note 135) as *comparanda*.

124. Vat. gr. 1613, fol. 108r.

extended, who abases himself before the assembly. Although the miniature occurs at the point where the text of the synaxarion mentions the Seventh Council, Salaville objected to this interpretation on the grounds that Constantine VI was only thirteen in 787, whereas the Menologion image shows an adult emperor, and similarly because it does not show his mother, the powerful empress Irene, at the center of the picture. He suggested instead that the picture represents the First Council of Nicaea, Constantine the Great, and the condemned, heretical Arius.[125]

The essential point is the centrality of the Cross in this miniature as against other Conciliar images dominated by the figure of the emperor.[126] It is the "cross on steps," the emblem of victory before which heretics are cast down.[127] Here the "iconoclast," groveling before the representatives of Church and State, turns his back on the Cross set between them. The *Horos* of the Seventh Council had affirmed proskynesis paid to the "precious and life-giving Cross" as the norm to which the veneration of icons should be compared.[128] But this statement merely underlined the long tradition, reverting at least to the end of the fourth century,[129] in which the Cross constituted the prime object of Christian veneration. The most significant step in the history of this form of reverence dates from the Quinisext Council of 692, when the Cross was defined as an instrument of the Incarnation, and therefore the object of honors proper to the mechanism of salvation rather than simply reverence as a symbol of the Crucifixion.[130] In the Menologion miniature, the Cross is raised in the middle, above the benches of the synod; prostration is made before it, not as an image of the Crucified, but as a figure of the true faith guarded by the powers of either side. An acceptably non-representational symbol for the Iconoclasts, before the Controversy, it had been used as the very emblem of imperial Orthodoxy flanked by images of Constantine I and Helena.[131]

125. Salaville, "L'Iconographie des 'Sept Conciles Oecumeniques,'" *Echos d'Orient* XXV, 1926, p. 150. Neither Salaville nor Walter (*Conciles*, pp. 37–38) suggests the possibility that the miniature may derive from a lectionary and synaxarion in which it did represent Nicaea I. However, Walter (ibid., pp. 83–87, figs. 38, 44) does show that prostrate heretics appear in images of both the First and Second Nicene Councils in the Church of the Nativity at Arbanasi in Bulgaria, decorated between 1632 and 1649. Galavaris (*Liturgical Homilies*, p. 148, fig. 177) sees the condemned heretics prostration as indicating that he lies under anathema and adduces parallels to be found in an eleventh-century Gregory manuscript.

126. As, for example, in Paris, B.N. gr. 1242, fol. 5v (Grabar, *L'Empereur*, pl. XXII,2), where John VI Cantacuzenus presides over the Council of 1351.

127. For the "cross on steps" and the literature on this controversial motif, see Breckenridge, *Justinian II*, pp. 33–35, and, most recently, K. Ericsson, "The Cross on Steps and the Silver Hexagram," *J.Ö.B.G.* XVII, 1968, pp. 149–164.

128. Mansi XIII, col. 377. See also the synod's letter to the *augusti* (ibid., col. 400).

129. The Greek evidence is collected by Kitzinger ("Cult of Images," p. 90); the Armenian, S. Der Nersessian ("Image Worship in Armenia and its Opponents," *Armenian Quarterly* I, 1946, pp. 67–81).

130. Mansi XI, col. 976.

131. A sculpted image of Constantine the Great and his mother crowned the Milion in Constantinople, which was further decorated—possibly in the reign of Justinian II—with images of the Ecumenical Councils. For this monument, see Grabar, *L'Iconoclasme*, pp. 55–56. In *de Cer.* I, 32, *C.S.H.B.* I, p. 172, the Cross appears as τὸ τῆς πίστεως σύμβολον, brought to the emperor on Palm Sunday by the

Nonetheless the guardians of the True Cross in Middle and Later Byzantine art appear in their capacity as saints as much as in their historical role of *augusti*.[132] And it is in a liturgical rather than an imperial context that we find the majority of later representations of proskynesis before the Cross. Weitzmann has called attention to the illustrations associated with the feast of the Elevation of the Cross in an eleventh-century lectionary closely related to the Basic Menologion.[133] The recurrent images of veneration of the Cross resting on an altar he justly explains as due to the repetition of this ritual on four consecutive days before the feast itself. But within the miniatures of the series the manner of reverence varies from a simple bow through successive degrees of inclination to a prostration as abject as that of the "Iconoclast" in the Menologion. Rather than the representation of a sequence of movements in time, which was not a Byzantine preoccupation,[134] we must read this as a demonstration of the variety of appropriate modes of proskynesis. No one attitude would seem to be uniquely fitting. This degree of tolerance perhaps still obtained in 1334, when Ibn Battuta saw attendants requiring prostration of everyone who passed beyond "the huge cross" at the entrance to Hagia Sophia.[135]

Similar lenience would appear also to characterize Middle Byzantine representations of icon veneration.[136] Given the extent of this cult after the Triumph of Orthodoxy, it is surprising how few examples are known in which an image within an image is shown as the object of reverence. If the surviving specimens constitute a fair sample, considerable diversity of practice is apparent. On the upper part of a silver cross, now at Dumbarton Oaks and recently assigned to the year 1057, the emperor Constantine acknowledges a pair of images of St. Peter and St. Paul held by Pope Silvester with a slight nod of the head.[137] This deference is in sharp contrast to the figures of Archippus, prostrate before the archangel Michael, and Joshua, crouched before the Angel of the Lord, on the horizontal axis of the same cross. It is the more remarkable

orphanotrophos, whose prostrations are addressed to the ruler rather than to the ritual object that he carries. While holding the Cross the *orphanotrophos* makes proskynesis μὴ τελείως πίπτων. After he has delivered it to the emperor, he throws himself to the ground and acclaims him.

132. The type is represented by the mosaic of Constantine and his mother in the narthex of Hosios Loukas (E. Diez-O. Demus, *Byzantine Mosaics in Greece* [Cambridge, Mass., 1931], fig. 47).

133. Vat. gr. 1156, fols. 248r,v (Weitzmann, "Byzantine Miniature and Icon Painting in the Eleventh Century" XIII *C.E.B.* [London, 1967], p. 219, pl. 33, a,b).

134. Although something of this sort was surely intended in the mosaic of the Communion of the Apostles in the apse of H. Sophia at Kiev (Lazarev, *Storia*, fig. 174), where successive apostles approach the Eucharist with first the left and then the right foot alternately advanced.

135. *The Travels of Ibn Battūtah A.D. 1325–1354*, trans. H.A.R. Gibb, II [Cambridge, 1962], pp. 510, 513.

136. For Roman precedents, particularly the adoration of the imperial image, see Alföldi, "Ausgestaltung," pp. 65–79; for the period before Iconoclasm, Kitzinger, "Cult of Images."

137. R.J.H. Jenkins-E. Kitzinger, "A Cross of the Patriarch Michael Cerularius," *D.O.P.* XXI, 1967, pp. 233–249, figs. 1, 2. Kitzinger (p. 246) describes Constantine's attitude as one of "reverence and submission." Reviewing this article, Grabar (*Cah. arch.* XX, 1970, pp. 235–236) has contested the association of this cross with the patriarch Michael Cerularius and suggested a twelfth- rather than an eleventh-century date for the piece.

since the import of the cross was quite probably a demonstration of imperial subjection to ecclesiastical authority.[138]

Strikingly different from Constantine's minimal gesture is the attitude of David before an image of Christ in the nearly contemporaneous psalter, Vat. gr. 752 (Fig. 46).[139] The king kneels, head lowered and legs drawn up tightly under his body, before the doors of a church above which the Pantocrator is set in a tympanum. An image of the type set over the Imperial Door of Hagia Sophia (Fig. 1) would seem to be intended here; David's attitude is virtually identical to that of the emperor in the narthex mosaic. There is nothing in the text of Psalm 37 [38] or in David's prayer, included in the inscription, to suggest prostration before an icon. In fact there is no significant distinction between his position in this miniature and in others in the manuscript where his entreaty is addressed directly to the person of Christ rather than to an image.[140]

If a historical personality like Constantine and a biblical figure like David are shown venerating icons in quite different ways, living beings—at least in the thirteenth century—are represented in yet a third fashion. The frontispiece of the so-called Hamilton Psalter in Berlin shows an unidentified Greek family venerating the icon of the Hodegitria under a ciborium.[141] While the mother and six children of the family kneel upright on the floor of the church, the father assumes a more inclined posture although his position is far from one of profound abasement. The overall impression is one of dignified respect—much as in a Flemish devotional picture—rather than the abject prostration of David in the Middle Byzantine psalter. This rare representation of the cult of icons is yet further and stronger evidence for the diversity of poses acceptable for the reverence of holy images.

Since both the Cross and icons receive veneration manifested in attitudes ranging from simple genuflection to almost total prostration, it might be supposed that the cult of saints received similarly varied artistic expression. And indeed such a hypothesis is vindicated in the light of examples varying widely in date, provenance, and medium. The manner of reverence of Early Christian Rome, as evidenced by the late-fourth-century wall painting in SS. Giovanni e Paolo,[142] is closely followed in the Leo Bible probably made after 940[143] and one of the purest expressions of the Macedonian Renaissance in Constantinople. On a page illustrating Constantine the *protospatharios* and the abbot Makar at the feet of St. Nicholas, we once again find the heraldic disposition of two figures whose huddled forms make the stature of the saint all the greater (Fig. 56).[144] Nicholas' body rises like a piston within the semicircular exedra, his vertical form seemingly unsupported in contrast to the firmly grounded bodies of his adorers.

138. Jenkins-Kitzinger, loc. cit., p. 240.

139. Fol. 128r (DeWald, *Vat. gr. 752*, pl. xxvi).

140. See p. 87 below.

141. Kupferstichkabinett cod. Hamilton 78 A9 (Grabar, *L'Iconoclasme*, p. 202, fig. 1).

142. See p. 62 and note 67 above.

143. C. Mango, "The Date of Cod. Vat. Reg. Gr. 1 and the 'Macedonian Renaissance,'" *Acta Norv.* IV, 1969, pp. 121–126.

144. Ibid., pl. III.

The compositional device of enhancing a martyr's height by setting him before architecture horizontally extended is common to much Byzantine hagiographical manuscript illustration, including that in the Basil Menologion.[145] But in one miniature, depicting the veneration of St. Simeon Stylites, an effect similar to that of the Nicholas page in the Leo Bible is achieved. Here a hunched form in "Levantine" garb prostrates himself before the saint's column. The impression of height is less than that suggested in the earlier manuscript because of the horizontal format of the miniature. But the cognate effects of the saint's remoteness and the abasement of the worshiper are again conveyed primarily by the horizontal attitude of the latter, only slightly modified as he lifts his head and hands in supplication.

That East Christian art knew other forms of adoration addressed to saints is amply suggested by the anatomically impossible attitude of a donor in a sixth- or seventh-century painting from Saqqara.[146] His proskynesis, made before a row of saintly monks, requires him to arch his body and lower his head to the hem of the garment of one of the venerated, while his open hands touch the feet of the neighboring figure. There appears to be no extant Constantinopolitan counterpart to this physiological oddity,[147] but from some major and possibly Eastern scriptorium emanated a Chrysostom manuscript that includes another sort of reverential *hapax*. Although similarities have been suggested between the figure of Arcadius in this miniature (Fig. 58)[148] and that of the basileus in the lunette mosaic (Fig. 2), the posture of the two emperors is in fact quite different. Arcadius is the much more extended figure: his legs are hardly drawn beneath his body and his arms reach further toward the objects of veneration than those of the emperor in the mosaic. Moreover, his covered hands denote a much more palpable and immediate relationship with the sanctity before him than is displayed between the isolated figures in the narthex of Hagia Sophia. The saints look directly at the emperor prostrate before them, again in contrast to the sacred figures who gaze past the imploring basileus in the mosaic. As in the case of the image from Saqqara, the artist was faced with the problem of demonstrating reverence paid to a group of saints rather than to an individual martyr. Here they are set in three-quarter view and confined to the left margin of the miniature. The unique quality of this work is the fact that its main subject is the imperial proskynesis rather than the figures to whom this reverence is offered.

So extensive a demonstration of piety is foreign to most representations of the cult of saints, where the prostrate figure is usually not only humbled but dwarfed by that which he venerates. Even in the more "personal" genres of Byzantine art such as seals—where the motif of proskynesis is significantly a rare one—the object of veneration towers over the adorer. This is evident, for example, on a fine seal in the

145. For a representative selection, see I. Ševčenko, "The Illuminators of the Menologium of Basil II," *D.O.P.* XVI, 1962, figs. 3, 5–16.

146. Now in the Coptic Museum, Cairo (Beckwith, *Early Chr. and Byz. Art*, p. 31, pl. 56).

147. Beckwith suggests of this work that "behind the idiosyncracy of provincial piety the germinal center was Constantinople."

148. Athens, Nat. Lib. cod. 211, fol. 63r Grabar ("Un Manuscrit des homélies," p. 280, pl. XXI,2) notices the common diadem and chlamys, the same hair style and type of face.

Zakos collection in Istanbul, the obverse of which shows Constantine Mesopotamites before a standing St. Demetrius.[149] Constantine, metropolitan of Thessaloniki in 1198, rises from full prostration to a position almost identical with that of Andronicus II Palaeologus on one of his *solidi* (Fig. 43). Indeed, the megalomartyr turns toward the cleric of his city exactly as Christ inclines toward the Palaeologan emperor. Compositionally, the seal is a manifest prototype for the coin. It preserves what, in the light of the Leo Bible and other Middle Byzantine manuscripts, we may fairly call the Constantinopolitan type of proskynesis before a saint. Outside the capital, as we have seen, quite other attitudes of veneration were known. In one instance a work that would seem to have originated in Constantinople presents an exception to the type of prostrate figure, legs drawn tightly beneath him, with head and hands raised toward a saint. A little-known, late-eleventh-century mosaic icon in the Greek Patriarchate in Istanbul displays a relatively gigantic frontal image of St. John Prodromos while, in the lower left corner of the icon, a diminutive male form kneels upright and looks directly at the saint.[150] But the figure here is that of a donor and the work thus falls within a different class of images with its own traditions and range of iconographical variants. To these traditions we must now turn.

Oblation and Dedication

The Constantinople in which circulated the *hyperpyra* of Andronicus II bearing the emperor in proskynesis before Christ (Figs. 41–43) was already familiar with a similar monumental image set up by his father, Michael VIII Palaeologus.[151] Its destruction in an earthquake in 1328 prompted Pachymeres to record this bronze statue; from his brief description, we know that it showed Michael presenting to his eponymous archangel an image of the city that the Byzantines had retaken. The emperor's position is described only as at the feet of St. Michael[152] but, since he is said to be offering up Constantinople to the archangel's custody, it is tempting to see whether we cannot discover more precisely the significance of his attitude in the light of the other, related monuments. Was there a conventional pose in Byzantine art for such images of oblation or did these assume the protean forms of Sicilian, Serbian, and Russian votive images that have been connected with the Michael statue?[153] There may, of

149. V. Laurent, *Corpus des sceaux de l'empire byzantin* I (Paris, 1963), no. 464; II (Paris, 1965), pl. 63.

150. G. Sotiriou, Ψηφιδωταὶ εἰκόνες τῆς Κωνσταντινοπόλεως, Πρακτικὰ τῆς Ἀκαδημίας Ἀθηνῶν XI, 1936, pp. 70–76, figs. 2, 4.

151. See note 79, above.

152. Buondelmonti's description of this statue, edited by G. Gerola ("Le vedute di Costantinopoli di Cristoforo Buondelmonti," *Studi bizantini e neoellenici*, III, 1931, pp. 275–276) is scarcely more precise concerning the emperor's attitude: ". . . in capite Angelus eneus est, et Constantinus genuflexus hanc urbem in manu sua offert."

153. Grabar (*L'Empereur*, pp. 110–111) cites the votive mosaic of William II at Monreale, and similar images of princes at Nereditsa and Studenica. Each of these figures is in different positions and none at the feet of Christ or the Virgin. In a paper presented at the fourteenth Congrès Internationaux d'Etudes Byzantines, M. Tatić-Djurić ("Iconographie de la donation dans l'ancien art serbe") stressed the variety

course, have existed a tradition peculiar to representations of the basileus in this situation. But unfortunately, whereas we have imperial Roman precedents for this iconography,[154] there exist no comparable Byzantine works. The evidence is confined to images of the oblations of lesser men.

The earliest Constantinopolitan example in this genre is unusual in that it shows a female figure in proskynesis. In the lower left quadrant of the dedicatory miniature in the Vienna Dioscorides, a disproportionate and inelegantly posed woman is squeezed between Anicia Juliana's footstool and the braid that adorns the picture.[155] The legend [EY]XA[P]ICTIA TΩN TEXNΩN appearing above her rump may describe only the attendant putti. Although her sex suggests that she is not the artist, the absence of any specific inscription—in contrast to those above Phronesis and Megalopsychia on either side of the princess—prohibits any positive identification of the figure as a personification. She may be a servant deferring to her mistress; there remains the possibility that she is the donor of the great book. Allegorical figure or not, she assumes an awkward version of the position that later characterizes the representation of sponsors of art in a variety of media.

Doubt as to the rôle of the prostrate figure equally attends an icon of St. Irene at Sinai assigned by Sotiriou to the eighth or ninth century.[156] The lower half of the figure, identified as NIKOLAOS [. .]AKANOS, is destroyed, but he evidently crouches beside the massive body of the saint. A huddled form, confined between her mantle and the border of the panel, he extends his open hands toward her right foot. The image contains no clue as to whether Nikolaos is the donor or artist of the picture, whereas, after Iconoclasm, such doubts are usually resolved by the presence of the offering in the hands of the prostrate figure. These oblations, moreover, are generally made to Christ or to the Mother of God rather than to a saint. This is exemplified in the page illustrating the dedication of the Leo Bible (Fig. 57).[157] The picture is organized according to the principle that we have previously recognized in this work[158] with the addition of an oblique axis along which Leo's oblation is metaphorically transmitted to the Pantocrator in the upper right corner. The beardless *patrikios* bends one knee before the Virgin, trailing his other leg behind his body in an evident concession to the demands of the composition. This odd position has no parallel before the late-twelfth-century image of St. Peter saved from drowning at Monreale (Fig. 65).

of attitude evident in such Serbian images. Until the publication of this volume of the *Actes* of the Congress, see the summary of her paper in *Résumés-Communications* (Bucharest, 1971), pp. 353–354.

154. E.g., and *aes* of Trajan showing the emperor presenting a kneeling Dacian to the Genius of Rome, on which see Grabar, *L'Empereur*, p. 111.

155. Vienna, Nationalbib. cod. med. gr. 1, fol. 6v (Buberl-Gerstinger, *Handschriften* I, p. 27, pl. V. A similar female figure, surely the wife of the donor who offers his book to Christ, occurs in the twelfth-century lectionary, Athos, Kutlumusi cod. 60, fol. 1v (S.M. Pelekanides et al., *The Treasures of Mount Athos* [Athens, 1973] p. 451, fig. 295).

156. Sotiriou, Εἰκόνες, no. 32.

157. Fol. 2v (*Miniature della Bibbia cod. vat. Regin. greco 1 e del salterio cod. vat. Palat. greco 381* [Milan, 1905], pp. 4–5, pl. 4).

158. See p. 73 above.

Much more common is the attitude of a bishop presenting his book on a late-tenth-
or eleventh-century ivory in Berlin (Fig. 59).[159] His pose is virtually identical with
that of the emperor in the lunette mosaic at Hagia Sophia and preserves the rigid
symmetry of that work. But the effect is softened by the sculptural, three-quarter
stance of John and Mary on either side of the Crucifix. With this modification, the
scheme of a central frontal figure adored by a much smaller form at his feet and
flanked by in-turning attendants became canonical in Middle Byzantine art.[160] It
was easily adaptable to the magnification of the imperial majesty as in the sumptuous
copy of St. John Chrysostom's Homilies made for Nicephorus Botaneiates.[161] Here,
in the physical disparity between the adored and the adorer, the latter is dwarfed not
only by the emperor but even by his footstool. While naturalism is utterly alien to the
form and meaning of this picture, from this point of view the equation between the
minuscule and the humble has been carried to the point of hyperbole. Nicephorus
appears as a figure to whom the archangel defers, to whom the saint presents his
orations. The size, and therefore the significance of the artist—or, less probably,
the copyist of the manuscript—is next to nothing compared to this sacred triad.

The posture of the diminutive craftsman is not unambiguous.[162] The oblique axis
of his figure is, obviously, closer to the anomalous attitude of the donor in the Leo
Bible (Fig. 57) than to the proskynesis made before the dead Christ on the ivory in
Berlin (Fig. 59). But since the class of representations of prostrate Byzantine artists
is extremely small,[163] it would be premature to suppose that his inclined, kneeling
pose is exceptional or that no distinction is made between depictions of donors and
those of artists.

At first sight it would seem that a more abased position was customary in Com-
nenian images of oblation. In the celebrated dedicatory mosaic at the Martorana in
Palermo the founder was surely rendered with his knees drawn up to his elbows
(Fig. 60).[164] Despite the destruction of the legs, George of Antioch must have originally
appeared huddled in proskynesis rather than posed in any more extended form of
prostration. His back is parallel to the ground as in the Berlin ivory and the narthex
mosaic at Hagia Sophia, a feature that distinguishes this position from such singular

159. Goldschmidt-Weitzmann, *Elfenbeinskulpturen* II, pp. 55–56, no. 102, pl. XXXIX.

160. An ivory in the Musée Cluny, Paris (inv. no. 1035), showing Christ crowning Otto II and
Theophano was considered by Goldschmidt-Weitzmann (ibid., pp. 50–51, no. 85) to be a Byzantine work
made for export. The German emperor and his Greek bride are shown entirely frontally, however, and,
like the image of the prostrate donor in the lower left corner, lack the plasticity accorded the figures in
the Berlin Crucifixion ivory. P.E. Schramm and F. Mütherich (*Denkmäle der deutschen Könige und
Kaiser* [Munich, 1962], no. 73) now attribute the Paris piece to a Greek workshop in Calabria.

161. Paris, B.N. MS Coislin, 79, fol. 2v (Omont, *Miniatures*, p. 34, pl. LXIV).

162. Omont (ibid.) describes the figure as "dans l'attitude de la prière."

163. In a twelfth-century manuscript of the *Ascetic Tracts* of St. Basil in Copenhagen, Gl. Kongl.
Samml. 1343, fol. lr (*Greek and Latin Illuminated Manuscripts in Danish Collections* [Copenhagen, 1917],
p. 3, pl. II), its monastic artist or scribe is shown in proskynesis before St. Basil.

164. For the date, the condition, and the inscriptions of this mosaic, see Demus, *Norman Sicily*,
pp. 82–84, 90, pl. 58b. The author justly remarks that because of clumsy restoration the Admiral now
resembles a turtle. For the iconographical context, see C. Walter in *R.E.B.* XXVI, 1968, p. 320.

attitudes as that of the eunuch Leo in Vat. Regin. gr. 1 (Fig. 57). In other respects, however, the mosaic in the Martorana is close to the type of dedication image exemplified in this Bible. In both, a half-length figure of the Pantocrator reaches beyond his aureole in the upper right corner to bless the donor. In both, Mary inclines her head and gazes down and past the abased figure to the spectator, whose point of view is the same in each case: looking up at the Virgin as if she were a statue towering above him. The spectator thus shares, insofar as possible, the viewpoint of the supplicant. This device is common to many Middle and Late Byzantine representations of prostration, including the eleventh-century mosaic icon in the Greek Patriarchate[165] and the Deësis image in the Kariye Camii (Fig. 73). The Sicilian example of proskynesis is thus once again related to the art of the capital, although by the nature of its composition rather than by any specific iconography of donation.[166]

The mosaic in the Martorana celebrates, of course, the oblation of a building rather than of a book: George of Antioch is represented as the *ktētōr* of the church. Yet, even for this more closely defined category, twelfth-century painting displays no canonical form. In the provinces, in particular, the variation of physical attitudes associated with the act of dedication is considerable. For example, in the cell of St. Neophytus at his Cypriot *enkleistra*, the founder is shown kneeling before the enthroned Christ of a Deësis group.[167] Beside a scroll that describes him as a supplicant at the "divine foot," Neophytus raises the upper part of his body so that he may grasp the right foot of Christ seated above him. In contrast, in the apse of the Panagia Mavriotissa at Kastoria, the monastic *ktētōr* abases himself before the throne at a respectful distance from the feet of the Platytera, without daring to raise his head toward her.[168]

It is only in the thirteenth century, when the political and artistic fortunes of the Greek East and the Latin West became more tightly intertwined than at any time since Iconoclasm, that we find a semblance of consistency in the poses assumed by Byzantine founders and donors. Shortly after the Fourth Crusade, a version of proskynesis was adopted by the papacy as the appropriate posture of oblation and supplication.[169] This Western appropriation was no more than a passing fancy, but Palaeologan

165. See p. 75 and note 150 above.

166. A twelfth-century manuscript example compositionally close to the Martorana mosaic, showing the Mother of God standing as intercessor between the bust of Christ and the donor, is Athos, Lavra cod. 103A, fol. 3 (S. Der Nersessian, "Two Images of the Virgin in the Dumbarton Oaks Collection," *D.O.P.* XIV, 1960, p. 84, fig. 13.

167. C.A. Mango-E.J.W. Hawkins, "The Cell of St. Neophytos and its Wall Paintings," *D.O.P.* XX, 1966, pp. 180–182, figs. 93–97, where the painting is dated before 1183. For the great variety of poses assigned to founders and donors in later Cypriot art, see Stylianou, "Donors and Supplicants," figs. 41–44.

168. Pelekanides, Καστορία, pl. 63.

169. Honorius III had himself represented in an extended position of prostration, with only his head, shoulders, and hands raised to the enthroned Christ above him in the apse mosaic of S. Paolo fuori le mura (Matthiae, *Mosaici medioevali* I, pp. 337–340; II, fig. 270). The mosaic, which Oakeshott (*Mosaics of Rome*, pp. 295–296) tentatively attributes to masters invited from Venice specifically for this purpose, probably dates between the time of this invitation—January 1218—and the death of Honorius in March

Constantinople seems to have paid more serious attention to the Latin attitude of prayer. The form taken by oblational figures in monumental works in the capital was not the upright kneeling attitude, common in the West in the thirteenth century, which became familiar in Latin-influenced Orthodox lands within a hundred years;[170] still it was far from the huddled proskynesis that survived in votive images in Palaeologan manuscript illumination[171] and that icon-painters in the Crusader states borrowed from Byzantium and transmitted to the West.[172]

The new metropolitan manner of dedicating a church is clearly demonstrated in the mosaic of Theodore Metochites presenting a model of his foundation to Christ in the Kariye Camii (Fig. 61).[173] His astonishingly earnest image, which confronts the visitor moving from the inner narthex into the nave, was apparently intended to correspond to the narthex mosaic of Hagia Sophia (Fig. 1). A similar intensity of expression colors the faces of the basileus in the older image and the Grand Logothete in the fourteenth-century mosaic. Their poses are, however, utterly dissimilar. Metochites' attitude is as far removed from the proskynesis of the emperor as it is from the unconcerned, standing images of Constantine and Justinian as they present their city and their church to the Virgin and Child in the mosaic in the south-west vestibule of the Great Church (Fig. 95).[174] It is hard to conceive of two figures, engaged in essentially the same act of dedication, more different than Justinian offering Hagia Sophia—an image created more than four hundred years after the event that it depicts—and Theodore, the living *ktētōr* of the Kariye. The cursory deference made with his head and shoulders by the builder of the Holy Wisdom has no counterpart in the Palaeologan image. The anxious attitude of Metochites, reflected as much in such details as the position of the knees—one advanced in front of the other—as in his face, is expressed primarily by the contours of his back. He leans forward, carrying the weight of the model, above which his head is raised in awe, awaiting the Lord's response. One senses that the slightest answer to his oblation will im-

1227. Honorius' pose is described by Ladner ("Gestures of Prayer," p. 250) as "an attitude of proskynesis of an extreme type which had not occurred in earlier surviving monuments of papal iconography." Indeed, the brevity of this fashion is indicated by the fact that on the façade of Old St. Peter's his successor, Gregory IX (1227–1241), was rendered in the familiar posture of kneeling upright (Wilpert, *Mosaïken und Malereien* I, 1, pp. 374–375). In the present state of research, there is no more evidence to suggest a peculiarly papal mode of prostration than there is to support any similar belief regarding the Byzantine emperor.

170. Stylianou ("Donors and Supplicants," pp. 124–128) notes the introduction of the upright kneeling pose in the wall paintings of Cyprus in the second half of the fourteenth century, alongside the traditional standing, supplicatory figure. From the sixteenth century, this kneeling attitude becomes predominant. It is already evident in votive images in such fourteenth-century manuscripts as the Sinai Tetraevangelion, cod. gr. 198, fol. 199v (Belting, *Illuminierte Buch*, pp. 39–40, fig. 20).

171. As in the image of the nun Theopempte prostrate before the enthroned Virgin and Child in a psalter of about 1274 at Sinai, cod. gr. 61, fol. 256v (Belting, loc. cit., p. 50, fig. 19).

172. E.g., a double-sided panel in the Byzantine Museum, Athens, showing a female donor prostrate at the feet of a standing St. George who looks toward the Pantocrator in the upper right corner of the icon. Cf. Athens Catalogue, no. 237.

173. Underwood, *Kariye Djami* I, pp. 42–43; II, pls. 26 (color), 28.

174. See p. 124 below.

mediately be reflected in a movement of this back. In contrast, Justinian seems a timeless if not a lifeless figure drawing upon some conventional iconographical type.

But the mosaic in the Kariye differs equally from the thirteenth-century survivals of the standing, oblational figure. In the dedicatory image at Nereditsa, painted about 1246, an impassive Yaroslav Vsevolodovich presents his Church at the Saviour to a seated Christ.[175] Only in the slightly earlier *Stifterporträt* at Mileševa, where the Virgin intercedes between Vladislav, carrying his foundation, and her Son, do we recognize a sense of timidity about the founder's person.[176] But the Serbian king's simple, almost childlike emotion no more resembles Theodore Metochites' complex of feelings than do his garments or his posture. A new sensibility as well as a change in physical attitude characterizes the High Palaeologan image of dedication.

Abject proskynesis did not disappear from the art of fourteenth-century Constantinople or the lands that remained its artistic, if no longer its political, dependencies. The double-sided reliquary icon known as the "Diptych of Toma Preljubović," dated between 1367 and 1384 and now in the cathedral treasury at Cuenca, shows the noble Serbian donor as a diminutive figure cowering prostrate before a gigantic standing Christ, although on its reverse Maria Palaeologina kneels with head and shoulders raised toward the Mother of God.[177] But even in the provinces, especially in works of royal oblation, the new forms of Constantinopolitan art found a response. In the great Deësis scene at St. Nicholas, Curtea-de-Argeş, the founder kneels before the enthroned Christ and at the feet of the standing Virgin.[178] In this narthex painting, which Stefanescu has justly connected with the Metochites mosaic, the princely donor kneels with straight back but leans toward the Saviour. His open hands are held apart and in prayer. In this respect, as yet unelucidated, he resembles not only the *ktetor* of the Kariye but the majority of other Byzantine founders and donors.

Entreaty, Penitence, and Prayer

Where the donor comes oblation in hand before the Lord or his representatives, the merely prayerful man arrives empty-handed. Instead of offering something he brings only his hope, his need to receive rather than to give. The case of the penitent is an extreme example of this situation. He prays not simply externally devoid of material to offer. He is internally, spiritually, destitute, a lacuna waiting to be filled with the grace of God. This lack of material encumbrance, it might be thought, would free the Byzantine artist to project his supplicant into total prostration.[179] Instead, he used

175. Lazarev, *Murals and Mosaics*, p. 127, fig. 57.

176. S. Radojčić, *Mileševa* (Belgrade, 1963), pl. VIII (color).

177. S. Radojčić (in Weitzmann et al., *Icons*, pp. XCVI, CIV [bibliography], pls. 196–197) describes the despot's attitude as "the liturgical position of proskynesis."

178. I.D. Stefanescu, *La Peinture religieuse en Valachie et Transylvanie depuis les origines jusqu'au XIXᵉ siècle* (Paris, 1930) I, p. 58; II, pl. XIV.

179. Such a material impediment obviously relieved the *orphanotrophos* of his obligation to prostrate

the opportunity to dispose his figures in many different manners, determined by the specific content of the scene or the demands of the composition but not by any canonical and traditionally binding modes of petitionary or invocatory expression. The physical attitudes to be considered under this head vary even more widely than those of oblation and veneration.

Next to its function as a token of submission, the attitude of abasement is perhaps most appropriate to an act of entreaty; the supplicant asking help *ipso facto* assigns superiority to the helper. The Gospels, as accounts of the Incarnation of Divine Love, contain numerous examples of such recognition but for their Byzantine illustrators—and for those borrowing scenes originally associated with Gospel illustration—two such incidents appeared as paradigmatic. Thus the artist responsible for the miniatures that adorn the first homily, *de Filio*, in the Paris Gregory begins his cycle of scenes from the life of Christ with a demonstration of Jesus' divine power to resurrect.[180] The Raising of Lazarus is represented in a manner that, if we can judge from the *ekphrasis* of Mesarites,[181] may have been as old as the sixth century, and that would generally persist into and beyond the Palaeologan period (Fig. 51).[182] Beside the inert mummy of their brother and before the active, gesticulating figure of Christ, Martha and Mary throw themselves to the ground. The contrast between the sisters is hardly less than that between Lazarus and the Saviour. With covered hands, Mary seizes Christ's right foot and kisses it, while Martha, her hands similarly draped, looks up imploringly at him. The different attitudes of the women are the more effective in that both seem developments of the same position, a huddled supplication before the Lord. The urgent, petitionary postures in the miniature are, moreover, thrown into relief by the contrast with the patient activity of the genuflecting *pornē* in the adjacent image.[183]

The approximation of cognate scenes is a familiar device in both the text of Gregory's *Homilies* and the great Paris codex. In one strip-illustration of this manuscript, however,

himself as he carried the Cross to the emperor in the Chrysotriclinos on Palm Sunday (*de Cer.* 1,32, *C.S.H.B.* 1, p. 172). Having presented his precious burden, however, he made a full proskynesis in the center of the room. For a situation in which a courtier's costume prevented prostration, see ibid., 1,50, pp. 258–259.

180. Cf. Der Nersessian, "Homilies of Gregory," p. 204.

181. Downey, "Mesarites," pp. 907–908.

182. Fol. 196v (Omont, *Miniatures*, pl. XXXVIII). So too at Chilandari (Millet, *Athos*, pl. 68,2) and Vatopedi (ibid., pl. 84,3), both wall paintings of the early fourteenth century, and in the *katholikon* at Dionysiou (ibid., pl. 202,1), dated by Millet to 1547.

J. Lafontaine-Dosogne (*Peintures mediévales dans le Temple dit de la Fortune Virile*, Brussels, 1959, pp. 35–40, pl. XI) has called attention to the appropriation of Mary's attitude at the Raising of Lazarus by painters wishing to represent less celebrated subjects. Thus in the Roman cycle that she discusses, a widow, pestered by an official of Caesarea, huddles in entreaty at the foot of St. Basil, which she kisses. The same scene in Paris gr. 510, fol. 104r (Omont, *Miniatures*, pl. XXXI) shows the woman in a relatively much more extended proskynesis since the space available in the register allowed the artist to portray a more elongated figure.

183. In some Palaeologan representations, e.g., at St. Nicholas Orphanos, Thessaloniki (Xyngopoulos, Τοιχογραφίες, fig. 20), an upright kneeling position is given to Martha.

the combination has its origins in the Gospel where the Woman with the Issue of Blood occurs as an incident in the narration of the Raising of Jairus' daughter.[184] The healing of the *Haemorrhoousa*—our second major example of a favored entreaty motif—occupies the central place in a complex register again devoted to scenes from the life of Christ (Fig. 62).[185] A rhythm, at once compositional and thaumaturgic, moves from the standing figure of the paralytic, his bed already on his shoulders, past the kneeling Woman, to the Daughter, still prone since Christ has not yet come to her. Jairus' proskynesis, directly in Christ's path, is seemingly ignored as the Lord turns back to the creature into whom his *dynamis* has passed. Her upright position is required by the press of figures in the strip; where the space of monumental painting permitted a more generous attitude, as in the pendentive of a narthex dome at the Kariye Camii, her prostration is much more fully extended (Fig. 63).[186] Here her serpentine form connects the two wings of the pendentive; a heavy horizontal bond between the two groups of standing figures otherwise related only by the gaze of Christ, Jairus, and their attendants. While the elongated Woman became canonical in later and post-Byzantine representations of this scene,[187] her proskynesis was never employed to better effect than in the mosaic at the Kariye.

Prostration as a gesture of entreaty to heal, was, of course, known to the Early Christians and by no means addressed only to the Saviour. An early-fifth-century ivory panel in the British Museum depicting the Raising of Tabitha shows the dead woman's servant in proskynesis at the feet of St. Peter.[188] Her back is parallel to the ground, her attention so exclusively devoted to the apostle's foot that she is unaware of the miracle that has already occurred above her. The eyes of the supplicants are again averted from the object of their entreaty in a pair of scenes in the Joshua Roll, which may ultimately derive from a model of the second century. The Gibeonites twice send ambassadors to the Israelite leader, once to ask for an alliance and then to beg for actual military protection.[189] While their first request is accompanied only

184. Matthew 9:20–22; Mark 5:25–34; Luke 8:43–48. Only the last speaks of the Woman as prostrating herself before Christ. Malalas (*Chronographia* X, C.S.H.B., pp. 237–239) identifies the Woman as Veronica of Paneada, a rich woman who later, with Herod's permission, erected a monument [$\sigma\tau\acute{\eta}\lambda\eta$] to Christ. Other than that it was made of bronze, adorned with gold and silver, and was still standing in his own day, Malalas tells us nothing of this monument. This passage was later used by St. John Damascene (*Pro imaginibus, oratio III*, P.G. 94, col. 1372C) as a *testimonium* to the antiquity and venerability of Christian images. But the literary archetype, both for a description of the monument and for the sanction this afforded Christian imagery in general, is to be found in Eusebius, *Historia Ecclesiastica* VII, 18, ed. Loeb, II, pp. 174–176), who records the *Haemorrhoousa* as represented before Christ "bending on her knee and stretching forth her hands like a supplicant."

185. Fol. 143v (Omont, *Miniatures*, pl. 33).

186. Underwood, *Kariye Djami* I, pp. 146–147; II, pls. 268, 270.

187. E.g., at the Athonite monastery of Kutlumusi, ca. 1540 (Millet, *Athos*, pl. 164,2).

188. Volbach, *Elfenbeinarbeiten*, pp. 60–61, pls. 38, 117. O.M. Dalton (*Catalogue of Early Christian Antiquities . . . of the British Museum* [London, 1901], p. 50, no. 292) suggests that the prostrate attitude may be a gesture of mourning. This interpretation hardly accommodates the woman's concentration on St. Peter's foot. Her attitude is intended to match the "proskynesis" of the Israelite drinking water from the rock struck by Moses on the other long side of the casket.

189. Weitzmann, *Joshua Roll*, pp. 25–27, 34, 109, fig. 37.

by a bow, at their second, more urgent appeal, the chief envoy drops to the ground. His physical position is not one that, in nature, can be sustained for more than a moment and the artist presumably intended to show him falling into (or possibly rising from) an attitude of prostration. His companion's pose should surely be read no differently—note the similar positions of each ambassador's left leg—but as a version of the Middle Byzantine solution to the problem of rendering two aligned figures engaged in the same act. The disposition of Martha and Mary in Lazarus scenes (Fig. 51) represents an alternative resolution of this difficulty.

The humility of the ambassadors' second deference is further emphasized by the fact that they approach the side of Joshua's throne, rather than the front of it as in the previous miniature. This enables the artist to create a triangular zone defined by the oblique side of the throne, the slope of the hill with the city of Gibeon behind it, and the base line of the miniature. Upon this triangle he imposes the similar forms of the envoys, an effect less easily obtained were they posed in any greater or lesser degree of prostration. Repeatedly in Middle Byzantine art, the form of the supplication employed seems to be a function of compositional requirements. It has been suggested, for example, that on the silver cross of Michael Cerularius, now at Dumbarton Oaks,[190] the proskynesis of the priest Archippus may well represent an attempt to balance the prostrate form of Joshua on the opposite arm of the cross: in most versions known of the Miracle of Chonae, the incumbent is shown standing before St. Michael, beseeching the archangel to save his chapel from the flood.

Except in Miracle cycles, standing figures, even while making a deferential inclination, are rare in the vocabulary of Middle Byzantine supplication. One such occurs in a hasty marginal illustration in a late-eleventh-century psalter at Sinai, where the narrow space available limits an image of almsgiving, frequently attached to Psalm 40:2, to the urgent petitioner for such charity.[191] But where a more concrete situation is represented, the supplicant's pose is determined as much by the organization of the picture as by the nature of the request or the rank of the petitioner's audience. This can perhaps best be demonstrated in the aisle mosaics of Monreale, which retain many schemes of New Testament illustration in use in Comnenian Byzantium. Located beside the mosaic of the Magdalen prostrate at Christ's feet (Fig. 49) in the northern aisle, the lowly and imploring position of the Lame Man seems both natural and appropriate (Fig. 64).[192] Yet, so far as I am aware, there is no justification in Scripture or in Greek commentaries upon this passage for placing the cripple upon hand-crutches. Rather, in this way, he becomes a pathetic figure affecting confined between the legs of Christ and those of the unseeing who can yet walk. A flurry of gestures enlivens

190. See p. 72 above. Kitzinger's opinion that the "standard iconography" of the scene shows Archippus in an erect position must be modified at least as regards the fourteenth century. At Kouneni, Crete, in a church dedicated to St. Michael, he appears kneeling upright before the archangel (K. Lassithiotakis, Δύο ἐκκλησίες στό Νομὸ Χανίων, Δ.Χ.Α.Ε., 4th series, I, 1960–1961, pp. 22–23, pl. 11,I). The pose here may owe something to Venetian influence.

191. Cod. 48, fol. 50r, K. Weitzmann, "Sinaiskaia psaltir s illiustralsiiami na poliach," *Vizantiia, iuzhnie slaviane i drevnaia Rus', Zapadnaia Evropa*, Moscow, 1973, pp. 120–121.

192. Demus, *Norman Sicily*, pp. 120, 143, 281, pl. 91b; Kitzinger, *Monreale*, pl. 74 (color).

the scene but these are, quite literally, above his head. The erect and varied poses of the apostles following Christ and the Pharisees standing behind the blind further emphasize the lame man's abasement. Most suggestive of all, the spastic twists of his contorted body parody the gentle contours of the Lord's figure and of the hilly landscape. Only from above, from the illumined zone at the top of the mountain, and through Christ, can come the power to straighten this twisted body.

From its place in the southern aisle of the same church, between the Healing of the Man with the Withered Hand and the Raising of the Widow's Son, much of the significance of St. Peter, saved by Christ as he walks on the water, can be inferred (Fig. 65).[193] Customarily the scene is not one of a generic series of miracles but a specific, soteriological reference: Peter's limp hand is seized by Christ, who raises him from certain death. In this instance, a notable iconographical change has occurred since the post-Iconoclastic conception of the scene. In the early Macedonian Paris Gregory the apostle of little faith is shown upright in the water, his vertical body submerged to the waist.[194] But at Monreale a powerful contrast is drawn between the calm and erect Christ, standing on the sea, and Peter's spasmodic, angular posture. Physically desperate in the mosaic, whereas the ninth-century miniature has him only emotionally disturbed, Peter jerks in the sea like a fish at the end of a line. Apart from his untroubled face, he presents a totally convincing image of anguished genuflection.

Save for the imploring figure of Adam in representations of the Anastasis,[195] there are no parallels to Peter's distressed attitude. East Christian art produced an extraordinarily wide repertoire of poses of entreaty, ranging from the standing figure with bowed head to the elongated but still hunched form of the Woman with the Issue of Blood (Fig. 63). Between these two extremes, almost every conceivable attitude is to be found, but nowhere, curiously enough, the total prostration recorded in the *Hortus Deliciarum* of Herrade of Landsberg (Fig. 66).[196] The awkward posture of the *débiteur insolvable*, fully extended in supplication before his king, may be an error in Bastard's drawing, although this would seem unlikely in the light of his other careful work. It is also true that there survives no body of medieval Greek secular decoration in which such a scene might be found. Yet the fact remains that there is no known analogue to this attitude as it occurs in a manuscript of approximately the same date as the mosaics of Monreale and commonly supposed to be very close to a Byzantine prototype.

In comparison with Herrade's debtor *in extremis*, Orthodox forms of prayer and penitence seem modest indeed. The ancient attitude of standing prayer survived beyond Iconoclasm, occuring frequently in psalters of the so-called aristocratic recension and used conventionally for the pose of the prophets in such manuscripts as Dumbarton Oaks cod. 3 of about 1084.[197] But the commonest type found in the

193. Demus, *Norman Sicily*, pp. 120, 278.
194. Paris, B.N. gr. 510, fol. 170r (Omont, *Miniatures*, pl. XXXVI).
195. See below, pp. 100 ff.
196. Fol. 111r (Straub-Keller, *Hortus*, pl. XXXIV, *bis*).
197. Der Nersessian, "Psalter at D.O."

category to which this psalter belongs, as well as in other books of the Old Testament, is a proskynesis very similar to that made by the emperor in the narthex mosaic at Hagia Sophia (Fig. 2). The "migration" of images among the manuscripts of this large group has been the subject of prolonged discussion since the beginning of the century,[198] and it is not our intention to summarize, and much less to adjudicate, the controversy here. Our sole concern is with the varieties of proskynesis thrown up by this group, a task made easier by Dufrenne's study of a group of psalters with marginal illustrations closer in time to the narthex mosaic.[199]

The first manuscript of this cluster (Athos, Pantocrator 61) shows David prostrate and wearing a mantle much like that of the emperor in our mosaic (Fig. 67).[200] His garment, however, covers his hands, unlike that worn by the basileus.[201] Otherwise, their attitudes are similar: each has his knees drawn up under him almost to the elbows and both figures present essentially the same rectangular mass. In one feature, nevertheless, the two images differ considerably. David's head is held much lower, closer to his hands, than is the emperor's and his eyes are directed toward the ground. One might well find this natural in an image where the object of his prayer is not represented. Indeed, the downcast eyes and unfocused gaze are repeated in the scene of his penitence in the Paris Psalter.[202] Since it has been suggested that the prototype of this famous, full-page illustration showed the prophet Nathan to the right of David,[203] it is important to consider those miniatures in which there appears the recipient of the king's prayer or the prophet hearing his confession. Before doing so, however, it is noteworthy that in the single illustration in Jerusalem, cod. Taphou 51,[204] commonly supposed to be a close copy of the Paris Psalter, David's head is not depressed but raised as if to engage the eyes of another figure beyond the picture frame.

In the "Bristol" Psalter, dated on palaeographical grounds to the end of the tenth or the beginning of the eleventh century, Nathan stands before the prostrate king whose head is raised and whose eyes follow the admonitory gesture of the prophet.[205]

198. Cf. Tikkanen, *Psalterillustration*. The most extensive discussion is in Weitzmann, *Roll and Codex.*

199. Dufrenne, *Psautiers grecs*, discussing Athos, Pantocrator 61; Paris, B.N. gr. 20; and London, B.M. Add. MS. 40 731.

200. Fol. 18v, illustrating Psalm 27 [28]:1 (Dufrenne, *Psautiers grecs*, p. 22, pl. 2). Cf. fol. 14r (ibid., pl. 1), where David's arms are further advanced and his head and shoulders raised slightly further from the ground, and fol. 220r, the similar posture of Manasseh as a prisoner (pl. 32).

201. For the significance, if any, of this feature, see Buchthal, *Paris Psalter*, p. 44, note 11.

202. Paris, B.N. gr. 139, fol. 136v (ibid., pp. 27–30, pl. 8).

203. Ibid., p. 230. Buchthal suggested that the unfocused gaze of David (and Metanoia) and the "open composition" resulting from the omission of Nathan creates a "motive deeply moving as an expression of the contrite mood of the sinful king." This interpretation was scorned by C.R. Morey ("The 'Byzantine Renaissance,'" *Speculum* XIV, 1939, p. 151). For further discussion, see now A. Cutler, "The Spencer Psalter. A Thirteenth Century Manuscript in the New York Public Library," *Cah. arch.* XXIII, 1974, pp. 139–142.

204. K. Weitzmann, "Eine Pariser-Psalter-Kopie des 13. Jahrhunderts auf dem Sinai," *J.Ö.B.G.* VI, 1957, p. 136, fig. 7.

205. London, B.M. Add. MS. 40 731, fol. 82v (Dufrenne, *Psautiers grecs*, p. 58, pl. 52). She finds in the painter of this manuscript (p. 50) "une méthode plus proche des influences antiques que des innovations médiévaux."

In the contemporaneous Basil Psalter, while Nathan stands much closer to the king and gestures above him, David's head is raised as he gazes directly at the prophet's knees.[206] And in the Paris Gregory, created within a generation of Pantocrator 61, the king has raised himself sufficiently from the ground to allow a view of the lower leg of the angel, whose dynamic pose epitomizes the extraordinary sense of activity instilled into this picture by the artist (Fig. 68).[207] Here David's pose suggests more than the proskynesis of penitence: he is raised from prostrate desperation by the prophet's assurance that his sin is remitted, that he will not perish.[208]

This aspect of the scene is emphasized by the inclusion of part of their dialogue as brief legends within the miniature, an element not present in the other versions under consideration. Again, none of the psalters shows David raised quite as far from the ground as Paris gr. 510. But many of them, as well as the illustration in the one surviving Book of Kings, show him with head elevated and quite different, therefore, from the dejected monarch of the Paris Psalter. The Kings book (Vat. gr. 333) clearly shows David still in proskynesis but with his head raised and a tautened, extended neck (Fig. 69).[209] The attitude is clearly motivated by the appearance of the *manus dei* from a star-studded arc at the upper right corner of the miniature. Moreover, it recurs as the position both of David in illustrations of several different psalms and of other figures in scenes patently modeled upon images of David in proskynesis.[210]

It is used, for instance, for the sick Hezekiah, illustrating his ode of thanksgiving after Isaiah's prophecy of recovery in Dumbarton Oaks cod. 3.[211] Although he does not look at it, his raised head and shoulders again occur beneath an arc of heaven, the zone to which his song is addressed. Behind him stands a female figure—probably a personification of prayer—and in this collocation of arc, standing form, and figure in proskynesis, we recognize a version of the compositional scheme used in the Leo Bible (Fig. 57) and monumental works such as the dedication panel of the Martorana (Fig. 60).

The second half of the eleventh century seems to be a particularly rich period for the conversion to other uses of the pose assigned to the penitent David—or rather for the manifestation of such conversions in manuscripts deriving from such older models. The "isolation" of the king, achieved in Vat. gr. 333 and Paris gr. 139 by having him look away from his companions, prophetical and allegorical, is apparently rendered absolute in Vatopedi 761. One page of this psalter contains the lone figure of St. John Chrysostom, dressed as a monk and shown in proskynesis. In fact, his posture and his raised head are to be explained by the presence of the Virgin and Child on the facing

206. See chapter 2, note 100, above. In this respect the Basil miniature resembles that in the psalter, Dumbarton Oaks cod. 3, fol. 27r (Der Nersessian, "Psalter at D.O.," pp. 169–170, fig. 6).

207. B.N. cod. gr. 510, fol. 143v (Omont, *Miniatures*, pl. XXXIII).

208. 2 Kings [2 Samuel] 12:13.

209. Fol. 50v (J. Lassus, *L'Illustration byzantine du Livre des Rois* [Paris, 1973], p. 75, fig. 92).

210. Thus the Ode pictures in such unpublished psalters as B.M. Add. MS. 11836, fols. 300r (Hannah) and 301v (Isaiah).

211. Der Nersessian, "Psalter at D.O.," pp. 159–160, 172, fig. 34. The king here rests on hands and knees, his arms being dropped vertically to the ground.

page; to them are addressed both his prayer and the copy of his Homilies on the Psalms, which he holds.[212]

In psalters of this period, the figure of David in proskynesis is associated with many different psalms with connotations by no means limited to penitence. Thus in a manuscript of Constantinopolitan provenance and dated to 1053–1054, he prays for deliverance to the Pantocrator seated on a backless throne, to the side of which another throne—the Hetoimasia—stands as a token of the coming Judgment.[213] The painter here has freely interpreted the first verse of Psalm 109 [110], which suggests session rather than prostration at the right hand of the Lord. A similar pose occurs in Vat. gr. 752, a less precisely dated psalter, in which David in proskynesis raises his head to request Christ's aid against his enemies.[214] In the first instance, the Lord is a frontal figure whose gaze and gesture suggest ignorance of the supplicant's presence and in this the composition recalls the narthex mosaic at Hagia Sophia (Fig. 1). But the emperor in this monumental work averts his gaze from the Pantocrator in contrast to David's direct and unequivocal appeal in both manuscript examples. They remain, nonetheless, the closest parallels that we have to the unique iconography of the image over the Imperial Door.

The Byzantine psalter, as the literary embodiment of David's supplications, was traditionally a book characterized by numerous representations of proskynesis. Yet, even in this light, Vat. gr. 1927, a psalter of the first half of the twelfth century, is an extraordinary phenomenon. DeWald pointed to the frequent occurrence in this manuscript of David "either in the rôle of a prophet or teacher . . . or as a suppliant standing or kneeling, asking for divine help in time of trouble."[215] But the comment does not begin to suggest the fact that this psalter contains probably more images of prostration and more varieties of proskynesis than any other Byzantine codex. Of its one hundred and forty-five miniatures no less than fifty-eight include some form of physical abasement. In addition to numerous representations of the Psalmist praying with inclined head, bowing, genuflecting, crouching, and prostrating himself before the arc of heaven or the figure of Christ, and such customary scenes as David praying for deliverance from enemies hot in pursuit or rebuked by Nathan, the psalter contains a prodigious number of images of the wicked cast into pits or otherwise laid low. Their position is almost invariably a version of proskynesis. In a representative miniature, David stands between one group of men who give thanks to God and another prostrate group as the earth dissolves in liquid fire (Fig. 70).[216] Below, with one hand, Christ pours onto the

212. Fols. 231r–232v (Weitzmann, "Vatopedi 761," p. 28, figs. 12–13).

213. Jerusalem, cod. Taphou 53, fol. 162v (A. Baumstark, "Frühchristliche-syrische Psalter-illustration in einer byzantinischen Abkürzung," *Oriens Christianus* V, 1905, pp. 304–305, pl. VII,1). Cf. Athens Catalogue, no. 281.

214. Fol. 104v (DeWald, *Vat. gr. 752*, p. 18, pl. XXVI, illustrating Psalm 34 [35]).

215. *Vat. gr. 1927*, p. 50. Cf. the psalter Athens, Benaki Mus. 34.3 (A. Cutler–A.W. Carr, "The Benaki Psalter," *R.E.B.* [in press]).

216. Fol. 135r (ibid., p. 22, pl. XXXI), illustrating Psalm 34 [35]. The composition and significance of the lower register is reminiscent of a miniature in the Menologion of Basil II (Vat. cod. gr. 1613, fol. 168r), in which Brenk (*Tradition und Neuerung*, p. 231, fig. 93) has recognized winged demons in proskynesis before the triumphant archangel Michael.

heads of groveling sinners the dregs of the cup that they must drink; with a staff in the other, he breaks the horns of the wicked similarly abased before him. Neither in the text excerpted as inscriptions about the figures nor in the body of the psalm as a whole is their any mention of prostration.

This manner of interpretation is canonical rather than exceptional throughout the manuscript. It is therefore hardly surprising that, where the text specifies "they who serve graven images,"[217] the artist should prefer this scene to other passages in the psalm that in the past had inspired illustration.[218] Here the idolaters occupy the right middle ground of the miniature while in front, from an arc of heaven, Christ's fire descends on four of his "enemies," who thus pay for their hostilities. In Middle Byzantine manuscripts, however, such heathen practices are often accorded the exclusive possession of a picture. A miniature in Pantocrator 61 illustrates the sins of the Chosen People with two Israelites worshipping Beelphegor, a monumental figure attended by a Nike-like demon.[219] Of the idol's devotees, both clad in "oriental" clothing, one kneels upright while the other raises his head from a position of proskynesis.

Manifestly, the worship of idols expressed itself in as many forms as that of God and his saints. This is not to be wondered at considering that, as in this miniature, the suggestion of veneration is the artist's invention and not required by the text. Where in the Psalms, or other books of the Septuagint, proskynesis is specified, the reference rarely evokes a particular physical attitude. But there are, in addition, both historical and artistic reasons that the Christian Greeks should represent pagan rituals after their own forms of reverence. In the Macedonian era, idol-worship was not some exotic practice, remote in time and space from the Byzantine experience. Constantine Porphyrogenitus, for example, refers to the inhabitants of the Mani as "idolaters and worshipers of images after the fashion of the ancient Hellenes" before their baptism in the reign of his grandfather.[220]

But if the cults were familiar, at least by report, cult-images were not. Weitzmann has suggested that for miniatures such as that of Hecate and her worshipers in an eleventh-century Gregory manuscript, no classical prototypes are known (Fig. 71).[221] The destruction of pagan emblems left the illustrator without a visual source and although, as has been argued, this Hecate figure may be based on a Byzantine version of another idol, this still does not solve the problem of the original Christian source for such compositions. It will be noticed that the goddess is a gigantic, frontal figure bearing a branch in one hand and gesturing with the other. Before her, two figures make prostrate supplication while, to each side, groups of standing figures respond with a variety of gestures. The only Christian composition possessing all of these characteristics is the

217. Psalm 96 [97]:7.

218. Fol. 177r (DeWald, *Val. gr. 1927*, pp. 28–29, pl. XLI). Cf. verse 2: "Righteousness and judgment are the habitation of his throne," used—among many other examples—in Paris, B.N. MS. Coislin 79, fol. 2r, and verse 5: "The hills melted like wax at the presence of the Lord," which occasioned a superb miniature in the Utrecht Psalter.

219. Fol. 153r (Dufrenne, *Psautiers grecs*, p. 34, pl. 24, illustrating Psalm 105 [106]:28).

220. *De administrando imperio*, 50, ed. Gy. Moravcsik (Washington, D.C., 1967), p. 236.

221. Jerusalem, cod. Taphou 14, fol. 321r (Weitzmann, *Greek Mythology*, pp. 58–60, 75, fig. 70).

Anastasis. However sacrilegious it may seem to modern notions of piety, it is not im-
possible that the model for this imaginary heathen ritual was the Descent into Limbo of
the colossal, cross-bearing *triumphator*. *Ex post facto*, the pagan gods may have revenged
themselves on the Orthodox iconographer who first appropriated the motif of Heracles'
seizure of Cerberus for a new type of Anastasis.[222]

The attitude of Hecate's worshipers is, as we have seen, a familiar position in Middle
Byzantine representations of prayer. It is, moreover, validated by the pose traditionally
assigned to Christ himself in the only Gospel scene that textually required an image of
the Lord in proskynesis. In the Agony in the Garden, Jesus' first prayer, when it was
depicted,[223] traditionally showed him on his knees with his back parallel to the ground.
This scheme survives in Early Palaeologan art, notably in the recently cleaned version
in Hagia Sophia at Trebizond (Fig. 72).[224] Much of the right side of the composition is
destroyed but what remains is sufficient evidence of the painter's quality. In particular,
Jesus' horizontal pose makes a powerful contrast to the movement of the angel in head-
long descent beneath a great splay of wing feathers. The dynamic form of the swooping
angel is perfectly foiled by the still, rectangular mass of the Lord in prayer, the more
effectively since the protagonists' nimbed heads are vertically aligned. In fourteenth-
century examples this antithesis is dissipated as Christ raises his head from his prone
position and the divine messenger is reduced to a hovering, subordinate figure.[225]

A similar proclivity to raise the head of the prostrate figure is evident in Palaeologan
and meta-Byzantine representations of prayer. The recently published wall paintings of
the "Christos" church in Veroia include a monk, dwarfed by the gallery of elongated
saints before whom he kneels.[226] Despite his disproportionate size, however, his intent,
alert eyes engage those of St. Arsenios towering above him; the monk's uplifted head is
as alive as the tremulous, parted hands with which he receives the saint's attention. No
more contrasting attitudes of prayer could be found than between this image of a living
being and that of the traditional, if iconographically rare, representation of Zacharias
at the Kariye, painted less than a decade later. Praying with downcast eyes before the
rods of the suitors, in a scene based upon the apocryphal Protoevangelium of James,[227]
the high priest all but effaces himself at the gates of the altar enclosure.[228] His huddled
form, like that of the diminutive Virgin behind the altar, is scarcely noticeable in a
monumental architectural setting all the more fantastic for its seemingly precarious

222. Weitzmann, "Das Evangelion," pp. 87–88.

223. For the abbreviation of the Gethsemane sequence in some decorative cycles and its total
elimination from others, see Millet, *Recherches*, pp. 41–52. The most complete representation of the
sequence (six scenes) is to be found in the west transept at St. Mark's Venice (O. Demus, *Die Mosaïken
von San Marco in Venedig 1100–1300* [Baden, 1935], pp. 43–44, 97, figs. 32, 33).

224. Rice (*Trebizond*, pp. 90–91, 170–171, pl. 24B) dates the decoration of Hagia Sophia about 1260.

225. E.g., at St. Nicholas Orphanos, Thessaloniki (Xyngopouloś, Τοιχογραφίες, fig. 41), and
Mateić [Serbia] (Millet, *Recherches*, fig. 662).

226. St. Pelekanides, Καλλιέργης ὅλης Θετταλίας ἄριστος ζωγράφος (Athens, 1973), pp. 11,
87, pls. 76, 77.

227. For the textual sources, see Lafontaine-Dosogne, *Enfance de la Vierge*, pp. 167–168, and
Underwood, *Kariye Djami* I, p. 78–79.

228. Underwood, *Kariye Djami* II, pls. 135, 137.

setting in the soffit of an arch. Zacharias' manner of prostration is akin to that assigned him in earlier Constantinopolitan Gospel books such as Florence, Laur. Plut. VI, 23.[229] But even before the end of the thirteenth century, at St. Clement, Ohrid, and particularly after the end of the empire, the high priest is shown kneeling with his back obliquely inclined and head raised to look to Mary.[230]

This tendency toward upright genuflection we have already seen clearly expressed in the dedicatory mosaic at the Kariye (Fig. 61). It is used again as the prayerful pose of the nun Melanie, kneeling beside Christ in the Deësis in the same narthex as the image of Metochites (Fig. 73).[231] Directly above this imperial supplicant (cf. Fig. 63) is the extended form of the Woman with the Issue of Blood. Whether this juxtaposition is deliberate must remain open to doubt; it is obvious, however, that Melanie's kneeling attitude is intended as a pendant to the figure of Isaac Comnenus, standing beside the Virgin as she pleads for him with her Son. Since the Deësis is the primary expression in Byzantine art of the liturgical supplication for Mary's intercession,[232] it is evident that both Isaac's standing position and the nun's genuflection must be interpreted as attitudes of prayer. Neither is in a physical state of proskynesis—as the term is customarily used—but both are supplicants in a fashion that the term must now be understood to include.[233]

An attitude similar to Melanie's is given to Manuel II Palaeologus (1391–1425) in a lost wall painting in the Hagioi Theodoroi at Mistra.[234] Here, however, the basileus raises both arms toward the Virgin with his hands parallel but apart in a manner reminiscent of Western attitudes of prayer. She responds by offering her right hand to him, as if to raise him from his suppliant position. The gesture is a moving one, especially since her other arm holds the Child: the effect is to suggest a tenderness available both to the Son and to the emperor. But on the basis of Roumpous' drawing—the only visual record we have of the painting—it is an illusion to believe that we can judge the human qualities of the picture. Something of this sort is, however, undoubtedly present in a manuscript portrait of Demetrius Palaeologus, Manuel II's son and Despot of Mistra until his death in 1471 (Fig. 76).[235] Since the kneeling figure is a bearded old man, it may be presumed that the portrait was drawn shortly before this date.[236] The Despot's

229. Fol. 5v. Lafontaine-Dosogne (*Enfance de la Vierge*, fig. 95) in her caption unaccountably describes this manuscript as a psalter. Another tradition, represented by Vat. gr. 1162, fol. 97v, and a mosaic in St. Mark's, Venice (ibid., figs., 98, 99), has Zacharias standing by the altar.

230. Ibid., figs. 23, 26, 28, 30, 31.

231. Underwood, *Kariye Djami* I, pp. 45–48; II, pls. 36, 37.

232. See the useful discussion by D. Mouriki, "A Deesis Icon in the Art Museum," *Record of the Art Museum, Princeton University* XXVII, 1968, pp. 13–28, with the principal literature on the Deësis. To this must now be added the studies by C. Walter, "Two Notes on the Deësis," *R.E.B.* XXVI, 1968, pp. 311–336; idem, "Further Notes on the Deësis," *R.E.B.* XXVIII, 1970, pp. 161–187.

233. In his original publication of this mosaic, Underwood ("Notes on the Work of the Byzantine Institute in Istanbul," *D.O.P.* XII, 1958, p. 284) described Isaac and Melanie as "two suppliant figures in proskynesis." This description is not repeated in his final publication.

234. See note 79 above.

235. Leningrad, Public Library cod. gr. 118, fol. 385v (Lazarev, *Storia*, p. 370, fig. 504).

236. Lazarev (ibid., pp. 415–416, note 56) suggests that the miniature should not be dated before the middle of the fifteenth century. In his caption, however, he retains the mid-fourteenth-century date suggested by Diehl (*Manuel d'art byzantin*, 2d ed., II [Paris, 1926], p. 875).

weary pose and apparently trembling hands—held together, unlike those of his father—convey a very different picture from the agile and importunate figure of Manuel II. But both are unmistakably images of princes praying for surcease in the last, anguished, half-century of the empire.[237]

The attitudes in which these Late Palaeologan entreaties are expressed could hardly be more unlike that of the basileus in the narthex of Hagia Sophia (Fig. 2). Yet this mosaic image shares with the Demetrius miniature an earnestness about the features and, with the portrait of Manuel at Mistra, the gesture made with parted hands. It would be folly at this stage to speculate about the precise function of the Macedonian ruler's proskynesis, even though his face is not the inscrutable mask worn by the emperor Arcadius venerating his saints in the Athens Chrysostom manuscript (Fig. 58). Grabar has suggested that, insofar as imperial iconography is concerned, adoration and prayer are both conveyed by a common repertoire of attitudes: both employ out-stretched arms and prostration.[238] We have seen that the prayers of lesser men—as much as that of Jesus—may be represented by proskynesis, as were their gestures of penitence, oblation, and submission. But this is not a specific attitude, tied to a parti-cular carriage of the supplicant's back, his arms, or his head. Rather it is an attitude of mind, susceptible to expression in a wide variety of physical positions.

We have no representation of the emperor in proskynesis earlier than that in the narthex mosaic at Constantinople. We know only from literary sources of images of the emperor Maurice and his family at prayer in the Chalke[239] and no way of knowing the medium, the attitudes, or the connotations of these works. And if the literary tradition concerning such ancient images is unhelpful, the artistic heritage may be positively misleading. An icon by Emmanuel Tzanes, painted about 1670–1680, purports to show an emperor in prayer ἐν τοῖς Χαλκοπρατείος σεβάσμος οἶκος (Fig. 74).[240] Leo VI, the Wise, kneels beside the *soros* containing the girdle of the Virgin, beseeching her to cure his empress. His pose is without parallel even in the vast range of attitudes under-stood as proskynesis. His upright genuflection, made without inclination, and his lightly touching hands, are not Late Byzantine elements influenced by the West. They are no more Greek than is the architecture of what in Tzanes' icon pretends to represent the church of St. Mary Chalkoprateia.

The Will and Glory of God

To this point we have considered only those representations in which proskynesis is a

237. For the brief inscription addressing the Virgin as intercessor in the Manuel painting, see G. Millet, *Inscriptions byzantines de Mistra* (Athens, 1899), pp. 120–212, no. 10.

238. Grabar, *L'Empereur*, p. 99.

239. Πάτρια Κωνσταντινουπόλεως II, 89 (=*Scriptores originum Constantinopolitanarum*, ed. Th. Preger, II [Leipzig, 1907], pp. 196–197).

240. Athens, Benaki Museum, Z', no. 1150 (N. Tomadakis, Ἐμμανουηλ, Κωνσταντίνος καὶ Μαρίνος Τζάνε Μπουνιαλῆς, Κρητικὰ Χρονικά I, 1947, p. 149, no. 50, pl. IA).

voluntary gesture. The positions assumed by men venerating the Lord and his saints, offering their dedications to these sacred figures or craving aid or absolution from them are attitudes that—however much defined by custom—remain acts of choice. Even the self-abasement required of barbarians in the Hippodrome, exhibited as a means of further exalting their imperial captor,[241] must be considered a ceremony in which these unfortunates consented to appear. For the fearful—and proskynesis is the expression *par excellence* of fear of one sort or another—the reward of their humiliation was their life. But Byzantine art abounds with other images of prostration, no less induced by awe but not the result of a conscious decision to abase oneself. Although far from unrelated to postures of submission or adoration, there is a mode of proskynesis in which closeness to the earth is not an act of will but an unconsidered and seemingly unavoidable response. For the Christian the supreme occasion of such a response was the revelation of the will or the glory of God.

The inhabitants of a world in which such theophanies occurred by no means always answered them with prostration. To the modern eye, one of the most astonishing responses to the unveiling of divine glory is the figure of a standing saint in the apse of Hosios David at Thessaloniki.[242] He leans toward the image of the youthful Christ enthroned upon the rainbow and surrounded by the evangelical beasts. Palms open and fingers spread, his hands are raised on either side of his head in wonderment at the vision. This is certainly no ordinary proskynesis;[243] equally surely, no voluntary gesture is shown here. The entire attitude is an utterly convincing and utterly unconventional expression of religious awe.

One of the most celebrated expressions of this experience in Byzantine art is the full-page miniature representing St. Paul's Journey to Damascus in the late-ninth-century manuscript of Cosmas Indicopleustes in the Vatican (Fig. 75).[244] Before falling to the ground, a groping and pathetic creature, the erstwhile persecutor gazes upward in astonishment at the source of the voice that questions him.[245] This reversal of the scriptural order of events is found in the illustration of this event in all surviving Cosmas manuscripts. The only major difference in the representations of the actual Conversion is in the figure of Paul. In Sinai cod. 1186—for Weitzmann a more accurate reproduction of the archetype than the Vatican manuscript[246]—the apostle's extended proskynesis is easily accommodated within the horizontal extension of the miniature. In the Vatican Cosmas, on the other hand, Paul is a huddled figure compressed between the frame of the picture and the standing "author portrait" at its center. The effect of this confinement and of his draped hands is to suggest an almost total helplessness; it would be difficult to conceive of a more cogent image of the mighty fallen.

241. Cf. note 94 above.

242. A. Grabar-M. Chatzidakis, *Greece: Byzantine Mosaics* (New York, 1963), pl. IV (color).

243. However, for a standing figure that L'Orange would recognize as making proskynesis see note 278 below.

244. Vat. cod. gr. 699, fol. 83v (Stornajolo, *Topog. crist.*, pl. 48).

245. Acts 9:4: καὶ πεσὼν ἐπὶ τὴν γῆν ἤκουσε φωνὴν λέγουσαν αὐτῷ, Σαούλ, Σαούλ, τί με διώκεις;

246. Fol. 128v (Weitzmann, *Roll and Codex*, p. 187, fig. 192).

Paul's prostration alludes in part to his acceptance of the divine will.[247] But we must also see his position as a reflex of his overwhelming experience. He has, in pagan terms, been thunderstruck. If Byzantine artists did not seek to represent the ring of heavenly light that surrounded the astounded apostle, they were aware of the text that has him immediately address the voice as "kyrie." And in the same way that he has not fallen of his own volition, his resurrection is not purely the result of his own muscular ability. In both the Sinai and the Vatican miniatures the narrative sequence closes with Paul's dependence upon Ananias. The Lord's "vessel" has been chosen but almost shattered in the process. It would be obtuse to deny a similar sense to an earlier miniature in the Vatican Cosmas illustrating the Reception of the Law on Sinai (Fig. 77).[248] The text of Exodus XIX, which presumably inspired the illustrator of this picture's prototype, makes no mention of prostration. Yet as the derived image before us indicates, Moses makes proskynesis on Sinai, his hands covered and his head raised to hear the Covenant of the Lord. Although the page is badly flaked, enough survives to recognize the artist's distinction between the erect Moses looking back at the Israelites in the upper miniature and the prone leader below, cut off by a cloudy arc from the people denied access to the mountain. Moses' prostration is neither ordained by God nor required by Scripture. It is the attitude of a man singled out to bear witness to the fire and smoke and quakings of Sinai filled with the presence of the Lord.

The analogous New Testament image that immediately springs to mind is that of the apostles at the Transfiguration—who, at least in the first Gospel as explicated by St. John Chrysostom, fall on their faces in fear of the voice out of the cloud.[249] The awful light of Tabor and its impact on Peter, James, and John is so integral and well known a part of Orthodox iconography, from the great sixth-century apse mosaic at Sinai[250] to the Paris Homilies of John Cantacuzenus,[251] that it needs no comment here. We have a detailed account by Nicholas Mesarites of the apostles' *bouleversement* represented at the Church of the Holy Apostles;[252] and the elaboration of the theme in the millennium after this mosaic was perspicuously elucidated by Millet.[253] Other, quieter images of divine revelation have been less well understood.

In contrast to the Transfiguration, Middle Byzantine images of Christ appearing to the Women at the Tomb suggest at first a less clamorous theophany. Both canonical types of composition are available to us in ninth-century manuscripts. In the psalter Pantocrator 61, the two Marys are shown in abject prostration, the further figure slightly more advanced so that she may clasp Christ's bare foot (Fig. 78).[254] The risen

247. H. Buchthal, "Some Representations from the Life of St. Paul in Byzantine and Carolingian Art," *Tortulae*, pp. 43–48.

248. Fol. 45r (Stornajolo, *Topog. crist.*, pl. 12).

249. Matthew 17:1–8. Cf. Chrysostom, *Homiliae in Matthaeum*, 56,4 (=*P.G.*, 58, col. 454).

250. G.H. Forsyth-K. Weitzmann, *The Monastery of Saint Catherine at Mount Sinai* (Ann Arbor, Mich., 1973), pls. CIII–CXIV.

251. Cod. gr. 1242, fol. 92v (Rice, *Art of Byzantium*, pl. XXXIX [color]).

252. Downey, "Mesarites," pp. 902–903.

253. Millet, *Recherches*, pp. 216–231. See also K. Weitzmann, "A Metamorphosis Icon or Miniature on Mt. Sinai," *Starinar*, n.s. XX, 1969, pp. 415–421.

254. Fol. 109r (Dufrenne, *Psautiers grecs*, p. 30, pl. 16).

Lord forms a perpendicular to their horizontal abasement, parallel to and seemingly more stable than the tall, narrow *aedicula* representing the tomb. Christ's upright stance is opposed not only to the pose of the Women but also to the oblique and lightly sketched figures of the sleeping soldiers. The unwatchful guards have no place in the *Chairete* of the Paris Gregory (Fig. 79),[255] where the page-wide register used by the artist enables him to separate the conjoined women of the marginal illustration. The Marys are here set heraldically on either side of the frontal Christ, who again, despite his salutation, gazes beyond them. This symmetrical composition, which would appear to be a post-Iconoclastic invention,[256] results in a more steadfast principal figure. Anchored, as it were, in the proskynesis of the two Marys, Christ yet seems to rise between the flowering bushes on either side of him to the point where his head breaks the ornamental border of the miniature. Grounded in this way, yet towering above the different prostrations of the Women, this image of Christ works as a demonstration of the fact of his physical resurrection.

This new substantiality serves also as a better illustration not of Matthew 28:9, which speaks only of the Marys' hold upon his feet and their worship of him, but of the passage in the psalter customarily illustrated by the *Chairete*. Here the Septuagint text compares the rising of the Lord to a mighty man shouting "by reason of wine."[257] This epic image is carried even further by Nicholas Mesarites in his *ekphrasis* of the picture in the Holy Apostles at Constantinople. To the early-thirteenth-century observer the risen Christ appeared "heroic," an adjective as appropriate to the Lord's probably larger-than-life stature in the mosaic as to the combination in him of both divine and human characteristics.[258] By Mesarites' time yet another version of the scene had been invented: in Paris, gr. 74, for example, the Lord appears in profile and greets the Women similarly disposed but falling down before him.[259] Silhouetted against the blank ground of the page, the image loses the monumental quality of its counterpart in the Paris Gregory. And it is this characteristic that surely accounts for the preservation of this ninth-century type in later Byzantine wall painting.[260]

The naturalistic realization of sacred figures and metaphysical concepts is among the supreme achievements of the Macedonian "Renaissance." The concept of such an artistic movement depends on the evidence of ivories and manuscripts, in one of which—the Joshua Roll—we have already found several forms of proskynesis expressing various types of supplication.[261] On the fourth of the sheets into which the rotulus is now

255. B.N. MS gr. 510, fol. 30v (Omont, *Miniatures*, pl. XXI).

256. Weitzmann, "Various Aspects of Byzantine Influence on the Latin Countries from the Sixth to the Twelfth Century," *D.O.P.* XX, 1966, pp. 13–14.

257. Psalm 87 [88]:65.

258. Downey, "Mesarites," p. 910. Cf. Downey's commentary on this passage, p. 884, note 4.

259. Fol. 61r (*Evangiles avec peintures byzantines du XIe siècle* I [Paris, 1908], pl. 54).

260. E.g., at St. Nicholas Orphanos, Thessaloniki (Xyngopoulos, Τοιχογραφίες, figs. 59–60, 164–165 [color]), where the diagonal axes of Christ's arms are continued by the inclined backs of the Myrrophoroi in proskynesis. The symmetrical, ninth-century type survives in early Palaeologan manuscripts such as Athos, Iviron cod. 5 (H. Brockhaus, *Die Kunst in den Athos-Klöstern* [Leipzig, 1891], pl. 23).

261. See pp. 65, 67, above.

divided, there occurs a manner of abasement different from the quick prostration of the Gibeonite ambassadors[262] and the imploring genuflection made by Joshua after the defeat by the men of Ai.[263] The Israelite leader drops into a profound proskynesis before the angelic *archistrategos* (Fig. 80).[264] It is important to note that the Roll (and other manuscripts in the same tradition) follows the biblical text in having Joshua greet the archangel and learn his identity *before* he prostrates himself. The gesture of abasement is made only after he discovers the divine source of the messenger's provenance. The classical contrapposto and idealized facial type, the ample span of St. Michael's[265] wings, and the space that he sculpturally displaces do more than affirm the hellenistic source of this figure. They convey to Joshua—and to the spectator—the physical embodiment of a celestial force. The Hebrew general's prostration is at once an acknowledgment of the words of the "captain of the host of the Lord" and his real presence. Joshua's gesture depends upon the conviction that divine authority is incarnate before him.

The illustrations of this scene in later manuscripts deprive both the archangel and Joshua of much of their corporeal substantiality (Fig. 99). St. Michael's statuesque three-quarter stance is replaced by figures drawn almost entirely frontally, while the Israelite leader's extended prostration tends to be squeezed into an inelegant and improbable huddle.[266] The resulting diversity of attitudes indicates, of course, that no precise position was required in the representation of Joshua's proskynesis in this instance nor, probably, in that of prostration before an angel in any situation. It also demonstrates the precarious hold that even derivative naturalism had upon Middle Byzantine art.

Following some Late Antique model, Joshua gazes directly at the archangel both while he is standing and after he has prostrated himself. No such boldness characterizes Abraham's encounter with the three angels in the mosaics of the Capella Palatina[267] and Monreale (Fig. 48).[268] The Septuagint text is no less explicit concerning Abraham's proskynesis[269] than it is about Joshua's meeting with St. Michael. Yet at Monreale the patriarch scarcely dares look at the foot that he clutches, while at the Palatina his hands do not touch the angel at all. Despite the major divergences that have been recognized between these two Norman programs,[270] Abraham's pose is remarkably similar in these versions of the *philoxenia*. In each he is a hunched rather than an ex-

262. Weitzmann, *Roll and Codex*, fig. 171.

263. Weitzmann, *Joshua Roll*, fig. 37.

264. Vat. Palat. gr. 431, sheet IV (ibid., p. 14, fig. 13), illustrating Joshua 5:14: καὶ Ἰησοῦς ἔπεσεν ἐπὶ πρόσωπον ἐπὶ τὴν γῆν, καὶ εἶπεν αὐτῷ, Δέσροτα, τι προστάσσεις τῷ σῷ οἰκέτη;

265. An identification based upon the inscription of a newly uncovered wall painting at Hosios Loukas, for which see A.K. Orlandos, Β.᾽ Ἀναστήλωσις καὶ συντήρησις μνημείων, (Πρακτικά, 1964), pp. 184–185, pl. 174.

266. Vat. gr. 1613, fol. 2r.

267. Demus, *Norman Sicily*, p. 45, pl. 33.

268. Cf. note 47 above.

269. Gen. 18:2.

270. Cf. Demus, *Norman Sicily*, pp. 263–264 and passim.

tended figure, an attitude in part the result of his compression within the spandrel of an arcade. In each his right knee is advanced and his bare hands project beyond the full sleeves of a mantle that falls in agitated, decorative folds. Finally, at both Monreale and the Palatina, there is absent that sense of a *grounded* figure that contributes so much to the impression of Joshua's energetic prostration. Abraham's body hovers above rather than rests on the rough land in which the Oak of Mamre grows, a terrain almost as convoluted as the drapery and movements of the figures in the scene.

Of course, neither the state of mind nor the physical attitude of those who recognize the presence of the numinous is likely to be affected by the condition of the ground. Whereas a figure's abasement, as in the case of the Magdalen anointing Christ's feet (Fig. 49), may convey to the spectator the notion of a proper humility, to the actor in the scene the physical circumstances must surely be understood as irrelevant. In the Magdalen's case, the floor of Simon's house means only proximity to the Lord's feet and a place to rest her unguent bottle. Where the divine is sensed but not seen, both the land and his posture on it are of even less consequence to the worshiper. Thus the Constantinopolitan illustrator of a late-eleventh-century lectionary in New York could show St. John in proskynesis in a barren terrain as an act of witness to God's invisible presence.[271] Faced with the iconodule's problem of representing the uncircumscribable, the artist delineates the Lord as a hand emerging from an arc in the upper right corner of the miniature. This is a concession to the user of the book, and unnecessary to the kneeling saint, whose own hands are raised as an indication that he recognizes the divine rather than that he perceives the *manus dei*. To assert otherwise would be to subvert the meaning of the text here illustrated. Sometimes the objectification of God is attempted in Scripture itself by ascribing to him material attributes. Thus the Psalmist bids Israel worship at the footstool of the Lord, an injunction interpreted literally in Vat. gr. 1927.[272] Between two groups of standing figures who call upon God—a bustate figure flanked by cherubim—Moses and Aaron make a kneeling proskynesis before the unadorned *hypopodion*. Far from abject, their attitudes mark the base of a pyramid of worship ascending to its apex in the figure of Christ.

Within this triangle of glorification two apparently wingless angels bend their knees but otherwise do not abase themselves before the Lord. Images of angelic proskynesis are less common in Byzantine art than might be supposed of a society whose angelological traditions and functional definitions of the various *asomatoi* were firmly grounded in the work of the Pseudo-Dionysus[273] and rehearsed in every liturgy.[274] Demus has recognized as a "standing proskynesis" the odd pose of the archangels in

271. Pierpont Morgan Library M. 639, fol. 2V (Weitzmann, "Constantinopolitan Lectionary," pp. 362–365, fig. 293).

272. Fol. 179v (DeWald, *Vat. gr. 1927*, p. 29, pl. XLII), illustrating Psalm 98 [99].

273. The best survey of this development remains J. Turmel, "L'Angélologie depuis le faux Denys l'Aréopagite," *Rev. hist. lit.* IV, 1899, pp. 217–238, 289–309, 414–434, 537–562.

274. The influence upon liturgical texts of successive interpretations of the rôle of angels is lucidly discussed by R. Bornert (*Les Commentaires byzantins de la divine liturgie du VII^e siècle* [Paris, 1966], passim, and esp. pp. 103, 163, 171, 176–177).

the cupola of the Martorana at Palermo,[275] figures that would march in adoration around the Pantocrator in the central medallion were it not for the roundel about him, which depresses their backs and flattens their wings. Less anomalous and much more impressive are the recently cleaned choirs of angels in a similar location at Hagia Sophia, Trebizond (Fig. 81).[276] Gabriel and Michael, opposed to each other and prostrate with bowed heads, lead successive waves of celestial beings in adoration of the Pantocrator at once above them and in their midst. The serried ranks of angels exhibit every mode of proskynesis from genuflection with raised head to almost total prostration. Some even look backward to survey the multitudes behind them, like the riders on the Parthenon frieze whose turned heads instill a sense of both interval and unity into that paradigmatic, processional liturgy. The variety here illustrates more than the absence of any one canonical attitude assigned to the praising throngs of heaven. More important, their multifarious positions, costumes, and coloration serve to fill the drum with the angelic host in all its clamorous diversity. Confined within the penultimate zone of the church's elevation, they yet seem united only by their common function, the paean implicit in the inscription *ΚΑΙ ΠΡΟCΚΥΝΙCΑΤΩΝ ΑΥΤΟΝ ΠΑΝΤΗC.*

In the bema of the same church the attitude of proskynesis is used again but in a context where it is not simply unusual but unique (Fig. 82).[277] The representation of the Mission to the Apostles traditionally included some form of acknowledgment of the Lord's will even if it were only a slight bow on the part of the standing apostles.[278] But at Trebizond the four surviving witnesses to the theophany bend to the point where their backs are parallel to the ground. The lower part of the painting is lost, but from the proportions of the other figures it would seem that at least one apostle—to the far left of our picture—was rendered prostrate on hands and knees, as opposed to the low bow made by the disciples closest to Christ. His form of abasement probably also characterized the attitude of the remaining apostles lower on the picture plane. Be this as it may, the painter of this version of the Mission has interpreted as a physical description the act of worship imputed to the apostles in the New Testament Greek: *καὶ ἰδόντες αὐτὸν προσεκύνησαν.*[279]

But what model, if any, did the painter use? Very few known representations of this scene employ a frontal Christ, his arms outstretched in blessing parallel to the prostrate

275. Demus, *Norman Sicily*, p. 79, pl. 46.

276. Rice, *Trebizond*, pp. 112, 180, color pl. III, pls. 40–41.

277. Ibid., pp. 126–127, pl. 48B, fig. 90. Rice (pp. 172–177) suggests many analogies in several different iconographic traditions, of which only one—the mid-thirteenth-century "model book" in Wolfenbüttel—includes a figure (St. Peter, fol. 78v) in a comparable proskynesis. For this manuscript, see K. Weitzmann, "Zur byzantinischen Quelle des Wolfenbüttler Musterbuch," *Festschrift H.R. Hahnloser* (Basel, 1961), pp. 223–250.

278. A bow of this type made by St. Peter in the *Dominus legem dat* mosaic at S. Costanza, Rome, led L'Orange (*Cosmic Kingship*, p. 168) to see the apostle's pose as "determined by the *προσκύνησις* as the ceremony demanded of one who stood before the emperor." The antique sources and Christian significance of this mosaic have been discussed by W.N. Schumacher (*R.Q.* XLIV, 1959, pp. 1–39).

279. Matthew 28:17.

and heraldically disposed forms below him.[280] This composition is, however, familiar in another act of the Resurrection drama and one that would be the neighbor of the Mission in any pictorial cycle illustrating the Gospel of Matthew.[281] The *Chairete* does not occur at Trebizond, but in most post-Iconoclastic representations (cf. Fig. 79) the appearance of Christ to the Myrrophoroi is organized in a manner strikingly close to the symmetrical arrangement of our scene. We have here an Appearance to the Apostles on the Mount of Galilee based upon the customary representation of the earlier theophany. Only the intrusive angels, which properly belong to the Ascension, suggest that the source of the Mission at Trebizond was not simply a direct appropriation from some version of the *Chairete*.[282]

No such conflation appears in the proskynesis scenes in the *parekklesion* of the Kariye Camii, the best preserved program of Palaeologan wall painting in the capital. The entire eastern vault of the chapel is given over to the Second Coming, a scheme in which Christ is surrounded by wheeling hierarchies and groups of figures, praising, interceding, or supplicating the Lord.[283] Attendant upon the Judgment, they have come to hear the will of God; their presence and their physical attitudes bespeak acknowledgment of his glory. The hub of the composition is the Son, flanked by Mary and the Prodromos and backed by his angels. Their concave group splays into two files of single figures, one assigned to each of the enthroned apostles. The *synthronon* of the chosen twelve forms the main north-south axis of the vault. In this massed assembly, figures either sit or stand, following the traditional scheme for representations of the Last Judgment. But from this stable base, more loosely organized and more rarely found choirs of worshipers[284] fan out toward the perimeter of the composition. The elect, disposed on clouds, are no less densely packed than the axial figures, but within each unit there is a much greater variety of posture. Some stand; others genuflect; still others kneel but incline their bodies sharply toward the Judge.

This last pose characterizes the leader of the prophets, the senior group in these adoring heavens (Fig. 83).[285] Partly obscuring the royal prophets, David and Solomon, he is poised on one knee totally absorbed in his attention to Christ. His oblique form

280. Cf. primarily a scene on the west wall of the presbytery at S. Maria Antiqua, interpreted by P.J. Nordhagen (*The Frescoes of John VII in S. Maria Antiqua in Rome* [=*Acta Norv.* III, Rome, 1968, pp. 35–38, pl. XXXVI]) as the Appearance of Christ to the Eleven Apostles (John 20:19–20). Since the upper portion of this painting is destroyed it is not possible to know if Christ's arms were outstretched to the apostles, who kneel on either side with curved backs and hands outstretched in adoration. Nordhagen's discussion of the relationship of this scene to illustrations of the Mission and of the Blessing of the Apostles (Luke 24:5off.) would appear to be uniquely useful.

281. Cf. Millet, *Recherches*, pp. 53–56.

282. In his discussion of the problems raised by this image of the Mission, Rice (*Trebizond*, p. 176) points to the historical conflation of this scene with other events in the Resurrection cycle. He sees only the "background of trees" as borrowed from the *Chairete*.

283. Underwood, *Kariye Djami* I, pp. 192–206; III, pls. 336, 368–391.

284. Individual assemblies of the "nations" (categories of mankind) are to be found primarily in sixteenth-century programs on Mount Athos, notably in the refectories of the Lavra and Dionysiou and in the *katholikon* at Dochiariou (Millet, *Athos*, pls. 142, 1 and 2; 210, 2; 248).

285. Underwood, *Kariye Djami* II, pl. 384b.

stretches from his open, uncovered hands to his right foot trailing behind him. Rehearsed in the figures behind him, the prophet's form scarcely seems to rest even on the nebulous setting assigned him here. Rather, like his fellows, his attitude is one of urgent striving, the most active proskynesis in this universe of worship. The other choirs, of apostles, martyrs, holy men and women, and bishops, are less actively posed. But, again, their diversity of position and the disposition of their clouds—as arcs subtended from the center of the vault—propounds a cosmic movement about a timeless center.

There is no uniformity about the figures in this dome of Heaven. The variety of attitudes, which Underwood noted in the apostles on either side of Christ,[286] pervades also the Elect, gathered from the four corners of the earth and set within the apparent confines of their clouds. Thus, while the leader of the prophets arches his neck, gazing intensely at the Lord, those behind him hold their heads quite differently. Hands, held alike, emerge in varying degrees from the mantles that envelop the prophets. And folds of drapery stretched or gathered about their arms, legs, and backs suggest a multiplicity of lesser, concealed motions. The unity of the composition derives in part from its planned axes: the north-south wedge of apostles and angels, the east-west sequence of Hetoimasia, enthroned Christ, and Scroll of Heaven. But, more expressly, coherence comes from its thematic unity and the subtle variation of significant attitudes.

One such pose particularly concerns this discussion. Suspended between the praising prophets and the Lake of Fire—between Heaven and Hell—Adam and Eve prostrate themselves before the Prepared Throne.[287] Related by their common concern and their draped hands, their postures are quite different yet each entirely within the range of proskynesis as we have seen it employed in images of prayer and entreaty. Eve is a huddled shape, her head raised and her legs drawn up tightly beneath her body. Adam, on the other hand, is a more diffuse figure, his left knee touching the "ground," his right leg extended till it reaches the mantle of the leading prophet. His attitude follows that of the adoring choir behind him. Just as its members kneel in ever more inclined positions, so Adam completes the series, his proclivity verging on prostration. Where in Middle Byzantine art the protoplasts appeared beside the throne, a distinction was customarily made between their attitudes. Adam, generally, was shown less erect than his partner.[288] But no monumental representations showed either figure so abased as they are at the Kariye.[289] Here, distinct from each other while engaged in the same act, they are both bent lower than any figure around them. While the choirs adore, Adam and Eve prostrate themselves beside the Hetoimasia. As the human protagonists

286. Ibid., I, pp. 202–203.

287. Ibid., I, pp. 204–205; III, pl. 386.

288. A notable exception is the narthex fresco at the Panagia Mavriotissa (Brenk, *Tradition und Neuerung*, p. 99, fig. 29), where the upper half of Eve's body is raised above the ground but less so than in Adam's inclined genuflection. This wall painting is also anomalous in that Eve's hands are covered while Adam's are not.

289. Furthermore, icons of this period, such as two illustrating the Last Judgment published by Sotiriou (*Εἰκόνες* I, pp. 128–131; II, pls. 150, 151), customarily show both protoplasts to the right of the Hetoimasia, Eve making an inclined genuflection and Adam prostrate before her.

they cower at Christ's feet; as representatives of mankind they entreat mercy for the race.

The place of the Kariye *parekklesion* as one of the supreme monuments of Byzantine wall painting is not determined by aesthetic considerations alone. The nobility of its figures and the excellence of the draftsmanship are only aspects of the achievement. The painters' command of space, their control and integration of iconography are of equal importance. Above all, the rank of the Kariye is due to the minds that planned its program, the intelligence that, for instance, connected the worshiping throngs about Christ with the attitudes of the suppliant pair before him. Moving down the single aisle of this chapel, the spectator perceives successive versions of proskynesis. Below the Judging Christ the protoplasts beseech his mercy. About him the elders of mankind kneel in adoration. And beyond this vault, flanked by other images of deliverance, the scene is rehearsed one last time. In the Anastasis on the bema wall—the evident climax of the entire scheme—Christ, in the archetypal act of salvation, raises Adam and Eve from their proskynesis (Fig. 84).[290]

Prostration and Resurrection

The understanding that the image of the Anastasis in Middle and Late Byzantine art signified more than merely the Descent into Limbo is not new to students of the subject. A generation ago Xyngopoulos suggested that an uncommon type of this scene, showing Christ standing on a hillock and exhibiting his stigmata to those waiting to be saved, was an attempt to suggest the concept of resurrection and redemption.[291] This type is found first in an eleventh-century lectionary in the Iviron monastery on Mount Athos[292] and, in the following century, in a Gregory manuscript in Paris.[293] For Xyngopoulos the dogmatic intention of the composition was expressed not only in its use of a rare version of the Anastasis but also through the panoply of figures surrounding the main scene in the Paris codex. The archangels, the disciples, the three Marys, and other attendant figures created, in sum, a monumental composition deriving from the Easter Sunday hymns contained in the *Pentekostarion*.

Xyngopoulos' interpretation was confined to images that, in his view, revealed this "hymnologic" origin. With no such limitation, the present writer suggested in 1965 that the attitudes assumed by Adam and Eve in representations of the Anastasis must

290. Underwood, *Kariye Djami* I, pp. 192–195; II, pls. 336, 340–351.

291. Xyngopoulos, Ὑμνολογικὸς τύπος.

292. Iviron cod. I, fol. IV (A. Xyngopoulos, Ἱστορήμενα Εὐαγγέλια τῆς Μονῆς Ἰβήρων Ἁγίου Ὄρους, [Athens, 1932], pl. I). Lazarev (*Storia*, p. 252, note 51) would assign this manuscript a twelfth-century date.

293. B.N. gr. 550, fol. 5r (Galavaris, *Liturgical Homilies*, pp. 73–77, fig. 401); here, too, a critique of Xyngopoulos' hypothesis concerning the "hymnologic" origin of this type. For the essential bibliography on the iconography of the Anastasis, see ibid., p. 70, note 128, to which must be added E. Lucchesi Palli, s.v. "Anastasis" in *Reallexikon zur byzantinischen Kunst* I (1963), cols. 142–148.

be understood as modes of proskynesis.[294] This opinion derived from consideration of the protoplasts' physical positions—rather than hypothetical textual sources—and the comparison of these attitudes with many of the forms and uses of proskynesis that we have considered. Although made in passing, and in a specifically numismatic context, it was submitted as having general application. Finally and more expansively, Grabar proposed that the genuflecting Adam and Eve beside the Hetoimasia in two Middle Byzantine icons of the Last Judgment[295] must be considered as supplicants exactly as in archaic representations of the Anastasis; indeed, such as image must be considered the source for their attitudes in these icons.[296]

These interpretations do more than connect two previously unrelated aspects of Byzantine iconography. In addition they require a broader interpretation of proskynesis as a description of a bodily attitude. Traditionally the term has been used by art historians only to designate positions akin to that assumed by the emperor in the lunette mosaic at Hagia Sophia (Fig. 2) or similar forms of prostration. Circumscribed in this way, the term would be inapplicable to numerous ceremonies said by Constantine Porphyrogenitus and later writers to have included proskynesis. Since, as we have seen, it is impossible to define precisely the attitude implied by the term in many such verbal descriptions of ritual, the limitation may in these instances be accepted. But, more important, the restricted use denies to a large number of images of entreaty, oblation, veneration, and so forth, the possibility of consideration in a light necessary to their comprehension. It is surely no accident that there is no specific, canonical pose for each of the modes of behavior that we have discussed above; that an attitude assumed, say, by a donor, is found equally in representations of prayer or salutation. In short, these pious positions belong to a complex "thought world" whose topography includes many interconnections invisible to the philologist, who insists that in the Christian Era proskynesis means only worship, or to the art historian, who uses the term exclusively as a synonym for abject prostration.

In his study of the "hymnologic" Anastasis type, Xyngopoulos pointed to one, almost self-evident, connection that had hitherto been neglected. He showed that the miniatures in such manuscripts as Vat. gr. 1231, illustrating the resurrection of Job, were derived from representations of the Anastasis.[297] The motif is justified by the beginning of the epilogue to the book, which reports this event.[298] Job is shown standing in a sarcophagus to Christ's right like Adam in many Late Byzantine images of the Descent into Limbo. He is, however, erect, and a pendant not to Eve but to David and another prophet on the far side of the Saviour. Albeit a standing figure, Job is obviously

294. Cutler, "Two Aspirants to Romania," p. 302.

295. Cf. note 289 above.

296. Review of E. Guldan, *Eva und Maria, eine Antithese als Bildmotiv, Cah. arch.* XVIII, 1968, p. 250. C. Walter ("Papal Political Imagery in the Lateran Palace, *Cah. arch.* XXI, 1971, pp. 114–115) has briefly developed Grabar's idea of the relationship between proskynesis and Anastasis.

297. Xyngopoulos, Ὑμνολογικὸς τύπος, pp. 125–127, figs. 6, 7 (line drawings).

298. Job 42:17a: Γέγραπται δὲ, αὐτὸν πάλιν ἀναστήσεσθαι μεθ'ὧν ὁ Κύριος ἀνίστησιν. Incorporated in the Septuagint version, this and the succeeding verses are excluded from most Roman and Protestant bibles.

still a supplicant. This hypothesis, in some respects misguided,[299] represents nonetheless a welcome reconsideration of the miniatures in the light of the text they were intended to illustrate. Although the concern of the Byzantinist may often be focused upon the discrepancy between the verbal and the visual form, a consideration of the literary foundations—even if they are not the immediate "sources"—can often illuminate an area too complex to be dealt with purely in terms of iconographical or stylistic innovation. Perhaps nowhere is this more true than in the study of the Anastasis.

Much earlier in the Book of Job the idea of bent knees is announced as connoting weakness and as an emblem of sin or death.[300] The words are addressed to Job by Eliphaz, and later a second comforter recalls to him God's promise to deliver his soul from the pit.[301] The saving power of the *numen tremendum* is further emphasized in the psalter, the source of many of the motifs that recur in the Gospel of Nicodemus,[302] and long since recognized as the basis of Anastasis iconography. Thus the advent of the King of Glory—the climactic event of this apocryphal Gospel—is proclaimed in the Twenty-third Psalm of the Septuagint text.[303] The Psalmist's account of the Lord's breaking of the gates of Hell and rescue of those "as sit in darkness and in the shadow of death"[304] further provided a canonical basis for the apocryphal if rousing events described in the Nicodemus text.

The promise of the *kathodos* is not directly fulfilled either in the Synoptic Gospels or in John. But David's hope of resurrection from Hell is related in a sermon of St. Peter[305] and, in his Epistle, the apostle alludes to Christ's preaching to the spirits in prison after the Crucifixion.[306] Again, the descent to the "lower parts of the earth" is referred to less specifically in Paul's letter to the Ephesians.[307] And, finally, the Epistle to the Philippians provided an essential constituent of the iconography: Paul enjoins that things under the earth, like those upon it and in Heaven, should bow their knee at the name of Jesus.[308] These diverse scriptural allusions to human salvation, concomitant with and contingent upon the Resurrection of Christ, provided the Fathers with a wealth of material susceptible to commentary, a body of exegesis that, for our purposes,

299. Cf. note 293 above.

300. Job, 3:4–5.

301. Job, 33:30.

302. C. de Tischendorff (*Evangelia apocrypha* [Leipzig, 1876], pp. 389–432—the usual reference cited) prints the two Latin versions of this Gospel. M.R. James (*The Apocryphal New Testament* [Oxford, 1924], pp. 117–146) translates both the Latin and one Greek text as part of the "Acts of Pilate." The relations between these recensions are discussed by Kroll (*Gott und Hölle*, p. 84).

303. Psalm 23 [24]:7–10. For C.R. Morey (*East Christian Paintings in the Freer Collection* [New York, 1944], p. 48, note 2), this source sufficed to explain "the prominence of David in the artistic representations" of the Anastasis. E. Baldwin Smith (*Architectural Symbolism of Imperial Rome and the Middle Ages* [Princeton, 1951], pp. 18–19) related this text to Hebrew new year festivals and then to Hellenistic epiphanies and Roman *adventus* ceremonies.

304. Psalm 106 [107]:10–16.

305. Acts 2:25–31.

306. 1 Peter 3:18–19.

307. Ephesians 4:9.

308. Philippians 2:10.

culminated in St. Ephraim's recognition of Adam as the representative of humanity.[309]

It has been claimed that Patristic explications of the Descent into Limbo had a detectable influence upon the Orthodox liturgy.[310] It must, however, be noticed that the earliest liturgies do not contain the celebrated reference to the Anastasis made in the Middle Byzantine period during the Little Entrance in the Liturgy of the Catechumens. Thereafter, however, the choir sang the command to make proskynesis before the Lord who rose from the dead.[311] This now familiar element is only the most salient of many connections made between prostration and Resurrection in the Liturgy of St. John Chrysostom. More frequently, the visual impact of the offices of Holy Week have been stressed.[312] Whether these ritual reenactments of the Anastasis can be considered liturgical drama remains doubtful, but their dependence on Patristic homilies on the Resurrection and their survival to the last days of the empire seems beyond question.[313]

Neither Pseudo-Codinus in the fourteenth century nor Constantine Porphyrogenitus, who mentions such ceremonies four hundred years earlier,[314] describes the attitudes assumed by the participants in these *mystagogia*. Despite this silence, it is clear that the ambiguous implications of proskynesis made on Easter Sunday, and indeed on the first day of the week throughout the year, were not lost on the Macedonian court. The *de Cerimoniis* specifies that on these occasions the emperor be revered with a deep bow rather than with the customary abasement.[315] This understanding is reflected in, and perhaps reinforced by, the new importance attached to representations of the Anastasis in post-Iconoclastic art and particularly in the sumptuous lectionaries of the Middle Byzantine period. While the image of the Descent into Limbo perhaps originated in an early cycle of illustrations to the Nicodemus Gospel, at least as early as the mid-ninth century it was understood as a full member of the cycle of Gospel illustrations, and in one case as part of a series of Christological representations antedating even the composition of the Gospels.[316] Possibly shortly after the restoration of Orthodoxy,[317] we find the Anastasis detached from this context in splendid isolation at the beginning of the Gospel lectionary. Attached to the Easter

309. *Carmina Nisibena*, ed. G. Bickell (Leipzig, 1866), LIV, LV. The extensive body of Patristic references is assembled by Villette (*Résurrection*, pp. 94–97).

310. Kroll, *Gott und Hölle*, p. 123.

311. Δεῦτε προσκυνήσομεν καὶ προσπέσομεν Χριστῷ, Σῶσον ἡμᾶς, Υἱὲ Θεοῦ, ὁ ἀναστὸς ἐκ νεκρῶν Φάλλοντας σοι. Ἀλληλούια.

312. G. La Piana, *Le rappresentazioni sacre nella letteratura bizantina* (Grottaferrata, 1912), p. 96; V. Cottas, *Le Théâtre à Byzance* (Paris, 1931), pp. 132, 141–143. For the office of the Anastasis in monastic and ecclesiastical *typika*, see Dmitrievski, *Opisanie* I, pp. 557, 830.

313. Cf. Verpeaux, *de Offic.*, pp. 232–235.

314. *De Cer.* I, 33; II, 52, *C.S.H.B.* I, pp. 177, 763–765.

315. Ibid., I, 9, I, 29, pp. 29, 162. Cf. II, 16, p. 599.

316. This extraordinary opinion is set out in an iconodule petition said to have been addressed to the emperor Theophilus by a council held at Jerusalem in 836. For the text, see L. Duchesne, *Roma e l'Oriente* V (1912–1913), pp. 273ff.

317. Weitzmann ("Constantinopolitan Lectionary," p. 370) suggests a date before the reign of Leo VI (886–912). For the development of Weitzmann's ideas in this regard, see his two articles in *Rev. ét. sud-est eur.* VII, 1969, pp. 339ff., and IX, 1971, pp. 617ff.

pericope taken from the Gospel of John, the scene assumes the quality of a monumental feast picture: the miniature in Leningrad cod. 21, with its urgent Christ, anxious protoplasts, and shackled Hades,[318] provided the Church at last with a full and fitting image of the ancient *troparion* celebrating the trampling of death and the resurrection of those in the tomb.[319]

The idea of a genuflecting Adam, with Eve set as a taller figure behind him, was not an invention of the tenth century. It is found on eighth-century reliquaries in the "Syro-Palestinian" tradition[320] and in psalters and other manuscripts of the time of Photius.[321] But the comparison with a late-ninth-century Gospel book immediately suggests the effects of transposing the scene from a traditional situation to its new and preeminent rôle in the lectionary. In Venice, Marciana cod. gr. I.8, the Anastasis is confined to a lunette above the head of St. John, who dictates the Gospel to his scribe Prochoros.[322] In the Leningrad manuscript, however, this "historical" basis has disappeared and the entrance of the King of Glory usurps the entire page.

The Venice Gospel book exemplifies the occasional "rationalization" of Adam's bent knee: here it serves to give him purchase on the edge of the sarcophagus. In the lectionaries this physiological contribution to the metaphysical act of salvation is frequently dispensed with, although in their representations of the deed there is no more consistency in the matter of Adam's pose than there is in that of the emperor abased before Christ on the coins with which this investigation began (Figs. 41–43). Sometimes the protoplast's right knee is bent, sometimes his left. The trunk of his body may be erect or inclined toward Christ. Like Eve and others who died outside of Grace, he is confined to Limbo and freed by the Lord who descends. The very fact of his plight and the nature of his representative plea are sufficient to justify his attitude.[323]

This is equally true of the most energetic type of the Anastasis scene represented by the lectionary in the *skevophylakion* at the Great Lavra (Fig. 85).[324] Within a richly ornate border, the scene is played out with remarkable economy. Flanked by three figures on either side, Christ balances on the shattered gates of Hell, towering over both those imprisoned and the rocks behind them. His complex pose and flying drapery

318. Fol. 1v (C.R. Morey, "Notes on East Christian Miniatures," *Art Bull.* XI, 1929, pp. 57–58, fig. 63).

319. Χριστὸς ἀνέστη ἐκ νεκρῶν θανάτῳ θάνατον πατήσας καὶ ἐν τοῖς μνήμασι ζωὴν χαρισάμενος.

320. E. Lucchesi Palli, "Der syrisch-palästinensische Darstellungstypus der Höllenfahrt Christi," *R.Q.* LVII, 1962, pp. 252–253, pl. 18a,b.

321. E.g., Pantocrator 61, fol. 83r (Dufrenne, *Psautiers grecs*, pp. 26–27, pl. 10).

322. Fol. 297v (Athens Catalogue, no. 305).

323. Of course there persisted in post-Iconoclastic art the Anastasis with Christ saving a *standing* Adam in an almost infinite variety of poses, although one of his knees is customarily slightly bent. Cf. such diverse works as the Khludov Psalter (E.O. Kostetskaiâ, "K Ikonografii voskreseniiâ Khristova [Anastasis] po miniâturam Khludovskoi psaltiri," *Sem. Kond.* II, 1928, pp. 61–70, pl. IX,2, 3); an eleventh-century ivory in Berlin (Goldschmidt-Weitzmann, *Elfenbeinskulpturen* II, p. 77, no. 217); and one of the ciborium columns at St. Mark's, Venice (E. Lucchesi Palli, *Die Passions- und Endszenen Christi auf der Ciboriumssäule von S. Marco in Venedig* [Prague, 1942], pp. 105–107, pl. va,b).

324. Fol. 1v (Weitzmann, "Das Evangelion," pl. II,1).

are matched by those of Adam. The other figures in the scene remain simple, standing forms whose gestures do nothing to distract from the drama unfolding before them. The Anastasis in the Iviron lectionary is no less symmetrical, but there the mood is almost contemplative. The protoplasts pray to an immobile god enclosed within his mandorla. In the "Phocas" Lectionary, however, Christ seizes Adam's right arm, leaving his left to gesticulate in a manner corresponding to that of David on the other side of the *triumphator*.

The serious calm of the Lord's gaze, turned upon the spectator, belies the vigor of his grip. But his bent arm and the cross-staff he carries in this version of the Anastasis led Weitzmann to the discovery of its model in the iconography of Heracles and Cerberus.[325] Many sources have been suggested for elements of the Byzantine Anastasis. Grabar pointed to the numismatic and literary evidence for the image of the *antiquus serpens* crushed by the emperor, recognizing in this a prototype of the defeated Satan.[326] For Christ's raising of Adam, he recalled the imperial *liberator* restoring a conquered and personified province—sometimes shown in proskynesis—to her feet.[327] The apprehension of Heracles' Twelfth Labor as a model for the Descent into Limbo similarly illuminates both the significance of this motif and the nature of artistic creativity in the Macedonian era. But, at the same time, it raises questions concerning the "Renaissance" of the tenth century, which, far from being answered, have not even been asked.

Weitzmann suggested that the entire cycle of illustrations of Heraclean labors must have been available to the artists of Constantinople at this period.[328] He drew attention to the many ivory caskets and slighter number of images in other media representing aspects of the *dodekathlon* and deriving from the *Bibliothēke*, ascribed to Apollodorus of Athens, or some similar antique, mythological handbook.[329] But the corpus of Middle Byzantine ivories, in fact, includes images of all the labors except the very theme upon which the Descent into Limbo was modeled. No medieval Greek work of art, to my knowledge, illustrates the taking of Cerberus, despite the ample account of this feat in the *Bibliothēke*,[330] the source for images of the Nemean Lion, the Augean Stables, and the rest of the Heraclean canon. What can account for this singular omission? When this lacuna is considered in relation to the analogous absence from the body of mythological representation of Odysseus among the shades or that of Orpheus in the underworld, it might be assumed that such journeys *ad infernos* smacked too much of a renascent paganism. But the charge could with equal justice have been levied at the Bacchic cycle, no less popular in the minor arts of Byzantium. We are tempted to argue—listening to the *voix des monuments*—that the club-bearing hero triumphing over the forces of darkness bore too closely on Christ's Descent into Limbo to allow

325. Ibid., p. 88.
326. Grabar, *L'Empereur*, pp. 238, 247.
327. Ibid., p. 248. Cf. Villette, *Résurrection*, pp. 98–99.
328. Weitzmann, "Das Evangelion," p. 88.
329. Weitzmann, *Greek Mythology*, pp. 157–165, figs. 174–202.
330. Apollodorus II, 5, ed. Loeb, I, pp. 232–236. Cf. Diodorus Siculus, *Bibliothēke Historikē* IV, 25–26, ed. Loeb, II, pp. 422–426, a text equally available to the Byzantines.

his representation. If this is so, then it speaks for some form of Orthodox jurisdiction over the exercise of mythological art in medieval Constantinople.

What form this control took, or how effective it may have been, we have no way of knowing. It is hardly possible to identify the motive forces behind the selection of different versions of a single theme. Even the classification of types according to their varying iconographical content is insufficient as a mechanism for determining their social or ecclesiastical origin. Demus sought to contrast a "classicist and humanist" type represented by the Anastasis at Daphni, Chios, and Monreale with a "monastic" type evident in the "hieratic frontality" of the saving Christ at Hosios Loukas.[331] It is true that the Daphni mosaic[332] preserves many elements of the miniature in the Lavra manuscript (Fig. 85), which in the light of Weitzmann's researches we may regard as "hellenistic." Christ's staff, his firm hold upon Adam, and the protoplast's pose must be counted among these. But many major features separate the two works: the imploring attitude of Eve and the prominence given to the Prodromos are absent in the lectionary. Above all, the almost frontal attitude of the Saviour—whose eye engages the spectator rather than the figure he is rescuing—and the absence of Hades relate the Constantinopolitan miniature much more closely to the image at Hosios Loukas[333] than to the mosaic at Daphni.

That no such simple distinction is possible is demonstrated above all by the multifarious versions of the Anastasis in Cappadocia. These offer almost every conceivable combination of iconographic elements, both "hellenistic" and "monastic." Christ carries a cross-staff treading either upon Hades[334] or upon nothing.[335] He reaches across his body to seize Adam, whom he contemplates,[336] or stands parallel to the picture plane, almost negligently holding the wrist of the patriarch by his side while regarding the spectator.[337] Adam appears kneeling,[338] in the act of rising with knees still bent,[339] or almost completely erect.[340] If there is any general tendency to be noted in Adam's attitudes, it is that, in the course of time, he is shown in ever less abased positions. But such an evolution, in its turn, only further underlines the heterogeneous poses assigned to him in this large group of monastic wall paintings.

331. Demus, *Norman Sicily*, pp. 288, 343, note 306.

332. G. Millet, "Mosaïques de Daphni. Adoration des Mages—Anastasis," *Mon. Piot* XI, 1895, pp. 204–214, pl. XXV.

333. Lazarev, *Storia*, pp. 151–152, fig. 172.

334. Karanlik kilise (chapel 23) at Göreme (Jerphanion, *Cappadoce*, album II, pl. 102,1; Restle, *Asia Minor* II, no. XXII, fig. 238).

335. Çarikli kilise (chapel 22) at Göreme (Jerphanion, *Cappadoce*, album II, pl. 130,3; Restle, *Asia Minor* II, no. XXI, fig. 210).

336. El Nazar (chapel 1) at Göreme (Jerphanion, *Cappadoce*, album I, pl. 41,4; Restle, *Asia Minor* II, no. I, fig. 20).

337. Karabaş kilise at Soğanli (Jerphanion, *Cappadoce*, album III, pl. 199,3; Restle, *Asia Minor* III, no. XLVIII, fig. 462).

338. Restle, *Asia Minor* III, no. XLVIII, fig. 462.

339. As in example in note 335 above.

340. As in example in note 334 above.

In the monastery churches of Norman Sicily no such diversity exists, for the Anastasis is known, apart from a hypothetical picture "above the apse" in the Capella Palatina,[341] only at Monreale. Even there, the image in the north transept was largely restored at the beginning of the nineteenth century and we are now dependent upon Gravina's lithograph for our understanding of it. As restored, the mosaic shows several most un-Byzantine features, even in its iconography. Christ advances toward the protoplasts over the gates of Hell, which lie on the ground in the form of an inverted Latin cross. This feature is only slightly more improbable as an accurate rendering of the original than the attitude of Adam, who crouches before the Lord extending both hands in supplication.[342] Given so uncharacteristic a position it is hardly surprising that, at Monreale, the relationship between the patriarch's attitude and that of proskynesis has been ignored. In addition to the abased pose that is usually admitted under this head, the Sicilian mosaicists employed an oblique disposition of the body, which, in the context of supplication, must be recognized as an alternative form of proskynesis. The attitudes of the cripple rising from his crutches to beseech Christ's aid (Fig. 64) and of Peter desperately extending his arm to the Lord as he flounders in the water (Fig. 65) are analogous to that of Adam craving salvation from Limbo. These images constitute a class certainly no less diffuse than that including the Magdalen anointing Christ's feet, Adam receiving the angels of the Lord, and Lazarus' sister expressing her gratitude, all of which we have recognized as modes of proskynesis.

The propinquity in meaning of St. Peter saved from drowning and Adam raised from Limbo is no twentieth-century idea foisted upon the Greek Middle Ages. Nor was it, in Byzantium, merely a theological analogy or literary figure. For Nicholas Mesarites the two images are distinctly and precisely linked. Describing the mosaic of the Saving at the Holy Apostles, he notes that Peter, plunged into the sea, wishes to prostrate himself before the Lord but is prevented by the waves.[343] As he flails about, his right hand is seized by those of the Pantocrator, "which drew Peter up completely like another Adam out of the depths of Hades." Mesarites completes his description, as much exegesis as *ekphrasis*, by comparing this resurrection to that of Lazarus "from the tomb by the Word." The Byzantine contribution to the interpretation of the deed is evident in both the literary and the artistic elaboration. The Gospel account[344] makes no mention of Peter's attempt at prostration. Similarly, the incident as represented, for example, at Dura-Europos shows the apostle standing in the water rather than beseeching the Lord's help from its depths.[345]

341. Demus, *Norman Sicily*, p. 218.

342. Ibid., pp. 117, 162, note 294, pl. 71B. Demus notes that the figure of Christ and the group including Adam "were entirely renewed, following, however, the original design." The type of Adam genuflecting with both arms extended toward Christ is common in post-Byzantine painting. Cf. A. Xyngopoulos, Μουσεῖον Μπενάκι, ᾿Αθῆναι. Καταλόγος τῶν εἰκωνῶν (Athens, 1936), no. 25, pl. 19,1.

343. Downey, "Mesarites," p. 907: ἐθέλει Πέτρος τῷ κυρίῳ προσαγαγεῖν τὴν προσκυνήσιν. Downey translates "Peter wishes to prostrate himself in adoration before the Lord."

344. Matthew 14:24–33.

345. *Excavations at Dura-Europos, Final Report* VIII,2 (C.H. Kraeling, *The Christian Building* [New Haven, 1967], pp. 61–65, 209–210, pl. XXXVI).

The correspondances suggested to Mesarites by his contemplation of the mosaics at the Apostoleion in Constantinople shortly before the Latin Conquest find a parallel in the so-called Hamilton Psalter in Berlin (Fig. 86).[346] The miniature illustrating Psalm 29:4 in this thirteenth-century manuscript suggests the power of the Lord's voice by means of the Raising of Lazarus. To one side Christ stands with Martha beside him and Mary Magdalen in proskynesis at his feet. On the other is Lazarus, barely awake and standing in a rock-cut tomb. None of these iconographical elements is unusual. But between the two groups Hades rises from an abyss, bringing the dead back to the world of light. It would be difficult to discover a more succinct image of prostration as an appeal for resurrection, an Anastasis achieved without a Descent into Limbo.

The Palaeologan period is especially rich in the recognition of such subtle relationships.[347] At Hagia Sophia in Trebizond, for example, the southeastern pendentive contains a seated St. John meditating at his lectern. Beside the Evangelist, from whose Gospel the Easter lection was taken, a swiftly moving Christ plucks Adam from among those awaiting salvation (Fig. 87).[348] The composition in this pendentive creates a pit in front of the Lord, on the slopes of which the protoplasts and the prophets are standing. Adam is raised from profound prostration as evidenced by the position of the upper half of his body. His bent knees and limp right arm suggest an inert mass impelled into motion, across the pit rather than upward, by Christ's saving force. This, however, is unusual, and to be explained by the form of the space assigned to this image. It is by no means uncommon to find in thirteenth- and fourteenth-century wall painting an extraordinary sense of the formal contribution made by the architectural setting. Thus in the north transept of the *katholikon* at Vatopedi, Christ seems to pull the protoplasts up the intrados of the vault in which the Anastasis is set.[349]

This early Athonite version of the scene serves also to demonstrate its iconographical accessions in the last era of Byzantine art. Below the shattered gates, two angels busily bind Hades' arms behind his back. An angel bearing the instruments of the Passion hovers above the Lord. Beyond the mandorla the number of figures has multiplied dramatically. And from within it Christ reaches toward both the protoplasts, seizing Adam with his left and Eve with his right arm. As in many Macedonian lectionaries (cf. Fig. 85), the first parents are still ranged on one side of Christ, but the Lord has now dispensed with the cross-staff and is thus able to offer the means of salvation simultaneously to each of them. The canonical disposition of the Late Byzantine Anastasis—announced at Chilandari[350] within a few years of the Vatopedi fresco— would put Adam and Eve on either side of Christ, creating a broad and symmetrical

346. Kupferstichkabinett cod. 78 A9, fol. 79r (Athens Catalogue, no. 286 [with bibliography]).

347. The assimilation of motifs in this period has sometimes led to curious errors. Above the head of Adam in a miniature of the Anastasis in Vat. cod. slav. II, fol. 71v (I. Dujčev, *The Miniatures of the Chronicle of Manasse* [Sofia, 1963], pl. 24), a later hand has written "noli me ta[n]ge[re]." Its author evidently confused the slumped form of Adam with that of the Magdalen.

348. Rice, *Trebizond*, p. 111, pl. 38B. The special doctrinal import of this arrangement is suggested by the fact that the Anastasis is repeated as part of a Christological cycle in the central bay of the north wall of this church. Of this painting only fragments survive.

349. Millet, *Athos*, pl. 85,3.

350. Ibid., pl. 69,3.

composition more appropriate to the apsidal conchs in which the scene customarily occurs in the churches of the Holy Mountain.[351] But, significantly, it is Adam's attitude, raised from prostration by Christ, that is applied to both the protoplasts, rather than Eve's more erect posture. We may infer that the upright attitude assigned her in those schemes where both protoplasts are placed on the same side is merely a device to differentiate between the two figures. In Palaeologan and post-Byzantine art, the proper and most frequently employed position vis-à-vis the saving Christ was the oblique proskynesis made by Adam at Vatopedi.[352]

At the Kariye, this is translated into a more nearly horizontal and much more passive position (Fig. 84). The protoplasts appear to fly from their sarcophagi, dragged thence by the most active Christ ever to figure in an Anastasis. His vigorous stride pulls taut the drapery across his legs, a motif that further binds together the two halves of the picture held in tension by the Saviour's grasp on the two primary supplicants. Christ's inclined stance, the oblique axis of the mandorla behind him, and the levitation of those whom he delivers do nothing to disturb the rock-like stability of the composition. It is this monumental steadfastness of the whole, as much as the firmness of details such as the indubitable corporeality of the Lord's hold upon Adam's wrist,[353] that must have left no doubt in the spectator's mind of the reality of this Resurrection. Here Metochites' painter pronounces Christ that "land of the living," the *Chora tōn zōntōn*, to whom the donor makes his oblation at the inner entrance of the church (Fig. 61). In this sense the *ktētōr's* purpose is elucidated and his plea answered. The book in Christ's hand is no less the Word for being closed, but the ultimate affirmation of human redemption is not made until the faithful come to the triumphant conclusion[354] of the program in the *parekklesion*.

In the corresponding mosaic at Hagia Sophia in Constantinople (Fig. 1) Christ's book is opened at an inscription that begins *Eirene hymin*, the first words that he spoke

351. The conch of the north transept is reserved for the Anastasis at the Lavra (ibid., pl. 129, 1); Dionysiou (ibid., pl. 197,1); and Dochiariou (ibid., pl. 223,1).

The "heraldic" disposition of Adam and Eve on either side of Christ is echoed in an unusual miniature in the Serbian Psalter at Munich, Staatsbib. cod. slav. 4 (Strzygowski, "Serb. Psalter," pp. 86–87, fig. 154). The manuscript contains three representations of the Anastasis. Immediately after the last of these, at fol. 229v, is found an image of the Theotokos with the Child in her lap. Flanking her are the protoplasts, raised from prostration by the Infant Christ.

352. At the same time, the type of Adam and Eve ranged on the same side of Christ is preserved in fourteenth-century works and in post-Byzantine icons following such models. The type is exemplified at its best in an icon signed by Michael Damaskinos in the Benaki Museum, Athens (Weitzmann et al., *Icons*, pl. 93). The effect of this composition is to focus direct soteriological attention on Adam while relegating the standing Eve to the ranks of similarly erect prophets behind her.

353. Underwood, *Kariye Djami* III, pl. 350.

354. I am aware that this interpretation reverses the order in which Underwood read and published the paintings of the *parekklesion*. This is not the place for a detailed exposition of this approach, which I hope to justify at length elsewhere. Here I will say merely that prolonged study of these paintings suggests that the program must be read as *beginning* with the Souls of the Righteous in the Hand of God, at the crown of the western arch where one enters the chapel. Similarly, it must end with the Righteous reclaimed by the hands of God in the conch of the apse, which binds together architecturally, pictorially, and theologically all the elements of the *parekklesion*.

to the apostles after they had recognized the truth of the Resurrection.[355] Mirković, in his attempt to show that the basileus prostrate before Christ was Leo VI, saw these words as the Lord's answer to the fears that emperor had confessed in his poetic vision of the Last Judgment.[356] The identity of the emperor remains in doubt and the hypothetical relationship between Leo's *hodarion* and the text in the lunette mosaic does little to demonstrate the connection. Who the basileus is, however, has no bearing upon the meaning of the image: the supplicant's entreaty and Christ's "response" draw upon an iconographical nexus the significance of which transcends matters of personality. The emperor's prostration is not an attitude *sui generis*. Whatever its immediate connotation in the mosaic, it is used, as we have seen, as a gesture of prayer and of veneration. It is rehearsed by penitents and founders, by those who acknowledge the divine will or the fact of military defeat.

Each mode of behavior that we have examined is expressed in a variety of attitudes. The range of expression may vary from a simple bow to almost total prostration. But it is equally evident, first, that this range is limited. Whatever the nature of the supplicant's plea, it is conveyed by one of less than a half-dozen different positions. Second, these are largely interchangeable. No matter what manner of supplication is intended, we find similar gestures used in its expression. There is no demonstrable pattern of gestures preferred in the Middle Byzantine period and replaced with others in the Palaeologan era. The variations of pose are functions not of time but of the interchangeability of recognized and acceptable attitudes.[357]

Nor is this surprising. The prostration of the Psalmist in the cave, imploring the Lord to bring his soul out of prison,[358] is analogous to the positions of the protoplasts in the cavern of Limbo, a situation understood by Ephraim the Syrian as a prefiguration of the Last Judgment.[359] He who abases himself dedicating a foundation, or before the Lord's glory, hopes to be lifted up. This is the purpose and hence the nature of the pose he assumes. The protean forms of proskynesis are ultimately equivalents. Cast down, a man is still able to express hope of rising. Casting himself down, he conventionally adopts a position in which his resurrection is implicit. In this sense all Byzantine expressions of prostration are subsumed in the proskynesis of Adam and Eve, representatives of humanity and first beneficiaries of the Anastasis. To the end of the empire, as Symeon, archbishop of Thessaloniki, noted shortly before that city fell to the Turks, the priest led the congregation in proskynesis as the fitting gesture before the God who descended into Hell to snatch out their souls and ascended again.[360]

355. Luke 24:36; John 20:19. The latter part of the text is taken from John 8:12.

356. Mirković, "Mosaik über der Kaisertür," p. 211.

357. The equivalence of the various attitudes of proskynesis is exemplified in a manuscript with illustrations of a Penitential Canon (Bucharest, Academy Lib. cod. gr. 1294), published by I. Barnea ("Un Manuscrit byzantin illustré du XI^e siècle," *Rev. ét. sud-est eur.* I, 1963, pp. 319–330, fig. 4). In this miniature five penitents indicate their simultaneous contrition with bows, doubled up in proskynesis or by fully extended prostration.

358. Psalm 142:6–7.

359. Cf. G. Voss, *Das jüngste Gericht in der bildenden Kunst des frühen Mittelalters* (Leipzig, 1884), p. 6. For textual problems concerning the authenticity of Ephraim's text, see D. Hemmerdinger-Iliadou, *Dictionnaire du spiritualité*, s.v. Ephrem, IV,2, cols. 800–819.

360. *De sacro templo*, 119, *P. G.*, 155, col. 324B.

4 *The Virgin on the Walls*

The Coins

On the obverse of the *hyperpyra* bearing his image in proskynesis before the standing Christ, the moneyers of Andronicus II Palaeologus (1282–1328) placed that of the Virgin surrounded by the walls of Constantinople (Figs. 41–43).[1] The type was preserved when the reverse changed[2] after the coronation of his son Michael as co-emperor in March 1295; before their joint rule ended in 1320 its use had been extended to electrum[3] and copper coins.[4] It has been suggested that this type of obverse persists on the *solidi* of Andronicus with his grandson, Andronicus III (1325–1328)[5] and, most recently, to the middle of the fourteenth century.[6] It then disappears—apparently with all imperial gold coins—until revived by Manuel II (1391–1423).[7] The Virgin may thus have appeared on coins struck little more than a generation before the Ottoman Turks broke through the walls along which she is stationed.

The longevity of the type is even more dramatically emphasized when its origins are investigated. That it was used in the very first years after the recapture of Constantinople in 1261 is evident from a famous passage in Pachymeres' history of Andronicus II, in which, tracing the origins of the debasement of the *hyperpyron*, the chronicler attributes responsibility in large part to Michael VIII's need to buy off the Latins.[8] The passage has widely been used by economic historians for its precious if

1. *B.M.C.* II, pp. 614–616, nos. 1–10, pl. LXXIV, 10–12. In the designation of obverse and reverse, I follow, *contra* Wroth, the technically correct view established by Breckenridge (*Justinian* II, p. 27, note 23) and Hendy (*Coinage and Money*, p. 251 and passim) that the convex face of these *trachea*—which bears the Virgin *orans*—is the obverse. It should be noted, however, that Pachymeres, in the passage cited in note 10 below, describes the face with the Virgin as the reverse [ὄπισθεν].

2. *B.M.C.* II, pp. 618–620, nos. 13–16, 18–19, 23, pls. LXXIV, 15–18. Cf. Hendy, *Coinage and Money*, p. 25, pl. 45, 14.

3. *B.M.C.* II, pp. 619–620, nos. 17, 20, 21–22, pl. LXXV, 1–2.

4. Ibid., p. 622, no. 29, pl. LXXV, 8. Wroth indicates that this crude specimen may not be a product of Constantinople. We await the final volume of *D.O.C.*, for more precise determinations regarding both the mints and the chronology of this and many other Palaeologan coins.

5. Hendy, *Coinage and Money*, p. 252, pl. 46, 3.

6. Veglery and Millas (cf. chapter 3, note 11 above) have assigned some of the gold *hyperpyra* with "the Virgin praying in the middle of the Walls of the City" to the joint reigns of John V and Anna (1341–1347) and John V and John VI (1347–1352).

7. *B.M.C.*, p. 635, no. 1, pl. LXXVI,8.

8. *C.S.H.B.* II, pp. 493–494.

perplexing account of the stages of monetary contamination in the thirteenth century,[9] but the matter and the manner of its central observation are no less important for historians of numismatic iconography. Pachymeres specifically notes that Michael, as a result of the capture of the capital and his pressing need for money, put the image of the city on his coins and thus replaced the ancient signs.[10] Considering, then, gold struck only in Constantinople, the type of the Theotokos within the walls of the city endured approximately one and one-half centuries. Indeed it is hardly an exaggeration to suggest that when and as long as gold was minted in the capital, the emblem remained canonical for Palaeologan die-cutters.

In the light of Pachymeres' cogent testimony, it has generally been assumed that *hyperpyra* of this type were issued only after Michael VIII's entry into Constantinople and that the setting of the Virgin *orans* represents the architecture of the recaptured city. Common sense suggests that the type, whose afterlife we have just considered, began as a commemoration of the triumphant event of July 1261.[11] The earliest coins of this series offer no intrinsic reason as to why this stylized setting must of necessity be regarded as an image of Constantinople. And it must be recalled that the problems of the numismatic relations between the capital and the various seats of the empire-in-exile have by no means all been solved. As Hendy has pointed out, in respect to many Thessalonican types, struck after 1258, there exists no adequate means of distinguishing those minted after the recapture of Constantinople from those struck in the second city of Greece before the repossession of the capital.[12]

If we grant, for want of positive evidence to the contrary, that the Virgin among the walls is a product of the mint of Constantinople, there is still no reason to see it as an image created *ex nihilo*. A generation before the coronation of Michael VIII celestial powers had appeared on East Christian coins in an architectural context. On a silver *trachy* of Theodore Comnenus Ducas, first emperor of Thessaloniki (1224–1230), St. Demetrius places a three-towered castle in the emperor's hands.[13] Any doubt that the emblem represents his realm must be assuaged by its recurrence on a billon *trachy* of Manuel Comnenus Ducas (1230–1237), where the three towers, rising above a wall held between the city's ruler and its patron, are collectively identified as ΘΕCCΑΛΟΝΙΚΗ.[14] Indeed the structure may symbolize not only the seat of

9. D. A. Zakythinos (*Crise monétaire et crise économique à Byzance du XIIIᵉ au XVᵉ siècles* [Athens, 1948], pp. 8–10) discusses the literature and identifies the deluded interpretations of this important passage.

10. Pachymeres, "Ὕστερον δὲ ἐπὶ Μιχαὴλ τῆς πόλεως ἁλούσης, διὰ τὰς τότε κατ᾽ ἀνάγκην δόσεις, καὶ μᾶλλον πρὸς Ἰταλούς, πετεγεγράφατο μὲν τὰ τῶν παλαιῶν σημείων, τῆς πόλεως χαραττομένης ὄπισθεν.

11. *B.M.C.* II, pp. 608–609, nos. 1–5, pl. LXXIV, 1–2.

12. Hendy, *Coinage and Money*, p. 295.

13. Ibid., p. 268 ("Type B"), pl. 37, 3–4. In the second half of the twelfth century, tower and city-gate motifs are common emblems on the coinage of the Kingdom of Jerusalem, the county of Tripolis, and lesser Crusader states (G. Schlumberger, *Numismatique de l'orient latin* [Paris, 1878], pls. III,12, 21–24, 26, IV,9–15, V,3,13).

14. Hendy, *Coinage and Money*, p. 277 ("Type G"), pl. 39,10–11.

Manuel's "despotate" but the entire Greek empire.[15] Long after Constantinople had been retrieved, Byzantine coppers would continue to display various fortifications presided over or protected by the image of the emperor.[16]

For such issues Bertelè has proposed a large number of German models of the mid-twelfth or thirteenth century, although in fact the bracteates of Brandenburg and Arnstein[17]—representative of this group—are closer to the imperial gold with which we are concerned than to any coins minted in Thessaloniki. Their ample modules accommodate circular or elliptical *enceintes* made up of towers, turreted walls, and a city-gate above or behind which hovers the principal emblem of the coin. On the *hyperpyra* the central eagle or helmeted warrior is replaced by the Mother of God but, here again, the search for a numismatic source need lead no further than Thessaloniki. The same series of *trachea* that displays Manuel Comnenus Ducas and St. Demetrius holding between them the three-towered, walled city also offers the Virgin *orans* wearing tunic and *maphorion* and identified by the sigla \overline{MP} $\overline{\Theta Y}$ on either side of her head exactly as on the Constantinopolitan gold of Michael VIII and his successors.

The *hyperpyra*, however, cannot be dismissed as a simple conflation of Western and Eastern motifs inherited through the mediation of Thessaloniki. They are characterized by a unique architectural projection—the element that defined their novelty for Pachymeres. The cities on the German bracteates are rendered in a familiar medieval version of bird's-eye perspective: gates, towers, turrets, and the central motif are disposed parallel to each other, the more distant elements rendered smaller and higher up the vertical plane of the image. On the Palaeologan gold, however, in a manner essentially unchanged from its first employment under Michael VIII to its last appearance under Manuel II, the towers are all of the same size[18] and distributed not according to a single viewpoint but pursuant to a scheme that, however irrational, provides a singular and effective frame for the Theotokos in their midst. Only the groups of towers immediately "above" and "below" her are aligned with the axis of her body. Above the median line of the coin, defined as a line connecting her raised hands, the lateral towers flare out to form a sort of corona above her head. Below this point, they lead inward, directing all attention toward her. The Virgin's body seems to rise above its architectural frame. Her half-length figure, and, in particular, her expansive gesture, inhabits but is not limited by the man-made constructions about her. The effect is, of course, partly a function of her size in relation to the walls. But the

15. Bertelè, *L'imperatore alato*, p. 40.

16. Ibid., pp. 41–42, pls. I,8–15, II,29–30, IV,54–55, V,56–59. Bertelè attributes these copper "castelli" to the mint of Thessaloniki, assigning them to the reigns of either Michael VIII or Andronicus II Palaeologus. From the middle of the fourteenth century, a stylized city wall, drawn in elevation and surmounted by a cross, appears on the coppers of Trebizond (*B.M.C. Vand.*, p. 299, no. 23, pl. XL,15, p. 304,13, pl. XLI,13–14, p. 309,1, pl. XLII,5).

17. Bertelè, *L'imperatore alato*, pp. 65–67, figs. 119, 122.

18. Absolute certainty on this point is not possible. These coins were frequently double- and sometimes triple-struck, which has not, of course, improved their legibility. Many specimens of these *trachea* have, moreover, been pressed flat so that the original relative height of the architectural features is frequently distorted.

simultaneous impression of her presence and her unboundedness would be lost were the circumferential elements disposed as they are on the bracteates of Brandenburg and Arnstein, or radially as in at least one Western tradition of representing the Heavenly Jerusalem in Apocalypse manuscripts. The Theotokos is evidently neither circumscribed nor confined by the *enceinte*. Only in the most profane sense could she be said to be "within" or "among" these bulwarks. Rising above them from the interior of the city, her station defies precise prepositional qualification. For this and other reasons yet to be considered we describe her only as the Virgin on the Walls.

For Wroth, this representation of towers and walls was "conventional," although, significantly, he did not suggest to what convention the fortifications as arranged here pertained. Following Pachymeres, he identified the city thus protected as Constantinople. The fact that never before in Byzantium had the capital, or any other city, been delineated in this fashion will become apparent later in the discussion. For the present it must be assumed that Wroth meant stylized or "idealized" rather than "conventional" since the circuit of eighteen towers, disposed in six groups of three, not only bears no relation to the form of a Palaeologan metropolis but none either to any representation of one. In reality the Theodosian land-wall—the only part of the *enceinte* portrayed on the coins—was punctuated by ninety-six towers, square or polygonal in plan and set at more or less equal distances from each other.[19] The only aspect of the bulwark as built indicated on the *hyperpyra* is the use of leveling courses, which may be indicated by the horizontal striations in the superstructure of the towers, if indeed these are not intended to represent the bands of revetment that covered the concrete core of both the wall and its towers. No attempt was made by the die-cutter to illustrate the merlons and embrasures—the "crenelations"—at the summit of the towers, and no gates pierce the masonry girdle about the Virgin. Finally, it will be recalled that the system, here represented as uniformly encircling her, ran only from the Sea of Marmara in the south to Blachernae near the Golden Horn. The sea walls, begun by Septimius Severus and joined to the landward ramparts only late in the reign of Theodosius II,[20] insofar as we can tell from their remains, were a much more heterogeneous assemblage.

The editor of the British Museum catalogue suggested that this device of the Mother of God might have occurred to Michael VIII when, shortly before his coronation, he entered the City accompanied by the icon of the Hodegitria, "or when his attention was directed—as soon as it was—to the restoration of the walls of the city guarded by God or by the Mother of God."[21] If a specific campaign of restoration is to be identified as the occasion of the coins, then the token repairs of Michael VIII—under whom these *hyperpyra* first appear—are quite overshadowed by the major reconstruction of the walls under Andronicus II.[22] Apart from our ignorance concerning the

19. Krischen et al., *Landmauer*. For the location of the towers in relationship to the outer wall and the major gates of the city, cf. ibid., I, fig 1.

20. F. Dirimtekin, *Fetihden önce Marmara surları* (Istanbul, 1953).

21. *B.M.C.*, p. lxix.

22. The historical sources for Palaeologan repairs to the walls are cited by Krischen et al. (*Landmauer* II, p. 6; a misprint on this page attributes the first of these coins to Michael III).

precise occasion that gave rise to this major Palaeologan series, an understanding of it has been hindered by aesthetic prejudice and an unwillingness or inability to read the evidence presented by the coins. To so eminent a scholar as Louis Bréhier, confronting a specimen in the Louvre, the coins represented "la dégénérescence à son dernier terme" of Byzantine coinage.[23]

Without pretending that the *hyperpyron* with the Virgin on the Walls represents either a major work of art or an unrecognized iconic type of the Mother of God, we can yet acknowledge it as an important formal innovation of the last era of the empire and, at the same time, as an image that, in both content and function, draws heavily upon Byzantine tradition.

The Monuments: The Virgin and the City

If the study of iconography has any pretensions to being a scientific discipline, then the observation of what is not represented in an image may well be as important a methodological step as the registration of what is present. Wroth records of the series of *hyperpyra* with which we are concerned that its obverse displays "the bust of the Virgin facing, *orans*, in usual dress."[24] This is to ignore a feature that one might have thought impossible to neglect and that would seem indispensable to any commentary upon the sudden appearance of the complex coin type, shortly after 1261. The absence of the Child from the breast of the Mother of God is not to be explained by the appearance of Christ on the reverse of the coins, raising Andronicus II from proskynesis (Figs. 41–43) or blessing Andronicus' predecessor, Michael VIII, presented to the Lord by his eponymous saint.[25] A simple bustate Virgin of this sort had appeared on the fractional silver of Constantine Monomachos in the middle of the eleventh century identified by inscription as the Blachernitissa.[26] The date and precise form of the ancient icon evoked on this coin are unknown: it was revered by the emperor in the tenth century according to *de Cerimoniis*[27] and images of the type (but lacking this inscription) occur as early as the sixth century.[28]

But the epithet was also applied to figures of the orant Mary with the Child before her, held in her arms, within a medallion, or entirely unsupported. As has recently been

23. Bréhier, *La Sculpture et les arts mineurs byzantins*, Paris, 1936, p. 95, pl. LXXV,h. Bréhier was even more at a loss to understand the reverse of the coin. He noted only a "monogramme du Christ" where, in fact, \overline{MP} $\overline{\Theta Y}$ is evident on the specimen he examined.

24. *B.M.C.* II, p. 608.

25. Ibid., pp. 608–609, nos. 1–5.

26. Ibid., p. 503, no. 18, pl. LIX,3–4. For the date of this two-thirds *miliaresion* and the most lucid discussion yet of the Blachernitissa type, see Grierson, *D.O.C.* III, 1, pp. 173–174. The half-length figure on the coppers and the full-length standing Virgin on the full *miliaresia* of Constantine Monomachos (*B.M.C.*, p. 503, nos. 19–35 and p. 502, nos. 16–17, respectively) bear inscriptions identifying Mary as Mother of God rather than as the Blachernitissa.

27. *De Cer.* II, 12, *C.S.H.B.* I, p. 533.

28. M. Tatić-Djurić, "Vrata Slova. Ka liku i znacenju Vlahernitise," *Zbornik za likovne umetnosti* [Novi Sad] VIII, 1972, p. 70, fig. 2.

demonstrated, this alternative version can with equal justice be identified with the Blachernitissa understood, in the light of a large body of Orthodox literature, as the "Gate of the Word." The Virgin as symbolic portal of the Incarnation was, then, represented in a large number of different ways. But it was only the type on the *hyperpyra*— the bustate Mother of God without the Christ Child—that is found in the specific association with actual gateways defined by an epigram on the decoration of the Chrysotriclinos:

τῆς εἰσόδου δ'ὕπερθεν, ὡς θεία πύλη,
στηλογραφεῖται καὶ φύλαξ ἡ Παρθένος.[29]

Shortly after the middle of the eleventh century, for example, the Virgin *orans* was set up in the Church of the Dormition at Nicaea, in the lunette above the door leading from the central bay of the narthex into the nave.[30] Sharing the bustate form of this mosaic, and again with a disproportionately large head and small hands, she appears at the end of the following century in the cathedral at Torcello, in a tympanum over the portal and immediately below the great mosaic of the Last Judgment, which commands the western wall.[31] Although we do not know whether the restoration of the mosaics in the Chrysotriclinos reproduced the original decoration of this great hall, the program, including the guardian-Virgin described in the epigram, dates from the reign of Michael III (842–867).[32] Its appearance in the Chrysotriclinos, taken in conjunction with the manifestations at Nicaea and Torcello, suggest an iconographical type employed from shortly after the restoration of Orthodoxy, at the latest, until the Fourth Crusade.[33] The wide diffusion in time and space of the motif further tends to deny the sense of a recent thesis, which maintains the infrequent association of the Mother of God with doorways in East Christian architectural decoration.[34] In

29. *Anthol. Pal.* I, no. 106, lines 8–9. Cf. ibid., no. 121.

30. Th. Schmit, *Die Koimesis-Kirche von Nikaia. Das Bauwerk und die Mosaiken* (Berlin-Leipzig, 1927), pp. 50–51, pl. XXXI.

31. Lazarev, *Storia*, p. 242, fig. 370.

32. Cf. P. Waltz, "Notes sur les épigrammes chrétiennes de l'Anthologie Grecque," *Byzantion* II, 1925, p. 320.

33. From the thirteenth century—as exemplified by the lunette fresco over the portal from the inner narthex to the naos of the Church of the Virgin at Studenića (R. Hamann-Maclean-H. Hallensleben, *Die Monumentalmalerei in Serbien und Makedonien* [Giessen, 1963], fig. 75)—the image of the Blachernitissa frequently occurs in this situation.

34. Ch. Bouras, *Les Portes et les fenêtres en architecture byzantine. Etude sur leur morphologie, leur construction et leur iconographie*, thèse de doctorat du 3ᵉ cycle, Ecole Pratique des Hautes Etudes (Paris, 1964), p. 224. The author is particularly exercised by the mechanical problem of disposing the single figure of the Virgin across both wings of a double door. This emphasis detracts from the understanding that the lunette above the door, single or double, was obviously considered part of the portal by Middle and Late Byzantine artists. This is particularly evident in the representation of the gate of Jerusalem in the Kariye (Fig. 88) where the tympanum bearing the Virgin is recessed behind the plane of the wall and set beneath the vault over the gate (cf. also Figs. 91, 92). The artistic association of the Virgin with doors and entrances is considered briefly by Kondakov (*Ikonografiìa*, pp. 338–339), to which discussion must be added the Virgin on one of the doors of Heaven above the Baptism in the Peribleptos at Mistra (Millet, *Mistra*, pl. 118,3). The frequent occurrence of images of the Virgin ac-

short, the half-length or bustate Mother of God, shown *orans* and without the Child, seems in later Byzantine art to be an image frequently reserved for the decoration of portals.

In post-Byzantine programs the Virgin appears in the lunette above the main gate of Jerusalem in scenes of Christ's Entry that otherwise adhere closely to pre-Conquest iconography.[35] But already in High Palaeologan art Holy Sion had been protected by closed gates and the Theotokos with outstretched arms in a tympanum above them. The celebrated fresco in the Kariye *parekklesion* representing the destruction of the Assyrians by the angel of the Lord (Fig. 88)[36] was brilliantly explicated by Underwood as an illustration of the Lord's promise, transmitted through his prophet Isaiah, that the army of Sennacherib would not enter Jerusalem. This unpromising and rare subject is masterfully handled by the artist, who balances the staunch, unbending figure of the prophet with the dynamic scourge of the Assyrians. Despite several *pentimenti*—evident, for example, behind the angel's left foot—the result is a figure whose flailing limbs seem to unfold from Isaiah's simple gesture as effect proceeds from cause. The prophecy is uttered across the portal behind which the city sleeps unharmed, the gate of the Virgin that is closed to all but the prince who shall sit in it.[37]

There is no reason to adduce the Akathist Hymn in this connection, rather than the scores of other Byzantine *kontakia* that similarly apostrophize the Virgin as θύρα σωτήριος or πύλη τοῦ θείου λογοῦ.[38] The *Akathistos* must, however, be related to the monumental figure in the apse of Hagia Sophia at Kiev.[39] The idea of Kiev and its cathedral raised on the west bank of the Dnieper as a bastion protecting Christendom from the nomads of the steppes may be, in part, a later medieval accretion.[40] But there can be little doubt that this image of the Virgin *orans* is not simply an adornment but also a personification of the "unshakeable wall" [*nerushimaia stena*] spoken of in the *kontakion* and introduced into Kiev around 1070, less than a

companied by Christ beside narthex doors is demonstrated by S. Der Nersessian ("Two Images of the Virgin in the Dumbarton Oaks Collections," *D.O.P.* XIV, 1960, pp. 80–86).

35. E.g., in the *katholikon* of St. Nicholas Anapavsas at Meteora (1547) (A. Xyngopoulos, Σχεδίασμα ἱστορίας τῆς θρησευτικῆς ζωγραφικῆς μετὰ τὴν Ἄλωσιν, [Athens, 1957], pp. 96–98, pl. 20,2). Half-length figures occur in the tympana above the two lateral gates of the city in the Entry scene in the Peribleptos at Mistra (Millet, *Mistra*, pl. 120,1). Their small scale precludes positive identification.

36. Underwood, *Kariye Djami* I, pp. 233–234; III, pls. 461–463.

37. Cf. Ezekiel 44:2–3. Underwood's introduction of this analogue, which is surely implicit in the composition, would seem to be denied by his observation that the portal of the city is slightly ajar. I can see no indication in the fresco that the gate is open. Paradoxically, a possibly contemporary wall painting at the Fetiye Camii, interpreted as representing the "Closed Door" of Ezekiel by C. Mango and E.J.W. Hawkins ("Report on Field Work in Istanbul and Cyprus, 1962–1963," *D.O.P.* XVIII, 1964, pp. 324–327, fig. 10), is rendered with its valves partly open. The variety of Palaeologan expressions of this symbolism are considered by G. Babić ("L'Image symbolique de la 'Porte Fermée à Saint-Clément d'Ohrid," *Synthronon. Art et archéologie de la fin de l'Antiquité et du Moyen Age* [Paris, 1968], pp. 145–151).

38. S. Eustratiades, Ἡ Θεοτόκος ἐν τῇ ὑμνογραφία (Paris, 1930), pp. 29, 67–68. On the Akathist Hymn, see pp. 136–138 below.

39. Lazarev, *Murals and Mosaics*, pp. 226–227, fig. 20.

40. Cf. J.H. Billington, *The Icon and the Axe* (New York, 1966), pp. 3–15.

generation after the mosaic was set up, probably by Greek artists.[41] The non-believer may be forgiven for suspecting a relationship between the epithet and the massive girth and height—2.23 meters—of this version of the Mother of God. She is, however, only the first of a series of Russian figures whose attitudes or locations caused them to be identified with the apotropaic function of the famous icon in the Blachernae, the Virgin protector of the walls of Constantinople.[42]

The association of the Theotokos with a rampart in the eleventh century was not confined to the northern provinces of Byzantium's artistic empire. A recently discovered tondo in a funerary chapel adjacent to the cathedral at Faras—the ancient Pachoras—in the Sudan, shows her as a bustate form holding the Child on her left arm (Fig. 89).[43] Once again she is a colossal figure, although here the wall appears as part of the pictorial context: the ground against which Mother and Child appear is painted to simulate blocks of brick-red ashlar. The precise iconographical significance of this much-damaged composition is as yet unelucidated. Christ appears to hold two chalices and, while Mary's left arm presumably supports him in the manner of a Hodegitria, her right hand is placed with palm outward before her breast. An inscription above the medallion's pearly circumference hails her as *MAPIA MH[TH]P TOY X[PICTO]Y C[OT]HP TOY KOCMOY.*

We shall see later that the brilliant frame of the tondo may have more than purely decorative significance. For now the early diversity of types of the Virgin in her association with Sion must be pursued. The frequent allusions of the Psalmist to the holy city are represented, for example, in the Khludov Psalter by a table of rock bearing a tall tower and an adjoining wall, above which projects the half-length figure of the Virgin as Hodegitria (Fig. 90),[44] by an image of the city on whose walls appears the icon of the Nikopoia (Fig. 91),[45] and by the same icon within a pearly roundel adhering to a sharp spur of rock.[46] In all save the last—where the rock represents Sion with the Theotokos at its summit—the holy mountain is identified by the Mother of God on its walls. It is her iconic presence that denotes "the city of the living God the heavenly Jerusalem."[47]

A similar variety attends representations of the Theotokos in other architectural contexts. A marginal illustration to a homily on the birth of Christ, inserted in the

41. The Greek verse hails the Virgin as τῆς Βασιλείας τό ἀπόρθητον τεῖχος. For the complete text of the hymn, see Trypanis, *Cantica*, pp. 29–39. For its introduction into Russia, see N. Scheffer, "The Akathistos of the Holy Virgin in Russian Art," *Gaz. B.-A.* XXIX, 1946, pp. 5–16.

42. Kondakov, *Ikonografiia* II, p. 17. Cf. A. Grabar, "L'Art profane en Russia pré-mongole et le 'Dit d'Igor,'" reprinted in his *L'Art de la fin d'antiquité et du moyen âge* (Paris, 1968), I, p. 320; III, pls. 71–72d. The author attributes this function to the external reliefs of saints on the Demetrius Cathedral at Vladimir.

43. K. Michalowski, *Faras I. Les fouilles polonaises, 1961* (Warsaw, 1962), pp. 106–109, fig. 41, pl. XXXII. The fresco is now in the National Museum at Khartoum.

44. Moscow, Hist. Mus. cod. gr. 129, fol. 79 (Grabar, *L'Iconoclasme*, p. 200, fig. 148).

45. Fol. 86v (ibid., p. 200, fig. 151). Cf. Pantocrator 61, fol. 121r (Dufrenne, *Psautiers grecs*, p. 32, pl. 18), where the Nikopoia is set within a roundel.

46. Fol. 64r (Grabar, *L'Iconoclasme*, p. 199, fig. 147), illustrating Psalm 67 [68]:16.

47. Hebrews 12:22.

text of Gregory Nazianzenus' homilies in cod. Taphou 14, shows a Persian indicating such an image to the Magi (Fig. 92).[48] Although the space she occupies is not a tympanum, her situation and presumably her function above the entrance to the structure are consonant with those assigned to the Virgin in the epigram from the Greek Anthology cited above. This half-length Hodegitria does not define a specific location any more than the Platytera in the vault represented in Emmanuel Tzanes' panel defines the church in which occurred the Miracle of the Girdle as the Chalkoprateia at Constantinople (Fig. 74).[49] Rather, in both cases, the icon makes known to the human actors in these scenes—and to the spectator—the presence and participation of the celestial figures in the events unfolding below.

It is precisely this immediacy of the Virgin that is suggested on the *hyperpyra* under consideration. Although her material relationship to the walls of the city cannot be precisely defined, she is "among" them in a manner that could be depicted only by a civilization unembarrassed by its belief in the immanence of the metaphysical in the realm of the mundane. The interpenetration of these two zones of being is an abiding theme of Byzantine art, and the means used to suggest it vary little in its millennial history.[50] Its most celebrated Palaeologan expression occurs in the Kariye Camii, where the entire western bay of the *parekklesion* is surveyed from above by the Theotokos enclosed within a segmented medallion in the dome (Fig. 94).[51] The origins of this rainbow border are to be found perhaps in Late Antique floor mosaic.[52] It occurs, apparently purely as ornament, in the sixth-century Vienna Dioscorides,[53] but before this had been used to define the periphery of the medallion enclosing the Lord's Parousia in the dome of the Rotunda at Thessaloniki.[54] In Middle Byzantine decoration it is used as a surround for the Pantocrator in the highest reaches of the church.[55] The early-fourteenth-century example simply extends the prismatic motif to the Mother of God, although in so doing the painter created the most convincing illusion of plasticity yet achieved with this device.

Of a similar form used in tenth-century decoration, it has been maintained that it marks "a purer light meeting a denser atmosphere."[56] This remains an unsubstantiated inference, yet it is an apt description of the effect of the medallion if the sense of the

48. Fol. 106v (Lazarev, *Storia*, p. 188, fig. 202); Galavaris, *Liturgical Homilies*, p. 224.

49. Cf. note 240, chapter 3 above.

50. This interpenetration has been discussed innumerable times with greatly varying degrees of intelligibility. Among the earliest and most lucid presentations is Millet, *Daphni*, p. 80.

51. Underwood, *Kariye Djami* I, pp. 213–214; III, pl. 411 (color).

52. Cf. A. Frantz, "Byzantine Illuminated Ornament," *Art Bull.* XVI, 1934, pp. 45–47.

53. Cod. med. gr. I, fol. 4v (Buberl-Gerstinger, *Handschriften* I, pp. 22–24, pl. III).

54. W.E. Kleinbauer ("The Iconography and the Date of the Mosaics of the Rotunda of Hagios Georgios, Thessaloniki," *Viator* III, 1972, pp. 27–107, fig. 3) would date the program between 450 and 480.

55. E.g., at Daphni (E. Diez-O. Demus, *Byzantine Mosaics in Greece. Hosios Lucas and Daphni* [Cambridge, Mass., 1931], pl. I [color]).

56. See Wood, *Divine Monarchy*, p. 26, on the "rainbow painted zigzags" on the arches leading from vestibule to the nave and from the nave to the bema of Tokale kilise at Göreme. For excellent black and white photographs, see Restle, *Asia Minor* II, pls. 61, 98–99.

remark is not confined merely to the domain of optics. At the Kariye, the Virgin, holding before her breast the Child who blesses in an *orans* attitude, is a version of the Nikopoia.[57] About her, but at a lower level, is ranged an honor guard of angels and archangels. And between them the elaborately decorated ribs of the cupola serve both to diffuse the brilliance of the principal image and to return the eye to this nodal point. In this way the Theotokos is at once at the midpoint of and apart from the architectural and iconographical infrastructure of the bay.

The centrality assigned to Mary both in Palaeologan vault decoration and on the coins became, after the fall of Constantinople, a dominant artistic theme in Greek, Balkan, and Slavic lands. Illustrating the hymn "In thee rejoiceth all Creation," found in the Liturgy of St. Basil,[58] the Mother of God is found adored by hierarchies of angels and mankind. The anthem identifies her as both sanctified temple and spiritual paradise and, accordingly, she is set within a polychrome aureole before the heavenly city in a field of paradisiacal vegetation.[59]

Despite the association of the Virgin and Sion, the many formal differences between these late painted images and the *hyperpyra* with the Virgin on the Walls must be emphasized. In the frescoes and icons illustrating the ʼΕπὶ σοι χαίρει Mary is enthroned, following the liturgical text, as the Platytera with the Child held in her lap before her. While placed within a medallion, she is not surrounded by the heavenly host so much as superimposed upon them: her aureole overlaps the bodies of the angels behind her. The "natural" relationship with the other iconographical features, which is evident on the coins, is here lost. Again, in post-Byzantine painting, the city is in no way disposed about her but rather acts as a backdrop to the composition, its vaults alone rising above the heads of the celestial army assembled before its walls.

Finally, it is apparent that all elements of these pictorial compositions are seen from the same viewpoint. Although the Theotokos is usually a disproportionately large figure, she is still rendered frontally, parallel to the picture plane, like the angelic hosts and the city behind her. It is precisely this point that distinguishes the coins (Figs. 41–43) from any contemporary or later Byzantine representation. As we have seen, they combine a frontal image of the Virgin with an aerial view of the walls and towers of the city. Parallels for this compound aspect are difficult to find. Even though Palaeologan renderings of architecture frequently led to highly anomalous situations,[60] in no representation of which I am aware is there attempted this particular combination of physically incompatible points of view.

57. A true Nikopoia—i.e., with both Mary's hands upon her son's shoulders—is to be found in an analogous mosaic in the north dome of the main church (Underwood, *Kariye Djami* II, fig. 68). For such an image venerated in one of the chapels of the Imperial Palace, see Kondakov, *Ikonografiia* II, pp. 124–125.

58. ʼΕπὶ σοι χαίρει (Brightman, *Liturgies*, p. 406). For the relationship of this hymn to the *Akathistos* and other Mariological material, see T. Velmans, "Une Illustration inédite de l'Acathiste et l'iconographie des hymnes liturgiques à Byzance," *Cah. arch.* XXII, 1972, pp. 159–162.

59. E.g., at the Ferapontov monastery, Moscow (E. Georgievski-Druzhinin, "Les Fresques du monastère de Therapon. Etudes de deux thèmes iconographiques," *Recueil Uspenski* II, pp. 122–128, pl. XV); another, dating to 1536, at Molivoklisia, Athos (Millet, *Athos*, pl. 157, 4).

60. Cf. T. Velmans, "Le Rôle du décor architectural et la représentation de l'espace dans la peinture des Paléologues," *Cah. arch.* XIV, 1964, pp. 183–216.

Such combinations are, however, not unknown in Late Roman and Early Christian art. One of the most notable examples is the *enceinte*, previously identified as the Hippodrome, on the column of Arcadius set up in that emperor's forum in 404 (Fig. 96).[61] The column was pulled down in 1729 but its reliefs are known from sixteenth-century drawings, on the basis of which it has been shown that the circular structure on the east face represents the Forum of Constantine.[62] Zosimus remarked upon the unique circularity of this forum and upon its surrounding porticoes.[63] The contrast between the manner in which these are rendered and that in which its contents[64] are shown is even more absolute than that on the *hyperpyra*. It is particularly striking when the stoas of the forum are compared with those of the *Mesē*, represented at top left of the first spiral. The former are shown directly from above but the porticoes along the street—like most other structures and figures on the column—appear in frontal (or profile) view.

The coins, however, have the walls and towers of Constantinople in albeit inconsistent elevation around the Virgin portrayed *en face*. A disjunction of this type occurs in the Vatican Cosmas manuscript, the miniatures of which generally revert to Early Christian prototypes.[65] Here the Stoning of Stephen is shown as occurring in an amphitheater with the hemicycle drawn in bird's-eye perspective, but the saint and his assailants either from the eye level, or above the level, of the artist (Fig. 97).[66] The figure to Stephen's left, and the hand of the apostle who demonstrates the event, both encroach upon the wall as do the lower groups of towers on the *hyperpyra*, while the aggressors in the upper portion of the picture radiate from the architectural perimeter like the towers about the head of the Theotokos. The analogy is even closer given the *orans* pose of the saint, an inspired attitude that owes its origin to Scripture[67] but that is betrayed, in terms of both faith and art, by the lower half of Stephen's figure shown on the run.

The site of the protomartyr's lapidation remains much disputed[68] and the suggestion of an arena is inconsistent with the Book of Acts, which relates that it took place *exō tēs poleōs*. That the semicircular building is not the wall of Jerusalem is suggested by the number of apertures—both windows and doors—in it and by the fact that Stephen is shown *inside* the edifice, the object of stones thrown toward a central target. The difference between this earliest surviving Greek representation of the Stoning and the "narrative" versions, preserved in later manuscripts such as the Menologion of Basil II, has recently been demonstrated. In the Vatican Menologion, as in the Florence

61. E.W. Freshfield, "Notes in a Vellum Album . . . drawn by a German Artist," *Archaeologia* LXII, 1922, pp. 87–104, pl. XXII.

62. G. Becatti, *La colonna coclide istoriata* (Rome, 1960), pp. 210–216.

63. Zosimus II, 30, *C.S.H.B.*, p. 96. The primary evidence for this forum has most recently been discussed by R. Guilland (*Etudes de topographie de Constantinople byzantin*, 2 vols. [Berlin, 1969], topographical index s.v. "Forum de Constantin").

64. For a useful summary, see R. Janin, *Constantinople byzantin* (Paris, 1950), pp. 68–69.

65. Weitzmann, *Buchmalerei*, p. 5.

66. Vat. gr. 699, fol. 82v (Stornajolo, *Topog. crist.*, p. 47).

67. Acts 7:55.

68. For this vexed question, see *D.A.C.L.* V, cols. 630–632.

copy of Cosmas Indicopleustes, a much older type is preserved,[69] in which the martyr meets his end on a hillside in open country. We may therefore infer that the arena setting in Vat. gr. 699 is an invention of the early Macedonian artist. But even if he in turn were following an ancient model, it would be one that ignores the biblical account. And, more important for our purposes, it would be one that, in refusing to set any buildings within the wall, is totally at odds with the Early Christian and Byzantine tradition of city representation. To this tradition we must now turn for the sources of the image of Constantinople on the coins.

Forma Urbis *and* Imago Clipeata

While the Stoning of Stephen in the Vatican Cosmas is shown as occurring within an arena rather than a city, the point of view adopted in this version of an Early Christian prototype is nonetheless common to other Macedonian manuscripts. The observation is necessary since the study of Byzantine city representations has been improperly if— given the abundance of the material—understandably limited to the examination of towns surrounded by a wall.[70] Nonetheless, the similarities and differences between such *enceintes* and other, less completely enclosed, localities is often instructive. For example, in the Paris Gregory, a manuscript approximately contemporary with the *Christian Topography* in the Vatican and similarly dependent upon much older models,[71] one scene from the life of the emperor Julian is represented in a manner analogous to that of Stephen's martyrdom. In the middle register of the page, St. Basil, in company with St. Gregory Nazianzenus and a group of monks and novices, prays for the death of the Apostate.[72] The setting is the courtyard of a monastery, its front wall "cut away" to reveal the standing figures of the clergy. This scheme thus resembles that employed in the Stoning of Stephen. The full-page miniature, furthermore, shares with the strip illustration the device of a raised, rear wall before and below which the action occurs. The wall of the arena is far more summarily handled than that of the monastery, yet each creates the effect of an enclosed space, the locus in which is depicted the subject of the painting.

In contrast, the uppermost register of the Julian page shows the walled city of Ctesiphon, separated from the advancing emperor by a bridge over the Euphrates. Again seen obliquely from above, the rear wall is now obscured by the full complement of buildings within the city, a crush so great that the farther structures actually usurp the terrain that the rear wall should occupy. Despite this, we are evidently intended to read a regular, quadrilateral figure, its walls meeting in four circular towers at the

69. H.L. Kessler, "Paris. gr. 102: A Rare Illustrated Acts of the Apostles," *D.O.P.* XXVII, 1973, pp. 214–215.

70. Cf. the exceptional study by Ehrensperger-Katz, "Représentations," and C. Nordenfalk in *Proc. Am. Philos. Soc.* CXVII, 1973, pp. 233–241.

71. Weitzmann, "Illustration for the Chronicles," pp. 110–113.

72. Paris gr. 510, fol. 409v (Omont, *Miniatures*, pl. LIX).

corner of the *enceinte*. The surround of the monastery below, on the other hand, is highly irregular and punctuated by rectangular towers.

The substitution of rectangular for round towers is hardly significant since, although such structures are usually circular in the Paris Gregory, towers that are square in plan stud the walls of cities elsewhere in the manuscript.[73] The towers in the Joshua Roll vary from clearly square (Fig. 80), rectangular, or circular (Fig. 52) to an amorphous shape that, like those on the coins, is impossible to categorize.[74] More remarkable in the depiction of the monastery is the absence of a frontal wall, the dominant aspect of Middle and Early Byzantine images of cities and other "self-contained" structures. In sixth-century mosaics[75] and in manuscripts from highly diverse parts of the empire,[76] such edifices may vary considerably in plan, elevation, and content, but they are suggested almost without exception in terms of an architecture elaborated behind and protected by a massive forward wall. The Hellenistic, Roman, and Early Christian sources of this type have been related too many times to require repetition here.[77] But, insofar as painting of the Macedonian era is concerned, the ubiquitous emphasis upon this first line of defense should suffice to undermine a recent suggestion that because the Byzantine capital was strongly fortified, its artists (as opposed to Carolingian and Ottonian painters) felt no need to dwell upon the city's walls.[78] Nor is this Middle Byzantine emphasis true only of cities. Images of sites that lack a circuit wall, such as the amphitheater of the Vatican Cosmas (Fig. 97) or St. Basil's monastery in Paris gr. 510, depart radically from Roman models in which camps,[79] amphitheaters,[80] and the like, although drawn in bird's-eye view, are yet contained by a wall most fully expressed in the plane before the building. They are anomalies, as are the Palaeologan *hyperpyra* with an aerial view of the city, precisely because they depart

73. E.g., Damascus in the miniature of Paul's conversion, fol. 264v (Omont, *Miniatures*, pl. XLII) and Jericho, fol. 424v (ibid., pl. LV).

74. E.g., sheet XII (Weitzmann, *Roll and Codex*, fig. 171).

75. E.g., at Gerasa (F.M. Biebel, "The Walled Cities of the Gerasa Mosaics," *Gerasa, City of the Decapolis*, ed. C.H. Kraeling [New Haven, 1938], pp. 341–351, pl. LXVII, LXVIII, and passim).

76. E.g., the Vienna Genesis, cod. theol. gr. 31, picts. 5, 7 (H. Gerstinger, *Die Wiener Genesis* [Vienna, 1931], I, pp. 151–162; II, pls. 9, 13); the Ambrosian Iliad, miniatures XXXIX and XXXX (R. Bianchi Bandinelli, *Hellenistic-Byzantine Miniatures of the Iliad* [Olten, 1955], figs. 192, 194).

77. Cf. Gerstinger, note 76 above; Weitzmann, *Joshua Roll*, pp. 61–62; Ehrensperger-Katz, "Représentations," pp. 1–2.

78. Ehrensperger-Katz, "Représentations," p. 25. The author's thesis, which is psychological rather than, as she believes, historical in nature, is contradicted by the ample pictorial evidence included in her article. Middle Byzantine painters were generally too intent (although not always successfully so) upon a faithful copy of their models to allow "le désir de securité" to intrude into their appropriations from the Antique. This degree of dependence is illustrated by G.M.A. Hanfmann ("Hellenistic Art," *D.O.P.* XVII, 1963, p. 88, figs. 24–25), who juxtaposes the Jonah miniature of the Paris Psalter with the Fall of Icarus from the triclinium of the House of Amandus at Pompeii. The city in the Pompeian fresco is realized as a spatial entity far more naturalistically than Nineveh in the psalter, but in each case the frontal walls are the predominant element.

79. E.g., on the column of Marcus Aurelius (G. Becatti, *Colonna di Marco Aurelio* [Milan, 1957], figs. 9, 67).

80. E.g., the frequently reproduced view of the amphitheater at Pompeii during the riots of A.D. 59.

from a tradition more than a thousand years old when that monumental resumé of earlier models, the Paris copy of the Homilies of Gregory Nazianzenus, was made for Basil I.

It may be that the prototypes of the "open-plan" arena and the monastery in the two late-ninth-century manuscripts were topographical forms akin to the manner in which Troy is represented in the Tabula Iliaca. The example in the Capitoline Museum in Rome, in particular, shows the city disposed in such a way as to emphasize its further reaches (Fig. 98).[81] Rendered obliquely from above, both its major colonnades and the flanking groups of humbler buildings in the upper register converge toward the rear wall, a tower-studded screen that, because of its irregularity, attracts the eye in a way that the plane of the forward wall does not. But the academic reduction of medieval art to a history of prototypes and derivatives can obscure the contribution of the "copyist" and even deny the possibility of novel creation. While this dependence upon models may be a central feature of the Byzantine artistic tradition, reinforced by modern prejudice in favor of naturalism, such an approach runs the risk of automatically derogating all later work. In an age that sets originality among the higher virtues, the judgment that one work is the paradigm for others cannot claim to be entirely free of evaluation.

The search for prototypes may cloud the history both of iconography and of style. Thus the mosaic depicting Justinian offering his church and Constantine his city to the Theotokos enthroned in the south-west vestibule of Hagia Sophia (Fig. 95), has been related to numismatic examples from Roman Asia Minor showing emperors presenting temples to the patron-goddess of a city. The observation is appropriate probably to the mosaic in question and assuredly to the theme of our present study. But it must not be allowed to obscure the fact that the image of Constantinople in this mosaic, set up at some indeterminate date about the year 1000, is unlike anything we have seen in the major Macedonian manuscripts so far considered. While the masonry faces, turned toward the Virgin and the spectator, still command major attention, the rear wall is no longer totally obscured by the buildings within the city. Rather, it rises behind them toward merlons pitched at angles that exaggerate the deflection of the wall from the plane surfaces established in the nearer parts of the circuit. The siting of the rear crenels is now determined not only by the location of the walls but also by some exterior consideration. This might be termed the viewpoint of the beholder were he not, in fact, looking up from the pavement some six and one-half meters below this lunette. In this light, the arrangement of the towers of Constantinople on the coins of Michael VIII and Andronicus II (Figs. 41–43) may look, if no more rational, at least not entirely without precedent.

At the same time, the tendency toward semicircularity in the rear walls of this image presages what would happen to this newly emergent part of the *enceinte* in the eleventh century. Deprived of its towers, it suffers also the more significant loss of its rectilinear-

81. *E.A.A.* VII, pp. 597–580, fig. 690. For the identification of the buildings, the date (early in the Principate?), and the literature on the Capitoline tablet, see A. Sadurska, *Les Tables iliaques* (Warsaw, 1964), pp. 27–37.

ity. The rear part of the faceted crystal that was the Early and Middle Byzantine image of the city now dissolves into formless obscurity. This transformation can already be observed at the hands of the various painters at work on the Menologion of Basil II. Whereas the city before which Joshua encounters the Angel of the Lord retains a vestige of its original, hexagonal aspect (Fig. 99),[82] many others—such as that which sets the scene for the Finding of Moses—in this great collaborative effort offer an unmistakable hemicycle by way of a rear wall.[83] Evidently the Moses miniature represents not so much a different model copied as a different concept of the city purveyed by another, and perhaps younger, artist. This "dematerialization" goes beyond a mere rejection of the further part of the wall as a prismatic and substantial mass located in real space. By the eleventh century the cities of Jerusalem and Damascus, which were set obliquely and represented as receding in perceptible, spatial graduations in the Vatican Cosmas (Fig. 75), have, in the Sinai copy of the manuscript, become flat screens parallel to the plane of the miniature.

No more than in the case of the analogous metamorphosis undergone by Roman art in the third and fourth centuries after Christ can this development—of which the reduction of the city is an epitome—be attributed primarily to technical incompetence. The intensification and acceleration of the process in many early Comnenian manuscripts produced in the capital shows that we are confronted here not with successive examples of careless copying but with evidence for a changing manner of looking at and representing the phenomenal world. The city as a highly complex visual image is among the clearest exemplars of this transformation. The *enceinte* representing the Egypt toward which the Holy Family progresses in Paris gr. 74 still retains a faceted aspect in its lateral wall and cornice (Fig. 54). Even this has disappeared in the corresponding miniature formerly in the closely related Gregory manuscript, cod. Taphou 14.[84] The city is now an almost perfect cylinder, its rear wall adorned rather than fortified with gratuitous turrets. It functions no longer as a topographical, if conventional, indicator. Instead it exists solely as a scripturally ordained haven for the Family: in each case one-half of the wall surface is given over to the gates that will receive the Lord.[85]

It has been suggested that the eleventh-century image of the city, with its large portal and semicircle of crenelation, is of another type than the Middle Byzantine versions with which we have been concerned and derived from a different model (known only on Roman coinage).[86] This leaves unconsidered the possibility that the newer image is only a reduction and simplification of the older. No reason is suggested why, at the end of the Macedonian era, painters should suddenly begin to employ fresh antique prototypes: as is well known, the age for this sort of innovation was in fact just

82. Vat. gr. 1613, fol. 3r (Lazarev, *Storia*, fig. 119).

83. A similar process is observable in the West, where the familiar hexagon of the Carolingian city type is replaced in the Ottonian era by a compound consisting of half a hexagon for the forward part of the image joined to half a cylinder at the rear.

84. Detached leaf in Leningrad, Public Library, cod. gr. 334 (Lazarev, *Storia*, fig. 203).

85. Cf. Ehrensperger-Katz, "Représentations," p. 27: "Dans l'art byzantin, toutes les représentations de villes servent d'indication topographique; elles ne comportent pas de signification symbolique."

86. Ehrensperger-Katz, "Représentations," p. 27.

closing. Rather, a comparison between a late-ninth-century depiction of the city (Fig. 23) and that in cod. Taphou 14 made two centuries later reveals the similarity between the two images and the evident fact that the later grew out of the earlier type. Both Ctesiphon and "Egypt" are drawn in bird's-eye view. Neither attempts a characterization of a particular locale; both are ideograms serving as textually motivated destinations rather than as the teeming habitations of men. Accordingly, the architectural contents of both cities remain purely schematic. But the relationship between the diverse structures inside the city assailed by Julian and the simplified and flattened buildings that will shelter the Christ Child is precisely the same as that between the two *enceintes*. As the relatively complex system of the walls of Ctesiphon was pared down to the simple cylinder enclosing "Egypt," so for the volumetric diversity of the buildings that it houses were substituted the spindly, token structures of the late-eleventh-century miniature. The change was the result of neither an impulse to seek new iconographical sources nor a stylistic adaptation appropriate to the smaller compass of early Comnenian manuscripts. At the end of the century we find the "reduced" city employed in so important and monumental a composition as the Entry into Jerusalem at Daphni.[87] Instead, it exemplifies the evolution toward a world in which the Greeks would no longer put their faith in masonry battlements. The history of city representations after the battle of Manzikert suggests the increasing importance attached to non-terrestrial defenses.

This shift of emphasis is evident in the part that the image of the city was called upon to play in Comnenian and Palaeologan art. It did not lose its perennial function as topographical denominator: the city of Nain in the background of the Raising of the Widow's Son at the Kariye,[88] and a host of similar examples, is clear evidence of this. But another example in the same church, the fresco of Isaiah and the Angel before Jerusalem, which we have already considered (Fig. 88),[89] suggests the new rôle assigned to the image. It is here an integral element of the action, an object the protection of which is the *raison d'être* of the composition. And in this new rôle, the form it assumes is the city in its post-Macedonian aspect. While Nain appears as a conventional if somewhat distorted hexagon, Jerusalem has a polygonal front but a semicircular rear wall. What we have called the "reduced" form is not an invariable concomitant of the actively defended city, as against the more elaborate form that the image assumes when it is but a background feature in an incident that happens to be assigned a place-name in Scripture. Yet it is generally true that when the city becomes an integral element in a miracle, rather than simply the setting in which a miracle occurs, it is represented in the fashion evolved only after the Middle Byzantine process of learning from hellenistic examples had been accomplished.

The image of the city from the second half of the eleventh century is smaller, less complex, and less "real." Most important of all, it is now shown to be under some form of heavenly protection. Constantinople, for example, appears without towers and with

87. Millet, *Daphni*, p. 162, fig. 165.
88. Underwood, *Kariye Djami* I, pp. 196–197, III, pls. 360–361.
89. Cf. p. 117 above.

a purely token ring of crenelations in the margin of a liturgical roll of this date in Jerusalem (Fig. 100).[90] The city is surrounded by a quasi-cylindrical wall in which, however, less faith is put than in its patrons, shown in a pendant image in the left margin. Constantine and Helena, their hands joined about the Cross, form the anthropomorphic initial letter of the invocation $M\nu\acute{\eta}\sigma\theta\eta\tau\iota\ K[\acute{\upsilon}\rho\iota]\epsilon$. Here the Lord is called upon to protect "the whole city and region and those who live faithfully therein."[91] Given the wide and early diffusion of this prayer,[92] it is remarkable that only at the end of the eleventh century do we find it illustrated with the representation of a specific city.

Hardly less certain is the identification of the city on a reliquary at Vatopedi defended by St. Demetrius (Fig. 93).[93] The assailants on this particular occasion remain the subject of scholarly debate, but there can be little doubt that the asymmetrical *enceinte*, from which all harm is single-handedly turned away by the saint, represents Thessaloniki. Its improbable architecture consists of ashlar blocks, apparently laid vertically about the portal, and twelve turrets capped with tiled cupolas. Obviously the silversmith was not at pains to suggest a particular or even a particularly defensible city. For him the important feature was the void inhabited by the saintly warrior and set like a vast, recessed tympanum above the entrance wall. In comparison with his gigantic figure the actual fortifications are insignificant: decoration rather than the preservation of *ein feste Burg* would seem to be their function. These proportions are not merely an expression of the familiar, post-Macedonian ratio of figures to architecture, but what we might expect in a cult image rather than a composition depicting a historical event.

The fragments of frescoes discovered in the basilica of St. Demetrius at Thessaloniki in 1907 and destroyed in the fire of 1917 may have constituted part of such a cult cycle.[94] The *Miracula sancti Demetrii*, upon which the legend of the megalomartyr's exploits primarily rests and which is probably the literary source for the cycle, also records a mosaic of the saint set up on the frontal wall of the church.[95] Whatever the relationship between this image and the wall paintings—possibly as old as the seventh century[96]—it seems reasonable to recognize this cult center as the fountainhead of an

90. Greek Orthodox Patriarchate cod. Stavrou 109 (A. Grabar, "Un Rouleau liturgique constantinopolitain et ses peintures," *D.O.P.* VIII, 1954, p. 164, fig. 17).

91. Brightman, *Liturgies*, p. 335.

92. An almost identical text occurs in the Liturgy of St. James, practiced from the fourth or fifth century in Palestine, Arabia, Greece, Georgia, and perhaps in Egypt before it was overtaken by that of St. John Chrysostom and the "byzantinization" of the Patriarchate of Antioch. For this earlier prayer, see B.-Ch. Mercier, *La Liturgie de Saint-Jacques* [= *Patrologia Orientalis* XXVI,2] (Paris, 1946), pp. 121–122.

93. A. Grabar, "Quelques Reliquaires de saint-Démétrios et le martyrium du saint à Salonique," *D.O.P.* V, 1950, pp. 3–5. Grabar, like the earlier literature that he cites, assigns this piece to the twelfth century.

94. Diehl, *Salonique*, p. 113. We await the forthcoming study of Thessalonican art and architecture by M. Vickers and R.S. Cormack. For now, see M. Vickers, "Sirmium or Thessaloniki? A Critical Examination of the St. Demetrius Legend," *B.Z.* LXVIII, 1974, pp. 337–350.

95. *P.G.* 116, col. 1220, 167, col. 1333.

96. Grabar, *Martyrium* II, p. 75.

iconographical cycle best preserved in Serbian painting of the Palaeologan period. Among the vast decorative programs of Dečani, the patron saint of Thessaloniki is shown restoring a crumbling tower of his city and again, actually poised on its battlements, staving off the adversaries who have scaled them with a ladder.[97] In this latter guise, although standing within the crenels rather than on the merlons, St. Demetrius appears again, in his own church at Peć, in a fresco painted some three hundred years after his first Serbian representation in this rôle about 1335–1350.[98] Finally, on the south wall of the Church of the Archangels at Lesnovo, close in time and spirit to the frescoes at Dečani, St. Michael stands triumphant before the city of Constantinople and above the upturned ships of the Saracen fleet.[99]

It is in the light of such admittedly later images that we must understand the confidence of the people of Constantinople, which Odo of Deuil remarked with some surprise in 1147. The Frank, unaware of the saints hovering above them, noted only the feebleness of the city's walls and towers and yet its inhabitants' traditional sense of security.[100] The polar opposition between the Latin and the Greek attitudes upon this point illumines the manner in which such paintings were created. The translation of historical incident into pictorial image is but the second stage of a process that begins with the conversion of the temporal event into myth. The onslaughts of Cumans, Saracens, and Avars upon Thessaloniki and Constantinople were occurrences in linear time; before they could be made into art both the foes and their temporal mode of being were annihilated by the saints, perennially watchful and eternally present.[101]

The disaster of 1453 made no difference to this cast of mind. If proof is needed, it is to be found in the well-known series of Moldavian wall paintings representing the Ottoman siege of the imperial capital. The best-preserved example, at Moldoviţa, shows Constantinople as an irregular hexagon, its angles protected by fanciful, many-storied towers (Fig. 101).[102] As on the coins, only the inner wall is depicted. From this, archers and cannon fire at the assailants approaching by land and sea. The actual defenders, however, are few in number beside the ceremonially vested deacons and other clerics with crosses and Gospel books in their hands. A procession led by the empress and her

97. V. Petković, *Manastir Dečani* (Belgrade, 1941), I, pp. 58–59. See also A. Stojaković, "Quelques représentations de Salonique dans la peinture médiévale serbe," Χαριστήριον εἰς Ἀναστάσιον Κ. Ὀρλάνδου, III (Athens, 1966), pp. 25–48, figs. 1, 2 (drawings).

98. Ibid., fig. 3.

99. N. Okunev. "Lesnovo," *Recueil Uspenski* I, pp. 230–231, 250–251, pl. XXX,2. This and thirteen other interventions are recorded in the manual of Dionysus of Fourna (A. Papadopoulos-Kerameos, Ἑρμηνεία τῆς ζωγραφικῆς τέχνης [St. Petersburg, 1909], pp. 174–175).

100. Odo of Deuil, *De profectione Ludovici VII in Orientem*, ed. V.G. Berry (New York, 1948), p. 64.

101. N.H. Baynes, "The Supernatural Defenders of Constantinople," *Analecta Bollandiana* LXVII, 1949 [=*Mélanges Paul Peeters* I], pp. 165–177.

102. V. Grecu, "Eine Belagerung Konstantinopels in der rumänischen Kirchenmalerei," *Byzantion* I, 1924, pp. 273–289, fig. 17. The decoration of Moldoviţa is dated to 1536–1537. Grecu considers this painting and three related examples to be modifications of an image of the Arab siege of the capital in the seventh century originating in illustrations to the Akathist Hymn. The most recent discussion, treating all known versions of this scene, is O.F.A. Meinardus, "Interpretations of the Wall-Paintings of the Siege of Constantinople in the Bucovina," *Oriens Christianus* LVI, 1972, pp. 169–183.

ladies closes with monks bearing icons of the *Mandylion* and the Theotokos. While a rain of fire falls on the enemy in a lesser battle outside the city, the prayers and icons of its inhabitants are all that they need to withstand the Turkish artillery trained upon them. Nothing in the painting suggests the eventual outcome of the blockade.

For all its Orthodox attitude to the fall of Constantinople, the Moldoviţa painter depicts the city in a manner unlike that of any Palaeologan artist. The interior of the city is bathed in light, while the external faces of the rampart are shaded. The lateral walls converge toward the rear in an attempt at linear perspective only slightly impaired by the overall bird's-eye aspect. By 1536 Moldavia had obviously acquired some of the techniques of the early quattrocento. But the *hyperpyra* with the Virgin *en face* and the towers of Constantinople disposed about her (Figs. 41–43), struck first some time after 1261, obviously cannot derive from such a source. Did the Latin West, through its occupation of the capital or its subsequent colonies there, impart a type of city representation that could be emulated by the die-cutters of these coins?[103] If the subject on their obverse is non-Western,[104] must this be necessarily true of their form?

The mid-thirteenth-century image of a city, at least as far as provincial French manuscript illustration is concerned, is perhaps fairly represented by a Psalter and Book of Hours illuminated at Arras (Fig. 102).[105] Within the upper half of the initial a frontal David is crowned by priests and monks. Their arms form a canopy over his head, an effect strengthened by the superstructure of the farthest tower. This and its four counterparts define the junctions of a pentagonal circuit seen in bird's-eye perspective. But the towers, the walls, and their inhabitants, here and in the coronation of Ish-bosheth below, are all drawn in elevation. The conventional Gothic city bears no relation to that on the *hyperpyra* with its combination of radically different points of view. The only Western architectural image that approaches this Palaeologan conjunction is one deriving from the Beatus tradition in Apocalypse manuscripts, of which the example nearest in date to the coins is at Trinity College, Cambridge.[106] About the image of Christ, the angel with the measuring rod and the river of living waters, the walls of the Heavenly Jerusalem are laid out in projection, coruscating surfaces punctuated by three towers on each side. Here walls and towers are at right angles to the central group, and to John and the angel below. In its way, the difference between the tradition represented by this page is as different from the image on the *hyperpyra*

103. For the impact of Western painting upon Palaeologan art, see T. Velmans, "Le Parisinus graecus 135 et quelques autres peintures de style gothique dans les manuscrits grecs à l'époque des Paléologues," *Cah. arch.* XVII, 1967, pp. 209–235.

104. The "Belleville Breviary," Paris, B.N. MS lat. 10483-4, has a calendar page with marginal illustration of the Virgin standing upon the open gates of Paradise (K. Morand, *Jean Pucelle* [Oxford, 1952], p. 10, pl. va).

105. New York, Morgan Library M. 730, fol. 78v (S.C. Cockerell, *Burlington Fine Arts Club, Exhibition of Illuminated Manuscripts* [London, 1908], no. 138, p. 93).

106. MS R.16.2, fol. 25v (P.H. Brieger, *The Trinity College Apocalypse* [London, 1967], p. 16). The date of this manuscript is disputed; Brieger assigns it to 1242–1250. An Anglo-Saxon parallel to this peculiar combination of different viewpoints on a figure within an architectural setting exists in the "Caedmon" Genesis, Oxford, Bodleian MS Junius 11, p. 11 (J.J.G. Alexander, *Anglo-Saxon Illumination in Oxford Libraries* [Oxford, 1970], fig. 16).

as is the miniature in the Arras manuscript. Beyond the fact that the towers on the coins are not flatly projected as they are in the Trinity Apocalypse, their orientation vis-à-vis the Theotokos is consistent. We do not need the Virgin to tell which way is "up"; but, were it not for the figures, the image in the Trinity manuscript would read equally well, whichever way the page is turned.

Not until the second half of the fifteenth century does there occur in Western art an image of a city comparable to that on the Byzantine coins of two centuries earlier. An untitled manuscript in the British Museum contains a representation of Constantinople full of topographical detail but in terms of spatial conception akin to that on the *hyperpyra* (Fig. 103).[107] As on the coins, the city assumes something of the pear-like shape that it had in reality; equally, too, it shows the towers in bird's-eye view, those of the land walls particularly inclined toward the monuments shown in elevation within the *enceinte*. The minarets that flank Hagia Sophia in the miniature suggest a *terminus post quem* for the manuscript, as well as the somewhat mournful reflection that it was only after the fall of Constantinople that the West, however imperfectly, saw Byzantium as had the Byzantines.

The medieval West, therefore, is not the source of the Palaeologan image in question, a view of the city that, as we have seen, has no prototype in Byzantine art. If we widen the range of our investigation, the history of city representations in its entirety offers precious few analogies for our peculiar combination of perspectives. Absent in medieval art both Eastern and Western, it was equally unknown to the Greco-Roman world. Before the classical age we must go back as far as the monuments of Assyria to find a city with walls depicted in bird's-eye view but contents either *en face* or in profile.[108] Such reliefs had no heirs and it is not until the sixth century after Christ that a city is represented in the main obliquely, but with the buildings within its circuit walls rendered from differing viewpoints. This is the image of Jerusalem on the celebrated mosaic map found at Madaba in 1896 (Fig. 104).[109] The city's *enceinte* is drawn correctly from the beholder's point of view, its towers rising in parallel from the walls that they attend. This first impression of rationality is reinforced by the clear orientation of the *cardo*. But once this is past, the elements of the city's interior are lost in a bewildering complex of aspects so diverse that a major monument like the

107. MS Arundel 93, fol. 155r (F.W. Hasluck, "Notes on Manuscripts in the British Museum relating to Levant Geography and Travel," *B.S.A.* XII, 1905–1906, p. 214, pl. 1,2). Despite the Reims-like gallery of figures on the façade of Hagia Sophia, this view is a radical departure from high medieval representations of Constantinople. B.M., Add. MS 42130, fol. 164v (E.G. Millar, *The Luttrell Psalter* [London, 1932], p. 42, pl. 81), for example, shows the city as a rectangle with circular towers at the corner of the battlements and a church at its center with a spire surmounted by a weathercock.

108. A.H. Layard, *The Monuments of Nineveh*, series I (London, 1853), pl. 77. For one view of the significance of the image of the circular city in Achaemenian and Persian art, see L'Orange, *Cosmic Kingship*, p. 92. Perhaps the nearest example the classical world can offer by way of a parallel to our peculiar combination of different points of view is a bronze coin of Caracalla showing the port of Mothone in the form of an amphitheater enclosing a statue seen *en face*, which F.W. Imhoof-Blumer and P. Gardner ("A Numismatic Commentary on Pausanias," *J.H.S.* VII, 1886, p. 72, pl. P VIII) relate to Pausanias IV, 35, 1, describing the maritime approach to this city.

109. M. Avi-Yonah, *The Madaba Mosaic Map* (Jerusalem, 1954).

Church of the Holy Sepulcher is inverted while St. Stephen's Column is shown on its side in the same plane as the main street. Hence, whereas the Jerusalem map shares with the *hyperpyra* the conjunction of various viewpoints, it entirely lacks that element of design that makes the coins readable: they do not have to be turned around in order to discover the correct orientation.

The walls and towers on the coins are consistently ordered in terms of a simple and appropriate visual logic. Although drawn in an utterly different plane from the Theotokos in their midst, their position and their degree of inclination depends upon hers. They are, in short, subordinate to the central image. The city is not the determining feature of the composition but rather is arranged about, and with exclusive regard to, the icon of the Virgin. Its rôle is not to suggest—and much less to dictate—Mary's physical situation. Instead, on the level of design, its fortifications provide her with a border, a shield-like frame. On the theological level, as we shall see, they are in fact defended rather than defensive. But the mystery of the Mother of God who is the strength of the walls that protect her must wait upon the recognition of the image as a whole for what it is.

If the walls are a subordinate rather than a dominant element in the composition, then it is pointless to look further for the sources of the image in the history of city representations. Before leaving the domain of architectural images entirely, however, it is necessary to consider a final example, one that reverts not to the iconographical tradition of the city but to that of one structure in it—the arena with which we have already been concerned.[110] The last manifestation of this theme in Constantinopolitan art would seem to be the martyrdom of St. Euphemia, the climactic image in a fresco cycle of her life in the church dedicated to her beside the Hippodrome (Fig. 105).[111] Painted perhaps within a generation of the time when the coins were first struck, its composition bears some striking resemblances to the Virgin on the Walls. We are at once confronted with an *orans* figure within a space enclosed by towers. The saint stands in an arena, her head projecting above its circuit in front of an arcaded gallery possibly suggested by the architecture of the Hippodrome itself. The flanking towers, turned obliquely, define the depth of the scene and hence the space within which her death occurs. But the illusion of depth is contradicted by the contours of the darkened arena, projected like a flat disc against the towers that it overlaps. As on the *hyperpyra*, the *orans* gesture contributes to the impression of a figure rising from within an architectural *enceinte*, a sensation eminently appropriate to a Christian martyrdom. But unlike the coins, on which the walls and towers create a circular frame for the Virgin, Euphemia—and the beasts fawning at her feet—are here cut off from the architecture of the environment. The ultimate impression is of an *imago clipeata* that has burst its bounds.

No such sensation attends the image of the Virgin on the coins. Her half-length figure is completely contained by the *clipeus* of the walls' circuit. Despite the

110. Cf. p. 121 above, and fig. 138.
111. R. Naumann-H. Belting, *Die Euphemia-Kirche am Hippodrom zu Istanbul und ihre Fresken* [*= Istanbuler Forschungen* 25] (Berlin, 1965), pp. 136–138, fig. 44, pl. 33a.

unfortunate effect produced by the double-striking of many surviving specimens, the fundamental design is extraordinarily well adapted to the form of an *orans* bust. And with or without the Child, the Mother of God in this attitude, enclosed within circular frames of considerable variety, became a major theme of Palaeologan decoration. The last era of Byzantine art produced more *imagines clipeatae* of the Virgin than all previous centuries combined. The image on the coins is but a particular expression of this type.

While in the greatest church of the empire the fourteenth century saw the setting up of a full-length image of the Virgin *orans*, elsewhere the bustate figure was generally adopted. The mosaic on the eastern arch of Hagia Sophia, known to us through a drawing of Fossati's, replaced one destroyed in the earthquake of 1346;[112] in newly built churches the preferred version was the half-length Theotokos set within a medallion at the apex of a major vault or centrally located on a wall of the nave. We have already considered such images, both in fresco (Fig. 94) and mosaic, at the Kariye.[113] Slightly earlier, in the Aphentiko at Mistra, the Virgin with the Child before her fills the cupola of the west tribune gallery (Fig. 106),[114] separated from the prophets in the drum by a broad medallion defined by two pairs of concentric circles. The scheme is repeated in the same location at the Pantanassa as late as 1428[115] and, in the same church, a virtually identical *orans* commands the central domical vault of the north aisle.[116] Elsewhere in Greece, as in the little chapel of the Archangels at Desphina, we find the bust of the Theotokos enclosed within a medallion supported by the taxiarchs Michael and Gabriel. It would seem that this image—part of a program dated by inscription to 1332—is the result of a specifically Palaeologan substitution of the Mother of God for Christ in the roundel.[117]

The enframement of the bustate Virgin within a *clipeus* that both separates and relates her to hierarchically subordinate figures was not an invention of the thirteenth century. Among lesser-known uses in the "minor arts," the composition is found on liturgical *panagiarias*, the dishes of ivory, silver, and other materials reserved for the Eucharistic bread [*artos*]. One especially fine example at Dečani, dated in the late twelfth century, shows the *orans* Mary, her Son before her in a medallion, surrounded by the archangels, the apostles, and other saints.[118] But the employment of the half-

112. C. Mango, *Materials for the Study of the Mosaics of St. Sophia at Istanbul* (Washington, D.C., 1962), pp. 72–73, fig. 95.

113. See pp. 119–120 and note 57 above.

114. Dufrenne, *Mistra*, p. 28, fig. 28.

115. Millek, *Mistra*, pl. 148, 1.

116. Dufrenne, *Mistra*, fig. 54. For another application of the Virgin in a cupola, cf. Millet, *Mistra*, pl. 132,2 (Hagia Sophia) and pl. 148,1 (Pantanassa).

117. M.G. Soteriou, Ἀι τοιχογραφίαι τοῦ βυζαντίνου ναυδρίου τῶν Ταξιαρχῶν Δεσφίνης, Δ.Χ.Α.Ε., 1962–1963, pp. 198–199, pl. 60.

118. M. Jevrić, "Panagia du trésor du monstère de Dečani," XII *C.E.B.* (Belgrade, 1964), III, pp. 151–157. For later examples employing either the bust of the Virgin or her full-length figure, cf. N.P. Kondakov, *Pamîamiki khristianskago iskusstva na Afonie* (St. Petersburg, 1902), pp. 225–229, pl. xxx–xxxiii. Cf. also A. Grabar in *Catalogo del Museo Sacro della Bib. Apost. Vat.* I, and C.R. Morey, *Gli oggetti del avorio e di osso* (Vatican City, 1936), nos. A129–130.

length Blachernitissa in architectural decoration is, in the main, a compositional device of the last phase of medieval Greek art. The main domes of Middle Byzantine churches were generally devoted to the Pantocrator or the Ascension. The descriptions of ninth-century buildings by Photius[119] and Leo VI[120] contain no reference to the Virgin in such a situation. And the programs surviving in eleventh- and twelfth-century churches do not include her in their cupolas:[121] until the Palaeologan era the prime location of the Theotokos is the conch of the apse.

The derivation of the Virgin in the vault from earlier images of the Pantocrator— which of course did not cease to be used in the main dome—is clearly indicated by the prismatic or otherwise vivid border that defines her station (Figs. 94, 106). Her half-length figure, and that of the Child before her, seems to be not so much truncated by as rising from behind this line of demarcation.[122] Her image corresponds exactly with that of the Pantocrator in the Apostoleion of Constantinople, described by Mesarites as "leaning out as far as his navel through the lattice at the summit of the dome."[123]

In the *clipeus caelestis* of Palaeologan vaults, the Virgin is removed from the narrative sequences unfolding on the walls beneath her. She is present without participating, in precisely the fashion that she appears in pre-Iconoclastic manuscripts, icons, and frescoes[124] as well as in the roundel of the mosaic over the Imperial Door at Hagia Sophia (Fig. 1). Removed by her location and the strongly defined medallion from the immediate, physical vicinity of the incidents drawn from Gospel and Apocrypha, the Theotokos yet surveys the entirety of the bay below her. As in the case of the Pantocrator, her location contributes greatly to the sense of her proximity and her involvement in the liturgy below.

The effect stems in part from the elaborate theory of theological and analogical relationships that seems to have determined the form and situation of images in the Middle Byzantine church.[125] But perhaps equally instrumental is the subtle transfiguration of the classical *imago clipeata* made in the eastern portions of the empire, a source on which medieval Greek art drew as freely as on Greco-Roman traditions. Whereas the figures of divinities in Hellenistic *clipeata* were almost always shown

119. Hom. X, on the inauguration of the Church of the Pharos (Mango, *Photius*, pp. 184–190, noting, however, in "the apse which rises over the sanctuary . . . the image of the Virgin, stretching out her stainless arms on our behalf and winning for the emperor safety and exploits against the foes" [p. 188]).

120. A. Frolow, "Deux Églises byzantines d'après des sermons peu connus de Léon VI le Sage," *Etudes byzantines* III, 1945, pp. 43–91.

121. One salient exception is the much-damaged mosaic of the Virgin surrounded by eight saints in the cupola of the inner narthex at the Nea Moni (G. Tsimas-P. Papachatzidakis, Ψηφιδοτὰ Νέας Μονῆς Χίου, ιά αἰὼν [Chios, 1931], pl. 43).

122. This impression is particularly strong in the western bay of the Kariye *parekklesion* (Fig. 94), where the inner edge of the medallion bisects her arm not neatly at the wrist but in a manner that overlaps a portion of her hand. The sense of a body hidden but continuing behind the roundel is thus made explicit.

123. Downey, "Mesarites," pp. 870, 901–902.

124. A. Grabar, "L'Imago Clipeata chrétienne," *L'Art de la fin de l'antiquité et du moyen âge* (Paris, 1968), I, pp. 607–613.

125. O. Demus, *Byzantine Mosaic Decoration* (London, 1948), pp. 5–39.

turning away from a completely frontal position,[126] in Palestine and in Egypt[127] the attitude became a direct, undeflected, and emotionless gaze. This is exemplified in a Nabatean relief tondo now in Cincinnati showing a goddess, *en face* and bustate, poised among the symbols of the zodiac (Fig. 107).[128] From the moon above her right shoulder and the ears of corn sprouting from her left, she might be thought to be a fertility figure. The celestial figures in the roundel about her suggest a "Lady of the Heavens," a Platytera *avant le lettre*. But the mural crown that she wears designates her primarily as a Tyche, the protective deity of Khirbet-et-Tannur, a city like Petra strongly influenced by Hellenistic-Roman art. The classical, oblique attitude is here modulated to the point where her unyielding stare prefigures the direct gaze of the Palaeologan frescoes we have considered and the long series of *hyperpyra* with which this investigation began. It may be that her function, as well as her form, was not very different from that of the Virgin on the coins.

Myth and History

Neither the figure nor the cult of Tyche was strange to the inhabitants of the city chosen by Constantine as his capital on the Bosporus. It is certain that the emperor, later celebrated as *philochristos basileus*, built or restored temples to this prophylactic goddess and that her statues adorned the public places of the capital.[129] It is equally sure that, long before the assertion appears in the pages of the city's chroniclers—the first such statement would seem to be by Cedrenus at the end of the eleventh century[130]—the Virgin had replaced Tyche not only as the protectress of Constantinople but as the goddess to whom the city was dedicated. The admission of this legend by the chroniclers, late as it is, exemplifies an instructive Byzantine confusion. Like the Israelites, whose travails they knew well, the Byzantines possessed the modern concept of neither mythology nor history and evinced little desire to distinguish between the two disciplines. Instead, for salutary purposes, they confounded one with the other. The successful resistance to a siege, or a fortunate withdrawal on the part of the enemy, was

126. E.g., the busts of Aphrodite and Artemis on the gold relief medallions found in Thessaly and now in the Benaki Museum, Athens (P. Amandry, *Collection Hélène Stathatos. Les bijoux antiques* [Strasbourg, 1963], nos. 233, 234).

127. E.g., a sixth- or seventh-century image of the Virgin in a *clipeus* from the monastery of St. Jeremias at Saqqara (Kondakov, *Ikonografiîa* I, pp. 158–159, fig. 89).

128. Cincinnati Art Museum, inv. no. 1939. 233 (N. Glueck, *Bulletin of the American Schools of Oriental Research* CIIVI, 1952, pp. 5–10, fig. 2). For the relationship to Coptic art of related second- and third-century sculptures from Khirbet-et-Tannur, see E. Kitzinger, "Notes on Early Coptic Sculpture," *Archaeologia* LXXXVII, 1937, pp. 206–210.

129. Frolow, "Dédicace," pp. 74–79.

130. Cedrenus, *Historiarum compendium*, C.S.H.B. I, p. 496. The *Synaxarium ecclesiae Constantinopolitanae* (ed. H. Delehaye, *Propylaeum ad AA. SS. Novembris*, col. 673) introduces an account of the foundation of Constantinople (11 May) with the observation that the city is under the protection τῆς παναγίας ἀχράντου δεσποίνης ἡμῶν Θεοτόκου καὶ ἀειπαρθένου Μαρίας καὶ ὑπ᾽ αὐτῆς διὰ παντὸς σωζομένος.

thereafter regarded as proof of the concern of God or his Mother; indeed, endurance in a present crisis was strengthened by reflection upon such past apotropaic interventions. Inconvenient as this may be to modern Byzantinists seeking to separate fact from fiction, for the subjects of their study, fiction was as much a wellspring of action as fact. The history of human motivation is filled with incidents where fabrications concerning the past have shaped a people's future. The occurrence in the chroniclers of the myth of the Virgin's watchfulness over the city is no more than a late echo of a belief that had long since determined its inhabitants' actions and colored both their religious and their artistic invention.

The idea of a city "Sought out, a city not forsaken"[131] but redeemed by the Lord was as old as the words of the prophet who, according to Photius, comforted Sion with words put into his mouth by the Mother of God.[132] When the Israelites felt abandoned by the Lord she assured them that he had painted their walls upon his hands so that the city was continually before him.[133] To Photius, this loving attention was again assured by the renewal in 867 of the image of the Virgin and Child in the apse of Hagia Sophia.[134] The restoration of icons, and of the apsidal Theotokos in particular, by the emperors Michael III and Basil I—created by the Lord to be "the eyes of the universe"—entitled them to his protection and, eventually, to his "endless and blessed kingdom."[135]

Among the host of city images offered in the Gospel lectionary, those describing Sion are the most numerous. The heavenly Jerusalem, like the Byzantine capital, is a place of walls, towers, and palaces. The reader of the Psalms is particularly enjoined to take pride in these,[136] and in the earliest post-Iconoclastic psalters saw the City peopled above all with the image of the Theotokos (Figs. 90, 91). For Paul, "all the buildings fitly framed together" make up the Lord's temple, God's habitation in which the Christian inhabitants of Ephesus are, together with the saints, fellow-citizens.[137] In Late Antique literature the city is either a heavenly locale above which the seer is

131. Isaiah 62:12.

132. *Hom.* XVII (Mango, *Photius*, pp. 292–293).

133. Isaiah 49:16.

134. The literature on the much-argued question of whether the apsidal image of 867 showed the Theotokos seated or standing is listed and discussed by Lazarev (*Storia*, pp. 176–177, note 70). Despite the detailed technical report of C. Mango and E.J.W. Hawkins, "The Apse Mosaic of St. Sophia at Istanbul. Report on Work Carried out in 1964" (*D.O.P.* 19, 1965, pp. 115–148), not all problems regarding the original form of this mosaic can be said to have been solved. Mango and Hawkins show that the present image is surely that unveiled in 867 and not a later replacement. Yet Photius describes the seated figure of the Virgin as ἀκίνητος ἕστρηκε and repeatedly stresses that she carries the Child in her arms, an unnecessary emphasis were Christ resting on her lap as in the mosaic visible today. R.J.H. Jenkins (*B.Z.* LII, 1959, p. 107) has argued that Photius' description is consistent with that of a seated figure. Nonetheless, the Patriarch's observation that "the image of the Mother rises up from the very depth of oblivion" remains a figure of speech more appropriate to the tall shaft of a standing figure, as in the apse of Nicaea or Kiev, than to the massive composition of an enthroned group.

135. *Hom.* XVII (Mango, *Photius*, p. 2–6).

136. Cf. Psalm 47[48]:12–13: "Walk about Sion, and go round about her: tell the towers thereof. Mark ye well her bulwarks, consider her palaces; that ye may tell it to the generation following."

137. Ephesians 2:19–22.

raised so that he may note its walls and gates,[138] or else a paradise like Libanius' Antioch, loved by the gods but firmly grounded on the earth.[139] Not until Constantinople are the two visions combined in imagery that suggests the blending of the celestial with the terrestial city. A sixty-foot inscription on the Marmara wall north of Değirmen kapisi records both Theophilus' faith in Christ, "a Wall that cannot be broken," and the emperor's plea that the Lord preserve the wall that he has newly built to the end of time "standing unshaken and unmoved."[140]

If, in the ninth century, lapidary texts invoked primarily the Son, earlier hymnographers had already assigned the prime apotropaic rôle to the Theotokos. The language of Theophilus' inscription particularly recalls the twenty-third strophe of the *Akathistos*, which salutes the Virgin as ὁ ἀσάλευτος πύργος and τό ἀπόρθητον τεῖχος.[141] While the Hymn celebrates her with a vast variety of epithets—notably as "thou through whom Paradise is opened"[142]—the emphasis throughout is upon Mary as a refuge. At the same time she is hailed as "container of the uncontainable God" and "seat of the Emperor,"[143] descriptions that, in conjunction with the repeated description of the Theotokos as a rampart, suggest a mystical topography in which she is at once the wall and the reason for its strength, as well as the city within the wall and the reason for its existence.

In this early anthem we are close to the ambiguities presented by the image on Palaeologan coins. That the centrality of the Virgin is not incompatible with the idea of her preserving the *enceinte* is already indicated by the analogous design of Justinian's fortresses on the frontiers of the empire. From Syria to Spain, square or rectangular strongholds with walls up to ten feet thick were protected on their exterior by projecting towers and internally by a church customarily dedicated to the Mother of

138. E.g., in the Apocryphal apocalypse known as 2 Baruch, 6:1–5 (R.H. Charles, *Apocrypha and Pseudepigrapha of the Old Testament*, II: *Pseudepigrapha* [Oxford, 1913], p. 483) and the Book of the Secrets of Enoch, 13:1–14:1 (ibid., p. 437).

139. *Orat. XI*, 66, 180 (G. Downey, "Libanius' Oration in Praise of Antioch," *Proceedings of the American Philosophical Society* CIII, 1959, pp. 661, 671).

140. F. Dirimtekin, *Fetihden önce Marmara surlari* (Istanbul, 1953), p. 62, no. 6. The inscription in a fuller state is transcribed by A. van Millingen, *Byzantine Constantinople. The Walls of the City and Adjoining Historical Sites* (London, 1899), p. 183. Cf. C.A. Mango, "The Byzantine Inscriptions of Constantinople," *A.J.A.* LV, 1951, p. 56, no. 31.

141. Trypanis, *Cantica*, p. 39. The essential literature on the Akathist Hymn and its vexed problems of chronology and attribution is given by Trypanis (pp. 26–27), to which must be added the seminal articles by M. Théarvic, "Photius et l'Acathiste," *Echos d'Orient* VII, 1904, pp. 293–300; VII, 1905, pp. 163–166, arguing for the Hymn's relationship to the Avar siege of 626 rather than the Russian attack of 860. The Avar association has been discredited by E. Wellesz, "The Akathistos: A Study in Byzantine Hymnography," *D.O.P.* IX–X, 1956, pp. 143–156.

142. Strophe 15, line 15: Δι' ἧς ἠνοίχθη παράδεισος. Weitzmann ("Fragments of an Early St. Nicholas Triptych on Mount Sinai," *Δ.Χ.Α.Ε.*, 1964–1965, pp. 17–18) has connected this motif in the *Akathistos* with the image of the Annunciation on the Royal Doors of the iconostasis. At *de Cer.* I,2, *C.S.H.B.* I, p. 38, in the Nativity reception at Hagia Sophia, the Theotokos is acclaimed as τὸν ἐν Ἐδὲμ παράδεισον ἠνέῳξεν ἡ Βηθλεὲμ ἡ Παρθένος, ἐξ ἧς ὁ Χριστὸς καὶ Θεὸς ἡμῶν εὐδόκησε τεχθῆναι.

143. Trypanis, *Cantica*, pp. 30, 35.

God.[144] Procopius describes scores of such outposts built or rebuilt by Justinian, rarely failing to note that the basileus provided them, in addition to a strong wall and a garrison, with a church of the Virgin "thus," as he says in one instance, "dedicating to her the threshold of the Empire and making this fortress impregnable for the whole race of mankind."[145] The capital itself, in Procopius' account, was well protected by Justinian's wisdom in choosing to build the Church of the Virgin at Blachernae and that of the Pegē "near the end of the line of fortifications, in order that both of them may serve as invincible defences to the circuit-wall of the city."[146] Indeed a glance at the map of medieval Constantinople suggests that while the interior of the city was liberally supplied with ecclesiastical structures, the land- and sea-walls were reinforced, often at intervals of less than a kilometer, with churches forming a spiritual girdle about the city.[147] This is not, of course, to impose a modern conception of conscious, overall planning upon the millennial history of the Byzantine capital. Rather, it is the sort of perception that occurred to her citizens who, like Nicholas Mesarites,[148] were aware of the symbolic relationship of a building to its site and to the general topography of the city.

While these churches seem to have constituted an abiding, sacred *limes*—that of the Blachernae, outside the walls until the construction of the Heraclian rampart in 627, is specifically referred to as the "phylactery" of the city[149]—critical occasions called for more direct intervention on the part of the Mother of God. The most celebrated of such appeals is perhaps that uttered in the year that preceded the building of this northwestern addition to the walls. To withstand the Avar attack on Constantinople, made while Heraclius was on campaign, the patriarch Sergius ordered images of the Theotokos to be painted on all the western gates of the city.[150] George Pisides, in his verse account of the event, maintains that the final defeat of the invader took place in front of the Church of the Blachernae, "where the Virgin-General had her house."[151]

The sanctuary owed its earliest eminence to its possession of Mary's *maphorion*, which, together with her girdle preserved at the church in the Chalkoprateia, remained

144. R. Krautheimer, *Early Christian and Byzantine Architecture* (Harmondsworth, 1965), pp. 186–187.

145. *De aedificiis* VI, vii, 16, ed. Loeb, p. 392. Cf. V, vii, 7, pp. 350–352.

146. Ibid., I, v, 9, p. 40. The translator of the Loeb edition comments upon Procopius' amendment to the actual topography of the city in his description of these two churches. But far from being "purely fanciful," the historian's depiction of their situation as guardians of the city-wall is a revealing insight into the Byzantine sense of the nexus between physical and metaphysical defenses.

147. See, for example, map no. I, inserted in R. Janin, *Le Géographie ecclésiastique de l'empire byzantin*, III,1: *Les Églises et les monastères* (Paris, 1953).

148. Cf. his account of the situation of the Church of the Holy Apostles (Downey, "Mesarites," p. 897).

149. *De obsidione CPolitanae sub Heraclio, Patrum nova bibliotheca*, ed. A. Mai, VI,2 (Rome, 1853), p. 431.

150. Ibid., p. 428. Kitzinger ("Cult of Images," pp. 111–112) discusses this and other documents relating to the use of pre-Iconoclastic *apotropaia* in battle and in time of siege; for a catalogue of such uses from the Macedonian through the Palaeologan era, see Frolow, "Dédicace," p. 103.

151. Pisides, *Bellum avaricum*, lines 444–445, C.S.H.B., p. 64. For the impact of this victory upon future Byzantine expectations of the Virgin, see Frolow, "Dédicace," p. 97.

the city's most honored relic of the Virgin.[152] More than any other sacred tokens, these were considered active participants in the defense of the capital, the city that the famous image of the Theotokos in the Chalkoprateia chose to abandon at the onset of Iconoclasm and to which it returned after the restoration of Orthodoxy.[153] The prophylactic rôle of the Virgin's robe and girdle is a main theme of the festal canons written by Joseph the Hymnographer, imploring her aid against famine, earthquake, and enemy assault.[154] In his appeal, Joseph echoes the conventional appellation of Mary as a wall without fissure, but here the epithet is used specifically in connection with the *maphorion*. It is not the immanent Virgin but her substantial robe that is described as the "holy *enceinte*" [ἱερόν περιτείχισμα] and "brilliant surround" [φαιδρόν περιβόλαιον] of Constantinople. Not Mary but the palpable relics of her person now demonstrated the bright, protective ring that she threw about her city. In this way she appeared to the ninth-century hymnographer and in this way the Theotokos was pictured in the cupola of the west bay of the Kariye *parekklesion*, surrounded by just such a luminous medallion (Fig. 94) above attendant angels and pendentives in which Joseph and three other poets compose their devotions to her.[155]

To Joseph, too, has been attributed the famous *prooemium* to the *Akathistos*, "To the Invincible General," traditionally associated with the destruction of the Russian fleet on the shores of the Bosporus in 860.[156] Two conflicting accounts attest to the Virgin's intercession on this occasion but both depend upon the agency of the *maphorion*. On his own admission, Photius, in company with "the whole city," bore the precious garment around the walls, which it "encircles" [περιεκύκλου], while the foes "for an unspeakable reason showed their backs." The patriarch repeatedly emphasizes the all-encompassing attitude of the robe and the consequence of this metaphysical quality. "The city put it around itself and the camp of the enemy was broken up as at a signal."[157] No such circumambient position is assigned to the *maphorion* in the version preserved in Leo Grammaticus, where Photius and the emperor are said to have immersed it in the sea rather than to have carried it about the city. The result, however, was no less decisive. Immediately there arose a violent storm from which few of the Russian ships escaped.[158]

152. J. Ebersolt, *Sanctuaires de Byzance* (Paris, 1921), pp. 44–60.

153. For this myth, see E. von Dobschütz, "Maria Romaia," *B.Z.*, XII, 1903, pp. 173–204.

154. *De depositione pretiosae vestis . . . in Blachernis*, P.G. 105, cols. 1003–1009.

155. Underwood, *Kariye Djami* I, pp. 217–222; III, pls. 408, 426–436.

156. Trypanis, *Cantica*, pp. 29–30. This *kontakion* is attributed to Joseph by Frolow ("Dédicace," p. 69), following others. Trypanis (p. 20) considers its attribution to the patriarch Sergius but ignores the possibility of Joseph's authorship. The language of the *prooemium*, in which the personified Constantinople calls itself the Virgin's city and thanks her for its preservation from misfortunes resembles that of the *troparion* τῆς Θεοτόκου ἡ πόλις τῇ Θεοτόκῳ in the so-called "Typikon of Patmos," published by Dmitrievski (*Opisanie* I, p. 124) and discussed by Frolow ("Dédicace," p. 70).

157. *Hom.* IV,4. In translating these passages I have slightly modified the versions of Mango (*Photius*, p. 102). The text used is that of B. Laourdas, Θωτίου ὁμιλίαι (Thessaloniki, 1969).

158. Leo Gramm. *Chronographia*, C.S.H.B., p. 241. For the sources and historical problems attaching to this account, see Mango, *Photius*, pp. 76–81.

It is scarcely surprising that, following ancient models, such myths became the basis of ritual invocations. Instances of the Virgin's aid supposed to have occurred at specific and critical moments in the past provided the rationale for ceremonially repeated appeals to the "source of life of the Romans"[159] to protect her city in the future. So she was hailed at the Feast of the Ascension by the Green faction, who, according to the *de Cerimoniis*, continue: "Fight alone with the sovereigns who have the purple, they who hold their crown from you, they who have always had you for an invincible shield...." At its climax they salute the Mother of God as the Christians' hope of refuge, salvation, and glorious victory and conclude with the prayer: "Cover us with the wings of your intercession."[160] This remarkable image, later and more weakly echoed in the Russian motif of the Virgin's veil [*Pokrov*],[161] evokes precisely the figure of the *orans* as on the coins, her raised arms extending the sleeves of her *maphorion* over the capital (Figs. 41–43). It must be emphasized that while some acclamations peculiarly associated with the Theotokos, such as the Ἐπὶ σοι χαίρει and the τεῖχος ἀκαταμάχητον accompanying imperial triumphs, were uttered in the unvarying setting of Hagia Sophia,[162] other offices—including those we have just discussed—took place in stations all about the capital. By the time the Book of Ceremonies was written, the cult of the Virgin in Constantinople was not confined to the sanctuaries specifically dedicated to her but, radiating from these, pervaded the entire city. As the tenth-century *Vita S. Andreae Sali* makes clear, the capital was given over into her cherishing hands from which she would not permit it to be snatched.[163]

Thus Photius' tour of the walls, bearing the *maphorion* against the menace of 860, was no isolated event. In 1186 the ceremony was repeated, at the order of Isaac II Angelus, this time with the icon of the Hodegitria rather than with the Virgin's robe.[164] Faced with the insurrection of his general, Alexius Branas, who had defeated the Normans and gone on to challenge him for the purple, the emperor placed Constantinople under the protection of the famous image. Branas died, along with his cause, in the fighting outside the city. This abiding trust, and its apparent, historical vindication, is sufficient to explain why the Virgin appears on the *hyperpyra* struck in the capital when, after 1261, it was again in Greek hands. Since before Iconoclasm Thessaloniki had been defended by St. Demetrius. Despite repeated sacks of the city, the credence persisted and spread. In the fourteenth century it finds expression at the Serbian foundation of Dečani; at Lesnovo, East Rome is shown under the aegis of the archangel

159. *De Cer.* I, 8, *C.S.H.B.* I, p. 55. The salutation derives from the name of the monastery to which the emperor traditionally repaired on the Thursday of Ascension week. Vogt (*Cérémonies* 1, 2, p. 87) disputes, however, that the text of *de Cerimoniis* at this point pertains to this feast.

160. *De Cer.* I, 8, *C.S.H.B.* I, p. 55.

161. For the Greek source of this myth—the vision of "Andrew the Fool" at the Church of the Blachernae—see *AA. SS. Maii* VI, p. 302.

162. *De Cer.* II, 19, *C.S.H.B.* I, p. 609.

163. *P.G.* 111, col. 853. The burden of the paean is that until the end of time Constantinople need fear no power more formidable than itself. Many races will besiege it by land and sea, but because of the Theotokos, will always be compelled to retire in confusion.

164. Nicetas Choniates, *de Isaacio Angelo* I, 7, *C.S.H.B.*, p. 497.

Michael.[165] But Constantinople, to its inhabitants, was sheltered by the rampart of the Mother of God and nowhere is this faith more evident than in the literature of the early fifteenth century.

The outstanding document is a hymn, "To our most holy Lady, the Mother of God, for aid in the present circumstances," composed by the emperor Manuel II during the siege of Musa Çelebi, probably in the spring of 1411.[166] The basileus implores the Virgin to drive away the hostile khan as she formerly did his father, Bāyezīd, calling her "the bulwark of the city" and the Byzantines, repeatedly, "her people." It was this same people that opposed the Ottoman onslaught of 1422, according to Cananus unarmed or armed only with stones.[167] The chronicler attributes the city's successful defiance to the Virgin, providing us nonetheless with a vast repertoire of siege terminology. For Joseph Bryennius the explanation of Constantinople's preservation was simpler: the icon of the Hodegitria was again carried around its walls.[168] It is the modern historian and not the Palaeologan monk who attributes Murad II's withdrawal to a rising of rebellious emirs in Anatolia.[169]

The fact that the assault of 1453 ended differently, and disastrously, did little to affect Greek trust in the Theotokos. Post-Byzantine painting represents the Siege— not the Conquest—of Constantinople, its banners still flying and its icons still borne about the walls. At Moldoviţa, the scene unfolds beneath three images of the Virgin and one of the Anastasis (Fig. 101).[170] Between 1539 and 1541, some three years after the Moldavian fresco was painted, the legend arose that the city had not fallen by storm to the Turks, an argument that the sultan, Suleiman I, was, fantastically, said to have accepted.[171] But the story was a crudely devised and venally supported invention designed to preserve the Christian *milet* from the appropriation of property traditionally allowed to Islamic conquerors of cities.[172] The patriarch Jeremias' fabrication,

165. Cf. p. 128 above.

166. This reference to Manuel's κανὼν παρακλητικός I owe to the kindness of George T. Dennis, who is preparing an edition of the emperor's letters. A Latin translation is to be found at *P.G.* 157, cols. 107–110.

167. *De CPoli oppugnata*, C.S.H.B., p. 473. It is important to notice that Cananus, while recognizing in the Virgin the city's salvation, distinguishes between this and the Ottoman devastation of the surrounding area. Rather than explain this disaster, he declares (ibid., p. 459) that it seems better to remain silent [σιωπᾶν ἡμῖν ἀμείνων ἔδοξεν].

168. Εὐχαριστήριος εἰς τὴν Θεοτόκον, ed. E. Boulgaris, Ἰωσὴφ μοναχοῦ τοῦ Βρυεννίου τὰ εὑρηθέντα ... II (Leipzig, 1768), p. 409. P. Meyer ("Des Joseph Bryennios Schriften, Leben und Bildung," *B.Z.* V, 1896, p. 84) and, following him, Frolow ("Dédicace," p. 103) report that Bryennius describes plural images of the Hodegitria placed at the city's gates. The text, however, quite clearly relates that the icon was removed from its normal resting-place and carried around the walls: ἅτε στρατηγὸν ἀπροσμάχητον τὴν σὴν εἰκόνα τῆς οἰκείας μεταστήσαντες στάσεως, περὶ τὰ τείχη τῆς Πόλεως προπολεμήσουσαν μεταγάγομεν....

169. S. Runciman, *The Fall of Constantinople* (Cambridge, 1965), p. 44.

170. See above, pp. 128–129.

171. This "modern myth by which Romaic vanity glorified its own talents" is fully recounted by G. Finlay (*The History of Greece under Othoman and Venetian Domination* [London, 1856], pp. 169–172).

172. Cf. H. Inalcik, "The Policy of Mehmed II toward the Greek Population of Istanbul and the Byzantine Buildings of the City," *D.O.P.* XXIII–XXIV, 1969–1970, pp. 230–249.

addressed to the sultan's vizir, insisted on the capital's voluntary surrender and contained, of course, no reference to the Virgin's intervention. In this, as much as in its vulgarity, it differed from earlier Greek accounts of the city's travails. Mythically elaborating Constantinopolitan history of the last eight hundred years, these had reached their climax in Cananus' relation of the last successful resistance. He describes how, in 1422, on the day when the Persian astrologers had predicted that the city must fall and when the Turks were in sight of victory, the besiegers turned and fled before the vision of a woman in purple robes walking upon the rampart of the city.[173]

173. *De CPoli oppugnata*, C.S.H.B., p. 478: τότε εἶδον γυναῖκα ὀξέα ῥούχα φοροῦσαν καὶ περιπατοῦσαν ἐπάνω τῶν προμαχιονίων τοῦ ἔξω κάστρου.

Sources Frequently Cited

Alföldi, "Ausgestaltung"
> A. Alföldi, "Die Ausgestaltung der monarchischen Zeremoniells am römischen Kaiserhof," *Röm. Mitt.* XLIX, 1934, pp. 1–18
———, "Throntabernakel"
> "Die Geschichte des Throntabernakels," *La Nouvelle Clio* IX, 1950, pp. 537–566
Amiranashvili, *Emaux de Georgie*
> Sh. Amiranashvili, *Les Emaux de Georgie*, Paris, 1962
Arnason, "Early Christian Silver"
> H.H. Arnason, "Early Christian Silver of North Italy and Gaul," *Art Bull.* XX, 1938, pp. 193–226
Athens Catalogue
> *Byzantine Art an European Art. Catalogue of the 9th Exhibition of the Council of Europe*, Athens, 1964
Avery, "Alexandrian Style"
> M. Avery, "The Alexandrian Style at S. Maria Antiqua," *Art Bull.* VII, 1925, pp. 131–149
Banck, *Byzantine Art*
> A. V. Banck, *Viz. iskusstvo v sobraniiakh sovetskogo soiuza*, Leningrad–Moscow, 1966
Beckwith, *Early Chr. and Byz. Art*
> J. Beckwith, *Early Christian and Byzantine Art*, Harmondsworth, 1970
Bellinger, "Const. Porph."
> A.R. Bellinger, "Byzantine Notes: 6. The Coins of Constantine Porphyrogennetus and his Associates," *American Numismatic Society Museum Notes* XIII, 1967, pp. 148–166
Belting, *Illuminierte Buch*
> H. Belting, *Das illuminierte Buch in der spätbyzantinischen Gesellschaft*, Heidelberg, 1970
Bertaux, *Italie méridionale*
> E. Bertaux, *L'Art dans l'Italie méridionale* I, Paris, 1904
Bertelè, *L'imperatore alato*
> T. Bertelè, *L'imperatore alato nella numismatica bizantina*, Rome, 1951
Bertelli, *Madonna*
> C. Bertelli, *La Madonna di santa Maria in Trastevere. Storia, iconografia, stile, di un dipinto romano dell'ottavo secolo*, Rome, 1961
Boulanger, *Orphée*
> A. Boulanger, *Orphée. Rapports de l'Orphisme et du Christianisme*, Paris, 1925
Bovini, "Osservazioni"
> G. Bovini, "Osservazioni in merito all'infondatezza del restauro del Kibel nel complemento dell'immagine di Cristo in trono nei mosaici di S. Apollinare Nuovo di Ravenna," *Polychronion. Festschrift Franz Dölger*, Heidelberg, 1966, pp. 117–120

Braunfels, *Welt der Karolinger*
> W. Braunfels, *Die Welt der Karolinger und ihre Kunst*, Munich, 1968
Breckenridge, *Justinian II*
> J.D. Breckenridge, *The Numismatic Iconography of Justinian II, N.N.M.*, no. 144, New York, 1959
Brenk, *Tradition und Neuerung*
> B. Brenk, *Tradition und Neuerung in der christlichen Kunst des ersten Jahrtausends. Studien zur Geschichte des Weltgerichtbildes* [= *Wiener Byzantinische Studien* III], Vienna, 1966
Brightman, *Liturgies*
> F.E. Brightman, *Liturgies Eastern and Western*, I: *Eastern Liturgies*, Oxford, 1896
Brilliant, *Gesture and Rank*
> R. Brilliant, *Gesture and Rank in Roman Art* [= *Memoirs of the Connecticut Academy of Arts and Sciences* XIV], New Haven, 1963
Buberl, *Miniaturhandschriften*
> P. Buberl, "Der Miniaturhandschriften der Nationalbibliothek in Athen," *Denkschriften, Kaiserliche Akademie der Wissenschaften in Wien, Phil.-hist. Klasse*, LX–LXI, 1918
Buberl-Gerstinger, *Handschriften*
> *Beschreibendes Verzeichnis der illuminierten Handschriften in Österreich* VIII,4, P. Buberl and H. Gerstinger, *Die byzantinischen Handschriften*, 2 vols., Leipzig, 1937–1938
Buchthal, *Paris Psalter*
> H. Buchthal, *The Miniatures of the Paris Psalter*, London, 1938
Cames, *Peinture romaine*
> G. Cames, *Byzance et la peinture romaine de Germanie*, Paris, 1966
Clédat, *Baouît*
> J. Clédat, *Le Monastère et la nécropole de Baouît* [= *Mémoires publiés par les membres de l'Institut français d'archéologie orientale du Caire* XII], Cairo, 1904–1906
Cutler, "Two Aspirants to Romania"
> A. Cutler, "Two Aspirants to Romania: Venetian and Serbian Ambitions in the Light of their Coinage." *Byzantinoslavica* XXVI, 1965, pp. 295–307.
De Cer.
> *De Cerimoniis*, 2 vols., *C.S.H.B.*
Demus, *Norman Sicily*
> O. Demus, *The Mosaics of Norman Sicily*, London, 1950
————, *Romanische Wandmalerei*
> *Romanische Wandmalerei*, Munich, 1968
Der Nersessian, "Homilies of Gregory"
> S. Der Nersessian, "The Illustrations of the Homilies of Gregory of Nazianzus, Paris gr. 510. A Study of the Connections between Text and Images," *D.O.P.* XVI, 1962, pp. 197–228
————, "Psalter at D.O."
> "A Psalter and New Testament Manuscript at Dumbarton Oaks," *D.O.P.* XIX, 1965, pp. 153–183
DeWald, *Vat. gr. 1927*
> E.T. DeWald, *The Illustrations in the Manuscripts of the Septuagint*, III,1: *Vaticanus Graecus, 1927*, Princeton, 1941
————, *Vat. gr. 752*
> *The Illustrations in the Manuscripts of the Septuagint*, III,2: *Vaticanus Graecus 752*, Princeton, 1942
Diehl, *Italie méridionale*
> C. Diehl, *L'Art byzantin dans l'Italie méridionale*, Paris, 1894

————, "St.-Démétrius"

 C. Diehl and M. Le Tourneau, "Les Monuments de Saint-Démétrius de Salonique," *Mon. Piot* XVIII, 1910, pp. 225–247

————, *Salonique*

 C. Diehl, M. Le Tourneau, and H. Saladin, *Les Monuments chrétiens de Salonique*, Paris, 1918

————, *Peinture byzantine*

 C. Diehl, *La Peinture byzantine*, Paris, 1933

A. Dmitrievski, *Opisanie*

 A. Dmitrievski, *Opisanie liturgicheskich rukopisei, chraniȃashchichsiȃ v bibliotekach pravoslavnago vostoka*, 3 vols., Kiev and St. Petersburg, 1895–1917

Downey, "Mesarites"

 G. Downey, "Nikolaus Mesarites: Description of the Church of the Holy Apostles at Constantinople," *Transactions of the American Philosophical Society* XLVII, 1957, pp. 853–924

Dufrenne, *Psautiers grecs*

 S. Dufrenne, *L'Illustration des psautiers grecs du moyen age*, I: *Pantocrator 61, Paris grec 20, British Museum 40731*, Paris, 1966

————, *Mistra*

 Les Programmes iconographiques des églises byzantines de Mistra, Paris, 1970

Ebersolt, *La Miniature*

 J. Ebersolt, *La Miniature byzantine*, Paris, 1926

Ehrensperger-Katz, "Représentations"

 I. Ehrensperger-Katz, "Les Représentations des villes fortifiées dans l'art paléo-chrétien et leurs dérivées byzantines," *Cah. arch.* XIX, 1969, pp. 1–27

Friedman, "Syncretism"

 J.B. Friedman, "Syncretism and Allegory in the Jerusalem Orpheus Mosaic," *Traditio* XXIII, 1967, pp. 1–13

Frolow, "Dédicace"

 A. Frolow, "La Dédicace de Constantinople dans la tradition byzantine," *Rev. hist. relig.* CXXVII, 1944, pp. 61–127

Galavaris, *Liturgical Homilies*

 G. Galavaris, *The Illustrations of the Liturgical Homilies of Gregory Nazianzenus*, Princeton, 1969

Garrucci, *Storia*

 R. Garrucci, *Storia dell'arte cristiana*, Prato, 1877

Goldammer, "Christus Orpheus"

 K. Goldammer, "Christus Orpheus. Der μουσικὸς ἀνήρ als unerkanntes Motiv in der ravennatischen Mosaikikonographie," *Zeitschrift für Kirchengeschichte* LXXIV, 1963, pp. 217–243

Goldschmidt-Weitzmann, *Elfenbeinskulpturen*

 A. Goldschmidt and K. Weitzmann, *Die byzantinischen Elfenbeinskulpturen des X.–XIII. Jahrhunderts*, 2 vols., Berlin, 1930–1934

Goodenough, *Jewish Symbols*

 E. Goodenough, *Jewish Symbols in the Greco-Roman Period*, 13 vols., New York, 1953–1968

Grabar, "Un Manuscrit des homélies"

 A. Grabar, "Un Manuscrit des homélies de St. Jean Chrysostome de la Bibliotheque Nationale d'Athènes," *Sem. Kond.* V, 1932, pp. 259–297

————, *L'Empereur*

 L'Empereur dans l'art byzantin, Paris, 1936

————, *Martyrium*
 Martyrium. Recherches sur le culte des reliques et l'art chrétien antique, 2 vols. text, 1 vol. plates, Paris, 1946

————, *Peinture byzantine*
 La Peinture byzantine, Geneva, 1953

————, *L'Iconoclasme*
 L'Iconoclasme byzantin. Dossier archéologique, Paris, 1957

————, "Virgin in a Mandorla"
 "The Virgin in a Mandorla of Light," *Late Classical and Medieval Studies in Honor of A.M. Friend Jr.*, Princeton, 1965, pp. 305–311

————, *Theodosius to Islam*
 Byzantium from the Death of Theodosius to the Rise of Islam, London, 1966

————, *Iconography*
 Christian Iconography. A Study of its Origins, London, 1969

Guilland, Προσκύνησις
 R. Guilland, "Autour du Livre des Cérémonies de Constantin VII Porphyrogénète. La cérémonie de la προσκύνησις," *Rev. ét. gr.* LIX–LXX, 1946–1947, pp. 251–259

Hahnloser-Volbach, *Pala d'Oro*
 H.R. Hahnloser, W.F. Volbach, et al., *Il tesoro di San Marco*, I: *La Pala d'Oro*, Florence, 1966

Harrison, "Ptolemais"
 R.M. Harrison, "An Orpheus Mosaic at Ptolemais in Cyrenaica," *J.R.S.* LII, 1962, pp. 13–18

Hendy, *Coinage and Money*
 M.F. Hendy, *Coinage and Money in the Byzantine Empire 1081–1261*, Washington, D.C., 1969

Ihm, *Apsismalerei*
 C. Ihm, *Die Programme der christlichen Apsismalerei vom vierten Jahrhunderts bis zur Mitte des achten Jahrhunderts*, Wiesbaden, 1960

Jerphanion, *Cappadoce*
 G. de Jerphanion, *Une Nouvelle Province de l'art byzantin. Les églises rupestres de Cappadoce*, 2 vols. in 4 parts text, 3 vols. plates, Paris, 1925–1942

Kitzinger, "Cult of Images"
 E. Kitzinger, "The Cult of Images in the Age before Iconoclasm," *D.O.P.* VIII, 1954, pp. 83–150

————, "Justinian to Iconoclasm"
 "Byzantine Art in the Period between Justinian and Iconoclasm," *Berichte zum XI. C.E.B.*, Munich, 1958, pp. 1–50

————, *Monreale*
 The Mosaics of Monreale, Palermo, 1960

Köhler, *Karolingischen Miniaturen*
 W. Köhler, *Die karolingischen Miniaturen*, Berlin, 1930ff.

Kondakov, *Ikonografiia*
 N.P. Kondakov, *Ikonografiia Bogomateri*, 2 vols., St. Petersburg, 1914–1915

Koukoules, Βίος
 Ph. Koukoules, Βυζαντινῶν Βίος καὶ πολιτισμός, 5 vols., Athens, 1948–1955

Krischen et al., *Landmauer*
 F. Krischen, *Die Landmauer von Konstantinopel* I, Berlin, 1938; B. Meyer-Plath-A.M. Schneider (ibid.), II, Berlin, 1948

Kroll, *Gott und Hölle*
 J. Kroll, *Gott und Hölle. Der Mythos von Descenscuskampfe* [= *Studien des Bibliothek Warburg* XX], Leipzig, 1932

Ladner, "Gestures of Prayer"
 G.B. Ladner, "The Gestures of Prayer in Papal Iconography of the Thirteenth and Early Fourteenth Centuries," *Didascaliae. Studies in Honor of A.M. Albareda*, New York, 1961, pp. 247–275

Lafontaine-Dosogne, *Enfance de la Vierge*
 J. Lafontaine-Dosogne, *L'Iconographie de l'enfance de la Vierge dans l'empire byzantin et en occident* I, Paris, 1964

———, "Güllü Dere"
 "L'Eglise aux Trois Croix de Güllü Dere en Cappadoce et le problème du passage du décor 'iconoclaste' au décor figural," *Byzantion* XXXV, 1965, pp. 175–207

Laurent, *Corpus des sceaux*
 V. Laurent, *Corpus des sceaux de l'empire byzantin* (in progress), Paris, 1963ff.

Lazarev, "Pisan School"
 V.N. Lazarev, "New Light on the Problem of the Pisan School," *Burl. Mag.* LXVIII, 1936, pp. 61–73

———, *Murals and Mosaics*
 Old Russian Murals and Mosaics, London, 1966

———, *Storia*
 Storia della pittura bizantina, Turin, 1967

L'Orange, *Cosmic Kingship*
 H.P. L'Orange, *Studies on the Iconography of Cosmic Kingship in the Ancient World*, Oslo, 1953

Mango, *Photius*
 The Homilies of Photius, Patriarch of Constantinople, trans. C.A. Mango, Cambridge, Mass., 1958

———, *Brazen House*
 C.A. Mango, *The Brazen House*, Copenhagen, 1959

Mansi
 J.D. Mansi, *Sacrorum conciliorum nova et amplissima collectio . . .*, 31 vols., Florence, 1759–1798

van Marle, *Italian Schools*
 R. van Marle, *The Development of the Italian Schools of Painting* I, The Hague, 1923

Matthiae, *Pittura romana*
 G. Matthiae, *Pittura romana del medioevo*, Rome, 1966

———, *Mosaici medioevali*
 Mosaici medioevali delle chiese di Roma, 2 vols., Rome, 1967

Mattingly, *Roman Empire*
 H. Mattingly et al., *Coins of the Roman Empire in the British Museum*, 6 vols., London, 1923–1962

Megaw, "Kanakaria"
 A.H.S. Megaw, "The Mosaics in the Church of Panayia Kanakaria in Cyprus," VIII *C.E.B.*, Palermo, 1951 [=*Studi bizantini e neoellenici* VIII, 1953], II, pp. 199–200

Millet, *Daphni*
 G. Millet, *Le Monastère de Daphni. Histoire, Architecture, Mosaïques*, Paris, 1899

———, *Mistra*
 Monuments byzantins de Mistra, Paris, 1910

———, *Recherches*
 Recherches sur l'iconographie de l'Evangile au XIV^e, XV^e et XVI^e siècles, Paris, 1916

———, *Athos*
 Monuments de l'Athos, I: *Les peintures*, Paris, 1927

Mirković, "Mosaik über der Kaisertür"
> L. Mirković, "Das Mosaik über der Kaisertür im Narthex der Kirche der Hl. Sophia in Konstantinopel," VIII *C.E.B.*, Palermo, 1951 [= *Studi bizantini e neoellenici* VIII, 1953], II, pp. 206–217.

Nordhagen, *S. Maria Antiqua*
> P. Romanelli and P.J. Nordhagen, *S. Maria Antiqua*, Rome, 1964

Nordström, *Ravennastudien*
> C.-O. Nordström, *Ravennastudien. Ideengeschichtliche und ikonographische Untersuchungen über die Mosaïken von Ravenna*, Uppsala, 1953

Oakeshott, *Mosaics of Rome*
> W. Oakeshott, *The Mosaics of Rome from the Third to the Fourteenth Century*, London, 1967

Omont, *Miniatures*
> H. Omont, *Miniatures des plus anciens manuscrits grecs de la Bibliothèque Nationale du VI^e au XIV^e siècle*, Paris, 1929

Orlandos, "Monastère de Patmos"
> A. Orlandos, "Fresques byzantines du monastère de Patmos," *Cah. arch.* XII, 1962, pp. 285–302

Pelekanides, Καστορία
> St. Pelekanides, Καστορία, I. Βυζαντιναὶ τοιχογραφίαι, Thessaloniki, 1953

Recueil Uspenski
> *L'Art byzantin chez les Slaves, recueil dedié à la mémoire de Th. Uspenski* [= *Orient et Byzance* IV], 2 vols., Paris, 1930–32

Restle, *Asia Minor*
> M. Restle, *Byzantine Wall Painting in Asia Minor*, 3 vols., Greenwich, Conn., 1968

Rice, *Art of Byzantium*
> D. Talbot Rice, *The Art of Byzantium*, London, 1959

———, *Trebizond*
> *The Church of Haghia Sophia at Trebizond*, ed. D. Talbot Rice, Edinburgh, 1968

Scharf, "Proskynese"
> J. Scharf, "Der Kaiser in Proskynese. Bemerkungen zur deutung des Kaisermosaiks in Narthex der Hagia Sophia von Konstantinopel," *Festschrift P.E. Schramm* I, Wiesbaden, 1965, pp. 27–35

Sotiriou, Ἁγίου Δημητρίου
> G. Sotiriou and M. Sotiriou, Ἡ βασιλικὴ τοῦ ἁγίου Δημτρίου Θεσσαλονίκης, Athens, 1952

———, Εἰκόνες
> Εἰκόνες τῆς Μονῆς Σινᾶ, 2 vols., Athens, 1956–1958

Stern, "Orpheus"
> H. Stern, "The Orpheus in the Synagogue of Dura-Europus," *J.W.C.I.* XXI, 1958, pp. 1–6

Stornajolo, *Topog. crist.*
> C. Stornajolo, *Le miniature della Topografia Cristiana di Cosmo Indicopleuste*, Milan, 1908

Straub-Keller, *Hortus*
> A. Straub and G. Keller, *Herrade de Landsberg. Hortus deliciarum*, Strasbourg, 1879–1899

Strzygowski, *Etschmiadzin Evangeliar*
> J. Strzygowski, *Das Etschmiadzin Evangeliar* [= *Byzantinische Denkmäler* I], Vienna, 1891

————, *Physiologus*

> *Der Bilderkreis des griechischen Physiologus, des Kosmas Indikopleustes und Oktateuch nach Handschriften der Bibliothek zu Smyrna* [=*Byzantinisches Archiv* 2], Leipzig, 1899

————, "Serb. Psalter"

> "Die Miniaturen des serbischen Psalters in München, *Denkschriften, Kaiserliche Akademie der Wissenschaften in Wien*, Phil.-hist. *Klasse* LII,2, 1906

Stubblebine, "Throne in Dugento Painting"

> J.H. Stubblebine, "The Development of the Throne in Dugento Tuscan Painting," *Marsyas* VII, 1957, pp. 25–39

Stylianou, "Donors and Supplicants"

> A. Stylianou and J. Stylianou, "Donors and Dedicatory Inscriptions, Supplicants and Supplications in the Painted Churches of Cyprus," *J.Ö.B.G.* IX, 1960, pp. 97–128

Taylor, "Ruler Cult"

> L.R. Taylor, "The 'Proskynesis' and the Hellenistic Ruler Cult," *J.H.S.* XLVII, 1927, pp. 53–62

Tikkanen, *Psalterillustration*

> J.J. Tikkanen, *Die Psalterillustration im Mittelalter* [=*Acta Societatis Scientiarium Fennicae* XXXI, no. 5], Helsinki, 1903

Tolstoi, *Viz. mon.*

> I.I. Tolstoi, *Vizantiiskia moneti*, 3 vols., St. Petersburg, 1912–1914

Treitinger, *Kaiseridee*

> O. Treitinger, *Die oströmische Kaiser- und Reichsidee*, Jena, 1938

Trypanis, *Cantica*

> C.A. Trypanis, *Fourteen Early Byzantine Cantica*, Vienna, 1968

Underwood, *Kariye Djami*

> P.A. Underwood, *The Kariye Djami*, 3 vols., New York, 1966

Veglery, "Narthex Mosaic"

> A. Veglery, "The Date of the Narthex Mosaic in St. Sophia at Istanbul," *Numismatic Chronicle* LXXIX, 1971, pp. 100–102

Verpeaux, *de Offic.*

> Pseudo-Kodinos, *Traité des offices*, ed. J. Verpeaux, Paris, 1966

Villette, *Résurrection*

> J. Villette, *La Résurrection du Christ dans l'art chrétien du IIe siècle*, Paris, 1957

Vogt, *Cérémonies*

> J. Vogt, *Constantin VII Porphyrogénète. Le Livre des Cérémonies*, 2 vols. text, 2 vols. commentary, Paris, 1935–1940.

Volbach, *Elfenbeinarbeiten*

> W.F. Volbach, *Elfenbeinarbeiten der Spätantike und des frühen Mittelalters*, Mainz, 1952

————, *Early Christian Art*

> W.F. Volbach and M. Hirmer, *Early Christian Art*, London, 1961

Walter, *Conciles*

> C. Walter, *L'Iconographie des Conciles dans la tradition byzantine*, Paris, 1970

Weigand, "Christogrammnimbus"

> E. Weigand, "Zum Denkmälerkreis des Christogrammnimbus," *B.Z.* XXXII, 1932, pp. 63–81

Weitzmann, *Buchmalerei*

> K. Weitzmann, *Die byzantinische Buchmalerei des 9. und 10. Jahrhunderts*, Berlin, 1935

————, "Das Evangelion"
"Das Evangelion im Skevophylakion zu Lawra," *Sem. Kond.* VIII, 1936, pp. 83–98

————, "Illustration for the Chronicles"
"Illustration for the Chronicles of Sozomen, Theodoret and Malalas," *Byzantion* XVI, 1942–1943, pp. 87–134

————, "Vatopedi 761"
"The Psalter Vatopedi 761: Its Place in the Aristocratic Psalter Recension," *Journal of the Walters Art Gallery* X, 1947, pp. 21–51

————, *Joshua Roll*
The Joshua Roll. A Work of the Macedonian Renaissance, Princeton, 1948

————, *Greek Mythology*
Greek Mythology in Byzantine Art, Princeton, 1951

————, "Constantinopolitan Lectionary"
"The Constantinopolitan Lectionary, Morgan 639," *Studies in Art and Literature for Belle da Costa Greene*, Princeton, 1954, pp. 358–373

————, "Crusader Icons"
"Thirteenth Century Crusader Icons on Mount Sinai," *Art Bull.* XLV, 1963, pp. 179–204

————, *Geistige Grundlagen*
Geistige Grundlagen und Wesen der Makedonischen Renaissance, Cologne-Opladen, 1963

————, et al., *Icons*
K. Weitzmann, M. Chatzidakis, K. Miatev, and S. Radojčić, *Icons from South Eastern Europe and Sinai*, London, 1968

————, *Roll and Codex*
Illustrations in Roll and Codex, 2d. ed., Princeton, 1970

Wessel, *Emailkunst*
K. Wessel, *Emailkunst vom 5. bis 13. Jahrhundert*, Recklinghausen, 1967

Whittemore, *Prelim. Report, Narthex*
T. Whittemore, *The Mosaics of St. Sophia in Istanbul. Preliminary Report on the First Year's Work, 1931–1932. The Mosaics of the Narthex.* Oxford, 1933

Wilpert, *Catacombe*
J. Wilpert, *Roma sotterranea. Le pitture delle catacombe romane*, Rome, 1903

————, *Mosaïken und Malereien*
Die römischen Mosaïken und Malereien der kirchlichen Bauten von IV bis XIII Jahrhundert. Freiburg-im-Breisgau, 1917

————, *Sarcofagi*
I Sarcofagi cristiani antichi, Rome, 1926–1936

Wood, *Divine Monarchy*
D. Wood, *Leo VI's Concept of Divine Monarchy*, London, 1964

Xyngopoulos, Ὑμνολογικὸς τύπος
Α. Xyngopoulos, Ὁ ὑμνολογικὸς τύπος τῆς εἰς τόν Ἅδην καθόδου τοῦ Ἰησοῦ, Ε.Ε.Β.Σ. XVII, 1941, pp. 113–129

————, Τοιχογραφίες
Οἱ τοιχογραφίες τοῦ Ἁγίου Νικολάου Ὀρφανοῦ Θεσσαλονίκης, Athens, 1964

Index

Illustrations

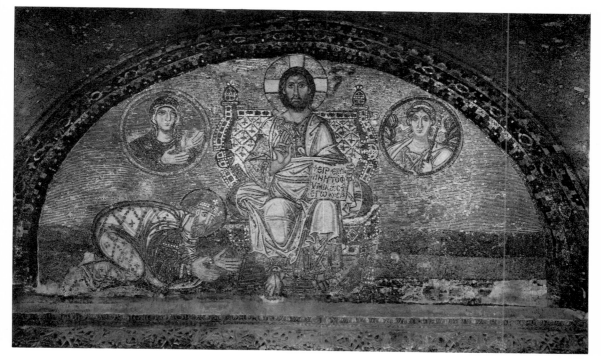

1 Istanbul, Hagia Sophia, An Emperor before Christ

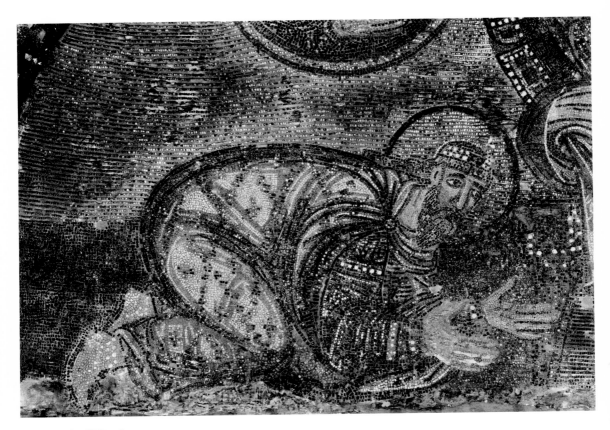

2 Detail of Fig. 1

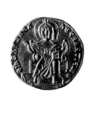
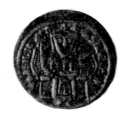
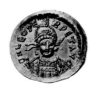

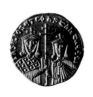
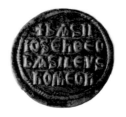

3 *Solidus* of Basil I 4 Copper of Basil I 5 *Solidus* of Leo I and II

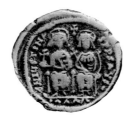

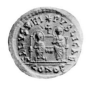

6 *Solidus* of Zeno and Leo 7 Copper of Justin II 8 Copper of Constantine V
 and Sophia and Leo IV

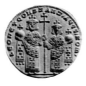
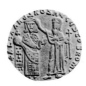

9 *Solidus* of Constantine V
 and Leo IV

10 *Solidus* of Leo VI
 and Constantine VII

11 *Solidus* of Alexander

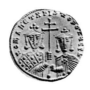
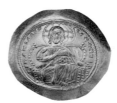
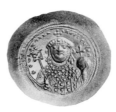

12 *Solidus* of Romanus I
 and Constantine

13 *Solidus* of Constantine IX

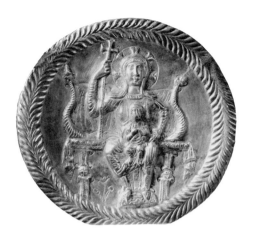

14 Grado, Cathedral Treasury,
Virgin and Child Enthroned

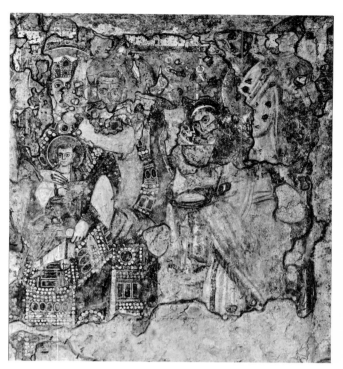

15 Rome, S. Maria Antiqua,
Virgin and Child Enthroned

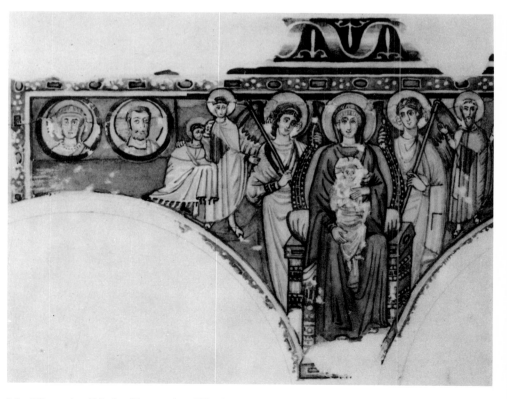

16 Thessaloniki, St. Demetrius, Virgin Enthroned (destroyed)

17 Lythrankomi, Kanakaria, Virgin and Child
Enthroned

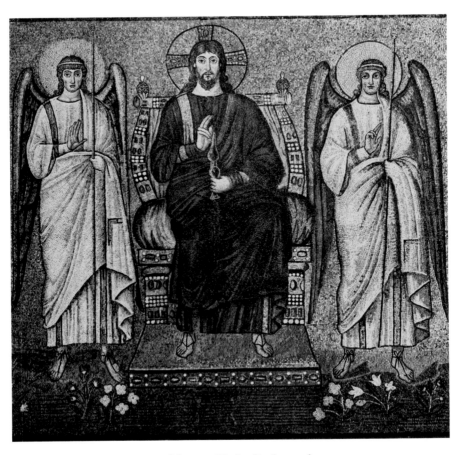

18 Ravenna, S. Apollinare Nuovo, Christ Enthroned

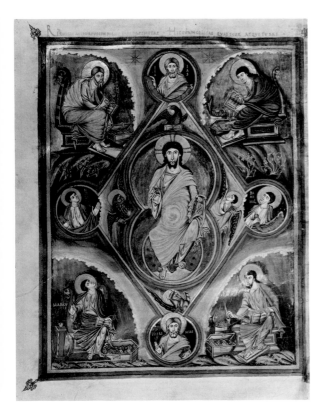

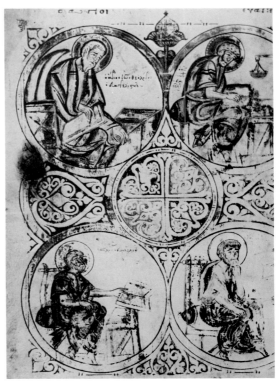

19 Paris, B.N. cod. lat. 1, fol. 329v, *Majestas Domini*

20 Athens, National Library cod. 70, fol. 2v, Evangelists

21 Göreme, chapel 3, Christ Enthroned

22 Paris, B.N. cod. gr. 510, fol. 104r, Emperor Valens at his Son's Deathbed

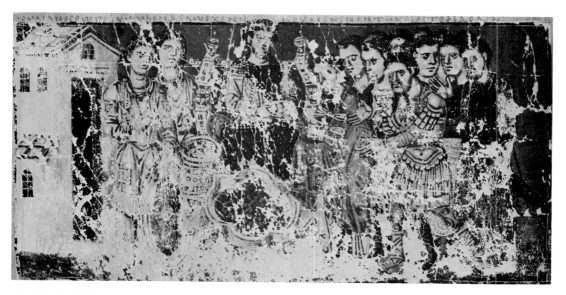

23 Paris, B.N. cod. gr. 510, fol. 374v, Emperor Julian Presenting the *Donativum*

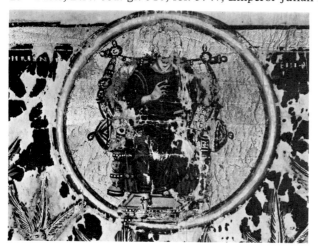

24 Paris, B.N. cod. gr. 510, fol. 67v, Vision of Isaiah

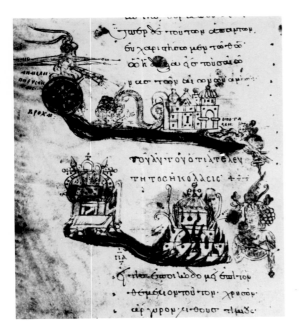

25 Athens, National Library cod. 211, fol.
151v, Eschatological Scene

26 Athos, Panteleimon cod. 6, fol.
163v, Birth of Dionysus

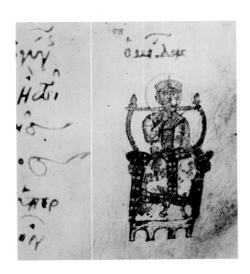

27 Athos, Panteleimon cod. 6, fol.
116r, Midas

28 Moscow, Kremlin Armory,
Virgin and Child Enthroned

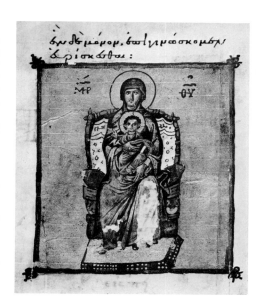

29 Vienna, Nationalbibliothek cod.
theol. gr. 366, fol. 16v, Virgin and
Child Enthroned

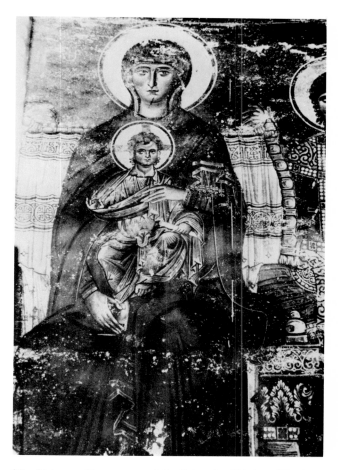

30 Patmos, Monastery of St. John the Divine, Virgin
and Child Enthroned

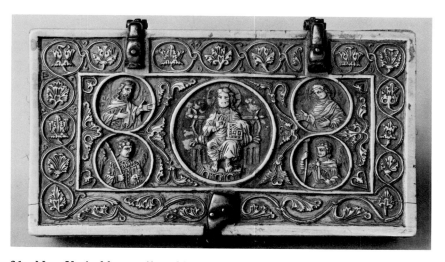

31 New York, Metropolitan Museum, Christ Enthroned

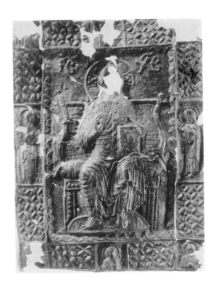

32 Leningrad, Hermitage,
Christ Enthroned

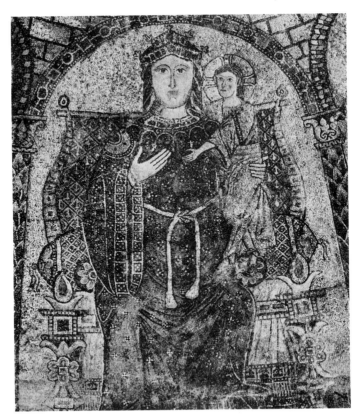

33 Rome, S. Francesca Romana,
Virgin and Child Enthroned

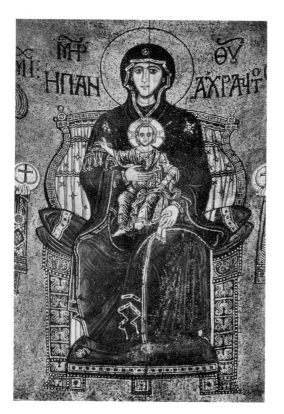

34 Monreale, Duomo,
Virgin and Child Enthroned

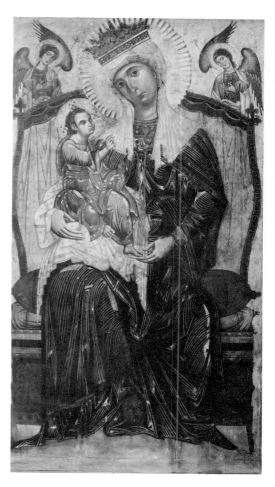

35 Orvieto, Servi, Coppo di Marcovaldo,
Virgin and Child Enthroned

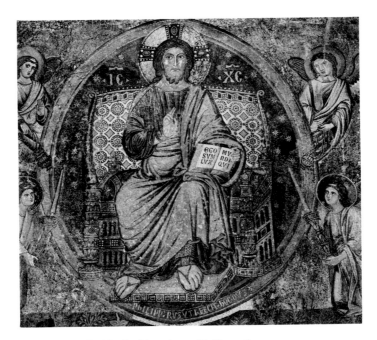

36 Rome, S. Maria Maggiore, F. Rusuti,
Christ Enthroned

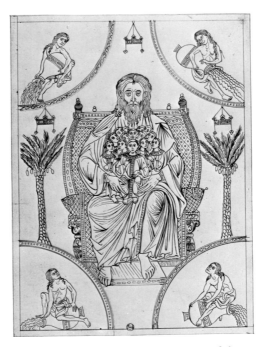

37 Paris, B.N., *Hortus Deliciarum*, fol.
123v, Abraham with Souls in
Paradise (drawing)

39 Athos, Panteleimon cod. 6,
fol. 165r, Orpheus

38 Nicosia, Cyprus Museum,
David Receiving Saul's Messenger

40 Palermo, Museo Nazionale, Orpheus

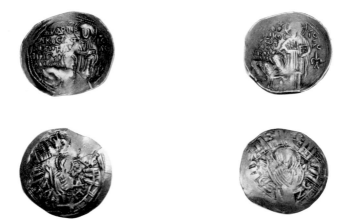

41 *Hyperpyron* of Andronicus II 42 *Hyperpyron* of Andronicus II

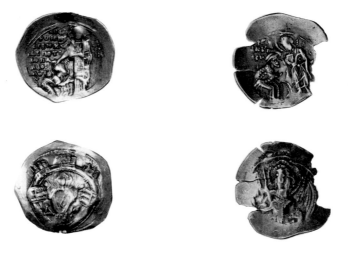

43 *Hyperpyron* of Andronicus II 44 Copper of Andronicus II

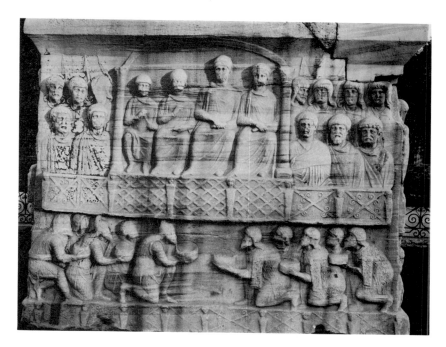

45 Istanbul, Obelisk of Theodosius, base

46 Vatican cod. gr. 752, fol. 128r,
David before an Image of Christ

47 Paris, B.N. cod. gr. 20, fol. 9v,
Christ Healing the Sick

48 Monreale, Duomo, Abraham before the Angels

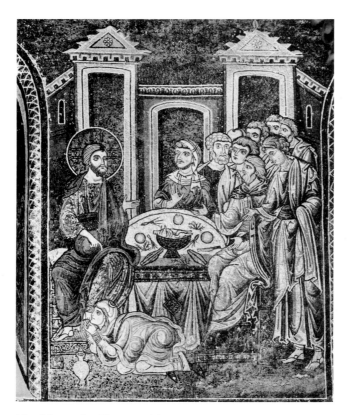

49 Monreale, Duomo, Mary Magdalen Anointing
 Christ's Feet

50 Paris, B.N. cod. gr. 510, fol. 226v,
Moses Striking Water from the Rock;
Joshua before the Angel of the Lord

51 Paris, B.N. cod. gr. 510, fol. 196v, Raising of Lazarus; Mary Magdalen Anointing
Christ's Feet

52 Vatican cod. Palat. gr. 431, Joshua and the Elders before the Lord

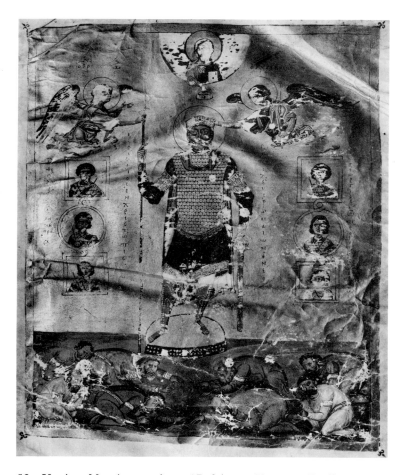

53 Venice, Marciana cod. gr. 17, fol. IIIr, Emperor Basil II

54 Paris, B.N. cod. gr. 74, fol. 4v, Flight into Egypt

55 Vatican cod. gr. 1613, fol. 108r, Ecumenical Council

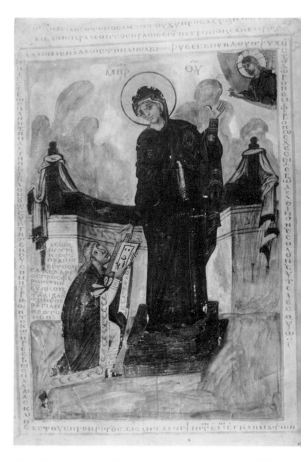

56 Vatican cod. Regin. gr. 1, fol. 3r, Veneration
 of St. Nicholas

57 Vatican cod. Regin. gr. 1, fol. 2v, Leo Offers hi:
 Bible to the Virgin

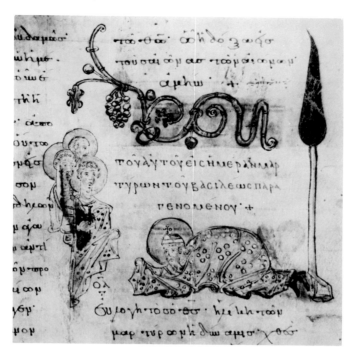

58 Athens, Nat. Lib. cod. 211, fol. 63r, Emperor Arcadius
before Three Saints

59 Berlin, Staatliche Museen, Crucifixion

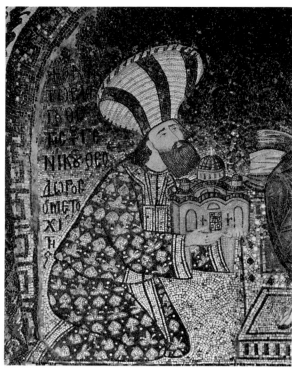

60 Palermo, Martorana, George of Antioch
before the Virgin

61 Istanbul, Kariye Camii, Theodore Metochites
before Christ

62 Paris, B.N. cod. gr. 510, fol. 143v, Christ Healing the Paralytic; The Woman with the Issue of Blood; Raising of Jairus' Daughter

63 Istanbul, Kariye Camii, Christ Healing the Woman with the Issue of Blood

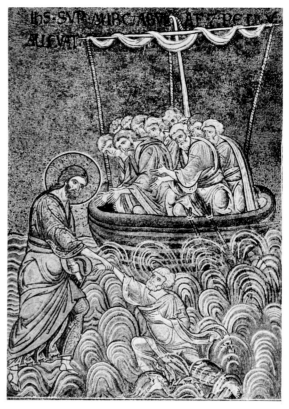

64 Monreale, Duomo, Healing of the Lame and Blind

65 Monreale, Duomo, St. Peter Saved from Drowning

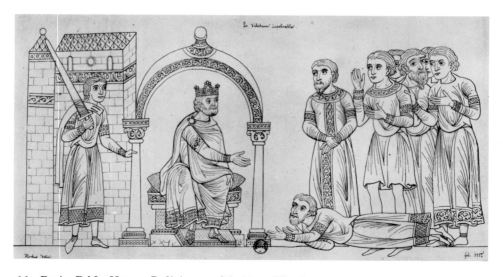

66 Paris, B.N., *Hortus Deliciarum*, fol. 111r, The Insolvent Debtor (drawing)

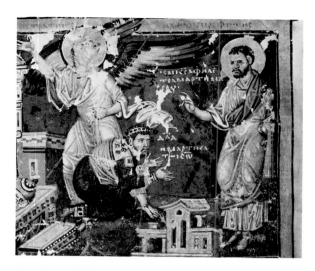

67 Athos, Pantocrator cod. 61, fol. 18v, David in Proskynesis

68 Paris, B.N. cod. gr. 510, fol. 143v, Penitence of David

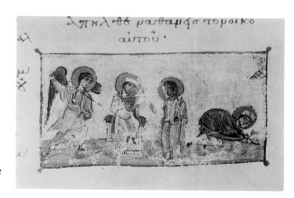

69 Vatican cod. gr. 333, fol. 50v, Penitence of David

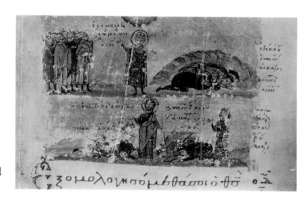

70 Vatican cod. gr. 1927, fol. 135r, Wicked of the Earth Prostrated

71 Jerusalem, Greek Orthodox Patriarchate cod. Taphou 14, fol. 312r, Adoration of Hecate

72 Trebizond, Hagia Sophia, Agony in the Garden

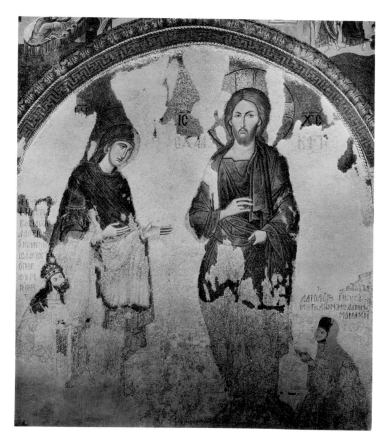

73 Istanbul, Kariye Camii, Isaac II Porphyrogenitus and
Melanie before Christ and the Virgin

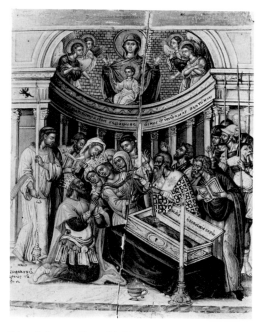

74 Athens, Benaki Museum, Emmanuel
Tzanes, The Miracle of the Girdle

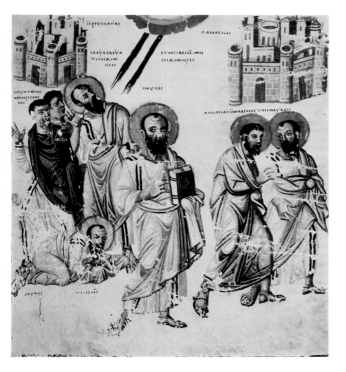

76 Leningrad, Public Library cod. gr. 118, fol. 385v, Demetrius Palaeologus at Prayer

75 Vatican cod. gr. 699, fol. 83v, St. Paul on the Road to Damascus

77 Vatican cod. gr. 699, fol. 45r, Moses receiving the Law

78 Athos, Pantocrator cod. 61, fol. 109r, Christ Appears to the Holy Women

79 Paris, B.N. cod. gr. 510, fol. 30v, Christ Appears to the Holy Women

80 Vatican cod. Palat. gr. 431, sheet IV, Joshua before the Archangel

81 Trebizond, Hagia Sophia, Choir of Angels

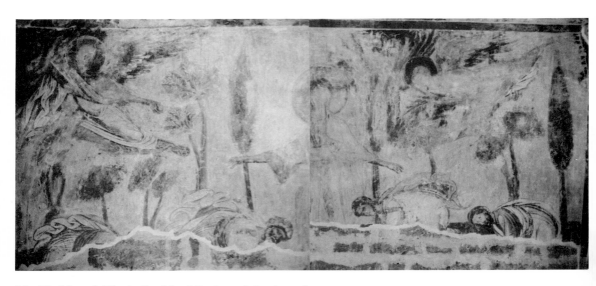

82 Trebizond, Hagia Sophia, Mission of the Apostles

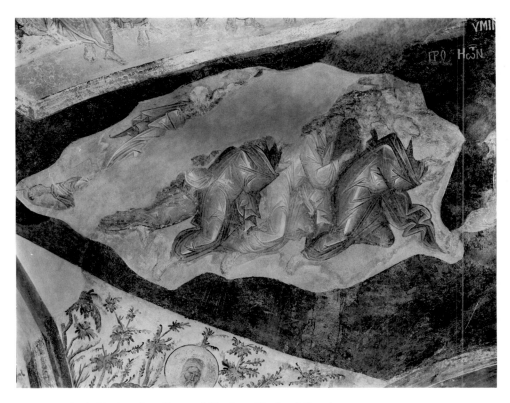

83 Istanbul, Kariye Camii, *parekklesion*, Choir of Prophets

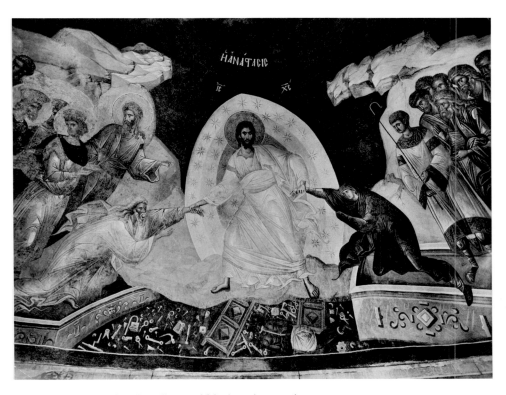

84 Istanbul, Kariye Camii, *parekklesion*, Anastasis

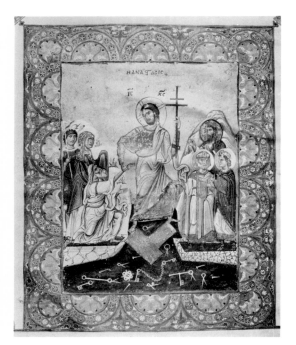

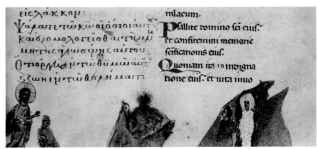

εἰϲλάκκον·
Ψαλατετῶκωοιὁότοιαυτ̄ω
καὶδομολογειθαιτῆμνη
μητϲαγιωϲυηϲαιτου
Ὁτιοργημρτωθϋμωαϋ
ϲζωηεμρτωθ6ρηματτ

inlacum.
Psallite domino sci eius·
et confitemini memorie
scificationis eius·
Quoniam ira in indigna
tione eius· et uita inuo

86 Berlin, Kupferstichkabinett cod. 78 A9, fol. 79r, Raising of Lazarus

85 Athos, Lavra, *skevophylakion*, fol. 1v, Anastasis

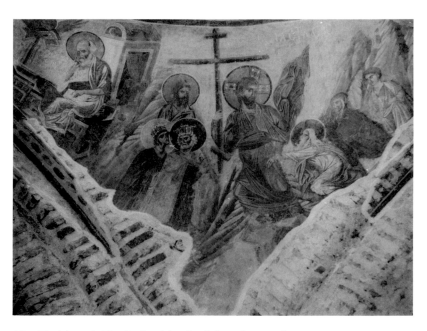

87 Trebizond, Hagia Sophia, St. John; Anastasis

88 Istanbul, Kariye Camii, *parekklesion*, Isaiah Commands
the Angel to Destroy the Assyrian Army

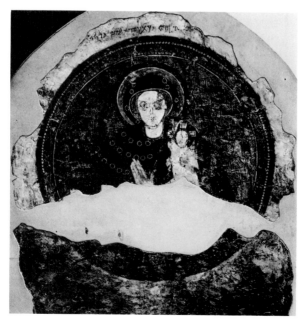

89 Khartoum, National Museum, Virgin and
Child before a City Wall

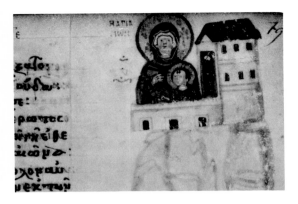

90 Moscow, Historical Museum cod. add. gr. 129, fol. 79r, Holy Sion

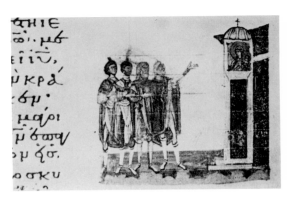

92 Jerusalem, Greek Orthodox Patriarchate cod. Taphou 14, fol. 106v, the Magi and a Persian before an Image of the Virgin

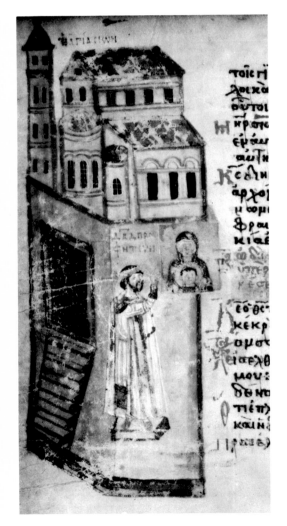

91 Moscow, Historical Museum cod. add. gr. 129, fol. 86v, David Prophesies the Glory of Sion

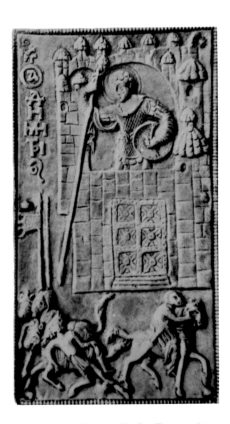

93 Athos, Vatopedi, St. Demetrius Defending the City of Thessaloniki

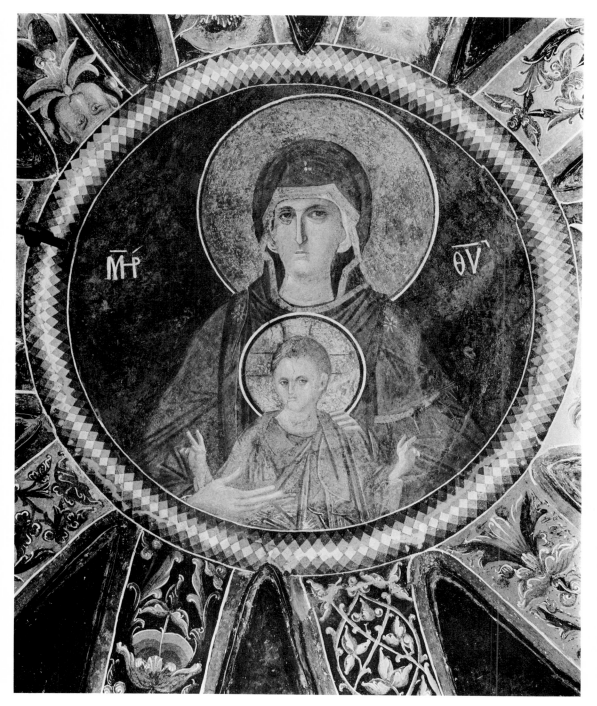

94 Istanbul, Kariye Camii, Virgin and Child

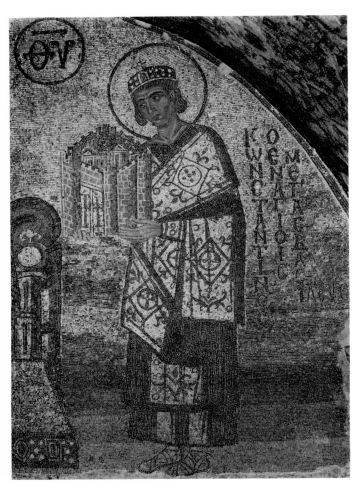

95 Istanbul, Hagia Sophia, Emperor Constantine with
an Image of the City

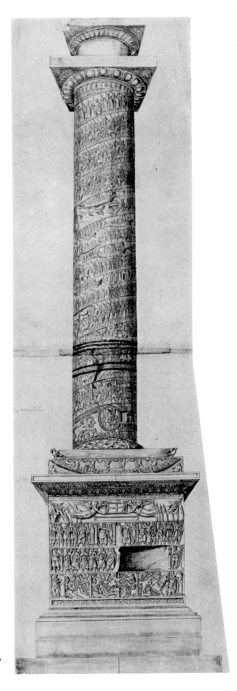

96 Cambridge, Trinity College Library,
Column of Arcadius (drawing)

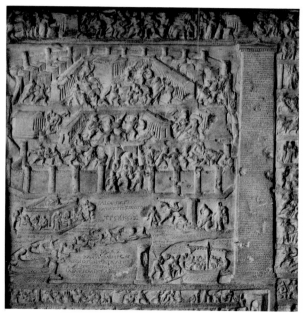

97 Vatican cod. gr. 699, fol. 82v,
The Stoning of Stephen

98 Rome, Capitoline Museum,
Tabula Iliaca, detail: Troy

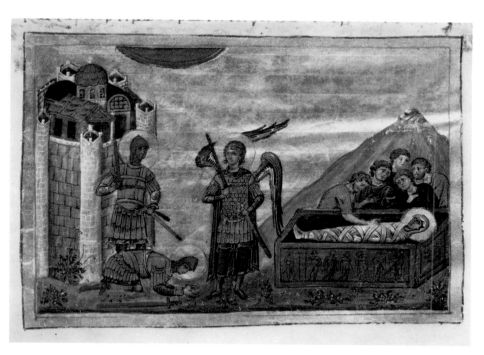

99 Vatican cod. gr. 1613, fol. 3r, Joshua before the Angel of the Lord

100 Jerusalem, Greek Orthodox Patriarchate cod. Stavrou 109, Constantine and Helena;
The City of Constantinople

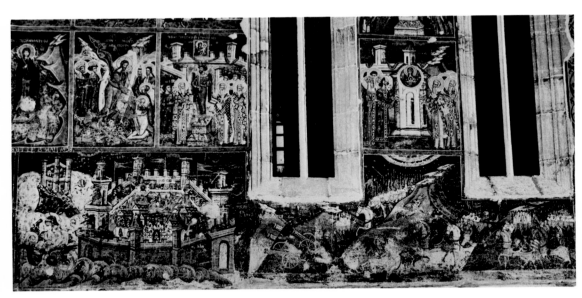

101 Moldoviţa, *katholikon,* The Siege of Constantinople

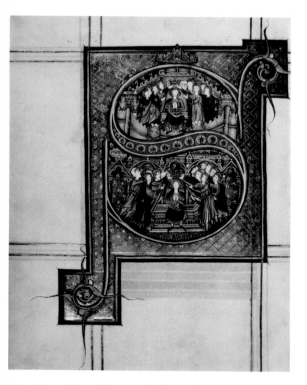

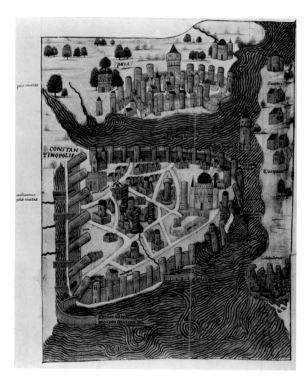

102 New York, Morgan Library M. 730,
 fol. 78v, David Crowned

103 London, British Library, MS Arundel 93,
 fol. 155r, Map of Constantinople

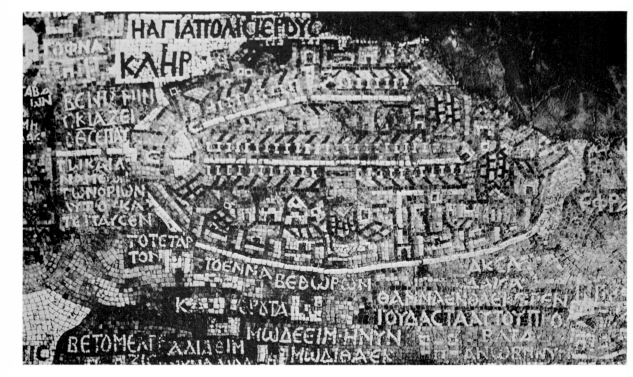

104 Madaba, Church of the Virgin, View of Jerusalem

105 Istanbul, St. Euphemia,
 Martyrdom of St. Euphemia

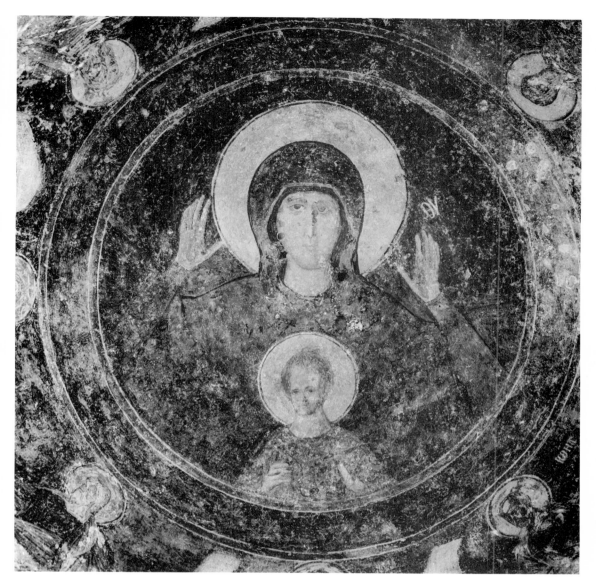

106 Mistra, Aphentiko, Virgin and Child

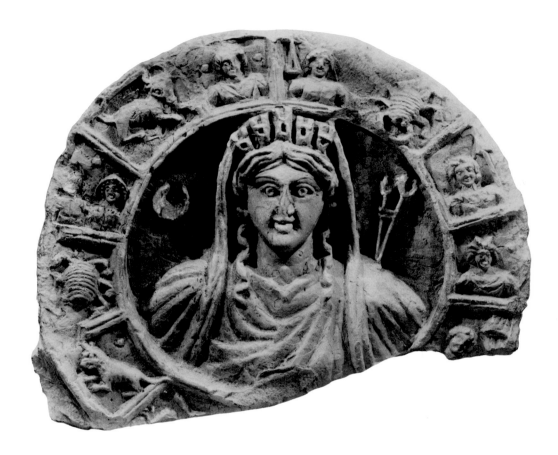

107 Cincinnati, Art Museum, Atargatis as Tyche of a City